Rao Khengarji
of Kutch

Appajirao Sitole

Maharaja Chhatrapati Maharaj of Kolhapur.

Dhangadhra

Rao Khengarji of Kutch

Bhupindar Singh of Patiala

Wahaduyafarkhan
of
Bhopal

Bijeysingh
of Dungarpur

Khan Bahadur
of Manipur.

Madhava Scindia Bahadur of ???
Shib 1911

Sultan Jahan Begum
of Bhopal

Kishen Singh
Bharatpur.

S. Mukho Singh.
Maharajah Jaipur

Rama Varma
Travancore.

Madansingh
Maharajah of Kishangarh

Krishnaraja Wadiyar

Ranjit Sinhji
of Nawanagar.

H. H. Himmatsingh
of
Idar.

गुलाब सिंह

Summair Singh
of Jodhpur.

Ganga Singh of Bikaner

Ahmad Ali Khan

Prabhu Narain,

Rao Bahadur Raja
chatur Sinha C.S.I.
of Alwora c.S.

Nawab of Malerkotla

Maharajah of Benares

Jey Singh — Ulwar
Delhi 1911.

महाराजा नरवरसीं भवासिं हदेवबहादुर

M. H. Sadul Singh
of
Bikaner
Bhawani Singh

Ram Singh
of Sitamau

Raja of Sikkim

महारावराजा रघुवीरसिंह

of Kishangarh

Usman Ali Khan
Nizam of Hyderabad

Madhav Rao Scindia
of
Dewas Junior Branch

Ali Mahmud Khan

Pratapsingh

Bhavsingji Tu
नानाशिटोले

Balwantrao Scindia

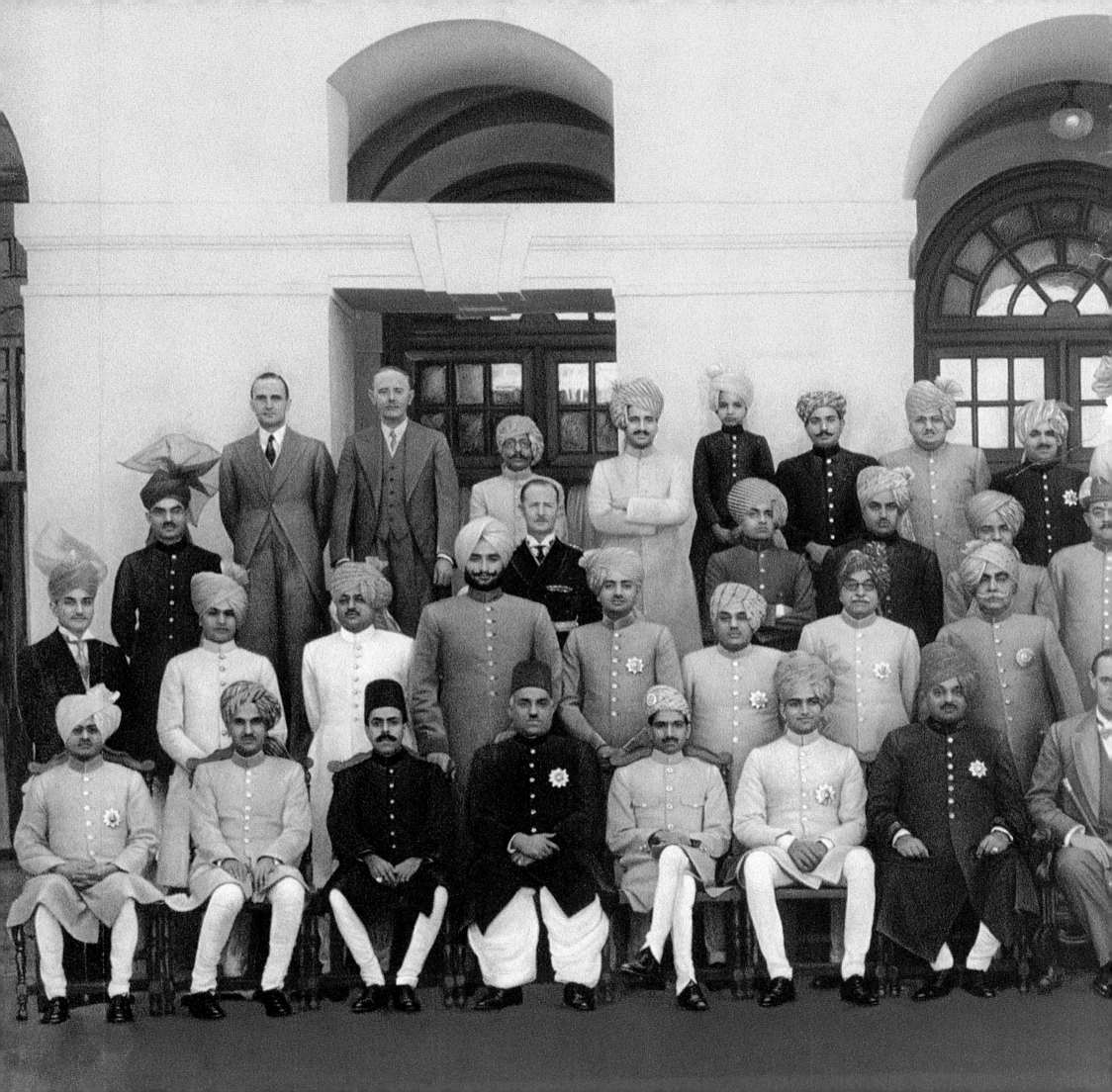

ACKNOWLEDGEMENTS

The Royal Archives, HM Queen Elizabeth II, Windsor Castle

Princely States of India

Baroda, Bharatpur, Bhavnagar, Bikaner, Dungarpur, Gwalior, Indore, Jamnagar,
Junagadh, Kapurthala, Kishangarh, Nabha, Orchha, Palitana, Pataudi, Patiala,
Porbander, Rajmata Gayatri Devi Collection (Jaipur)

The Victoria and Albert Museum, London

Musée Guimet, Paris

The British Library, India Office Library, London

The Sir Henry Royce Memorial Foundation, UK

National Portrait Gallery, London

Hulton Archives

Courtauld Institute of Art

Bates & Hindmarch

Martand Singh Collection (Kapurthala)

E. Jaiwant Paul Collection

Roli Private Collection

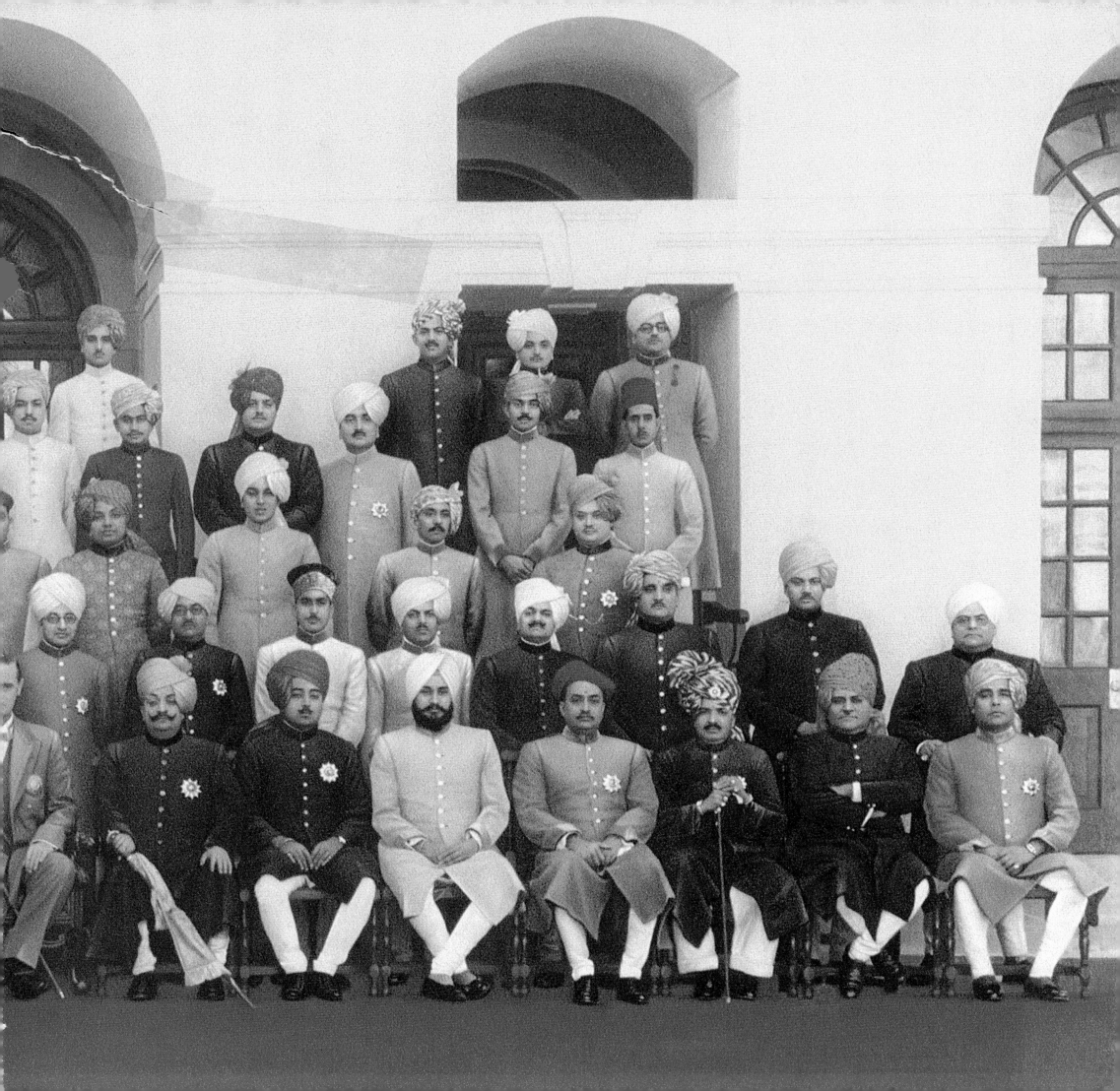

THE UNFORGETTABLE
MAHARAJAS

One hundred and fifty years of photography

THE UNFORGETTABLE
MAHARAJAS

Text
E. JAIWANT PAUL

Photo Research & Editing
PRAMOD KAPOOR

Lustre Press
·
Roli Books

PRECEDING PAGES 2-3: THE CHAMBER OF PRINCES WAS SET UP IN 1921, LARGELY THROUGH THE EFFORTS OF THE MAHARAJAS OF PATIALA AND BIKANER, LORD CHELMSFORD AND EDWIN MONTAGU. THE CHAMBER WAS, AS LORD CHELMSFORD DESCRIBED IT, 'A WEIRD ASSEMBLY, RANGING IN IDEAS FROM THE TWENTIETH TO THE SIXTEENTH CENTURY'. MEETINGS WERE HELD IN DELHI. ALL 118 SALUTE STATES WERE MEMBERS; 12 NOMINEES REPRESENTED THE 127 STATES NEXT IN IMPORTANCE.

THE UNFORGETTABLE MAHARAJAS

Page... 19

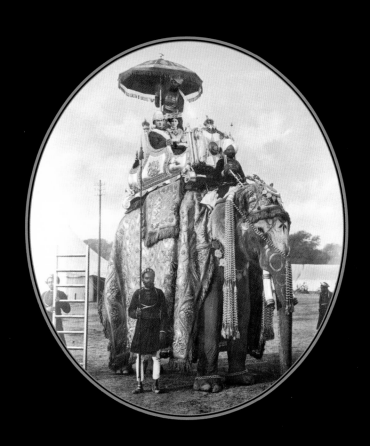

*Picture stories of the men and
women who, individually and as
a group, formed the cream of
Indian royalty.*

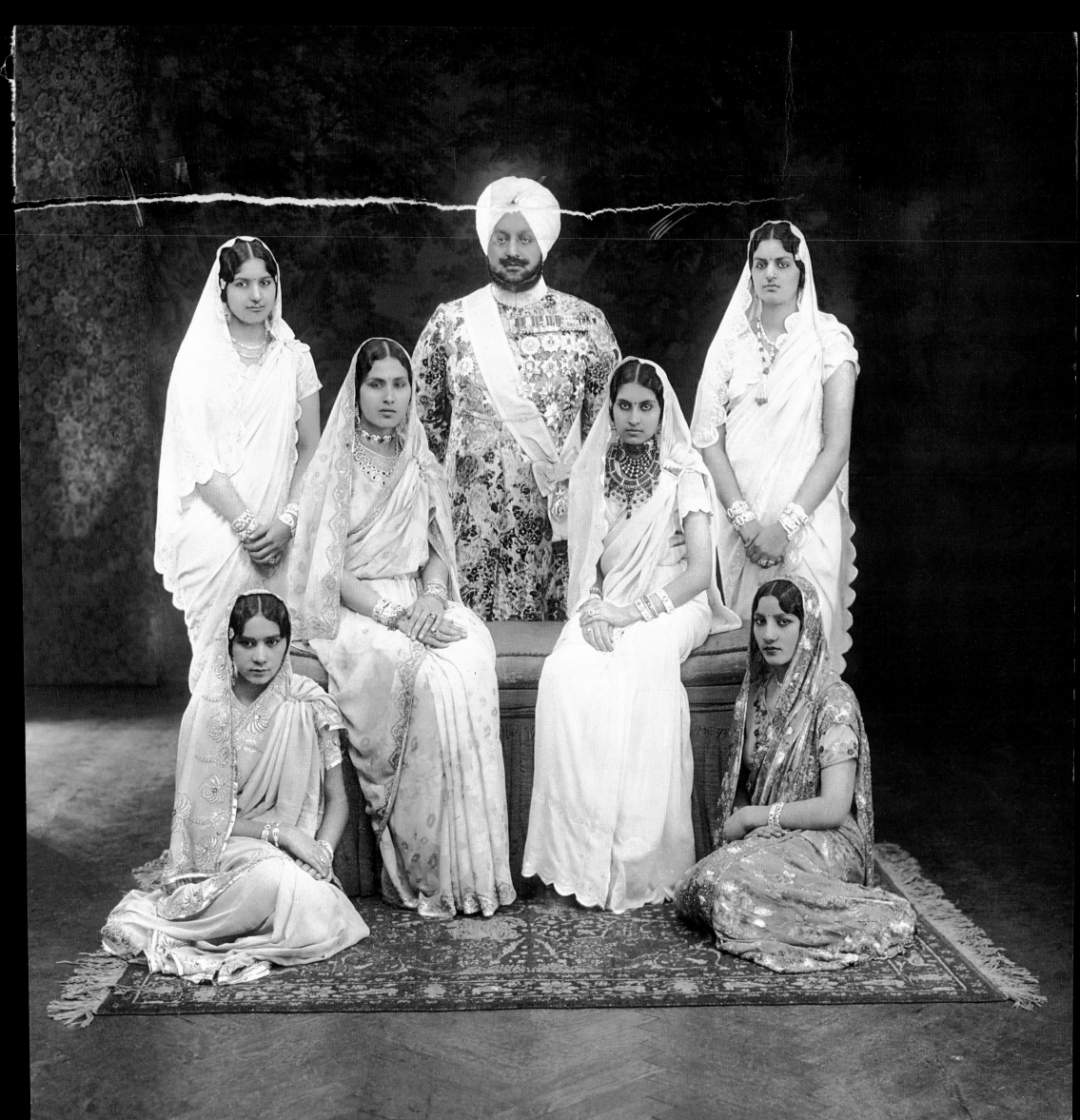

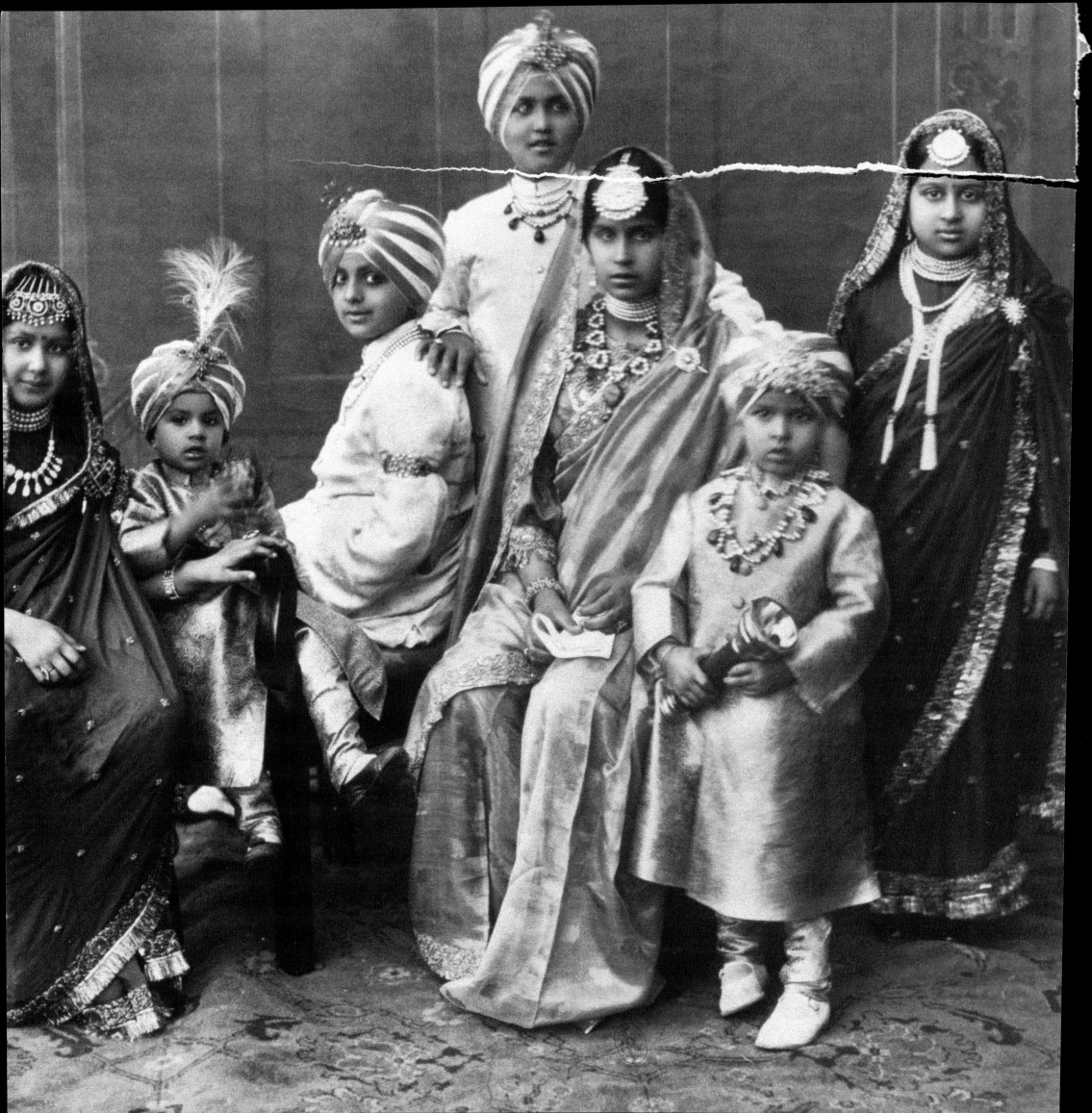

These are the fairy tale years,
untouched by the cares of the throne,
an innocence still uncorrupted by the
wealth draped over them.

TOP: GAYATRI DEVI OF JAIPUR AS A CHILD.

FACING PAGE: PRINCES AND PRINCESSES FROM PATIALA. THE LITTLE PRINCE IN FRONT PROUDLY HOLDS A NEW TOY: A FLASHLIGHT!

AND THEY POSED FOR POSTERITY

Page… 55

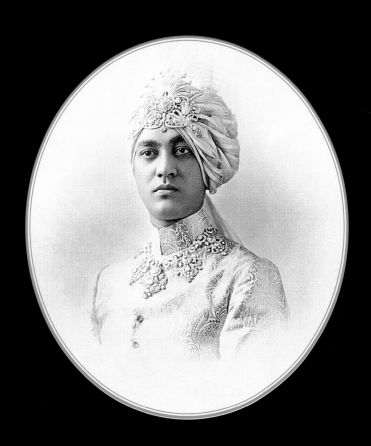

*Portraits of Indian royalty taken by the
leading photographers of the time. The
story of royal fascination with the
evolving art of studio portraiture.*

TOP: THE MAHARAJA OF COOCH BEHAR, SIR JITENDRA NARAYAN BAHADUR (1886–1922).
FACING PAGE: MAHARAJA HIRA SINGH OF NABHA WITH HIS HEIR AND OTHER NOBLEMEN.

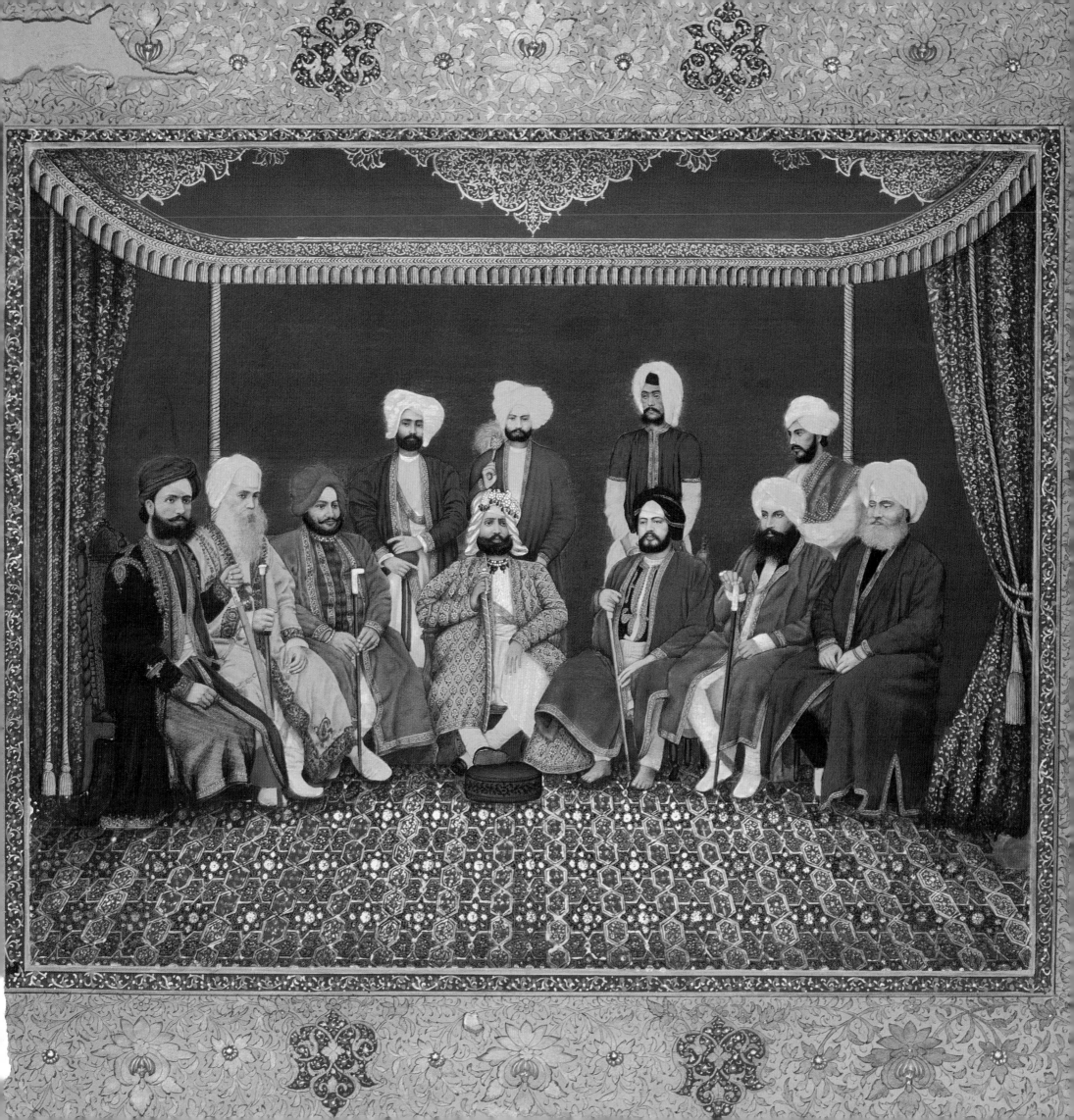

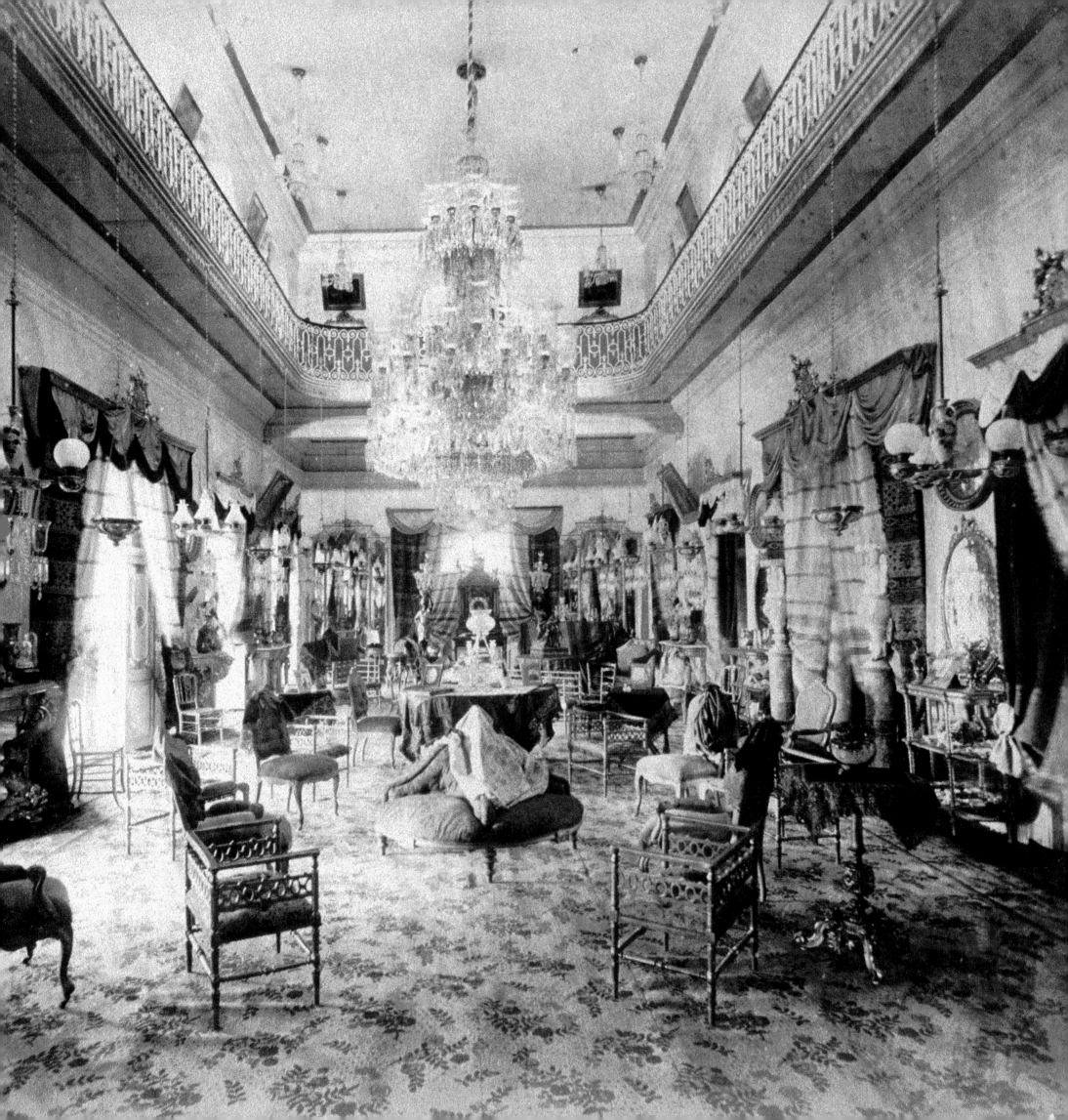

CITADELS OF POWER

Page... 133

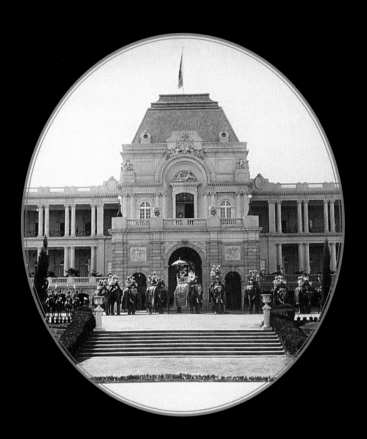

*Imposing royal residences in a vast range
of locations built for the Maharajas to
suit royal whims and grand designs, or
simply to overawe the world.*

TOP: THE ELYSEE PALACE BUILT BY MAHARAJA JAGATJIT SINGH OF KAPURTHALA.
FACING PAGE: THE FALAKNUMA PALACE OF THE NIZAM OF HYDERABAD.

CELEBRATING AN ERA

Page... 159

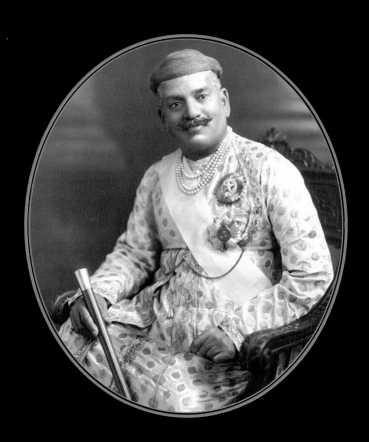

*The pomp and splendour of courtly life
enshrined in charming and quixotic tales
of traditional values and, occasionally,
royal eccentricities.*

TOP: THE MAHARAJA OF BARODA, SAYAJIRAO GAEKWAD.
FACING PAGE: A DURBAR AT THE LAXMI VILAS PALACE, BARODA.

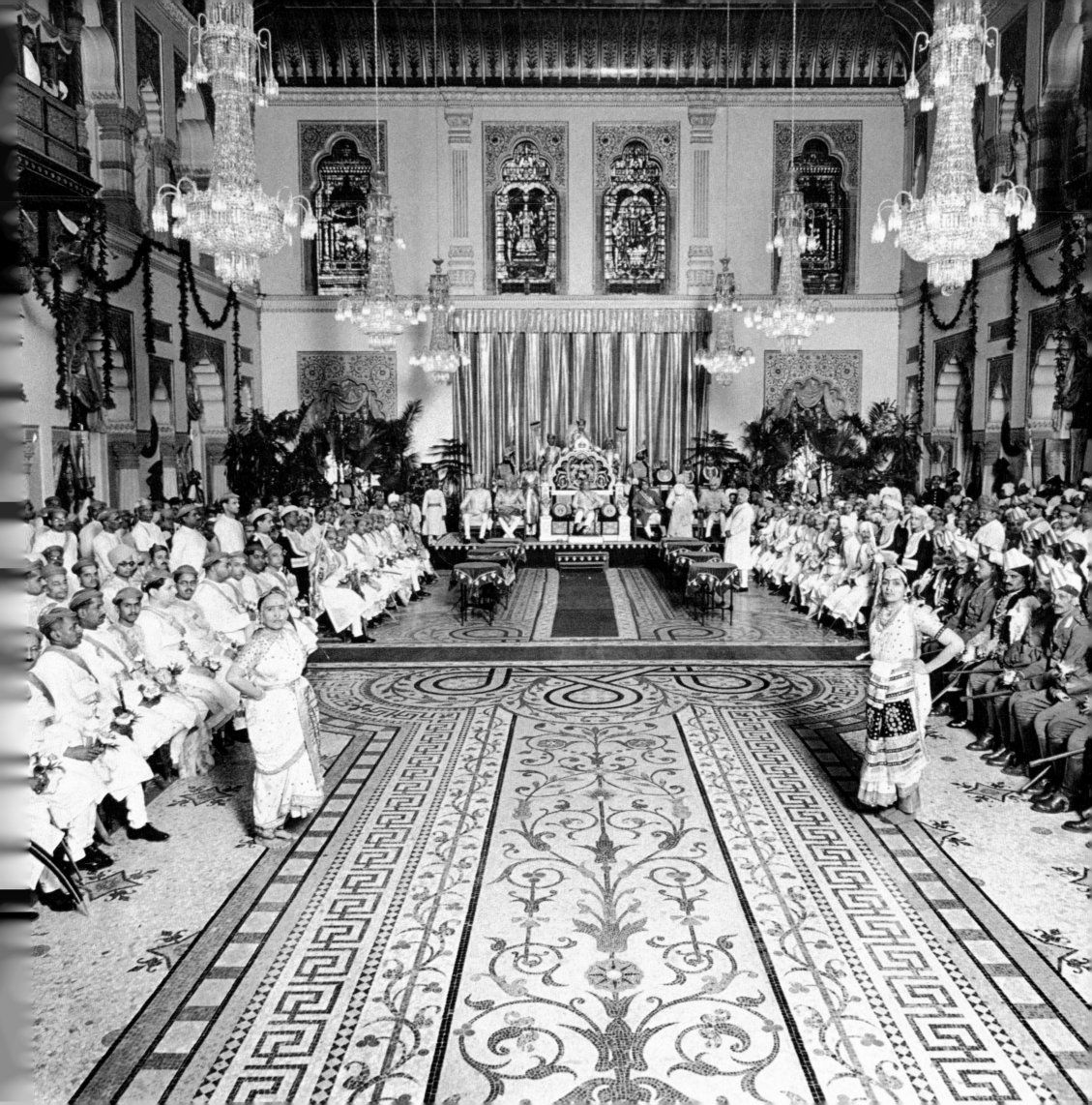

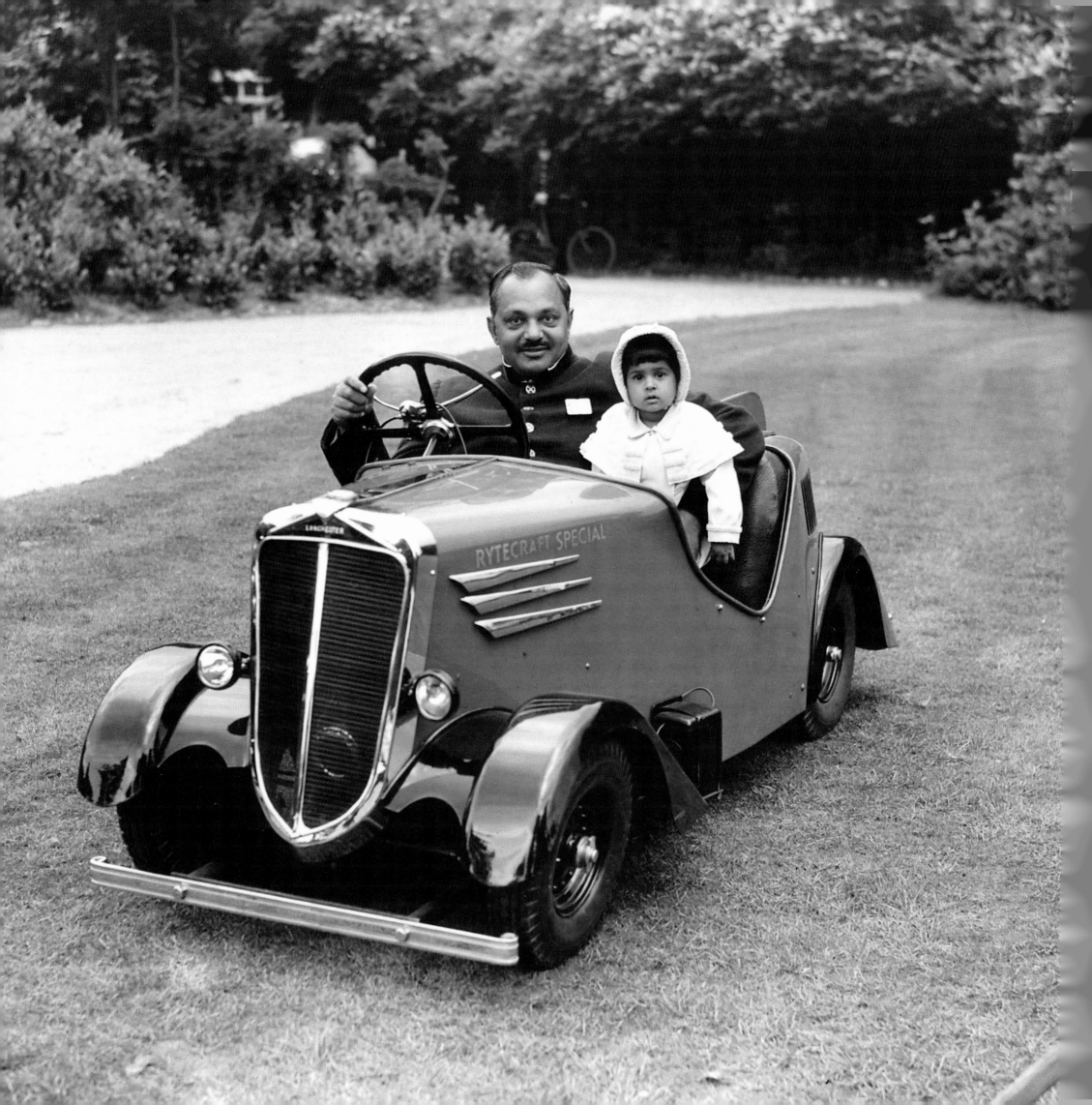

PRINCES AT PLAY

Page... 217

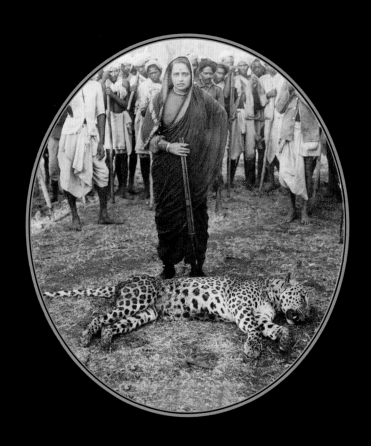

Hunting, shooting, playing cricket and
polo, or driving fast cars—these were a
few of their favourite things.

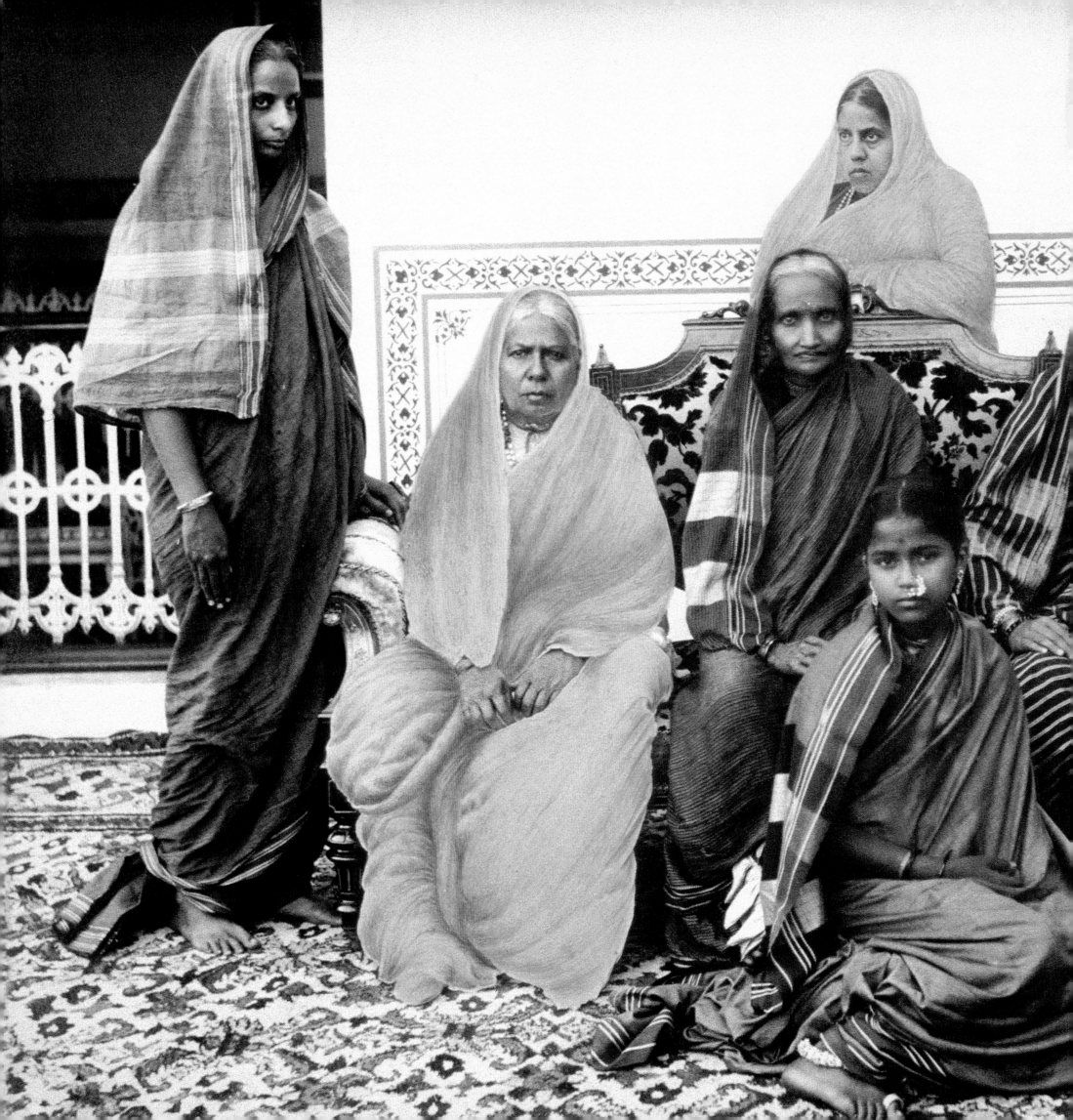

THE UNFORGETTABLE
MAHARAJAS

Imperious, shy, nervous or coy—the princes and rulers captured in these photographs recall the quintessential atmosphere of a bygone age. Almost all these colourful rulers have passed away, and with them has vanished an era that was unique. The only reminders of those days are the photographs of princely India and the Raj, taken between 1800 and 1950. Lying in forgotten private collections or in royal archives, they document a way of life that gave rise to legends and fairy tales about Indian kings and queens, their palaces and fabulous jewels.

Yet the photographs of those times, however evocative, reveal only a small part of the stories behind them: many remain tantalizingly opaque. The seven women on the facing page are obviously from Maharashtra. But who are they? Who tinted two of them and why? To answer these questions, the glimpses of the lives seen in the photographs need to be supplemented and the lives and times of the Maharajas have to be recalled.

The Princes of India were undoubtedly one of the great anachronisms of the twentieth century. Among them were enlightened rulers and profligate princes, saints and scoundrels, heroes and cowards, sadists and boors, charmers and eccentrics. Yet whatever they were, in the eyes of the people they ruled they had the divine right to do so. This power, coupled with their enormous wealth, gave them a status that made them larger than life. They were seldom nonentities and rarely lovable. Yet, good or bad, they had a royal personality and their photographs reflect that unmistakable aura of majesty that they effortlessly carried. The pictures in this book convey the romance of India represented by the princes and their pomp,

pride and circumstance. They are also an archive of princely India, a historical record of an age we will never again experience.

India was the jewel in the crown of the British Empire. It was the largest foreign market that any country has ever been able to exploit for its own advantage. No wonder then that for economic reasons as well as national prestige, India was considered the 'Brightest Jewel in the Imperial Crown.' Lord Curzon (Viceroy, 1899–1905) once declared, 'As long as we rule India, we are the greatest power in the world. If we lose it, we shall drop straight away to a third-rate power.'

Until the early 1800s, the British held only one-third of the country's territory, mainly in southern and eastern India. Their territory and power grew, not in a few decades, but over a century and a half. This gradual expansion has perhaps no parallel in history. The subjugation of India by the British was not a case of an outright conquest of one country by another, but a story of slow penetration in

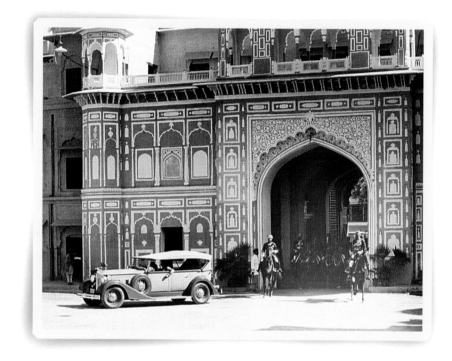

which the people of the land themselves helped the foreign intruder.

Initially, a trading company that had a small army to protect its interests, the East India Company underwent a change after the British became powerful enough to challenge the Marathas, who were then the premier power in India. The Peshwa in Pune, Scindia in Gwalior, Bhonsle in Nagpur and Holkar—all took up arms against the East India Company's force, but never together. In the north, the Sikhs continued to fight the British forces till 1849, but ultimately they too succumbed.

A turning point in the history of British rule in India was the Revolt of 1857. Without the princes of India the British forces would not have won India or subjugated it for a hundred years. During the Revolt, several princes gave invaluable support to the British. The Nizam sent his troops to assist them, as did Patiala. The Maharaja of Jind marched in person with his army to help the foreigners. No wonder Lord Canning gratefully acknowledged the role of the states, especially the Scindias of Gwalior, when he declared them

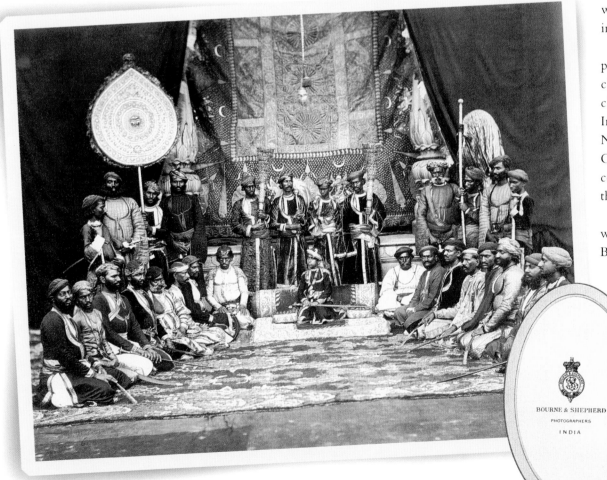

BOURNE & SHEPHERD
PHOTOGRAPHERS
INDIA

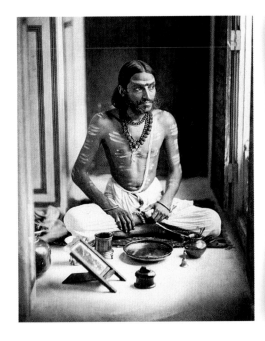

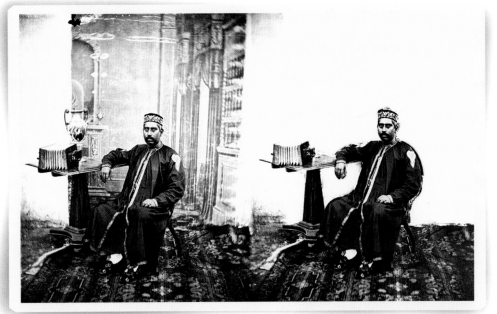

to be 'breakwaters in the storm which would have swept us in one great wave'.

The Revolt of 1857 was undoubtedly the point in history when the political emasculation of the Indian rulers began. Despite the help given by the Indian princes in the immediate period after the Revolt, the British considered them potentially dangerous, as they were the traditional rulers and military generals who commanded a following. Obsessed at the time with the necessities of military defence, the British chipped away at the sovereignty of the princely states so that individual states never became powerful enough to threaten British hegemony.

An Act of Parliament in 1858 formally ended the rule of the East India Company in India and the British Crown took direct control of all its Indian territories. Pax Britannica, as this treaty was called, defined the rules of a new relationship. Under it, the size of state armies was restricted and the princes had to relinquish control on Posts and Telegraphs in their principalities. Their right to mint copper and silver coins, except in a few larger states, was taken away and British Indian currencies become legal tender. Paramountcy was now sternly thrust down on the princes. The list of rulers deposed or forced

to abdicate in the last two decades of the nineteenth century is long and included, among others, the rulers of Panna, Bharatpur, Tonk, Alirajpur and even the eminent Maharajas of Baroda, Indore and Mysore.

While the iron hand of the British government was much in evidence during this period, their treaties with the states simultaneously guaranteed the princes total protection from any enemies outside their states, thus assuring their territorial integrity. Their incomes and privileges were also safeguarded. What is more, the rulers were granted protection from insurrection even from within their states. Thus they were no longer accountable to their own people. Such insurance from public responsibility had terrible consequences. While they retained a kind of independence, the princes became totally reliant on the British. With no incentive to govern faithfully or well, they lapsed into extravagances and absurdities and a moral inertia inevitably set in.

The predicament of the princes is best illustrated in the sentiments expressed by the Maharaja of Vijayanagram at the turn of the century. A keen polo and cricket player, he was once mildly reproved by the Viceroy for drinking too much. 'I know I am an idle, drunken fellow,' he confessed ruefully, 'but

MORNING PUJA: SAWAI RAM SINGH II OF JAIPUR WAS A LIFE PATRON OF THE PHOTOGRAPHIC SOCIETY OF BENGAL (ESTABLISHED IN 1856). HE STARTED OFF ON PHOTOGRAPHY IN THE EARLY 1840S WHEN STILL IN HIS TEENS, AND HAD SET UP A PHOTOGRAPHY STUDIO (CALLED TASWIRKHANA OR FOTOO-KA-KARKHANA) IN HIS PRIVATE PALACE APARTMENT. A SKILLED PHOTOGRAPHER, HE USED THE CALO-TYPE AND THE COLLODIAN PROCESS, AND HAS LEFT BEHIND AN ASTONISHING COLLECTION. SEEN HERE ARE A SELF-PORTRAIT (*LEFT*) TAKEN C. 1860 AND A 'STEREO' PHOTOGRAPH, ONE OF HIS MANY PHOTOGRAPHIC EXPERIMENTS.

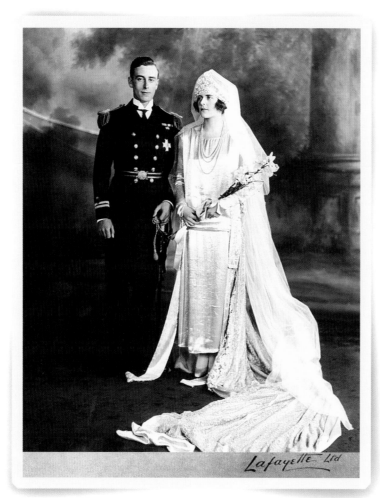

what can I do? Your Pax Britannica has robbed me of my hereditary occupation. What is my hereditary occupation? It is fighting.' When he died in 1897, he was sadly aware that he was the third generation of his family to die in bed rather than on the battlefield.

By the early 1900s, the British realized that the danger from the princes was long past and the new menace was the nationalist movement and the revolutionaries who threatened both the British and the princes. The Maharajas were now perceived as allies of the Empire: a bulwark against the Indian Congress, and the iron hand now donned a velvet glove. The princes were disdainfully labelled 'pampered and petted favourites' or 'bulwarks of the Indian Empire' by the nationalists. After the outbreak of the First World War, the princes were asked to help by providing men and money to Britain. Between 1905 and the mid-1930s, paramountcy became less assertive and the princes were given a free hand to govern as they wished. The more enlightened ruled their states in a sensible way, giving due regard to public welfare but many others ruled according to whim and persisted in their autocratic ways.

However, the British would not tolerate gross misrule, dastardly crime or inflammatory sentiments for they considered all agitation dangerous to the interests of the Empire. Depravity, however, was accepted as long as it did not cause a public scandal. A certain Maharaja used to amuse himself in a shallow swimming pool where the water came up to mid-thigh level. Forty naked women, each holding a candle of a special shape, accompanied him into the pool. The candles were adjusted in the most erotic spot on the ladies' bodies and then lit. The lady who could best protect the flame of her candle from the watery splashing was rewarded by being pleasured by the prince.

Naturally, the policy of non-interference by the British in state affairs led to several anomalies in state governance and administration. While some of the larger states, such as Hyderabad, Mysore, Gwalior and Baroda did attempt to apply some principles of good governance, the smaller states, that formed the bulk of princely states in India, were often disorganized and badly administered. The 'good' states generally had High Courts and a decent judicial system. Many appointed experienced and talented administrators as Diwans or Chief Ministers, supported by an Executive Council, and the ruler delegated significant authority to them. All this added up to an efficient and professional administration with higher standards of literacy and social progress than British India. Diwans, such as Sir M. Visveswarayya, Sir Akbar Hydari, K.M. Pannikar, Sir Mirza Ismail and M.A. Srinivasan, were universally considered men of sagacity and vision. Apparently, King-Emperor George VI once asked, 'Why is it that the Indian rulers are continually exchanging divans?' It had to be gently explained to him that Diwans did not refer to furniture but to Chief Ministers!

The smaller states, however, were generally administered

poorly and on the whims of the rulers. Many were governed on the paternalistic principle that viewed the ruler as the father and mother (*mai baap*) of the people. One ruler refused to put down the state budget on paper, saying that he carried it in his head. In the early 1900s, the Maharaja of Indore had to seek the help of moneylenders. Fed up with their demands, the disgusted Maharaja finally ordered all six be put into harness and had them pull his carriage around Indore. In the small Bundelkhand state of Datia, in the early 1900s, the Controller of Dancing Girls drew Rs. 400 for his services in that capacity, and Rs. 150 for his services in his additional capacity as Chief Justice. There are hundreds of stories about the farcical atmosphere of these tiny principalities, but it must be said that some of these are apocryphal.

Yet the Maharajas were generally benevolent autocrats. They maintained close personal touch with their people, regularly toured their states, supervising the administration and meeting the people. Any person could air his grievance before his Maharaja and usually some redress was made.

The princely states of undivided India comprised a little under half of the subcontinent, covering an area of over 700,000 square miles. Their territories extended 2,000 miles from the border of Afghanistan to Cape Comorin, the southern extremity of India. The 565 Indian states enjoyed varying degrees of autonomy depending on their size and importance.

Broadly, the princely states fell into three categories. First came the ancient states, which could trace their ancestry to a thousand years or more. These included the Rajput states of Rajasthan as well as some in Central India, Saurashtra in the west coast, and a few minor ones in the north. The southern states of Mysore and Travancore also fell into this ancient group. The antiquity of these states was aptly underlined by Benjamin Disraeli speaking in the British Parliament in 1876, when he said, 'Some Indian Princes sat on thrones which were in being when England was a Roman colony.'

The second group of states was established in the chaos that followed the fragmentation of the Mughal empire in the 1700s. Mughal governors who declared their independence from Mughal rule founded independent kingdoms, such as Hyderabad and Rampur. Avadh (or Oudh), another important

state, was also a fragment of the Mughal empire, but it was liquidated by the British after the Revolt of 1857.

In the third group of principalities fell those that were carved out by military adventurers at the point of the sword by the Marathas, Jats and Sikhs. Of these, the most important were the Maratha states of Gwalior, Baroda and Holkar, the Jat state of Bharatpur and the Sikh states of the Punjab, notably Patiala. The Muslim states of Bhopal and Bhawalpur also belong to this category.

Yet another minor group may be mentioned: these were set up by the Rajputs who had moved out of their homelands into Orissa and its neighbouring areas, notably Mayurbhanj and Bastar. It is of interest to note that other than the Muslim states, the rest of the princely states were largely established and ruled by the Rajputs, Marathas, Dogras, and the Sikhs.

A map of the Indian states at the time of Independence in 1947 will show that there is almost contiguous state territory from the areas bordering Central Asia to Kanyakumari, the

TAKEN DURING THE VISIT OF THE PRINCE AND PRINCESS OF WALES IN 1911 TO MAHARAJA RAGHUBIR SINGH OF BUNDI. THE INDIAN ATTENDANTS MAKE SURE THAT THE STRONG INDIAN SUN DOES NOT SCORCH THEIR ROYAL GUEST.

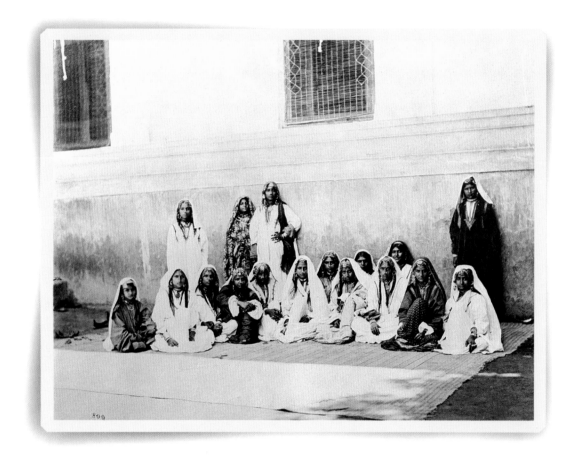

coastal forests. Similarly, from west to east, from the Indus almost up to Calcutta, the country remained outside direct British rule.

Another important feature of the princely states was their diversity. Their great differences in race, religion and culture kept the Maharajas from ever functioning as a homogenous body. Old antipathies lived on, traditions refused to die. Added to these were personal differences. The result was that the Indian rulers were a motley tribe: from those educated at a British public school to those who could barely read or write. Some ran their states on modern lines, others on personal whim. Some were brilliant administrators: in the 1930s, those who stood out were Ganga Singh of Bikaner, the Marwar dynasty of Udaipur, Hamidullah Khan of Bhopal, Bhupindar Singh of Patiala and the Maharaja of Travancore. They were progressive rulers, lawgivers, educationists, builders of roads and canals and had the courage to resist British domination. At the other end of the scale were the sinister and the impotent, some of who had to be deposed from their thrones for their misrule and heinous crimes.

There was a similar diversity of size. The largest state was Hyderabad that was equal to the size of France. Kashmir was another state that covered a huge geographical area. And there were the absurdly small 250-odd states of Saurashtra. Almost half of these statelets were less than ten square miles in size, some a mere five square miles. Naturally, the revenues of the states varied enormously. The 12 largest states had revenues of over 10,000,000 rupees per annum each with the biggest collecting two or three times this figure. In the 1930s, these were astronomical figures. At the bottom of the princely pyramid, however, were 170 states with incomes of under 10,000 rupees.

There could be no common ground between the large sovereign principalities and the small chieftainships. To deal administratively with this diversity and to separate the princely sheep from the princely goats, the British had divided the 565 states into three main classes. The First Division States had full powers of internal administration, made their own laws, and had absolute powers of life and death over their subjects. These were known as the Salute States and the princes of these states were honoured by gun salutes, fired when they officially

southern-most point of the Indian peninsula. Thus, one could travel the length of India, all of 2,000 miles, without touching British India. From the rugged mountainous areas of Chitral (the ruler of which state was oddly called *Mehtar*), princely India ran through the beautiful vale of Kashmir to the equally scenic, though small, Rajput states of Himachal. Then on to the Sikh state of Patiala on the Punjab plains, the home of stalwart soldiers. Rajasthan came next, where the fiercely mustachioed Rajput warriors clustered around the ancient fortresses of Bikaner, Jaisalmer and Jodhpur and the palaces of Jaipur and Udaipur. Central India was dominated by the Maratha states of Gwalior and Holkar. Further south lay the great Muslim state of Hyderabad, where the descendants of Asaf Jah ruled a vast area of the Deccan plateau. Then into Mysore territory with the exquisite and jewel-like Hoysala temples of Belur and Halibid. And at the tip of the peninsula was Travancore, with the unrivalled beauty of its backwaters or lagoons amidst thick

visited the imperial capital and on all formal occasions. The Salute States numbered 118, roughly one in five, and their gun salutes were graded from 21 guns down to nine guns. The Salute list had considerable significance as it provided the only basis for the gradation and control of the states. The rulers of the five largest states, which included the Nizam of Hyderabad, the Maharaja of Jammu and Kashmir, Maharaja Scindia of Gwalior, Maharaja Gaekwad of Baroda and the Maharaja of Mysore, were honoured by 21-gun salutes. Another six states were entitled to a salute of 19 guns and included Maharaja Holkar of Indore, the Nawab of Bhopal, the Maharana of Mewar, the Khan of Kalat, the Maharaja of Travancore and the Maharaja of Kolhapur. These were followed by states with salutes of 17, 15, 13, 11 and 9 guns. Maharajas bickered among themselves about their gun salutes and efforts were constantly made to achieve a higher level of bombardment, for the salutes not only gave special status but certain privileges went with the scale of salutes. The honorific of 'Maharaja' generally applied to states with 13 guns or more, while 'Rajas' were confined to the ranks of 11- and 9-gun categories. A further indication of status was the title of 'His Highness', accorded to most of the Salute States. The Nizam of Hyderabad was, however, always 'His Exalted Highness.' The gun salute for the Viceroy was 31 guns, and for the King Emperor an unrivalled 101.

After the Salute States, came 117 non-salute states. These states submitted to a greater British control over general administration. Such states could only make laws after approval by the Government of India, and their judicial powers were limited to minor offences. However, this category of states had full relations with the British government and were represented in the Chamber of Princes through 12 nominees.

At the bottom of the heap were 327 'other' states where executive, legislative and judicial powers were controlled to a much greater extent by the British Residents or Political Agents attached to those states. These could be categorized as Estates rather than true states, and were headed by Thakurs, Talukdars and Jagirdars. However, 'the states were not British territory and their subjects were not British subjects'.

Protocol and ritual were not empty symbols in relations between the paramount power and the princes and so their observance received high priority. Intensive thought and

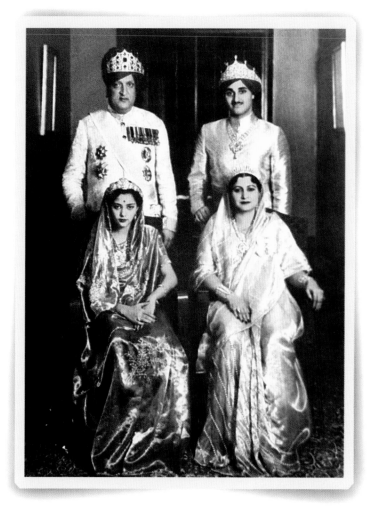

research had gone into this aspect. In addition to gun salutes, there were other honours due to the princes. The Nizam of Hyderabad and the 21-gun salute rulers had special privileges. They had to be met at the front door of Government House by the Viceroy and escorted through the public rooms. A minor prince with fewer gun salutes was only entitled to a couple of steps in front of the Viceroy's throne. Similarly, when the Viceroy went visiting the five largest states, the Maharaja was expected to meet him at the door of his drawing room, but a lesser prince had to await him in the porch and an even lesser one had to meet him at the border of his state or at the railway station.

In trying to establish a loyal Indian aristocracy, the British gave the princes crests and coats of arms devised by an expert

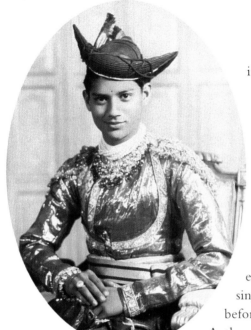

in British heraldry, although some of these were meaningless and even foolish. Another form of ceremonial followed was the National Anthem. Some of the larger states had invented one for themselves. Nawab Iftikhar Ali Khan ruled the tiny state of Pataudi near Delhi. As a student at Oxford he and some friends once visited Spain. A small town council decided to give the young prince from India a civic welcome at which the Spanish National Anthem was played. At the end of it, Pataudi and his friends were asked to sing the Indian National Anthem. This was well before Independence and there was no Indian Anthem as such. Such a confession would have been most embarrassing and not one for ever letting the side down, Pataudi stood up solemnly and without batting an eyelid sang, '*Bibi Mendki re tu to hai kuan ki Rani*', a folk song about a lady frog! He claimed to have sung it in perfect tune, evoking much appreciation from the Spanish listeners.

The King Emperor also used decorations and honours as a means of strengthening the loyalty of the Princes. Sometimes he went overboard and it was not unusual for a Maharaja to have the following titles: Maj. Gen. His Highness *Farzand-i-Dilband* (Beloved Son), *Rasikh-ul-itikad* (Trusted Friend), *Daulat-i-Inglisha* (Treasured by the English), *Maharaja-dhiraja* (King of Kings), GCIE (Grand Cross of the Indian Empire) or GBE (Grand Cross of the British Empire). As the omission of a title in official dealings could lead to unfortunate consequences, the British Resident in Hyderabad devised a precaution. He only used printed envelopes almost completely covered by the titles of the august correspondent while writing to the Nizam.

Interestingly, the British were particular in never referring to the Indian princes in any way that suggested the word 'royalty'. In fact, the words 'royal' and 'royalty' were virtually expunged from the official vocabulary. Indian rulers were referred to as Chief or Prince; for the British officers there was, and could be, only one royalty—their own.

However, Maharana Fateh Singh of Udaipur was one of those worthy souls who stood on his Rajput dignity and resisted British domination. To soften him up, the British King conferred on him the exalted order of Great Commander of the Star of India, the highest honour that the British Government could bestow on a ruler. When the British Resident approached the Maharana and offered him this honour, with the accompanying sash and a star set with precious stones, the Maharana told the Resident that it made him look like one of his own *chaprasis* (peons). Fateh Singh then put the sash and star round the neck of his favourite horse! The Maharanas of Udaipur had never paid obeisance to the Mughals nor visited Delhi. Upholding this tradition, Maharana Fateh Singh avoided appearing before the Viceroy. However, he was forced by Lord Curzon to attend the Delhi Durbar in 1903. The Maharana, accompanied by his nobles, came by train to Delhi, but returned to Udaipur without

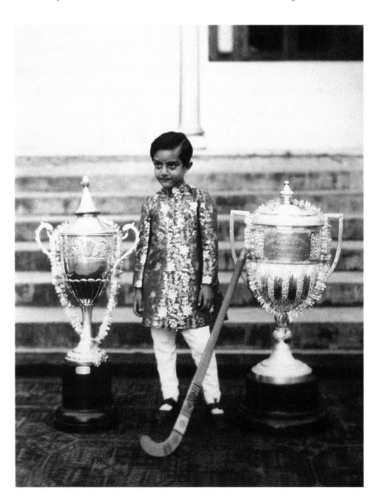

setting foot in the capital, ostensibly on grounds of ill health. He repeated the same performance when he was invited to attend the Durbar held in 1911 in honour of King George V, even though the King Emperor personally came to the Delhi station to receive him. Eventually, however, in 1921 the British found some excuse to depose Maharana Fateh Singh in favour of his son.

To return to the honours and decorations bestowed by the British, some rulers had these decorations and insignia made in diamonds and others, who had no decorations, found ingenious ways to decorate themselves. The Raja of Saket was quite happy to put a small clock made of diamonds on his gold ribboned turban with an aigrette!

The administration and maintenance of relations between the Viceroy and the rulers was the responsibility of the Political Department, which appointed local representatives known as Residents and Political Agents. The five largest states in the country, the 21-gun salute ones, had a permanent British Resident, who kept a close watch on the Maharajas. Lesser states were grouped together under one Resident assisted by two or three Political Agents. The Resident and the political officers exercised wide discretionary powers and sometimes their advice became a command, particularly in the case of smaller states. Some Residents interfered rarely while others were too meddlesome and gave the ruler, as one of them put it, 'the sensation of a rat in his pajamas'. The Residents lived in palatial residences, called Residencies. After all, they had to keep up with the princes. Some Residencies had Durbar halls for the reception of the princes and large park-like grounds and gardens enclosed with defensive walls to prevent any recurrence of the infamous Lucknow Residency massacre during the Revolt of 1857. Ironically, in some cases the ruler himself had to build and provide the Residencies.

A strict protocol existed between the Maharaja and the Resident. For instance, at the spectacular Dussera procession that took place at Gwalior every year, the caparisoned elephants of the Maharaja and those of the Resident walked abreast but since Gwalior was one of the five largest states, the Maharaja's elephant was always exactly one elephant head ahead of the Resident's throughout the route, which wound many miles through the city. One can only marvel at the expertise of the mahouts in maintaining this exact distance between the two elephants. Not directly relevant, yet still worth mentioning, is that in this procession the ministers of Gwalior state had to sit astride their elephants which, considering the width of the animal, was quite a feat. This rendered some ministers incapable of walking for at least a week!

No account of the Maharajas is complete without reference to three aspects of life in the princely states: the zenana, purdah, and their fabulous jewellery.

The zenana maintained in the princely states has been the subject of several apocryphal stories. The popular impression

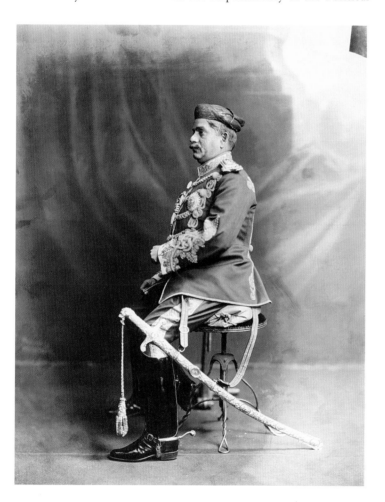

about it is that hundreds of women, many of them young, lived thwarted and unnatural lives, with much of it spent in idleness and boredom in the dark labyrinths of the palaces. While much of this is true, the zenana also had its compensations. Its inmates lived in the lap of luxury with handmaidens at their beck and call. Much time was spent on an elaborate toilette since it was believed that 'if a wife be not elegantly attired, she will not exhilarate her husband. A wife gaily adorned means the whole house is embellished.' The women played dice games and were entertained by folk tales, song and gossip by their servants. Their children romped around and were a source of joy as was the celebration of festivals, with lively music and dancing. Life was also spiced with intrigue and jealousy. Rani contended with Rani and this added to the flavour of life. The zenana was, by and large, accepted as a way of life by the women married into royal families in India. Maharaja Bhupindar Singh of Patiala's zenana was particularly well known in the 1920s and 30s, and had over 300 inmates. The Maharaja

was a tall, handsome man, with sophisticated tastes and a seemingly demonic sexual appetite. As an Englishwoman wrote, 'with his gleaming black thigh boots, a long red tunic and white buckskin trousers, he was never inscrutable. He had a curving moustache, waxed to perfection, and vivid staring eyes and in Simla he made the poor British I.C.S. look moistly pink and insipid. The memsahibs might have tittered about the "Favoured Son of the British Empire", but in the fantasies of at least a few of them he was a tiger of a man.' However, women were also the cause of his downfall. He once 'abducted' the niece of the British Viceroy in Simla and disappeared with her for a weekend. Naturally, there was anger and outrage at the Viceregal Lodge and Maharaja Bhupindar Singh was banned from ever visiting Simla again. However, till today a popular tourist spot in Simla is called 'Scandal Point' in memory of the episode.

More than the zenana, it was the purdah system that affected the lives of the common people in the states. It was originally designed for the protection of the royal women. Yet, over the centuries, it became deeply entrenched as a way of life in the princely states mainly due to Muslim influence. In Muslim states, the burka, a tent-like garment that covered a woman from head to toe, with slits for the eyes, was in common use. While Hindu women never adopted the burka, they used to keep the *ghungat*, a veil that covered their heads and faces with the sari end.

However, the purdah system had its funny moments. An oft-repeated story is that of the Nawab of Palanpur and his relatives who went visiting a nearby state. They were told that the wives of the local notables, though in purdah, wanted to see the princes of Palanpur. The occasion was memorable, for as one of the princes later recounted, 'We were sitting like idiots on these chairs wondering how these women in purdah were going to see us, when suddenly we saw a big carpet with holes in it coming towards us. The carpet stopped about six feet away from us and we could see eyes at all the holes! We did not know where to look! Then, after about ten minutes or so, the carpet went back.'

In the princely states, an important role was assigned to costume and attire, jewellery and other symbols of kingship. On special occasions, jewellery was worn in profusion by both women and men as there were vast accumulations of

jewellery in state vaults. With their monopoly of the gem-producing mines and the rights to retain the best for themselves, and the treasures that they had plundered from their neighbours, the Maharajas in India were custodians of no less than 3,000 years of wealth. The large amounts that were plundered and carried away by foreign invaders at various periods of history did not constitute more than a small proportion of what the rulers inherited. The quality and quantity of state jewellery was incomparable and the treasures of many princely states is the stuff of legends. Much of this has now gone and all we are left with are the visual records.

Yet the royal jewels often posed a particular problem for the princes. One Maharaja complained that his jewellery was a totally worthless asset: 'We cannot keep it here because of the wealth tax and we cannot sell it abroad,' he moaned. As antique national treasures, their export was banned. Consequently, much of this treasure left India through unorthodox channels. No one seems to know where it has gone. Several fabulous pieces that were sent to Europe have been broken up and reset. Individual and distinctive gems have, however, been identified when they have resurfaced in international sale houses.

Maharaja Yadavindra Singh of Patiala, who stood at six feet and four inches, wore a turban that added another six inches to his height. Handsome and kingly, he was a striking figure when dressed for a ceremonial occasion. He wore a long coat, (shervani) with diamond buttons. An aigrette (kalgi) would be pinned to his turban which would also be adorned with strings of pearls. Five necklaces of diamonds and emeralds were draped in tiers round his neck. Around his waist he wore a belt of diamonds and a gold lamé scarf held by an emerald four inches long. He carried a lavishly decorated sword, its hilt sparkling with gems, with the scabbard fittings damascened in gold. He looked every inch a king. According to Charles Allen, once when the Diwan's daughter saw the Maharaja dressed and bejewelled she gave a wolf whistle. He was flabbergasted for a moment but then laughed out aloud!

On another occasion, seeing a Maharani laden with jewels, a guest said, 'I calculated that the eighteen-year-old queen was wearing more than her own slight weight in treasure.'

The late Duchess of Windsor is reputed to have bought an Indian emerald drop necklace from a well-known dealer in 1957. Soon afterwards, she wore it at a grand reception where the Maharani of Baroda was also present. The Maharani instantly recognized the necklace, with its fine stones, as having been made from a pair of Indian anklets recently sold from the Baroda collection. 'My dear,' she announced to her companion in a rather loud voice, 'do you notice, she is wearing the beads I used to have on my feet!' Seething at her humiliation, the Duchess returned the necklace to the dealer the very next day.

The Nizam of Hyderabad's fabulous collection of jewellery led the rest. After Hyderabad, the finest collection of jewellery was reputed to lie hidden in the vaults of Jaipur. Raja Man Singh, an early ruler of Jaipur, led the Mughal army in the time of the Emperor Akbar on various foreign expeditions. The loot he brought back from Afghanistan, Bengal and other places was taken back on camels. Of every 100 laden camels, 80 went to Delhi, while the remaining 20 came to Jaipur. This treasure lay hidden in the Jaigarh fort, built on a peak above the Rajput palace of Amber. Here it was guarded by the Minas, a primitive tribe that had lived in the area long before the Rajputs came. So careful and secretive were the Minas that few ever knew the great weight of gold and jewels that lay in their keeping. A Maharaja was allowed to see this treasure trove only once during his tenure and could select one item from it. The story goes that in 1947, when the princely state of Jaipur was about to be merged with the Indian republic, the Maharaja met the Minas at the fort and told them that they had two choices: they could either hand over the whole hoard to the ruling family or they would have to surrender it to the new government of India. Several years after the takeover, when the Indian Government launched a meticulous search at Jaigarh fort, nothing was found there. It is also said that the ruling family is one of the richest in the country.

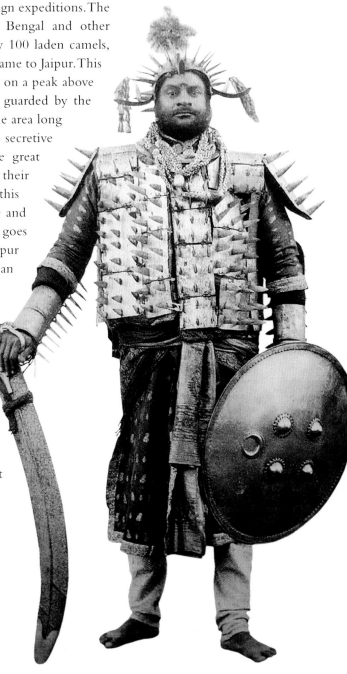

THE EXECUTIONER OF REWA STATE, 1890. IN MOST STATES, THE MODE OF EXECUTION WAS BY HANGING, BUT IN SOME THE CUSTOM WAS TO BEHEAD WITH ONE STROKE OF THE SWORD. THIS CALLED FOR A STRONG ARM AND A BROAD SWORD WHICH THE EXECUTIONER IS HOLDING.

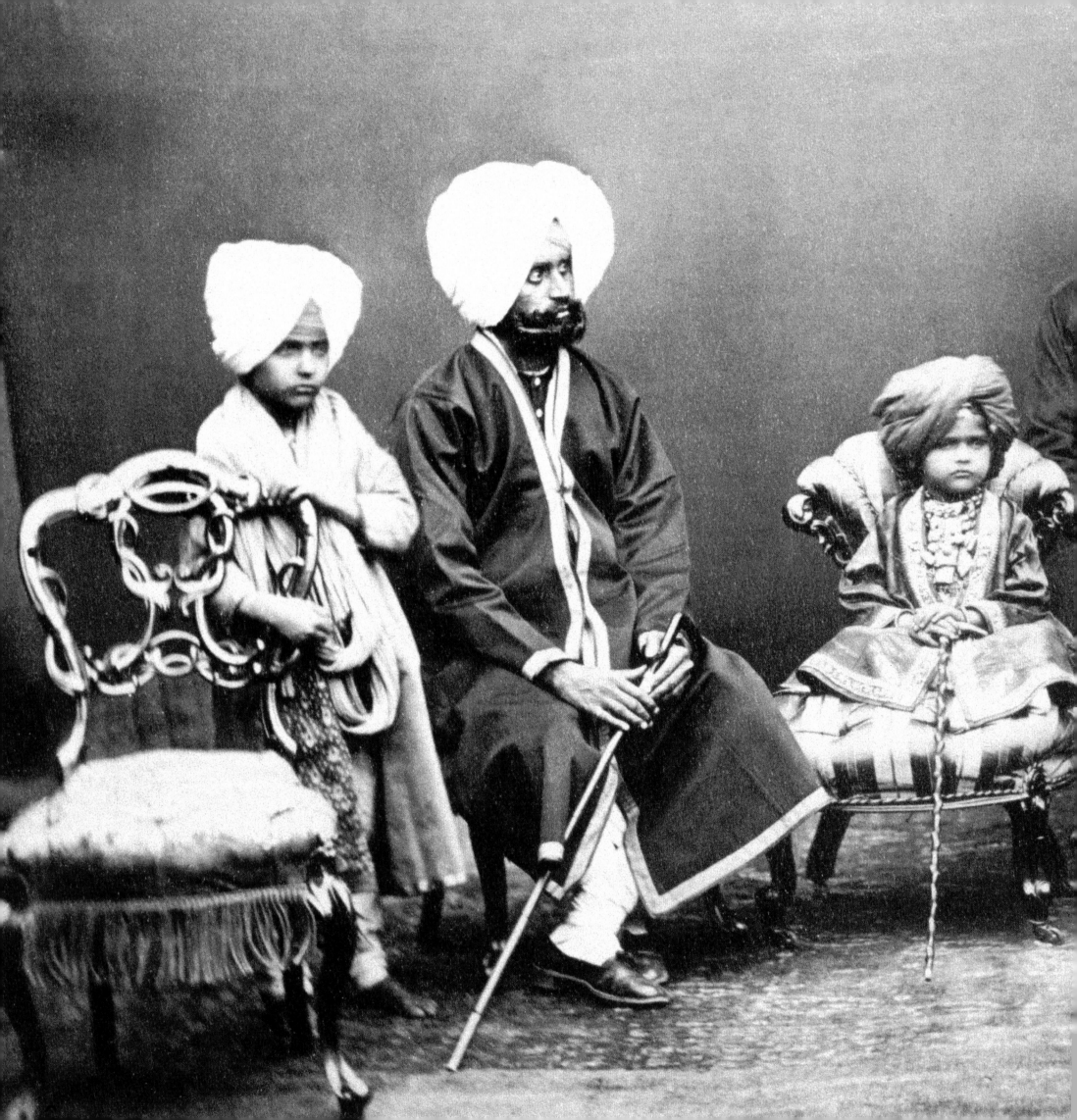

BORN TO RULE

I f other princes were born with silver spoons in their mouths, Indian princes were born with gold ones. It is difficult in these proletarian times to imagine the sheer grandeur and scale of opulence in which the princes were reared. They actually inhabited a world that others, much much more common, can only imagine: a fairy-tale world, rich, luxurious, spoilt, where everything could be had for the mere asking.

However, this world lasted only till near the middle of the twentieth century. The princes and their right to rule became an anachronism in modern politics.

In fact, the twentieth century, especially the years that saw the colonial sun sink, was inclined not so much to be ruled as to rule itself. Today, nation states elect all manner of administrators and invest them with authority; and regularly hold loud and noisy contests of political power. Even nation states that are not democratic have methods of intra-party elections and participative features.

In a word, the divine right of kings (and all that went with it) has gone out of the window. No ruler is seen to have been conferred the mantle of God, no Prime Minister, President, or King is seen to be a repository of absolute authority. Authority itself has been divided into many modes: judicial, administrative, political, local.

Yet, there was a time when people did believe that their king or queen was God himself on earth. When monarchs held sway atop the stooped backs of their subjects, commanded fealty over knights, raised all manner of taxes, and ruled unquestioned and untrammelled, when life itself was 'nasty, brutish, and short', then the territory of the unknown, the unexplainable, the untamed was vast and a force in

31

itself. It was propitiated, and protection from it sought from those more capable.

Historically, the priestly and warrior classes were the able ones. Both had a symbiotic relationship: the priest often providing credibility to the raja or warrior prince, upholding his authority and, thereby, securing his own niche as well.

The institution of the raja has an astonishingly long history in India: it is a testament to the effectiveness of the warrior-priestly ties. The earliest rajas ruled in northern India in the second half of the second millennium B.C. The raja was selected from the warrior nobility and gained credence from the support of his council. Soon, however, kingship became hereditary and a paternal relationship existed between the raja and his subjects, the raja's main role being that of provider and protector.

In today's view, thus, monarchs became necessary evils. After the Revolt of 1857 (also dubbed the First War of Indian Independence), the British allied themselves with the rajas, recognizing 565 so-called 'native states.' This changed the relationship between the raja and his *praja* or his subjects. No local sanctions could be imposed on those born to rule since they were now answerable to a greater or lesser extent to the paramount power—the British. The rajas effectively became princes. They continued to rule, but now did not hold the right to protect their subjects.

Simultaneously, the two great wars shaped the political contours of the world. A number of movements for independence worldwide shook off the shackles of the colonisers. These hesitant movements towards self-rule, that later took a democratic shape, sounded the death knell in India for the princely states.

When India was fighting against British occupation, the princely states were a gaudy throwback to the time of the monarch, a painful reminder of the very method of governance—more imperious than enlightened, more by fiat than by power to the people—that the freedom fighters were fighting so hard to change. The British had taken their power away and showered them with its trappings: titles, honours, gun salutes.

By the very logic of the situation in which they were placed vis-à-vis the Indian independence movement, the princely states had to fight for their survival. For it was certain that independence would take away their autonomy and the privileges and luxuries that went with it. Though some princely states decided to support the freedom movement, a few of the princely states were forced to hobnob with the British Empire, put themselves at the disposal of the Viceroy, win the favour of his political agents and toe a fine line between the indigenous aspiration for freedom and the political imperative of a foreign controlling hand.

But even in those days, the birth of an heir to a princely state was an occasion celebrated for days all over the state. This was hardly surprising considering the importance of such an event: put together the children of princely India exercised autocratic rule over almost half the subcontinent. Befittingly thus for that time, grand war drums or *nakkaras*, some 10 feet in diameter, announced the event. Gun salutes boomed, amnesty was granted to prisoners, and myriad religious ceremonies performed. The pomp and ceremony of the Indian royals were still intact. But precariously so. Telegrams had to be sent to the Viceroy and to the King Emperor announcing the birth of an heir. Their acknowledgement was eagerly awaited. A congratulatory return telegram to the ruler was considered a subtle recognition of a legitimate son. It put the seal of British approval to the succession. For the ruler, the continuation of his dynasty was assured—for whatever little time was left before an Indian republic swallowed up the states.

The heir-apparent or *Yuvraj* (or *Walihad* in a Muslim state) was born into a large family. There were many other *chhut bhaiyas,* or younger kin, brothers and cousins who, as part of the royal family, had to be brought up and educated in a manner befitting their high birth. They all—boys and girls—lived in the zenana, the area in the palace reserved for the royal women. They saw their parents for brief periods in the evenings when they were expected to be on their best behaviour. Their relationship with their father and mother was rarely as close as in other families and far more formal. As in most of India, the birth of a son was always more welcome than the arrival of a daughter.

For the most part, life in the zenana, the exclusive preserve of the royal ladies, was not the ideal disciplined life for a young kid. The princes and princesses were looked after, spoilt and pampered by a doting army of nurses, ayahs and servants. The

adulation of servants and companions and the close proximity of harems (nearly every ruler had one) made it impossible for the young princes to grow up to be worthy of their responsibilities. The caretakers of the young princes and princesses, for the most part, indulged their whims and fancies and unwittingly supported the formation of those habits which were to prove ruinous for most states.

The larger and grander states, therefore, employed British nannies and governesses. The British were now ruling by other means! It was as though the nannies could bring about some degree of discipline and western influence to bear upon the children. The British were not averse to this. It played into their hands, after all. In fact, the British laid considerable emphasis on the proper education of young princes. This practice served their interests well: the supervision of the education of the princes provided them with an appreciation of their duties as rulers. Moreover, at the same time, it moulded them into loyal pillars of British rule.

English guardians provided the solution to keeping the princes straight in some states. Another step that was taken was the founding of the four Chief's Colleges. They were set up in the nineteenth century for scions of royal families and made a far more valuable contribution. They tried to transform the wayward and spoilt little boys into 'admirable young men' who would be effective props of British rule. The Mayo College at Ajmer fulfilled this objective for the princes of Rajasthan, the Daly College at Indore for Central India, the Rajkumar College at Rajkot for Saurashtra, and the Atchison College, Lahore, for the states of Punjab and the hill states of the north.

When the schools opened, admission was restricted to scions of princely families. A royal admission always made room for a lavish spectacle. It was not unusual for retinues of private servants, tutors, motorcars, horses, and dogs to follow a prince to school. The school uniform remained closed collar coats, breeches and turbans—very elegant, but rather uncomfortable in the hot Indian weather. After school, the hostel servants dutifully pulled off the breeches of their young masters. Every evening the student princes had to dress for dinner in black Jodhpur jackets and white trousers. Yet, formal etiquette, however impressive, also had its absurdities: even the humble chapati had to be eaten with fork and knife. Woe betide any boy who used his fingers.

In the course of time, these institutions were reorganized on the model of English public schools and opened their doors to students from respectable Indian families as well. Thus, instead of remaining outmoded nurseries for the pampered young princes, who finished school with an easy 'Prince's Diploma', the Chief's Colleges were transformed into some of the best public schools in India. While academic standards were raised considerably, the firm belief that a relentless playing of games best hardens muscle and character remained. Many a schoolboy attained high enough standards in cricket to represent the provinces in the Ranji Trophy. Riding and rifle shooting were high-priority sports.

The imposing buildings that house Mayo College at Ajmer and Daly College of Indore, with their marble domes, slender minarets, and huge arches, are excellent examples of Indo-Saracenic architecture. Huge painted portraits of many Maharajas adorn the walls of the marble assembly halls and the state coats of arms are displayed on shields hung in various classrooms. In fact, they look more like palaces than public schools. The playing grounds, pavilions, gardens, and lawns of these institutions covered an area of more than two hundred acres.

The faculty of the Chief's Colleges upheld a high standard. Before 1947, the Principal was always British. The staff had a sprinkling of British teachers, but the majority were Indians. However, it is doubtful whether these institutions produced the Tom Browns desired by the British in any significant number. The roots of the royal students were deeply ingrained in an Indian culture and while these institutions brought in a degree of westernization, the princes retained many of the basic values they had learnt in the palace.

If they had not been completely spoilt, these values served their state and their country ably when the time came for the heirs-apparent to rule. Born to rule, the princes had to adapt quickly to the new realities. No titular rights, no kingdom, no subjects and, later, not even the income from a privy purse. Most took responsible decisions, converting grand palaces to exquisite resorts and, thereby, saved their heritage from being consigned to the dustbin of history.

MAHARAJA HANWANT
SINGH OF JODHPUR AS A
CHILD. THIS PICTURE,
TAKEN IN 1925, SHOWS
HIM PLAYING WITH A
DOLL'S HOUSE. HANWANT
SINGH WAS EXTREMELY
FOND OF FLYING AND
WAS ONE OF INDIA'S
EARLY 'FLYING PRINCES'.
HE DIED TRAGICALLY IN
AN AIR CRASH, LEAVING
HIS HEIR, GAJ SINGH,
THEN JUST FOUR YEARS
OLD, TO SUCCEED HIM.

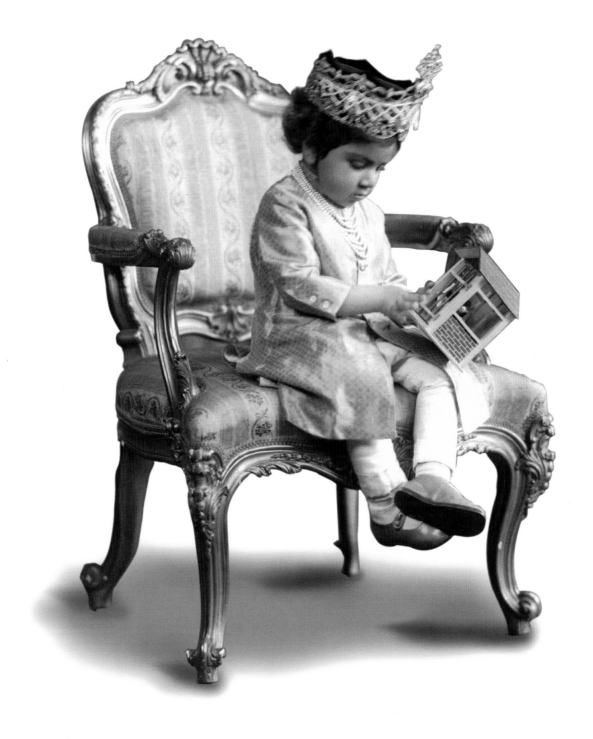

TAKEN IN 1935, THE ELDER SON OF THE MAHARAJA OF JODHPUR (*TOP LEFT*) KEEPS AN EYE ON HIS BABY BROTHER. HIS SON, THE PRESENT MAHARAJA, GAJ SINGH, IS POPULARLY CALLED *BAPJI* (FATHER) BY ALL HIS SUBJECTS— INCLUDING HIS MOTHER! SEVERAL ROYAL CHILDREN HAD EUROPEAN NAMES, OFTEN GIVEN TO THEM BY THEIR ENGLISH TUTORS AND NANNIES WHO PROBABLY FOUND IT DIFFICULT TO PRONOUNCE THEIR INDIAN NAMES. MADHAVRAO SCINDIA OF GWALIOR, A GREAT FAVOURITE OF LORD CURZON, REPORTEDLY REQUESTED THE PRINCE AND PRINCESS OF WALES TO BE GODPARENTS TO HIS CHILDREN (*SEEN FAR LEFT AND LEFT*) AND CALLED THEM 'GEORGE' AND 'MARY' IN ADDITION TO THEIR 'INDIAN' NAMES.

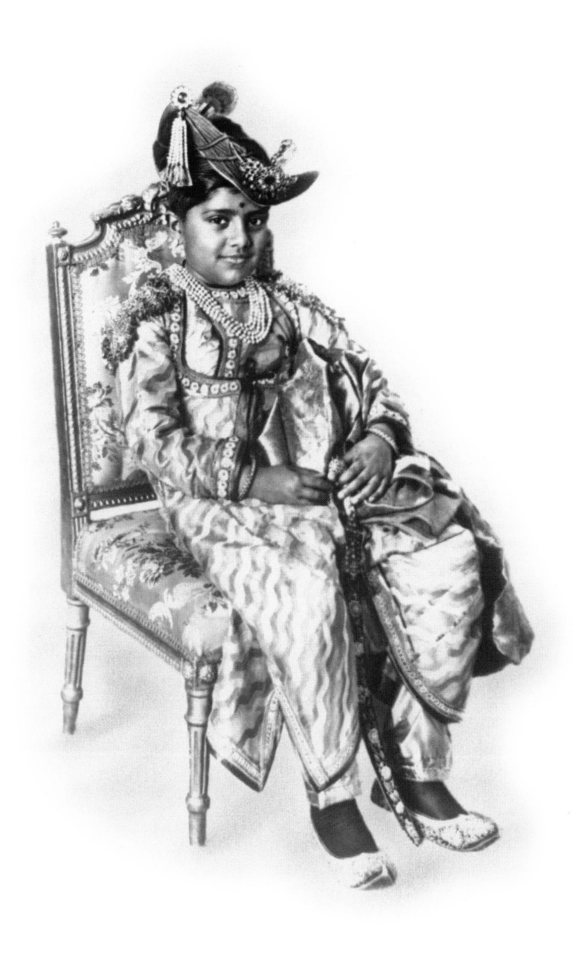

JIWAJI RAO SCINDIA
('GEORGE') OF GWALIOR,
WEARING THE
TRADITIONAL HEADDRESS
OF THE SCINDIAS OF
GWALIOR. JIWAJI RAO
DIED FAIRLY EARLY IN
LIFE BUT HIS FAMILY
CONTINUES TO PLAY AN
IMPORTANT ROLE IN
INDIA'S PRESENT
POLITICAL LIFE.

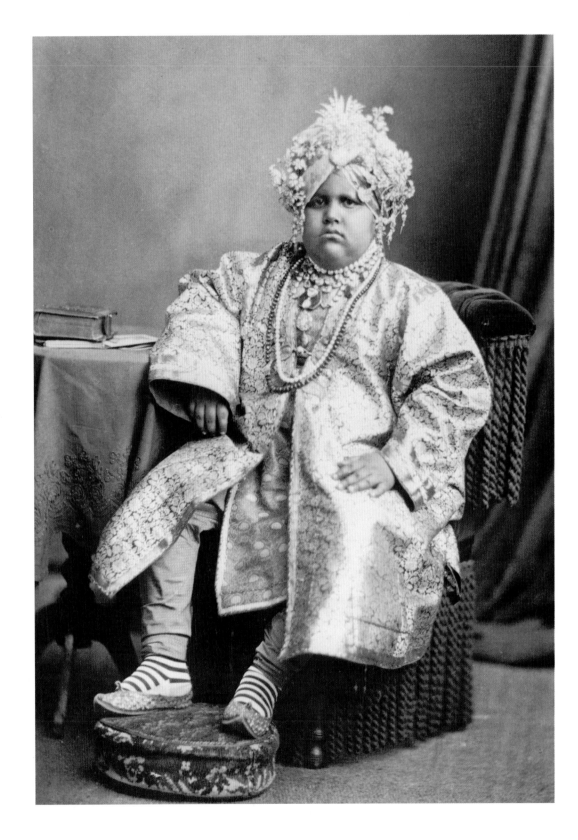

SPOILT AND FUSSED
OVER BY ADORING
WOMEN IN THE HAREM
AND THEIR STAFF,
SEVERAL PRINCES GREW
UP TO BE OBESE. AS A
YOUNG MAN, JAGATJIT
SINGH OF KAPURTHALA
WAS FAT AND UNGAINLY.
HE IS SAID TO HAVE
WEIGHED 10 STONE
AT THE AGE OF 10.
HOWEVER, HE GREW
INTO AN ELEGANT
MAHARAJA BY THE
TIME HE GREW OLDER
(*SEE PAGE 193*).

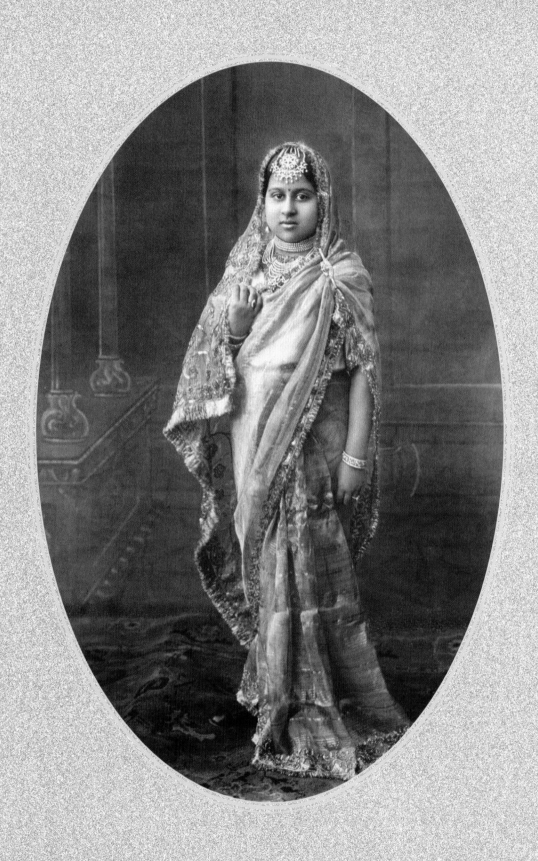

PRINCESS YADUNANDINI
KUMARI, ONE OF THE
DAUGHTERS OF
MAHARAJA BHUPINDAR
SINGH OF PATIALA. SHE
WAS MARRIED TO THE
RAJA OF NALAGARH.

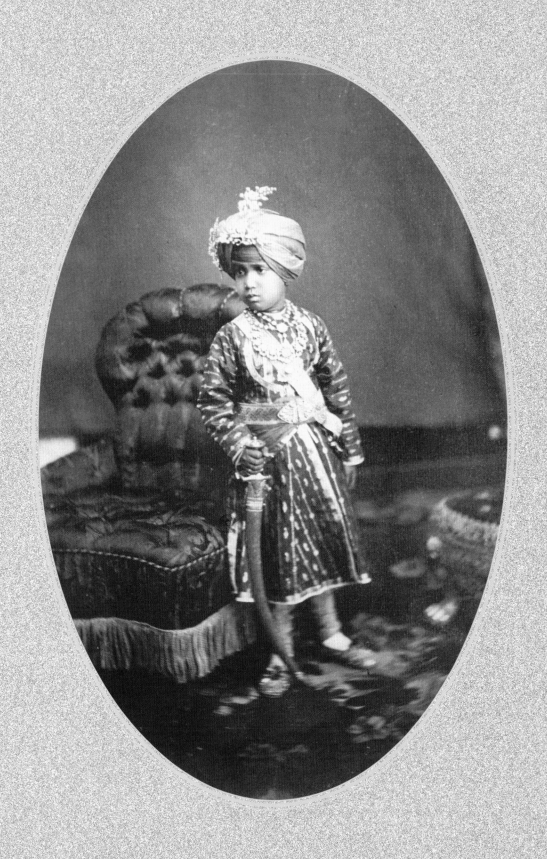

PRINCE RAJINDAR
KUMAR, LATER THE
MAHARAJA OF PATIALA.
EIGHT OF THE ELEVEN
RULERS OF PATIALA DIED
BEFORE REACHING THE
AGE OF FORTY. RAJINDAR
SINGH ALSO DIED YOUNG
AND WAS SUCCEEDED BY
HIS SON, BHUPINDAR
SINGH, THEN JUST NINE
YEARS OLD.

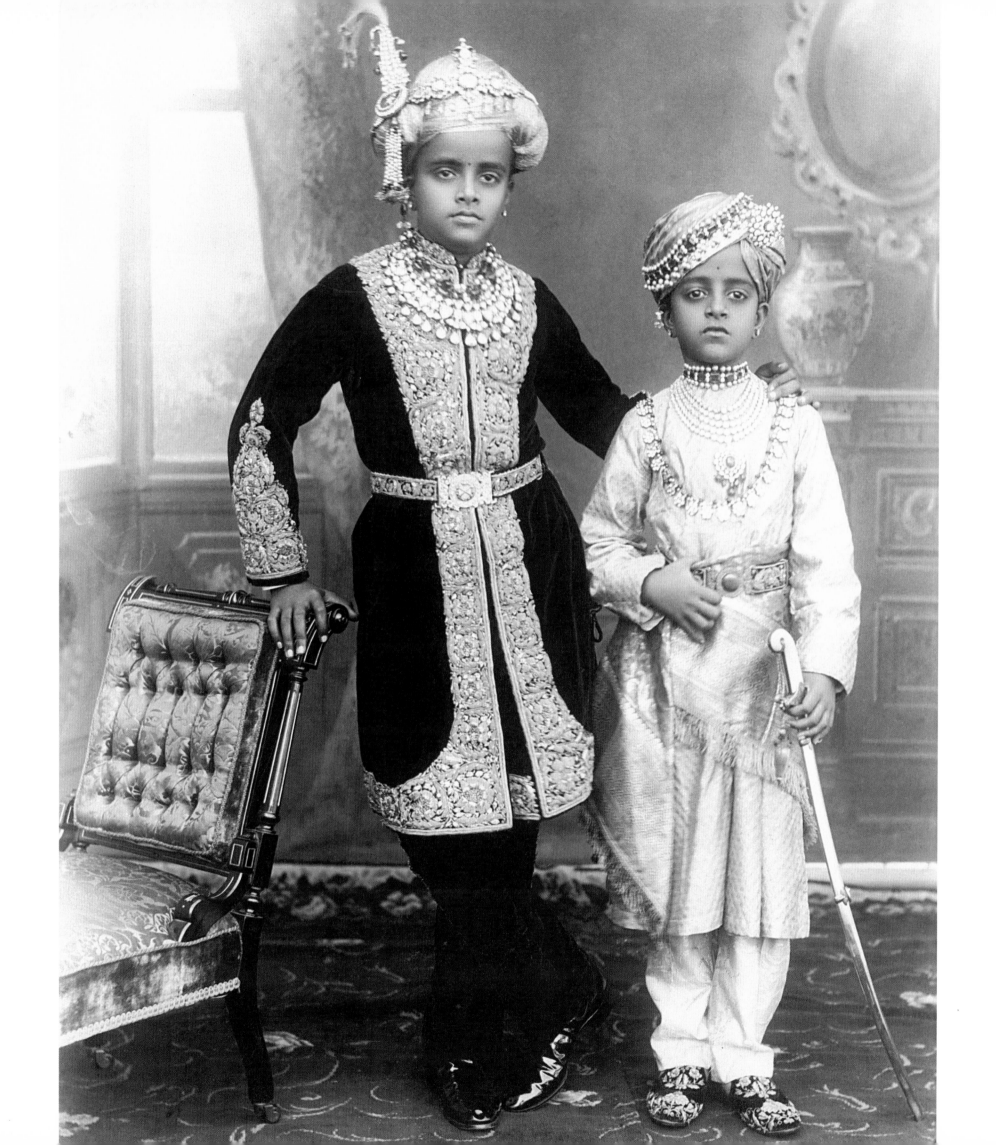

The young Maharaja of Rewa, Venkat Raman Singh. Indian princes were accustomed to the heavy ceremonial robes and jewellery they were expected to wear on such festive occasions. This young prince wears clothes and jewels almost the equivalent of his own weight.

Facing page: Most Indian princely states followed the tradition of male primogeniture. Often, a ruler would marry several wives in the hope of a son. Adoption was also common among princely families. Krishna Raja Wodeyar Bahadur IV at his installation to the Mysore throne. Krishna Raja was born on 4 June 1884 and ascended the Musnad on 1 February 1895. His marriage ceremonies were performed five years later on 6 June 1900. He was the third child and eldest son of his late highness of Mysore.

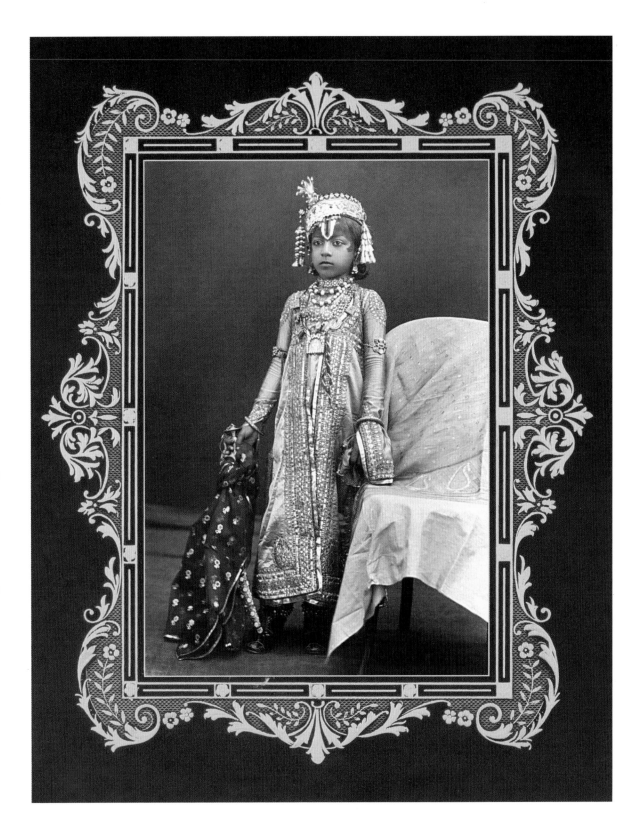

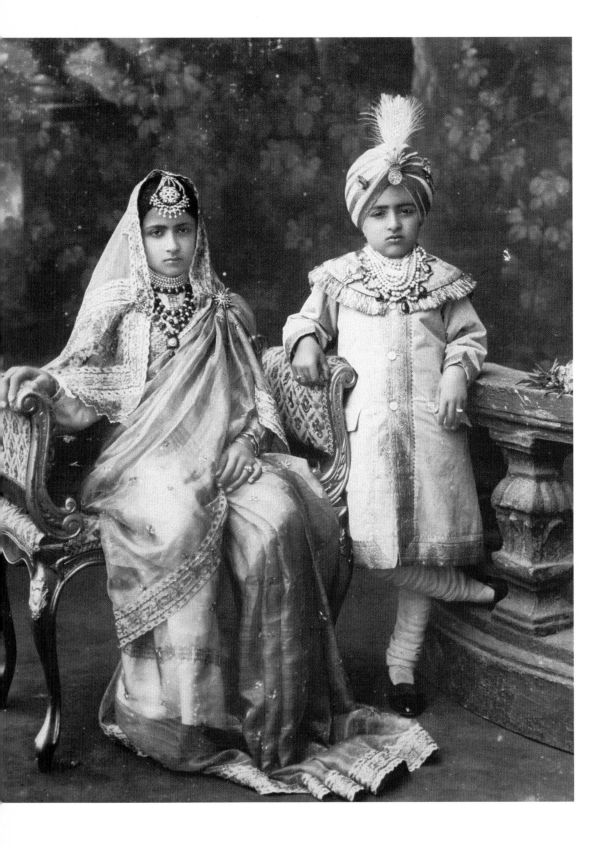

PRINCESS SURINDRA KUMARI AND PRINCE YADAVINDRA SINGH WERE THE ELDEST OF MAHARAJA BHUPINDAR SINGH'S SEVERAL CHILDREN. THE CHILDREN WEAR 'GROWN UP' CLOTHES FOR THIS FORMAL PHOTOGRAPH AND SEEM TO CARRY THE WEIGHT OF THEIR JEWELS AND ROBES WITH REMARKABLE APLOMB.

FACING PAGE: ANOTHER GROUP OF THE PATIALA ROYAL CHILDREN. SEEN HERE (FAR RIGHT) ARE RAJA BHALINDRA SINGH, WHO HEADED INDIA'S OLYMPIC COMMITTEE FOR SEVERAL YEARS. THE CROWN PRINCE YADAVINDRA SINGH IS SEATED IN THE CENTRE. PRINCESS DINESH KUMARI (BACK ROW, LEFT), THE FAMILY BEAUTY, WAS LATER MARRIED TO THE RAJA OF BIJAWAR, AND PRINCESS YADUNANDINI KUMARI IS SEEN SECOND FROM THE FRONT. THE YOUNGER CHILDREN OF THE FAMILY ARE PERCHED RATHER UNCOMFORTABLY ON A ROLLED CARPET.

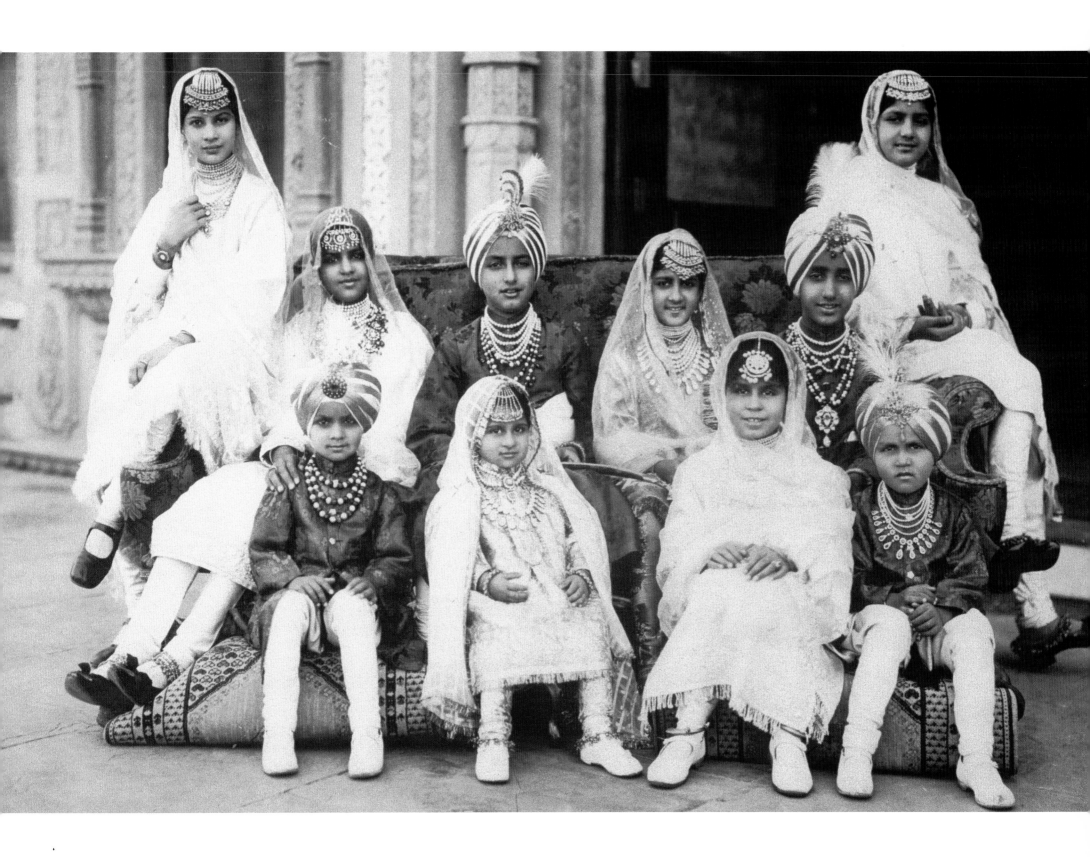

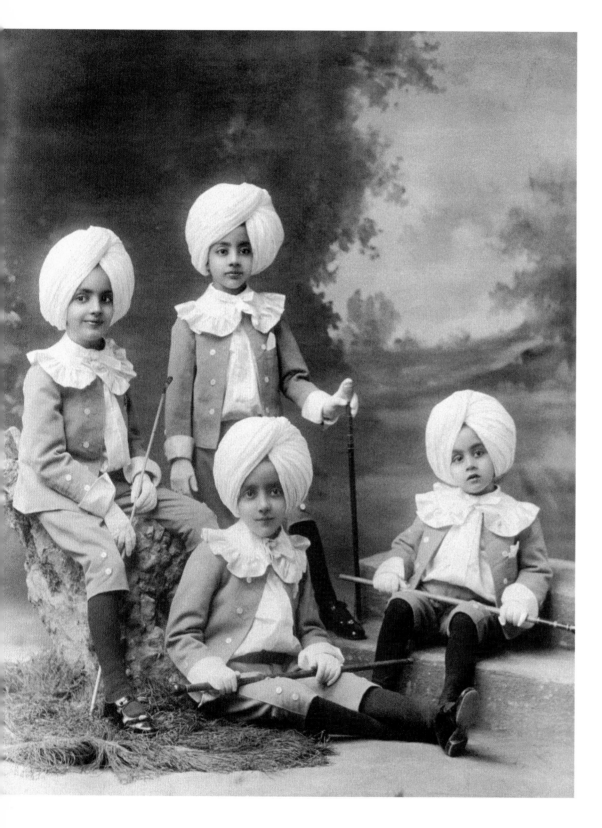

LEFT TO RIGHT: THE PRINCES OF KAPURTHALA. MAHIJIT SINGH, AMARJIT SINGH, KARAMJIT SINGH; (SEATED) THE CROWN PRINCE, TIKKA PARAMJIT SINGH. THE KAPURTHALA FAMILY HAD A STRONG EUROPEAN FIXATION. THESE PRINCES WITH THEIR CRAVATS AND WAISTCOATS, REMIND ONE OF LORD FAUNTLEROY. A CHARMING ADDITION IS THE LARGE AND FUSSY TURBAN AS THE RULING FAMILY OF KAPURTHALA FOLLOWED THE SIKH RELIGION.

FACING PAGE LEFT TO RIGHT: THE KAPURTHALA PRINCES. MAHIJIT SINGH, KARAMJIT SINGH, AMARJIT SINGH, AND THE CROWN PRINCE, TIKKA PARAMJIT SINGH. A PORTRAIT OF THE SAME SET OF BROTHERS AS YOUNG BOYS. THIS TIME THEY ARE SEEN IN THE TRADITIONAL INDIAN COURT DRESS.

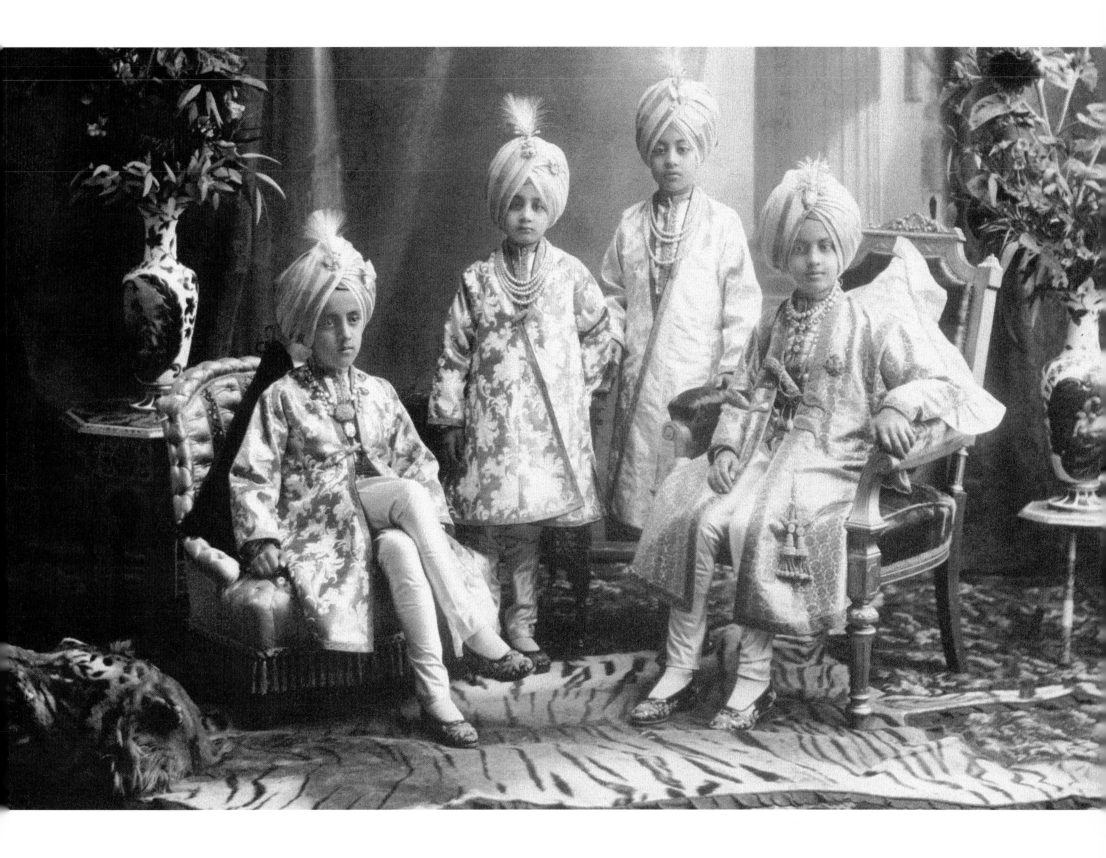

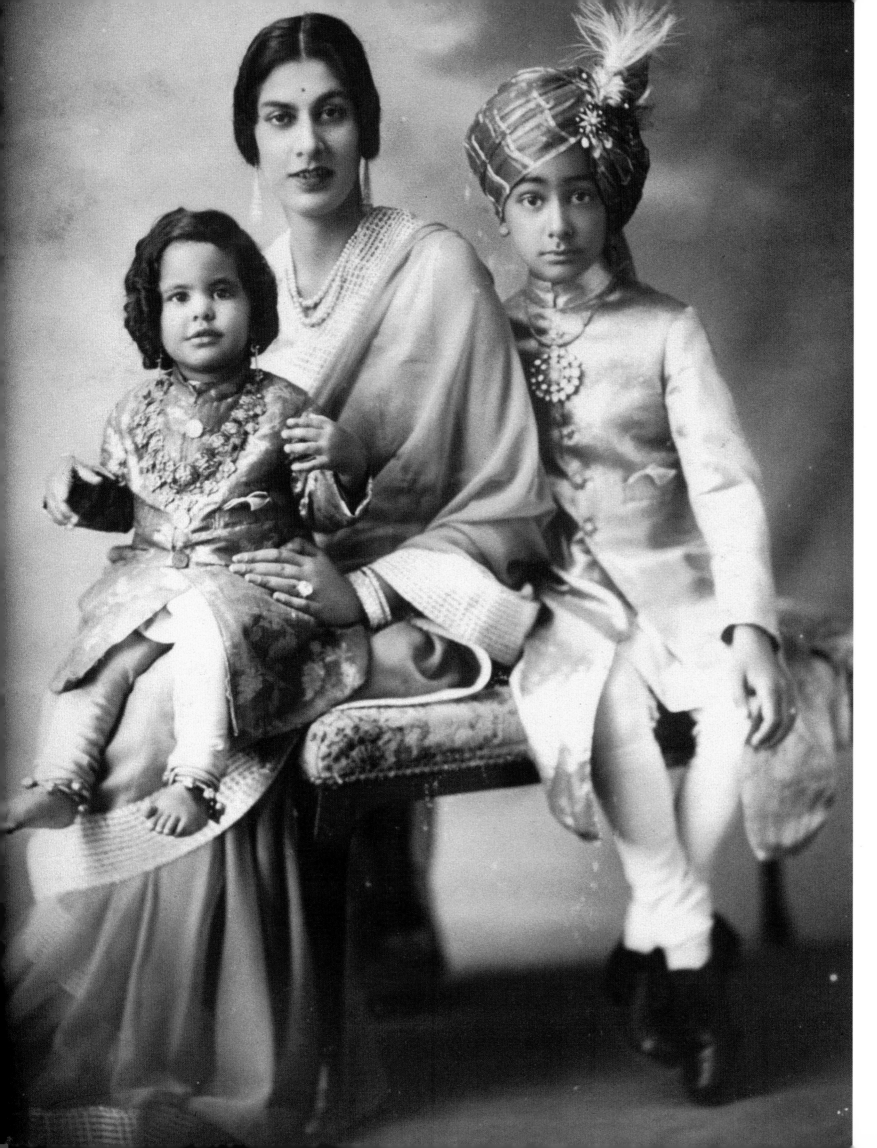

RANI AMRIT KAUR OF
MANDI, THE ONLY
DAUGHTER OF MAHARAJA
JAGATJIT SINGH OF
KAPURTHALA WAS
MARRIED TO COLONEL
RAJA SIR JOGENDRA SEN
BAHADUR OF MANDI. HE
WAS LATER THE INDIAN
AMBASSADOR TO BRAZIL
(1952–56) AND A
MEMBER OF PARLIAMENT
FROM 1957 TO 1962.
SHE IS SEEN HERE WITH
HER CHILDREN.

MAHARAJA GANGA SINGH
OF BIKANER MARRIED
THE PRINCESS OF
PRATAPGARH WHEN SHE
WAS SEVENTEEN. HERE
HE IS SEEN HOLDING
PRINCE SARDUL SINGH
AND HIS DAUGHTER,
PRINCESS CHAND
KANWAR. THE DAUGHTER
FELL ILL DURING WORLD
WAR I AND DIED, WHILE
THE SON WENT ON TO
BECOME THE LAST
CROWNED RULER OF
BIKANER.

MAHARANI GAYATRI DEVI OF JAIPUR WAS THE DAUGHTER OF THE MAHARAJA OF COOCH BEHAR AND WAS BORN ON 23 MAY 1919 IN LONDON. HER MOTHER DECIDED TO CALL HER AYESHA AFTER THE HEROINE OF RIDER HAGGARD'S NOVEL *SHE*. LATER, HER MOTHER'S ENGLISH STAFF DUBBED HER PRINCESS MAY. EDUCATED AT SHANTINIKETAN AND IN SWITZERLAND, SHE IS SEEN IN THE EXTREME RIGHT. TO HER LEFT IS HER SECOND BROTHER INDRAJITENDRA NARAYAN, BORN IN 1918; IN THE CENTRE IS ILA, BORN IN 1914 AND THE ELDEST OF THE SIBLINGS. TO ILA'S LEFT IS JAGADDIPENDRA NARAYAN, BORN IN 1915 AND CALLED BHAIYA (BROTHER), A NAME THAT STUCK TO HIM THROUGHOUT HIS LIFE. GAYATRI DEVI'S YOUNGEST SISTER, MENAKA, WAS BORN A YEAR AFTER HER.

49

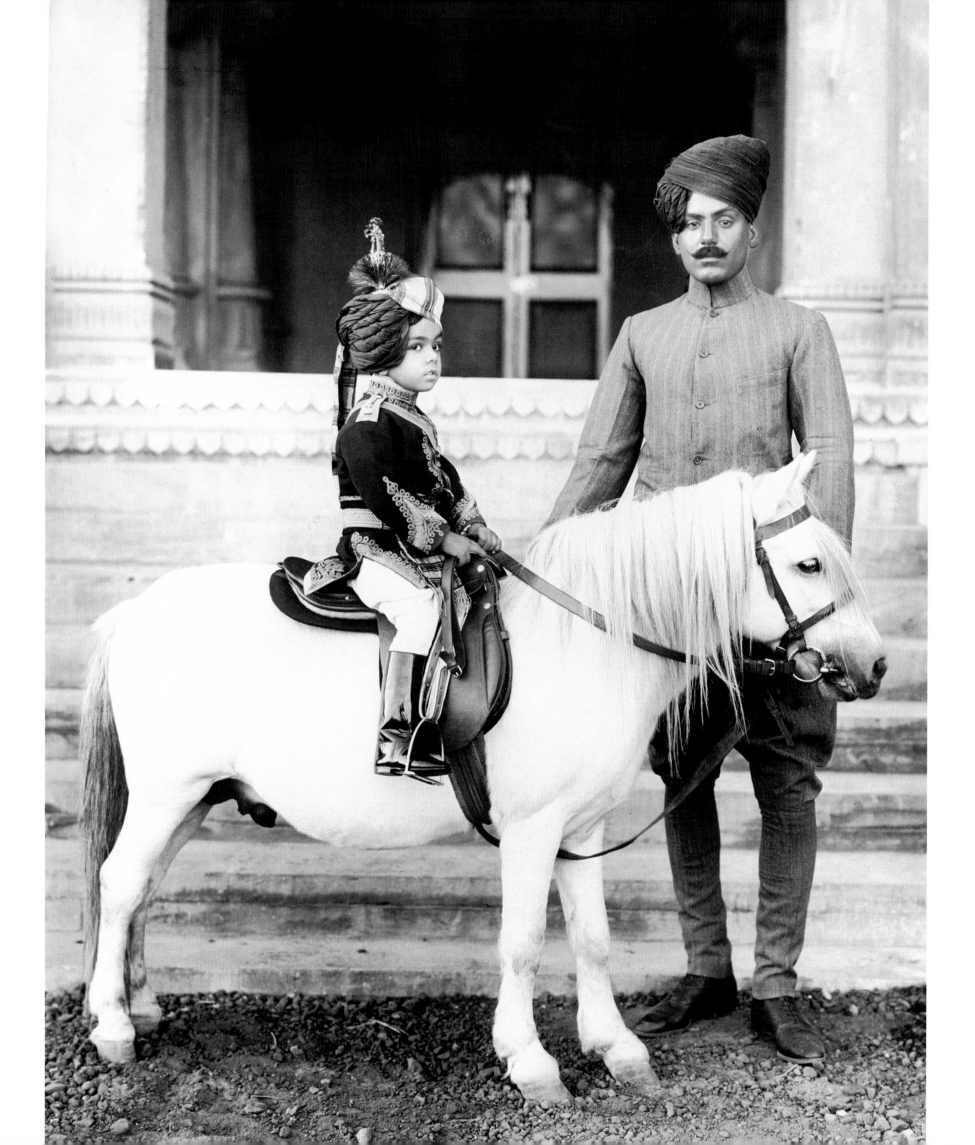

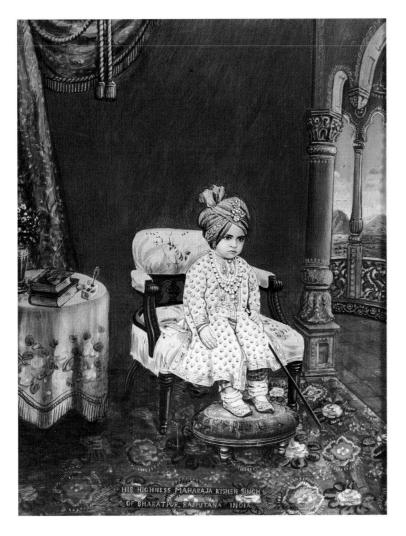

HIS HIGHNESS MAHARAJA KISHEN SINGH
OF BHARATPUR, RAJPUTANA INDIA

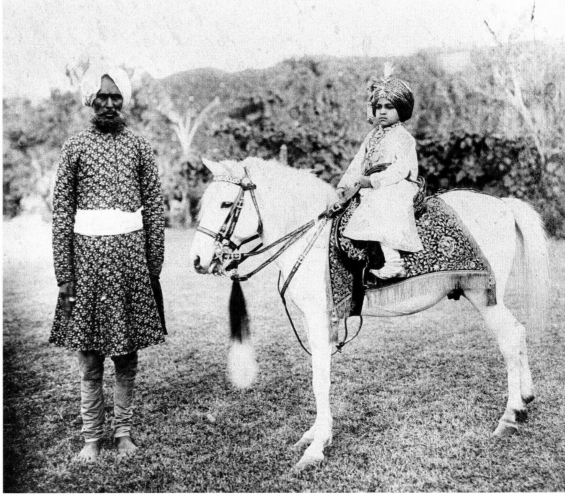

FACING PAGE: INDIAN
PRINCES WERE TAUGHT
HOW TO RIDE ALMOST
BEFORE THEY COULD
WALK. SARDUL SINGH OF
BIKANER, LIKE ALMOST
ALL PRINCES OF HIS
TIME, IS TAUGHT HOW TO
SIT ELEGANTLY BY A
PALACE GROOM.

MAHARAJA KISHEN
SINGH OF BHARATPUR.
THIS PICTURE WAS TAKEN
IN 1901 WHEN HE WAS
NOT YET THREE YEARS
OLD. HE LOOKS
EXCEEDINGLY GRAVE AS
BEFITS A MAHARAJA.

KISHEN SINGH OF
BHARATPUR, ASTRIDE A
HORSE HERE, CAME TO
THE THRONE IN 1900,
AFTER HIS FATHER WAS
DEPOSED. IN 1918, HE
WAS INVESTED WITH
FULL POWERS BY THE
VICEROY. HE DIED IN
1929.

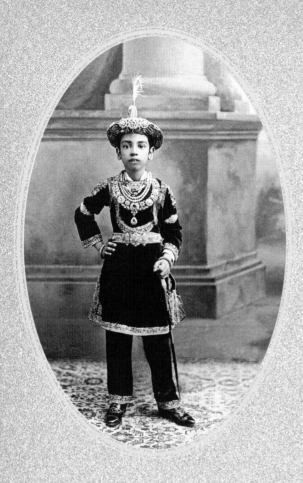

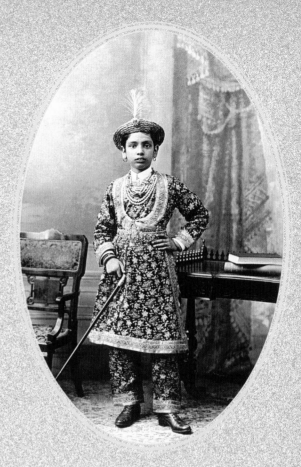

With their rich ceremonial costumes and priceless jewels, Indian princes made a splendid subject for studio photographers. Once studio photographs became popular, they began to slowly nudge out the traditional miniature and oil paintings that had hitherto served to preserve royal likenesses.

These four cameos of a prince from Hathwa, a little-known principality in the north Indian state of Uttar Pradesh capture the growth of a young prince on four separate occasions. They are an interesting study of changing royal fashions and provide a glimpse of the superlative brocades and zardozi embroidery that royal families preferred. The changing headdress is always surmounted by a *sarpech* (the jewelled turban ornament) with a feather that announced their royal status to the world.

The backdrops are similarly worth noting. At first, we see the prince pose before a pillar. By the next portrait, he has a table with books arranged to indicate that his childhood is behind him and he is preparing himself for the duties that lie ahead. The third and fourth cameos are designed to show off his spelndid jewels and costumes. Yet, equally, they capture the confidence of a young prince who is aware of the special responsibility that he was born with. His gaze, directed at the photographer, is of a man who is accustomed to attention and knows how to handle it.

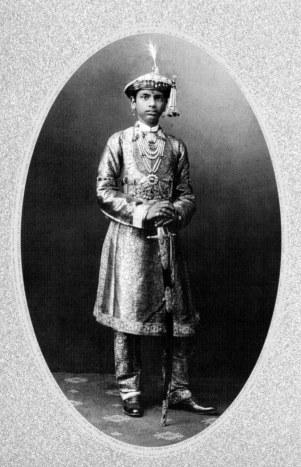

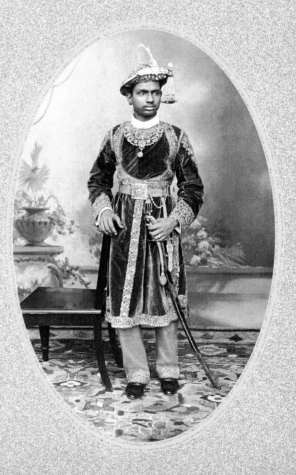

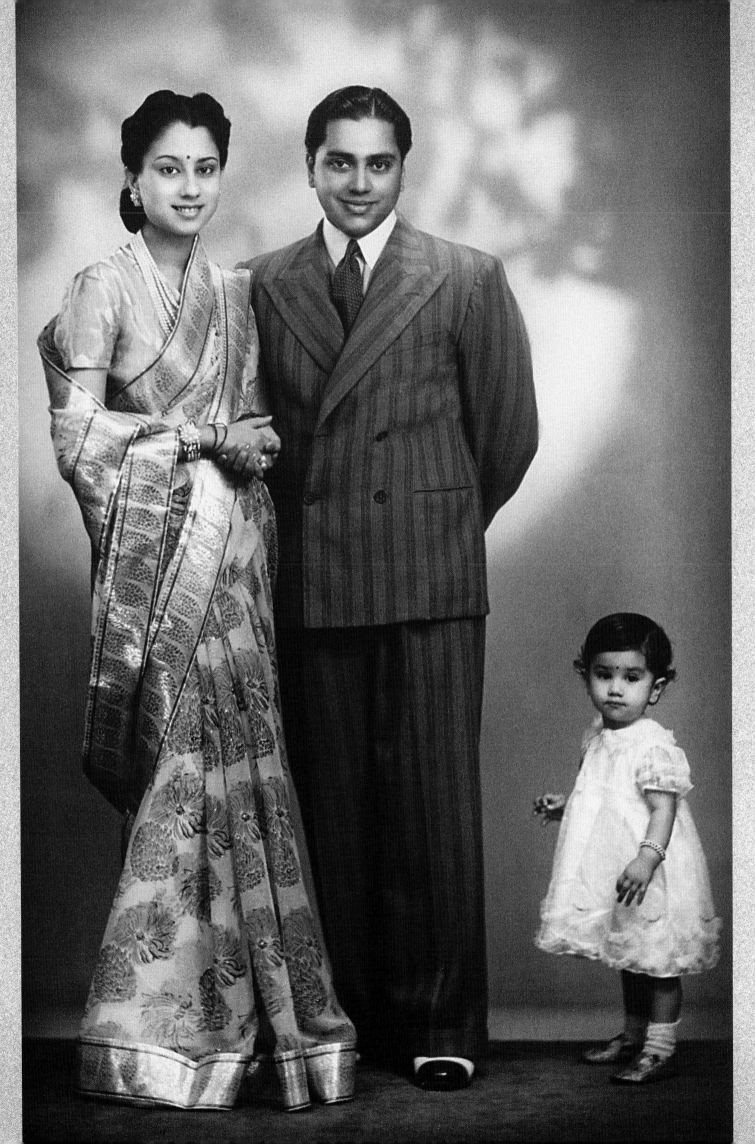

Vijayaraje Scindia and Jiwaji Rao Scindia with their daughter. Vijayaraje Scindia was widowed early and joined the Right-wing Jan Sangh party. She was elected Member of Parliament several times and was an honoured member of the party till her death a few years ago. Along with Maharani Gayatri Devi of Jaipur, she was among the handful of Indian princesses who chose to join politics after the merger of the states. Almost all of Vijayaraje's children joined politics and continue to benefit from her political legacy. Ironically, her only son, Madhav Rao Scindia, chose to side with the Congress party, a party that Vijayaraje bitterly opposed throughout her parliamentary career. This royal portrait taken as a memento of a happy trip abroad is one of the few pictures of Vijayaraje Scindia as a glamorous queen. After her husband's death, she wore only white saris.

53

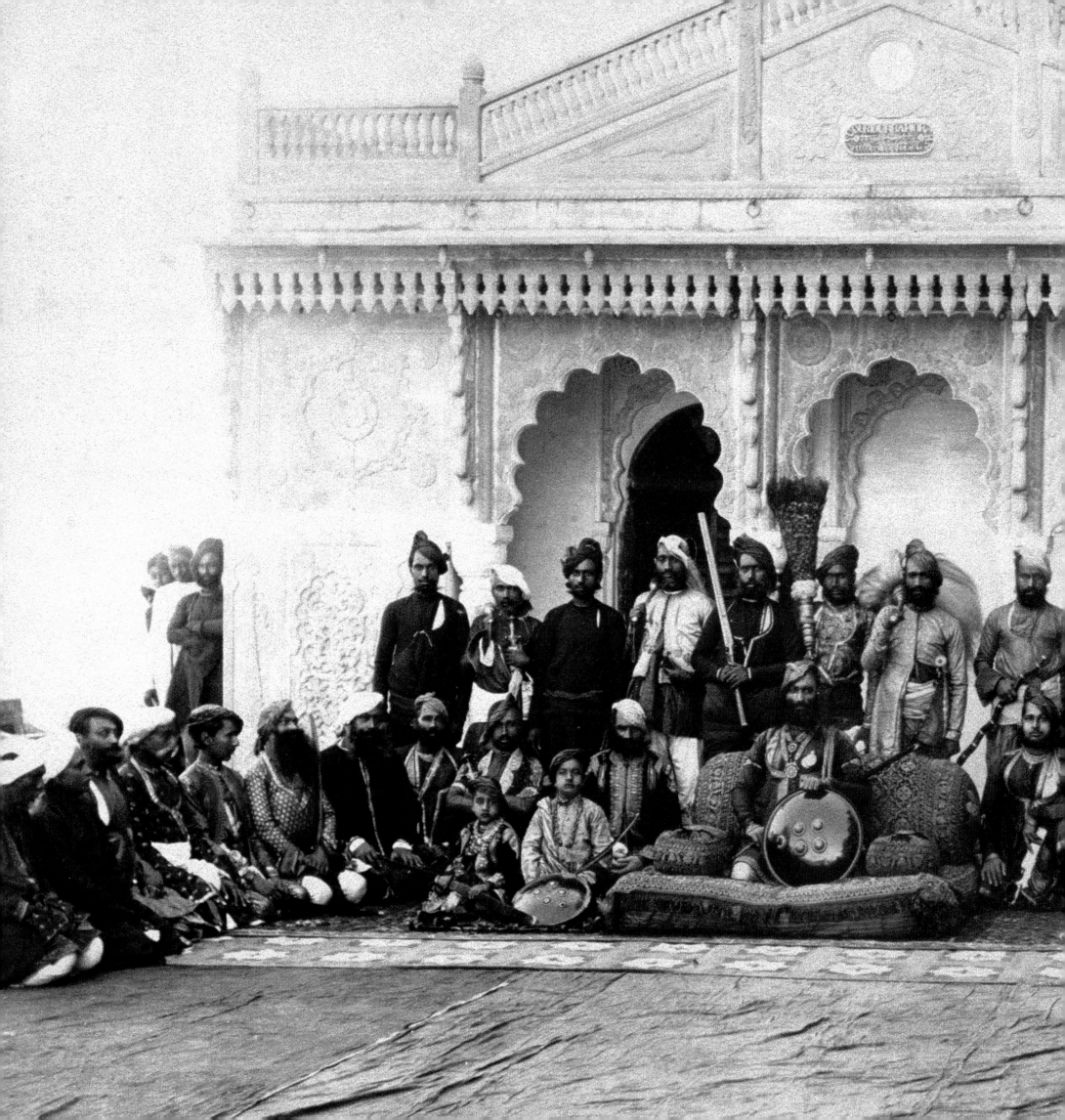

AND THEY POSED FOR POSTERITY

The photograph, says Roland Barthes, is only a signifier. Like a footprint, it points to a larger reality that we must imagine. When viewing the photographs of princely India, therefore, one must remember that human vanity and an urge for immortality are served well by a pictorial record.

Chronicling the lives and times of rulers in pictures has taken many forms in India. In medieval times, miniature painters had reigned supreme for three centuries or more at the royal courts of the Indian rulers. The Mughals have left behind them exquisitely detailed portfolios that are studded with their portraits and memorable events. The *Baburnama*, *Akbarnama,* and the *Padshahnama* record the reigns of the three most famous Mughals, Babur, Akbar and Shah Jahan, in intricate and colourful detail. This fashion was soon to spread to other parts of the country and ateliers sprang up in virtually every Rajput kingdom after the eighteenth century. They provide a permanent pictorial legacy that kept alive their rulers in the memories of future generations.

All this was to change with the advent of the camera. Photography arrived in India in the 1840s and interest in it grew fast. The Maharajas, who longed to be remembered forever by their subjects, were fascinated by it. Some, notably Sawai Ram Singh of Jaipur were gifted practitioners themselves and set up elaborate private studios in their palaces. Others had eminent photographers attached to their courts, in the same way that their ancestors had once patronized painters. Photography was considered by them a more realistic

medium in that it could not only do all that painting could but do it better, and it is not surprising that many felt 'painting was dead'. The advent of photography thus, not only diminished the position of the artist by the end of the nineteenth century, it almost supplanted painting in the princely courts.

Equally significant was the narcissistic preoccupation of the Indian princes with themselves. Once they were valiant warriors who carved out their kingdoms at the point of a sword and retained them against predators by indomitable courage and sacrifice. The powerful fortresses on the precipices of the Aravalli ranges in Rajasthan, the strongholds in the hill masses of central India and the escarpments of the ghats in Maharashtra are reminders of their military prowess. But all that was in the past and when the last pictures of princely India were being taken, the photographers must have seen the Maharajas transformed from warrior kings into carpet knights. With the collapse of their hereditary role all that the princes could do, says Kipling is 'offer mankind a spectacle.' This aspect was enthusiastically exploited by not just the photographers, many of whom made fortunes out of their professional expertise, but by others as well. Several photographs of those times project the glory of the British power in India: the best example are the pictures of the Durbars that were held between 1903 and 1911. The spectacle of the Durbars occurred in a specially created amphitheatre which recreated, for the pleasure of the visiting British royalty, a moving picture of India's diversity and colour and provided a brilliant record of an era that has vanished into the past.

A photographer much favoured by the Maharajas was Raja Deen Dayal, the court photographer of the Nizam of Hyderabad. Deen Dayal was a trained draughtsman from the Thomason Civil Engineering College in Roorkee and took up photography in the 1870s. His skill as an architectural photographer preceded his reputation as a studio photographer. Deen Dayal had studios both in Hyderabad and Bombay and his royal portraits soon acquired a reputation for excellence all over the country. He was invited by several princes to their states where he was commissioned to take portraits of the prince and his family. Often, he was provided with a house fit for a nobleman and accorded a status enjoyed by the court painters of yore. Between 1850 and 1950, the redoubtable Raja Deen

Dayal (among others) busied himself with immortalizing the princely rulers, their women, weddings, hunting, sports and royal celebrations. Incidentally, the 'Raja' in Deen Dayal's name comes from the title bestowed on him by the Nizam of Hyderabad: Raja Musawir Jung or Bold Photographic Warrior. Some stories about his innovative techniques endorse this 'warrior' photographer's guts. The Journal of the Photographic Society of India of January 1892 records a studio Deen Dayal had set up in Hyderabad for photographing ladies in purdah: 'As this studio is for photographing native ladies only, special arrangements had to be made to protect them from the gaze of the profane and the stern. So the place is surrounded by high walls, and all day long within this charmed enclosure, Mrs. Kenny-Levick, aided by three native female assistants, takes the photographs of the high-born native ladies of the Deccan.' On a visit to Bhopal, Deen Dayal so endeared himself to the Begum that she arranged for him to take photographs of her daughter and herself dressed in the elaborate costumes of the past.

Another famous photographic firm of this era was the Lafayette Studio, founded in Dublin in 1880 by James Stack Lauder. Lauder, who later called himself Lafayette, was a magician with the camera and his firm became the premier portrait studio in Ireland. News of his skill soon reached the world outside Ireland and in 1887, he was invited to Windsor to photograph Queen Victoria and was granted the royal warrant as Her Majesty's Photographer in Dublin. Later, when this royal warrant was renewed by King Edward VII and George V, he became known as the Photographer Royal. This brought Lafayette not just prestige but hundreds of new clients as well. As business boomed, Lafayette opened a studio in London's fashionable Bond Street. A knighthood followed and by the 1890s, Lafayette had opened studios in Glasgow and Manchester as well.

Rulers from many countries, princes, debutantes and society ladies came to Lafayette to have their official portraits taken. Virtually every European ruling prince and colonial administrator had a Lafayette portrait taken. Among the most interesting photographs of the studio, however, were the portraits of the Indian rulers and princes taken between 1885–1933. Indian princes, with their colourful costumes, and dazzling jewels were the stuff that fairytales are made of. Among

those who had their portraits taken at the Lafayette are the Maharaja of Baroda, a great favourite of Queen Victoria, Ranji, the famous cricketer, the regal Maharajas of Kapurthala and Patiala, and the Maharaja of Mysore. The beautiful royal family of Cooch Behar also figured prominently in the Lafayette portfolio and is among the most pristine examples of royal portraiture anywhere in the world.

After the photograph was taken at the studio, the glass negative was sent to a workshop where skilled artists were employed to 'touch up' the flaws. This could mean removing unflattering wrinkles, a loose hair, creases from clothes. In extreme cases of cosmetic retouching, inches vanished under the artist's brush and unflattering reminders of age were erased gently. Lafayette paid these magic workers well and many were reputed to be paid very handsome wages for their work.

By the 1870s, photographic technology became simpler and this provided a further fillip to its popularity. In addition to court photographers like Raja Deen Dayal, the princes patronized other commercial photographers of those times as well. Photographic studios sprang up in virtually every large city in India, especially in Calcutta, then the imperial capital. Simla, the summer capital of the Raj, and other hill stations also had photographic studios where portraits were routinely taken. Often, photographers were summoned to princely states to cover an important event, such as a wedding, birth or coronation.

Moreover, as they had to make official visits to the old capital Calcutta to meet the Viceroy, the princes often took advantage of their Calcutta visit to go for a formal portrait to the photographic firm of Bourne and Shepherd, renowned for its technical and artistic skill. Interestingly, Bourne was a landscape photographer who first set up a studio in Simla to photograph the upper Himalayas. Later, he joined hands with a partner, Charles Howard, and also undertook some studio portraits. However, most Indian princes preferred to go abroad to have their portraits done. By this time, the Indian princes had also been introduced to the pleasures of foreign travel and many had apartments in London and Paris where they spent the summer in pleasurable activities.

These photographers initially worked with the wet plate process, where a glass plate replaced paper as the support base for a light sensitive emulsion. The wet glass plate required an exposure of one to sixty seconds. Although the process was cumbersome and delicate, it was valued for its sharpness of definition and extremely fine grain. These qualities have not been bettered even by today's photographic films. Since the glass plates had to be coated, exposed and developed while still wet, this was a continuous process and postponement was not possible.

In addition, early cameras were cumbersome for it was generally stipulated that they 'be made of substantial mahogany, clamped with brass, to stand extremes of heat.' Interestingly, the camera was described by the media in the 1880s as the 'witch machine' as it was still regarded as a wondrous product. It is a tribute to the photographers of those times that they did not allow such problems to come in the way of their enthusiasm. This is specially the case when one views the extraordinary landscapes that we have from those times. Taken in a mind-boggling variety of locales, often in remote mountain areas or hot deserts, they are a stunning reminder of the skilful wizards who wielded the 'witch machines' with such dexterity.

The glass negatives of these old photographers have suffered from wear and tear and many of them are damaged beyond repair. What remains is therefore of special interest as a visual and historical record of the times which have gone.

An interesting development in the evolution of studio portraits taken in India was the introduction of tinted photographs. Unlike painted portraits where the court painters could erase, delete or lie with the paintbrush—stroking away the lines that were unkind to the royal visage—no such sleight of hand could be practised by the photographer. Photographs capture in one swift instant an image that would last forever, warts and all. Soon, a way out of this embarrassing situation was discovered. Much like the artists who were employed by Lafayette to 'touch up' their photographs, Indian photographers began to use the paintbrush to tint their pictures, adding gold and rose to flatter the dull sepia tones. At other times, artists painted in the intricate weaves of the brocades worn by the Maharajas, picking out the fantastic motifs that were the hallmark of Indian brocades. The dull studio backdrops were livened up as rich velvet drapes, festooned with gold trimmings, were added. At other times, furniture and even chandeliers were painted in.

Finally, the artist and the photographer joined hands.

PORTRAIT GALLERY

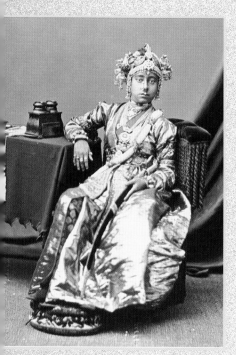

A princess from Tanjore, c. mid-1880s.

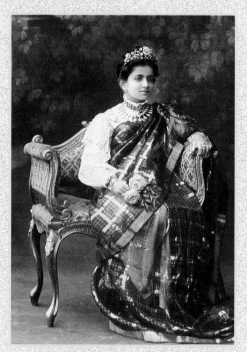

Princess Sunindra Kumari of Patiala.

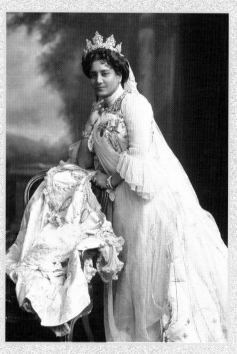

Siniti Devi, Maharani of Cooch Behar

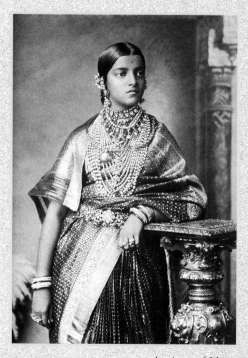

A princess of Mysore

If art is imitation, then photography is nearly the truth. It is the closest one can get to freezing faces as they are, stilled in a moment for posterity. Photography has a focus and sharpness denied to nearly all other media. However, it must be remembered that if the Indian princes and princesses loved to have their photographs taken, they were some of the most interesting subjects. The camera loved the

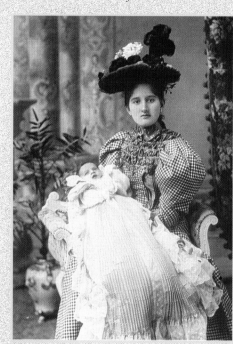

Rani Kanari of Kapurthala

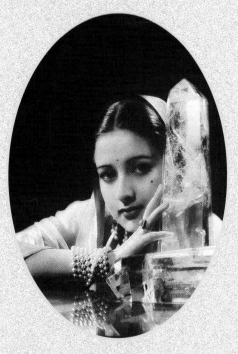

Princess Sita Devi of Kapurthala

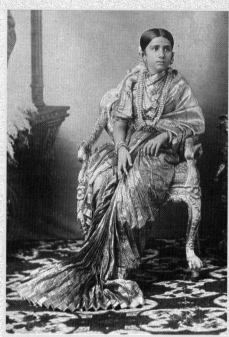

A Mysore princess

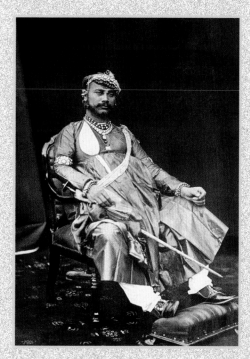

Maharaja of Indore

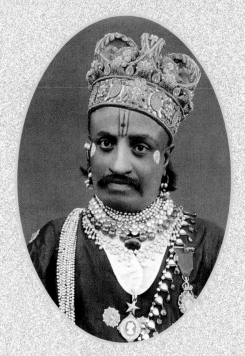

Maharaja of Rewa

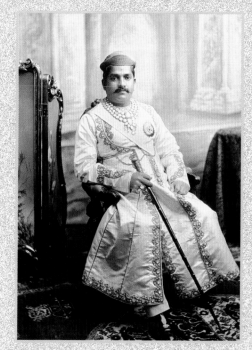

Maharaja of Baroda

Maharajas almost as much as the Maharajas loved the camera. Taking a photograph was never, however, a simple matter. Early daguerreotypes required sitters, or models, to remain stationary for nearly half an hour, the exposure time. The wet collodion process introduced in the mid-1850s cut down this time to one to three minutes. The process, where prints made from glass plates were made on paper coated with albumen and salts, had another advantage: changing the concentration of albumen salts and the fixing bath of gold toning led to shades of colour. The process was a hit for the next thirty years. Also, negative glass plates could be stored and that is how they have come down to us. Fixing the environment in which the photograph was to be shot, and more often than not adding to it, made an artist out of the photographer. For 'fixing' was not restrained to the environment at hand, it often intruded upon the image as well. In India, the paintbrush was delicately applied to lead to the development of the tinted photograph. Royalty could, therefore, be seen in splendid backdrops of choice. Photography had come close to the truth and then—coloured it.

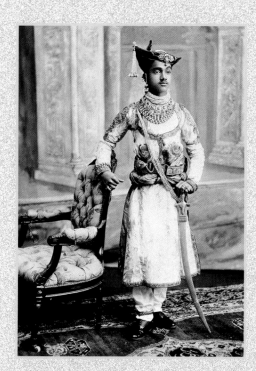

Maharaja of Dewas

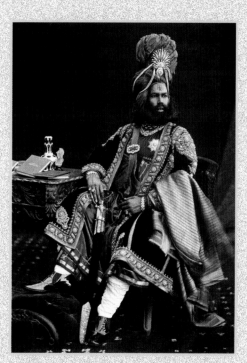

Maharaja Rudra Pratap Singh of Panna

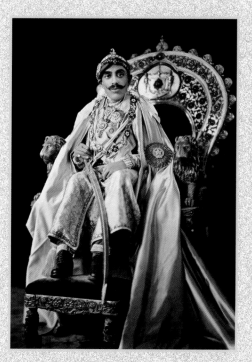

Maharna Bhopal Singh of Udaipur

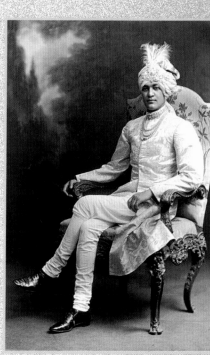

Maharaja Jitendra Narain of Cooch Behar

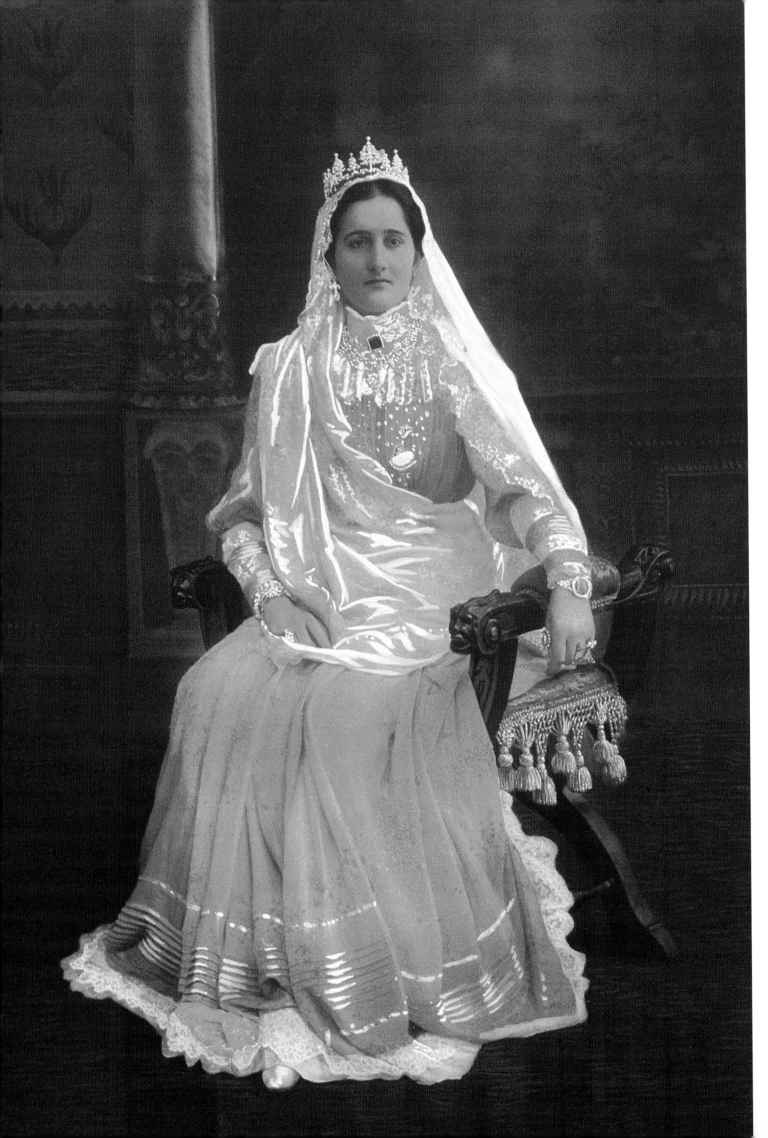

INITIALLY, THE ROYAL
LADIES OF THE INDIAN
PRINCELY STATES WERE
HESTITANT ABOUT
POSING BEFORE MALE
PHOTOGRAPHERS.
HOWEVER, AS THE
FASHION FOR STUDIO
PHOTOGRAPHY BECAME
MORE FIRMLY
ESTABLISHED, THEY
QUICKLY LEARNT TO
POSE CONFIDENTLY
BEFORE A CAMERA.
WESTERN FASHIONS
BEGAN TO APPEAR IN
SUCH PORTRAITS.
JEWELLERY DESIGNED
BY EUROPEAN
JEWELLERS, SUCH AS
CARTIER, INTRODUCED
THE TIARA AND
BROOCHES, WHILE LACE
PETTICOATS PEEPED
UNDER TRADITIONAL
SILK SARIS. THIS
PORTRAIT OF RANI
KANARI OF KAPURTHALA
WAS TAKEN AFTER SHE
HAD VISITED THE QUEEN
AT BALMORAL CASTLE.

An interesting addition to studio portraits was the marriage of the art of the painter to that of the photographer. As sepia could hardly be expected to do justice to the rich colours of the costumes and jewels that Indian princes wore, it was not unusual for photographs to be tinted by hand to highlight the original colours. While adding pink to a royal achkan, the painter sometimes added a flattering tint to the royal face as well.

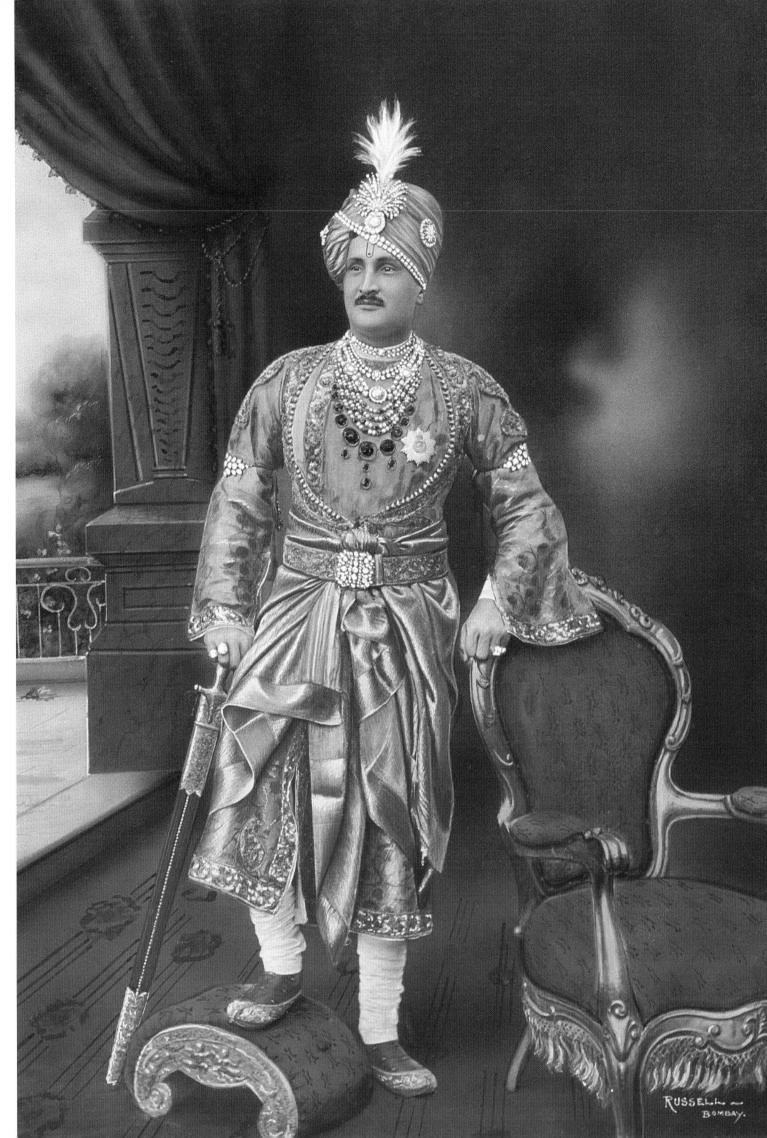

RUSSELL & Co.
BOMBAY.

A RARE PHOTOGRAPH OF BHUPINDAR SINGH OF PATIALA WITH HIS DAUGHTERS. THE MAHARAJA IS SEEN WITHOUT A TURBAN AND WITH HIS SPECTACLES PERCHED ON HIS FOREHEAD. HE LOVED ALL HIS DAUGHTERS DEARLY AND OFTEN TOLD THEM TO BE PREPARED FOR A LESS LUXURIOUS LIFE AFTER THEY GOT MARRIED.

FACING PAGE: A FORMAL PORTRAIT OF MAHARAJA BHUPINDAR SINGH OF PATIALA WITH SOME OF THE LADIES OF HIS FAMILY, TAKEN BY VANDYK. TWO OF HIS WIVES, RANI VIMAL KAUR AND RANI YASHODA DEVI ARE SEATED; ON THE MAHARAJA'S LEFT IS HIS DAUGHTER PRINCESS KAILASH DEVI WHO WAS MARRIED INTO A PRINCELY FAMILY IN ORISSA.

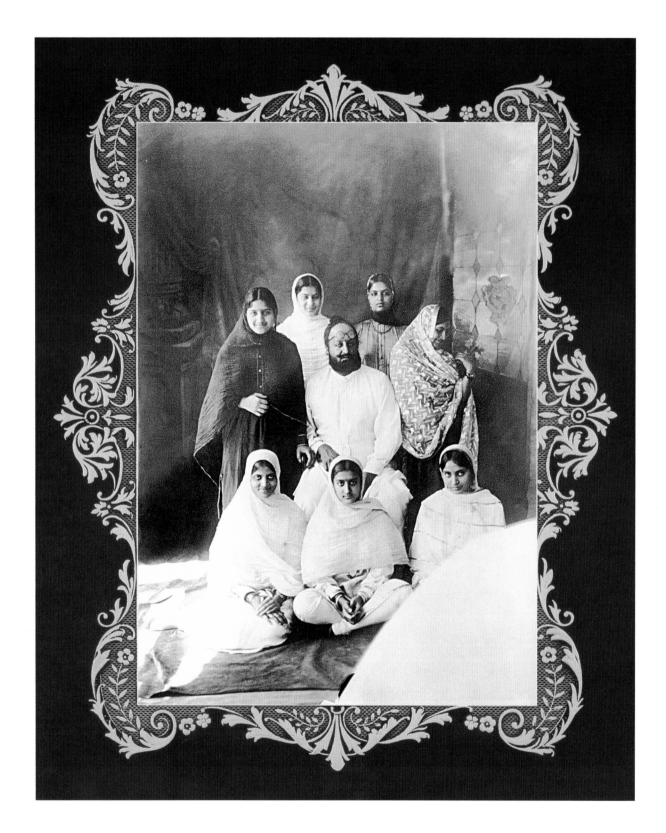

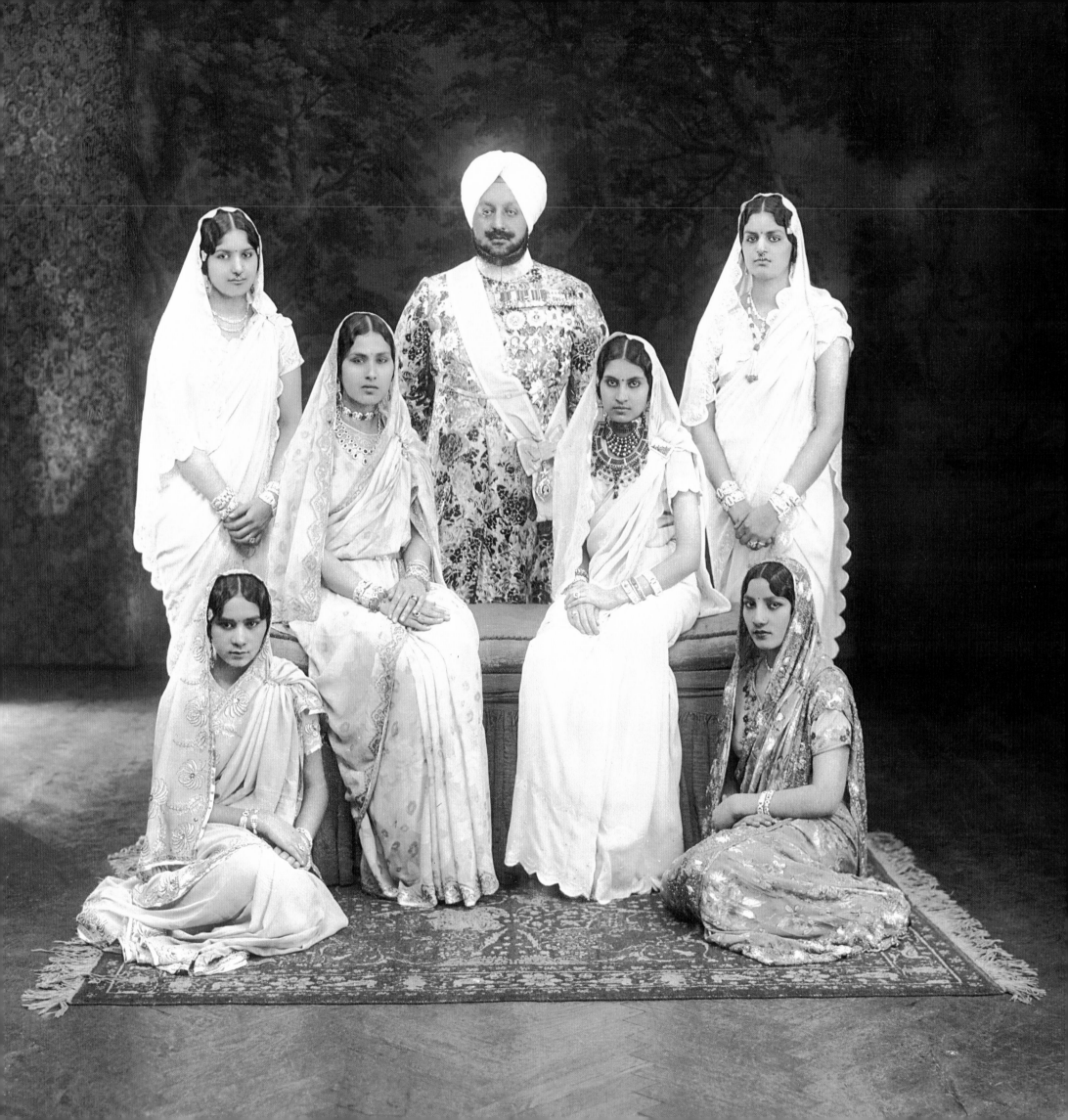

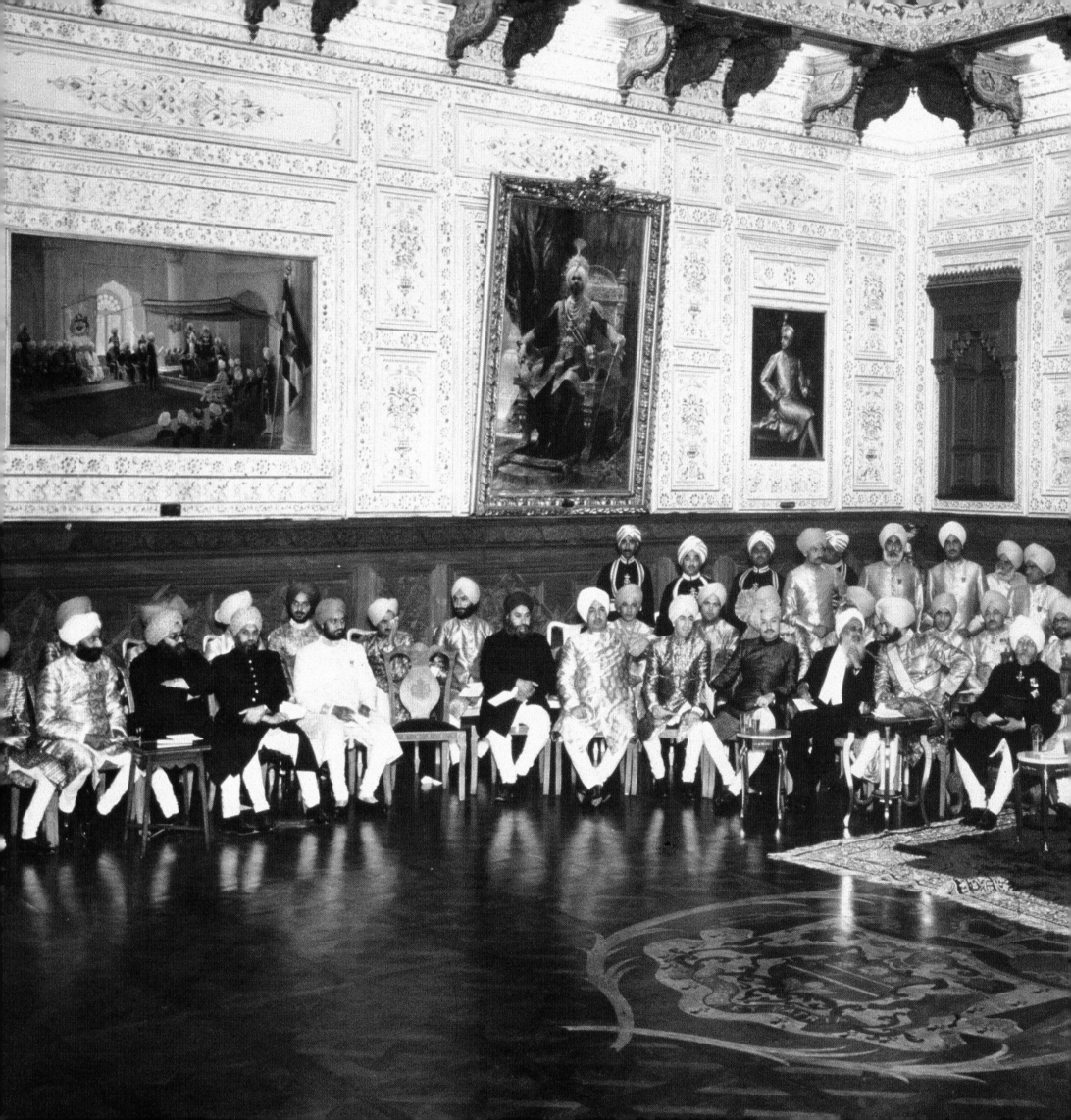

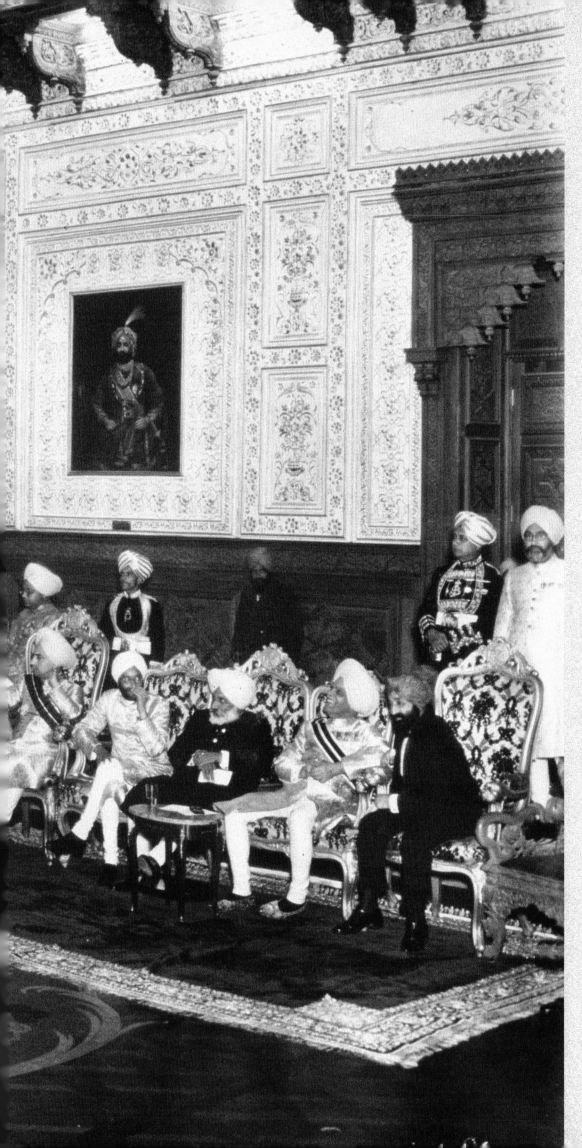

Group photographs of the Indian princes were usually taken on historic occasions, such as state visits made by them to each other's kingdoms. Such occasions could also mark the visit of the Viceroy, a royal wedding, coronation or even a successful house party organized for a hunt. There are some group photographs in this section that have come from private collections and mark innocent fancy dress parties or romps of that nature. Less formal than the sit-down groups that followed strict protocol and hierarchy, these are charming pictures of children dressed up in fancy dress, perhaps to mark an unusual birthday party. Others are more formal, with solemn looking courtiers and attendants arranged around the central figure of an important Maharaja.

Often, these group photographs carry the names of the characters in fine copperplate, terribly faded and so hard to decipher. At other times, they are neatly labelled and mounted in impressive frames and hung from the walls of palaces and forts. Some have been lovingly preserved, others have suffered from neglect and the ravages of time. It is also not always possible to identify the provenance of these photographs. Some were unearthed from forgotten attics and trunks and it is easy to confuse one ruler from another after decades have passed.

However, each one of them has a story to tell and freezes a moment of history forever. Whether it is a picture of a solemn gathering or a forgotten event, it is always a moving record.

State banquet, Jagatjit Palace, Kapurthala, to celebrate the visit of his Highness Mahrajadhiraj Yadavindra Singh of Patiala to Kapurthala. He had come to inaugurate the Gurdwara Sri Ber Sahib at Sultanpur Lodi in February 1941. The banquet was attended by the eminent citizens of Kapurthala. Seated in the front row are: (beginning sixth from left) Kunvar Jasjit Singh of Kapurthala, Prince Ajit Singh of Kapurthala, the Kunvar Sahib of Khairagarh, Sir Joginder Singh, Mahrajadhiraj Yadavindra Singh of Patiala, Raja Sir Daljeet Singh of Kapurthala, Tikka Raja Paramjit Singh of Kapurthala, Raja Ravi Sher Singh of Kalsia, Sir Jawahar Singh of Mustafabad, Maharaja Jagatjit Singh of Kapurthala, and Sardar Natha Singh.

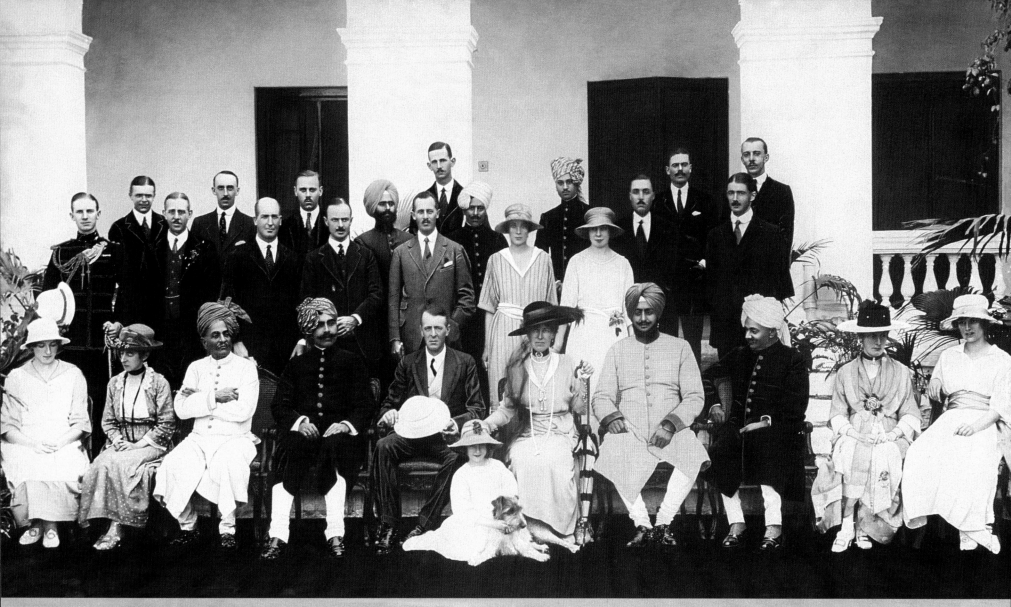

VICEREGAL PARTY 8th NOVEMBER, 1919.

FRONT ROW:- The Hon'ble Mrs.Sheepshanks; The Hon'ble Margaret Best; Lt._General His Highness Maharaja Bahadur Sir Pratap Singh (of Jodhpur);Major General His Highness Maharaja Sir Ganga Singh Bahadur of Bikaner;His Excellency the Viceroy;The Hon'ble Margaret
(from left to right) Thesiger; Her Excellency the Lady Chelmsford; Major General His Highness Maharaja Sir Bhupinder Singh Mohinder Bahadur of Patiala; Lieut._Colonel His Highness Maharaja Sir Ranjitsinghji Vibhaji of Navanagar; Miss Anderson; Miss Villiers.
SECOND ROW:- Captain the Hon'ble D.E.F.O'Brien,A.D.C.to the Viceroy; Lt.Colonel H.Austen Smith,Surgeon to the Viceroy; Major R.D.Alexander,A.D.C.to the Viceroy; Captain R.H.Sheepshanks 12th Cavalry; Lt._Colonel R.Verney,Military Secretary to the Viceroy
 The Hon'ble Joan Thesiger; The Hon'ble Gwladys Ridley;Captain D.S.Frazer,A.D.C.to the Viceroy.
THIRD ROW:- Mr.H.E.Lynch Blosse, Asst.Private Secretary to the Viceroy;Captain J.A.Denny,A.D.C.to the Viceroy;Captain the Hon'ble A.G.Agar-Robartes,A.D.C.to the Viceroy; Major Balwant Singh,Asst.Military Secretary to H.H.the Maharaja of Patiala; Captain
 G.H.Harvey,Adjt Viceroy's Body Guard;Thakur Asu Singh,Staff Officer to H.H.the Maharaja of Bikaner;Lieut.Hanut Singh Staff Officer to H.H.the Maharaja Bahadur Sir Pratap Singh of Jodhpur; Captain A.Brooke, Comdt. Viceroy's Body Guard; Captain
 C.W.G.Gordon Ives,A.D.C.to the Viceroy; Captain E.H.Heare,A.D.C.to the Viceroy.

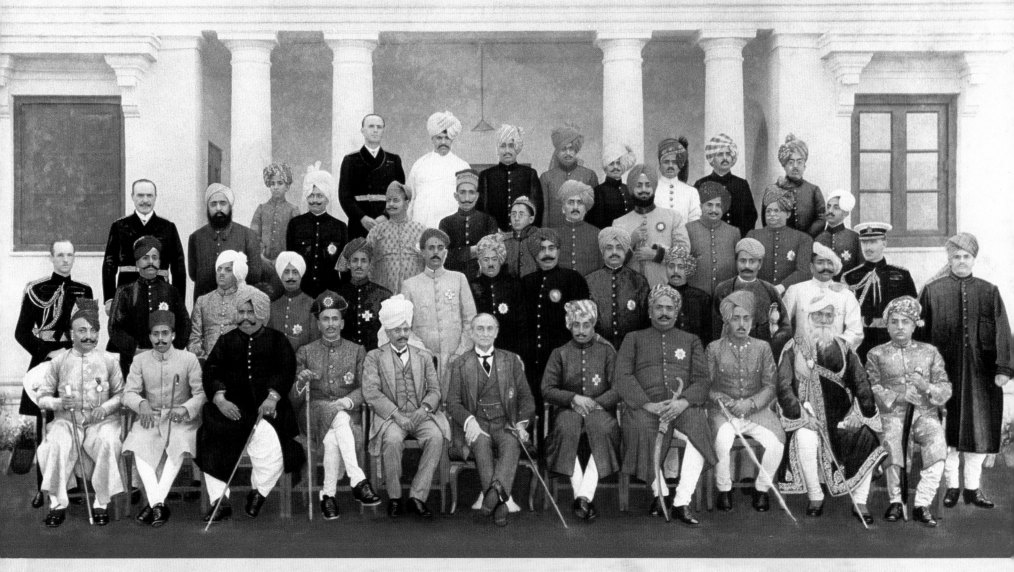

THE CHAMBER OF PRINCES (NARENDRA MANDAL) DELHI, FEBRUARY, 1923.

FRONT ROW (SEATED):- H.H. the Raja of Jhabua, The Nawab of Banganapalle, H.H. the Mir of Khairpur, H.H. the Maharaja of Alwar, H.H. the Maharaja of Gwalior, H.E. the Viceroy, H.H. the Maharaja of Jodhpur, H. H. the Maharawal of Jaisalmer, H. H. The Maharaja of Dewa, H. H. the Maharaja of Orchha, H.H. the Maharao of Cutch.

SECOND ROW (STANDING) Captain G.D.Raines, H.H. the Raja of Sitamau, H.H. the Nawab of Baoni, H.H. the Nawab of Malerkotla, H.H. the Nawab of Bahawalpur, H.H. the Maharaja of Dhar, H. H. The Nawab of Jaora, H. H. the Maharaja of Bikaner, H. H. The Raj Sahib of Wankaner, The Raja of Talcher, The Rao of Alipura, H.H. the Maharaja of Datia, Lt.-Col.C.K.Craufurd Stuart, C.V.O, C.B.E. D.S.O, The Nawab of Dujana.

THIRD ROW (STANDING) The Hon'ble Mr. J.P.Thompson, C.S.I, H.H. the Maharaja of Nabha, H.H. the Raja of Rajgarh, H.H. the Maharao of Kotah, The Nawab of Loharu, H. H. the Maharaja of Sikkim, The Raja of Jubbal, H.H. the Maharaja of Patiala, The Rao of Khilchipur, The Thakur Sahib of Limbdi, H.H. the Maharajrana of Dholpur.

FOURTH ROW (STANDING) Rajkumar of Sitamau, Major G.D.Ogilvie, H.H. the Maharaja of Kolhapur, H.H. the Maharaja of Porbandar, The Thakur Sahib of Rajkot, The Chief of Sangli, H. H. the Raja of Bariya, The Thakur of Kadana, The Raja of Keonthal.

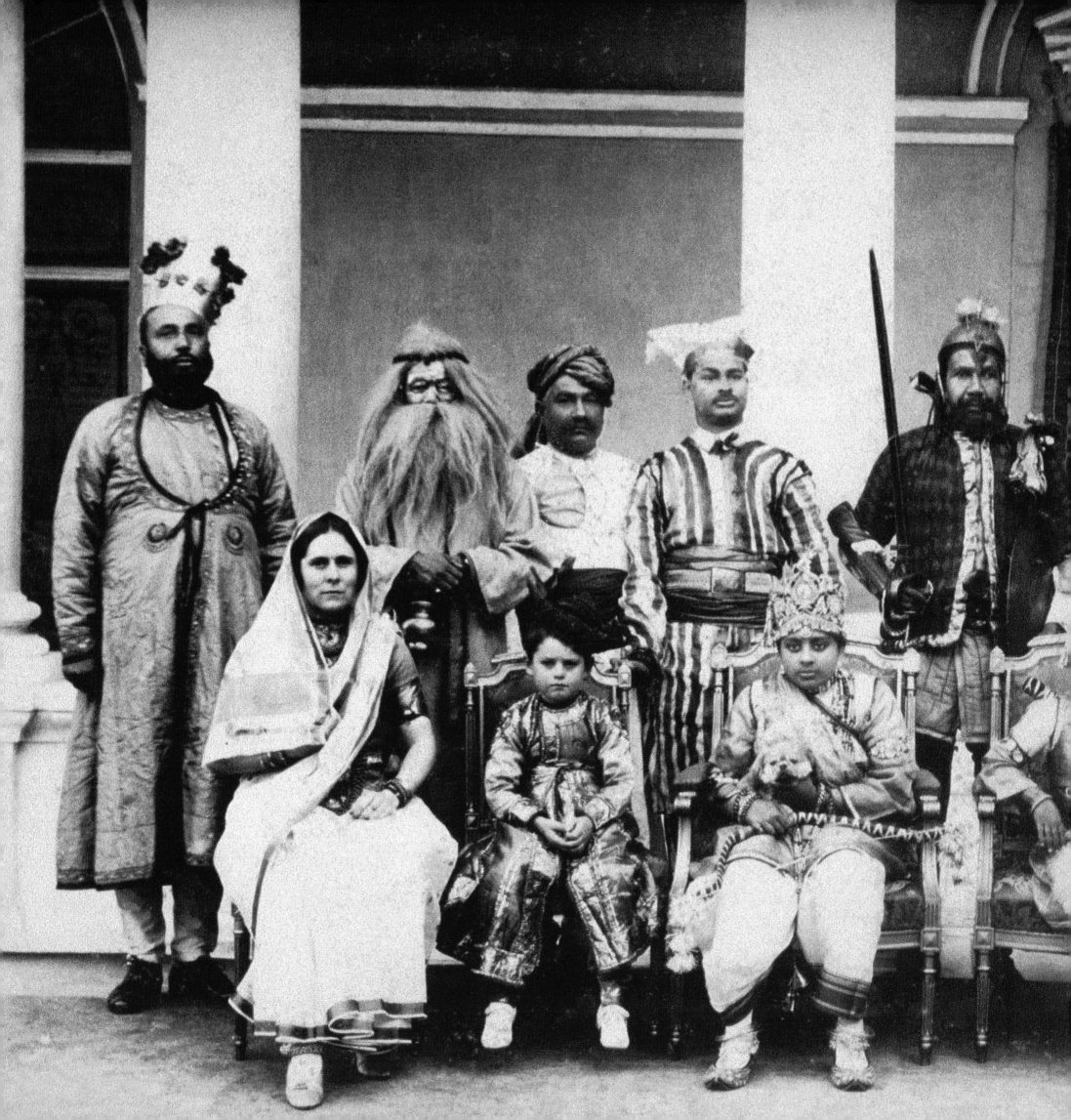

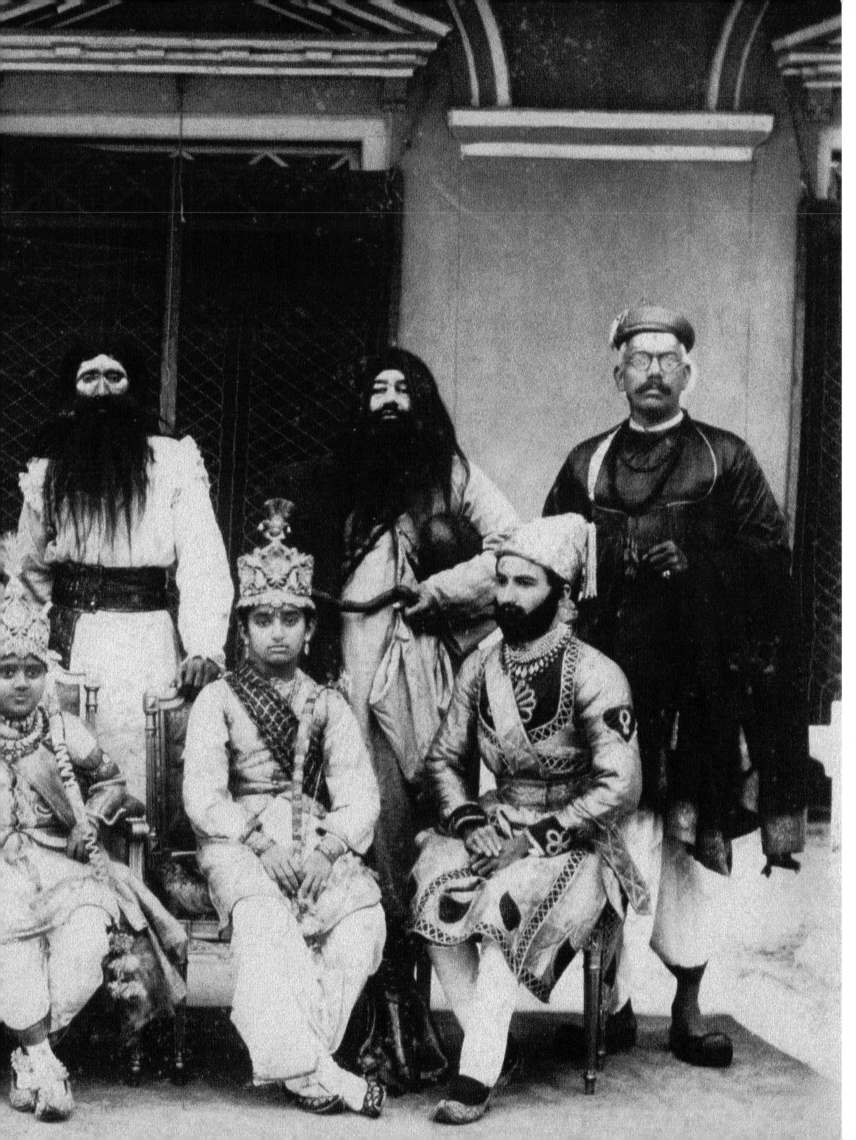

DUSSERA IS A TIME OF
FESTIVITY ALL OVER
INDIA. THE RAMLILA,
A CYCLE PLAY OF
STORIES FROM THE
EPIC RAMAYANA, WAS
PERFORMED BY
TRAVELLING BANDS
OF ACTORS. OFTEN
THERE WERE COMMAND
PERFORMANCES FOR THE
LADIES OF THE ZENANA.
THIS PHOTOGRAPH OF
A RAMLILA GROUP IN
GWALIOR IN THE EARLY
YEARS OF THE LAST
CENTURY PROBABLY
PERFORMED FOR THE
MAHARAJA'S FAMILY.

PRECEDING PAGES 66-67:
THESE TWO PHOTOGRAPHS
TAKEN IN 1919 AND
1923, AS THE TEXT
ON THEM INDICATES,
CELEBRATED A SPECIAL
OCCASION. A 1919
VICEREGAL VISIT AND
A 1923 CHAMBER OF
PRINCES MEET.

69

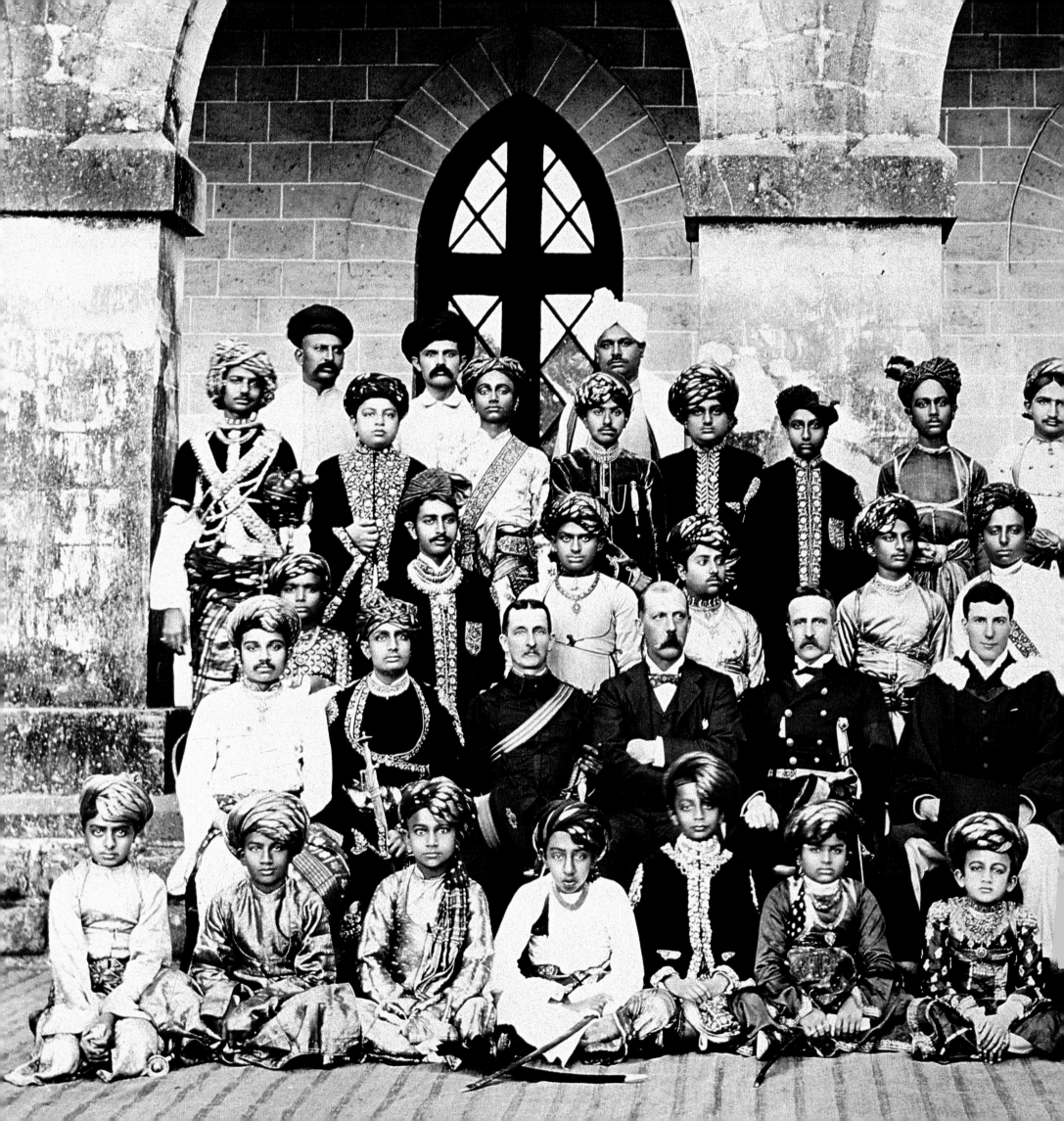

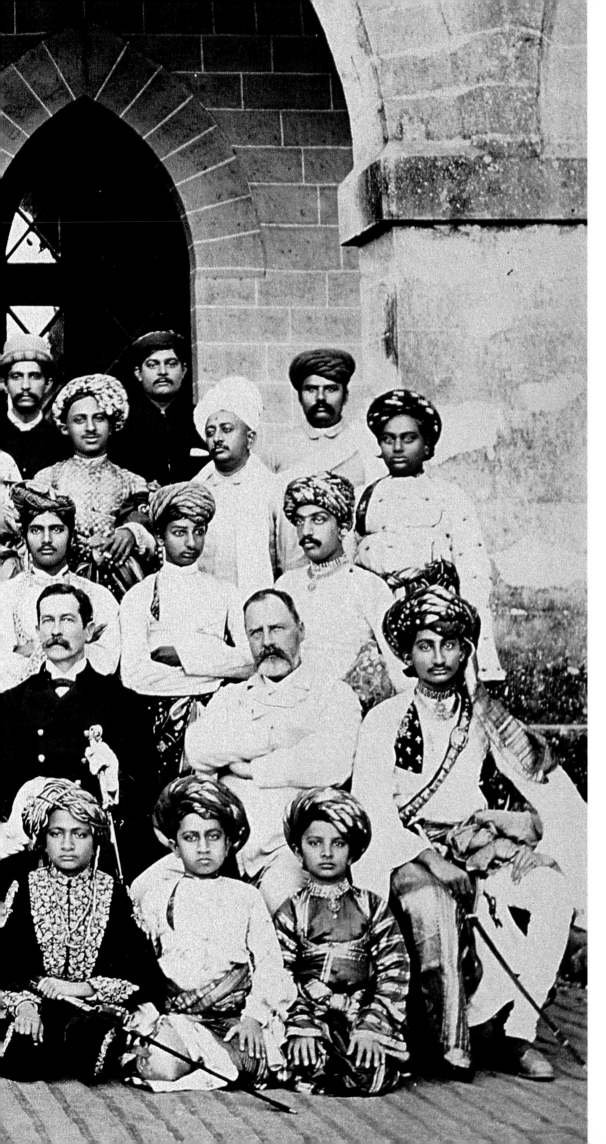

THE RAJKUMAR COLLEGE IN RAJKOT WAS AMONG THE SPECIAL PRINCELY SCHOOLS SET UP BY THE BRITISH TO EDUCATE THE PRINCES OF KATHIAWAR. MANY INDIAN PRINCES WERE GIVEN PRIVATE LESSONS AT HOME BEFORE THEY WERE SENT ABROAD OR TO BOARDING SCHOOLS IN THE HILL STATIONS. IN THE LARGER AND GRANDER STATES, BRITISH NANNIES AND GOVERNESSES WERE EMPLOYED SO THAT THEY COULD BRING ABOUT SOME DEGREE OF DISCIPLINE AND WESTERN INFLUENCE TO BEAR UPON THE CHILDREN. IT WAS BELIEVED THAT THE BRITISH LAID CONSIDERABLE EMPHASIS ON THE PROPER EDUCATION OF YOUNG PRINCES. THIS PRACTICE SERVED BOTH INTERESTS WELL: THE SUPERVISION OF THE EDUCATION OF THE PRINCES PROVIDED THEM WITH AN APPRECIATION OF THEIR DUTIES AS RULERS AND AT THE SAME TIME, IT MOULDED THEM INTO LOYAL PILLARS OF BRITISH RULE. IN THE CENTRE OF THE GROUP IS MR MCNAUGHTON, A LEGENDARY PRINCIPAL OF THE SCHOOL.

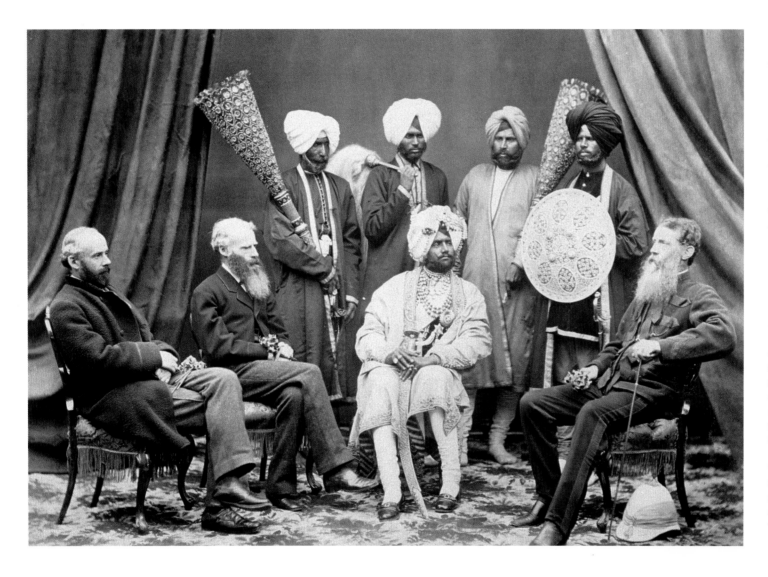

MAHARAJA MOHINDAR
SINGH OF PATIALA WAS
TEN YEARS OLD WHEN HE
SUCCEEDED HIS FATHER,
NARENDAR SINGH. IN
HIS SHORT REIGN OF
FOURTEEN YEARS, HE
STARTED THE FAMOUS
SIRHIND CANAL PROJECT
TO BRING WATER TO THE
FARMERS OF HIS
KINGDOM AND SET UP A
COLLEGE, NOW NAMED
AFTER HIM. A
BENEVOLENT RULER, HE
DONATED TEN LAKH
RUPEES FOR FAMINE
RELIEF IN BENGAL IN
1873.

FACING PAGE: THIS
PHOTOGRAPH FROM ONE
OF THE PHULKIAN
STATES OF PUNJAB,
SHOWS THE RULER
SEATED WITH HIS
MINISTERS. THE
STIFFNESS IN THE
POSTURE OF THE SITTERS
INDICATES THAT THEY
WERE ASKED TO 'HOLD' A
POSITION WHILE THE
PHOTOGRAPHER
ADJUSTED THE LENS FOR
THE PERFECT PICTURE.

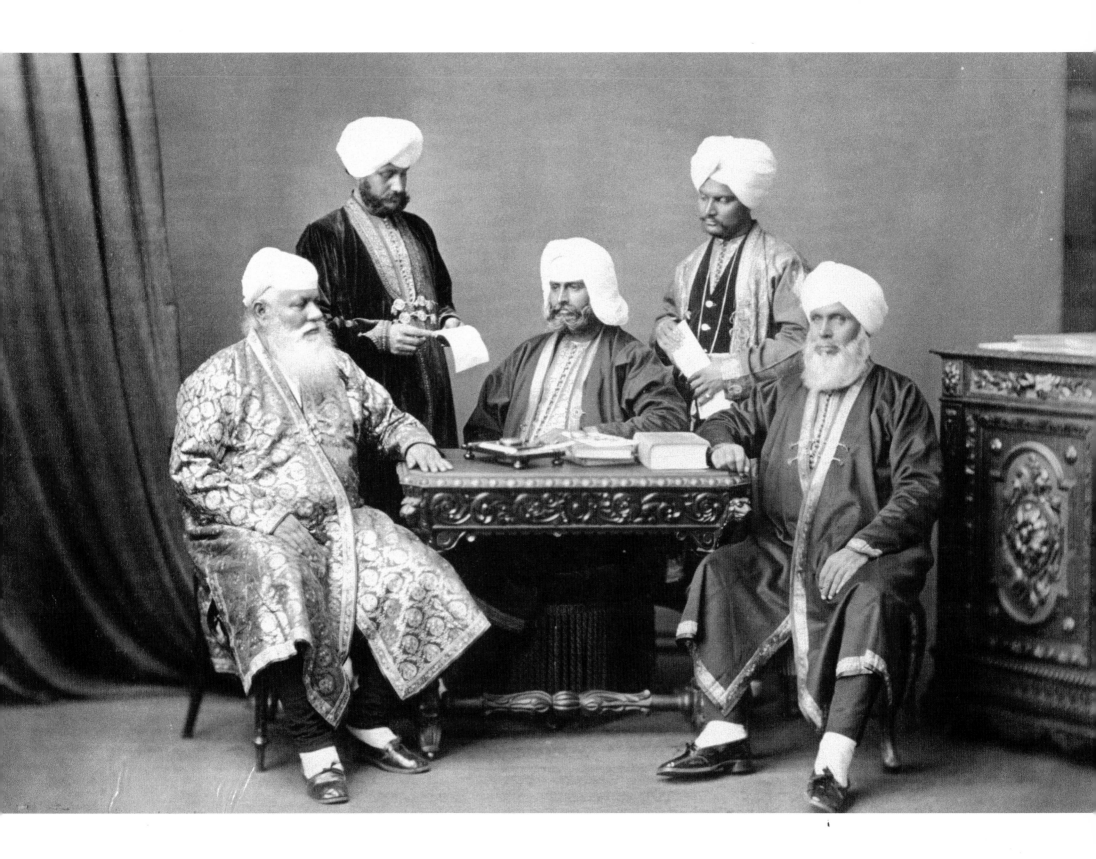

A MAN WITH A
COMMANDING PRESENCE,
MAHARAJA GANGA SINGH
OF BIKANER WAS ONE OF
THE GREAT RULERS OF
HIS TIME. HE HAD A
REPUTATION AS A
STATESMAN AND
SPOKESPERSON OF THE
COUNTRY IN THE
COUNCILS OF THE
WORLD. HE
REPRESENTED INDIA AT
THE IMPERIAL WAR
CONFERENCE IN 1917,
AT THE PEACE
CONFERENCE IN 1918,
AT THE LEAGUE OF
NATIONS, AND AT THE
ROUND TABLE
CONFERENCE. HE
FOUGHT FOR THE
BRITISH IN THE CHINA
WAR OF 1900–1901,
COMMANDING THE GANGA
RISALE (CAMEL CORPS).
IN WORLD WAR I, HE
SAW ACTION IN WEST
ASIA.

FACING PAGE: THIS
PHOTOGRAPH WAS TAKEN
ON THE OCCASION OF
THE WEDDING OF GANGA
SINGH'S DAUGHTER,
PRINCESS SASHIL
KUMARI, WITH BHAGWAT
SINGH, SON OF
MAHARANA BHOPAL
SINGH OF UDAIPUR IN
1940. THE WEDDING
WAS CONSIDERED A
LANDMARK AT THE TIME
AS AN ALLIANCE
BETWEEN THE TWO
MOST FAMOUS RAJPUT
DYNASTIES AND WIDELY
CELEBRATED. GANGA
SINGH AND BHOPAL
SINGH ARE SEATED
SECOND AND THIRD
FROM LEFT.

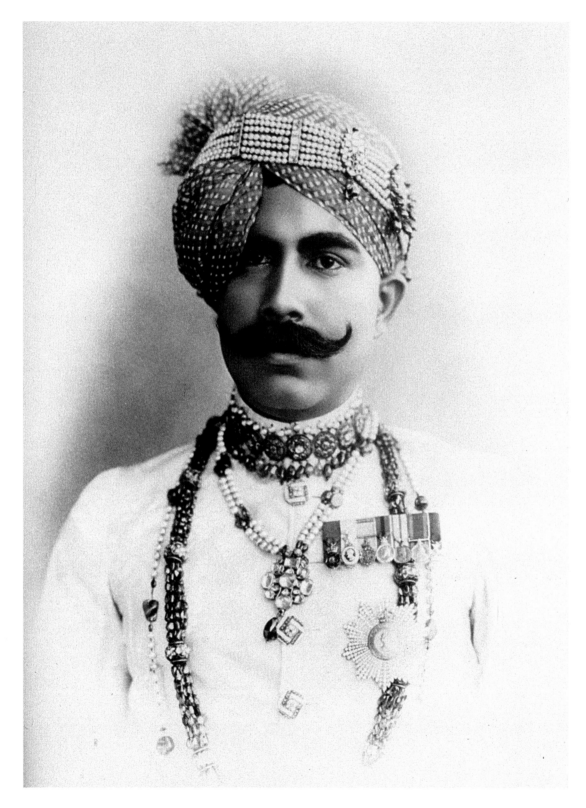

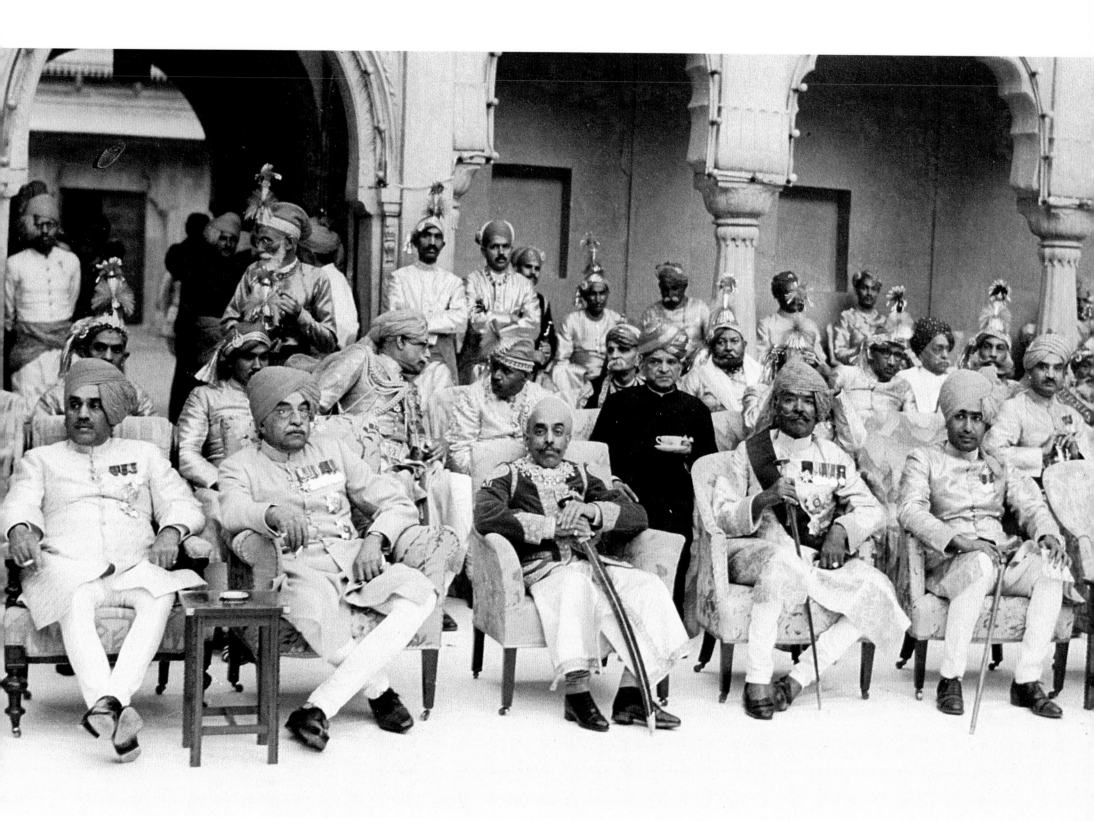

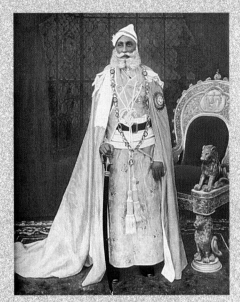
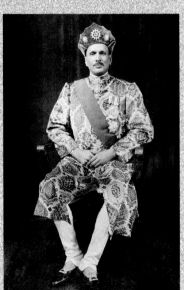
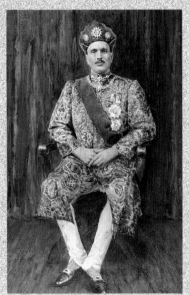
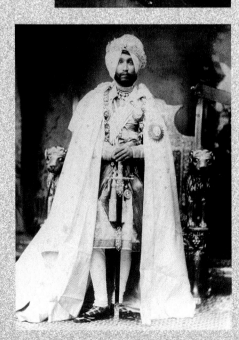
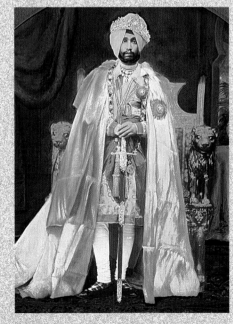

PALIMPSESTS

The art of portraiture was the preserve of the painter for a long time in India. Superb and intricately detailed portraits were executed by painters skilled in the art of using colour and brush. All this was to change after the introduction of photography. While some declared that painting was now a dead art, others said deprecatingly that photography was the refuge of failed painters. There were some occasions, however, when the art of the painter and the photographer joined hands. The result is an interesting blend of the truth as seen by the two mediums. For a while the camera captured each detail of the subject and was faithful to scale and form, it was unable to do justice to the quality of grandeur and lacked the colour that only a painter could provide.

The painted studio portraits seen here arose from just such a discovery. In each case, while the photograph remains clearly visible, the eye is arrested by the colour that has been added by a skilful painter to highlight details that need to be stressed. The result is an enriched photograph. Jewellery and clothes such as the Indian princes preferred to wear could not be seen in their full splendour unless the red of the rubies, the green of the emeralds or the blue of the sapphires was visible as well. Similarly, the intricate weaves of the rich Indian brocades need to be seen in the vivid colours that the originals possessed. The yellow turban of the young prince on the facing page matches the yellow sash that adorns his father's costume, a fact that the original photograph could neither show nor highlight.

In a further development, artists also added or deleted objects to the background. In these portraits, a rich velvet curtain hides the window or a blue drape is tinted in to complete the study in blue. An entire mantelpiece with vases of flowers and other bric-a-brac is added to the portrait on the facing page. Chandeliers miraculously appear in the painted version, no doubt an addition that the prince wanted to be added. The artists, skilled in the art of hand-tinting, used coloured powders and fixed the colour to the copperplate with gum arabic.

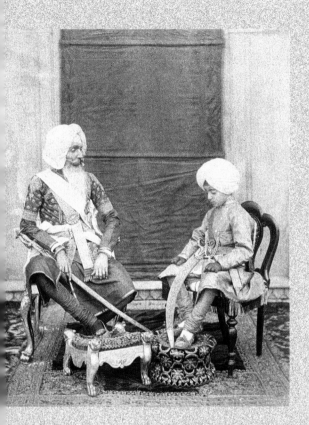

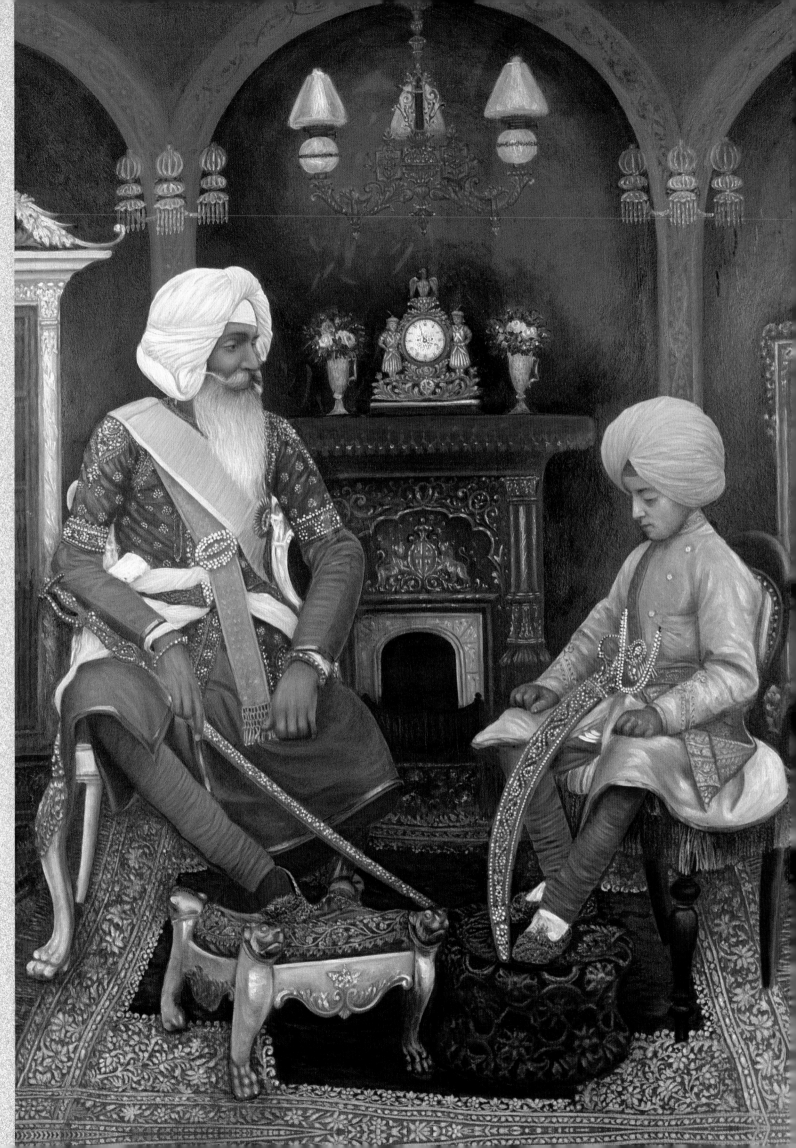

Maharaja Hira Singh with his son, Tikka Ripudaman Singh in the Nabha Fort. The tinted picture is richer version of the original.

Facing page top: Maharana Fateh Singh of Udaipur (1849–1930), one of the most respected rulers of his time. *Middle:* Maharaja Jai Singh of Alwar always wore a crown and insisted on being called 'Prabhuji' (God) as he traced his descent from Lord Rama. He died in Paris.

Bottom: Maharaja Rajindar Singh (1876–1900) of Patiala.

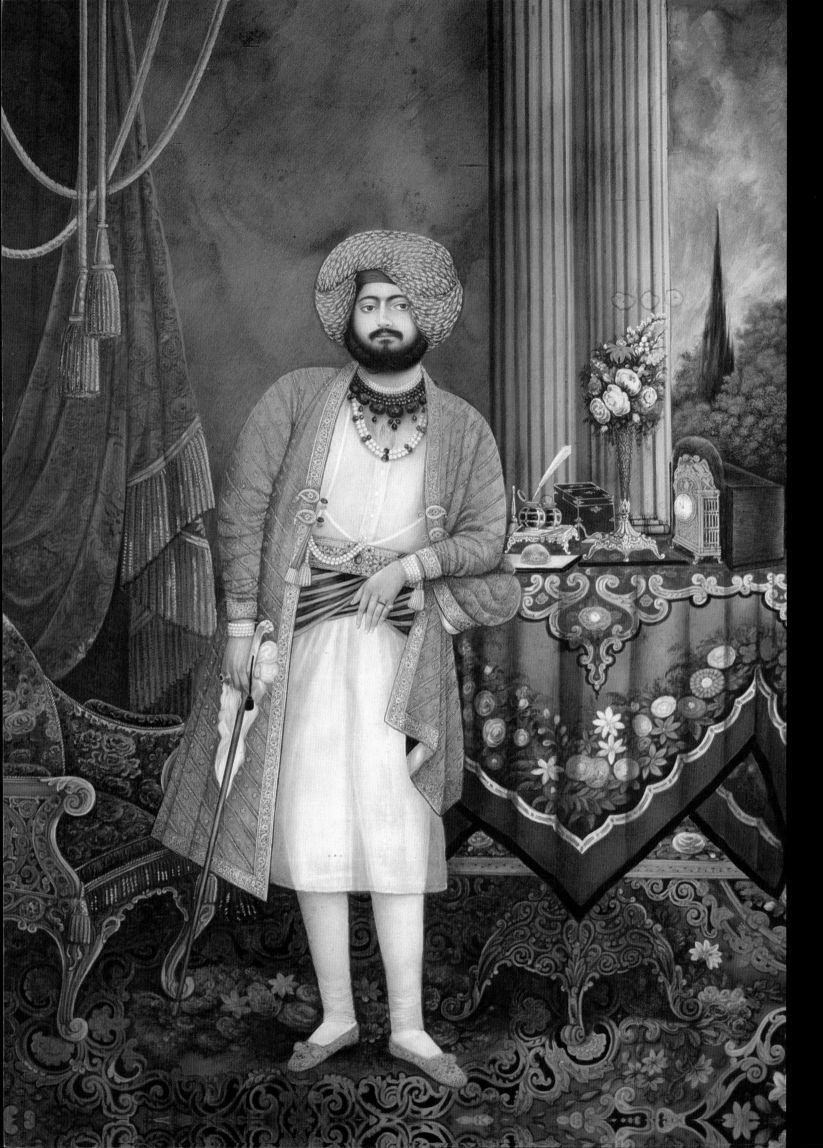

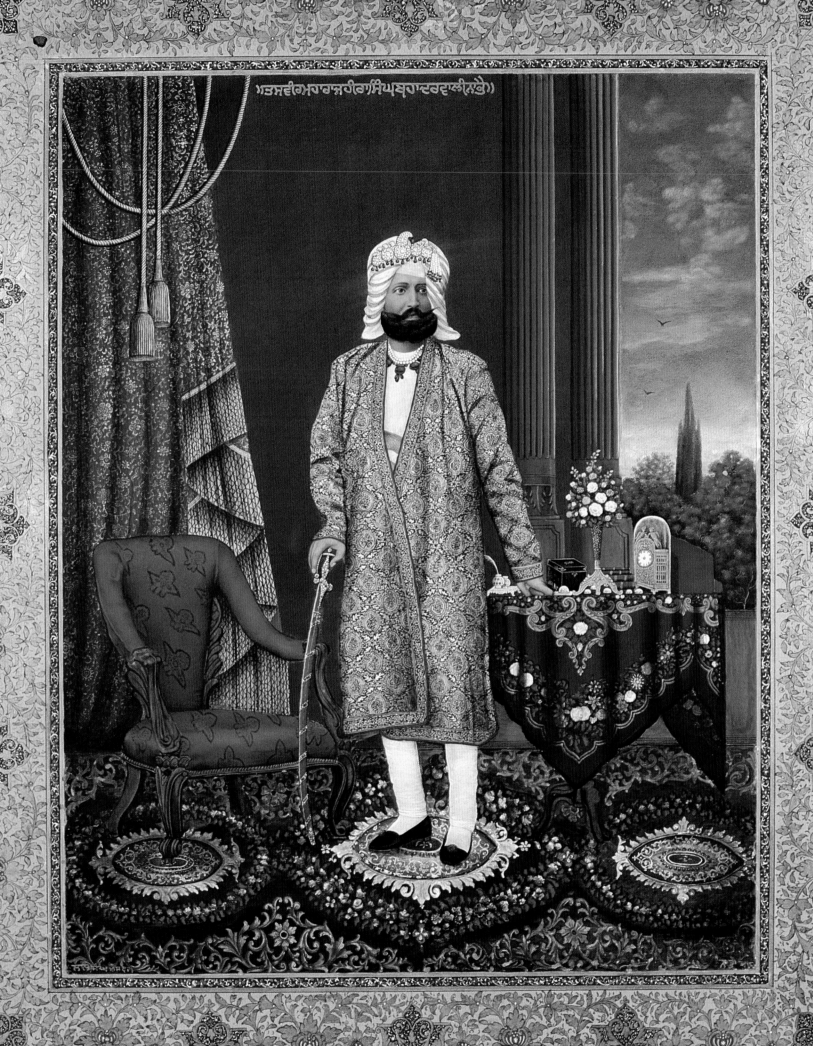

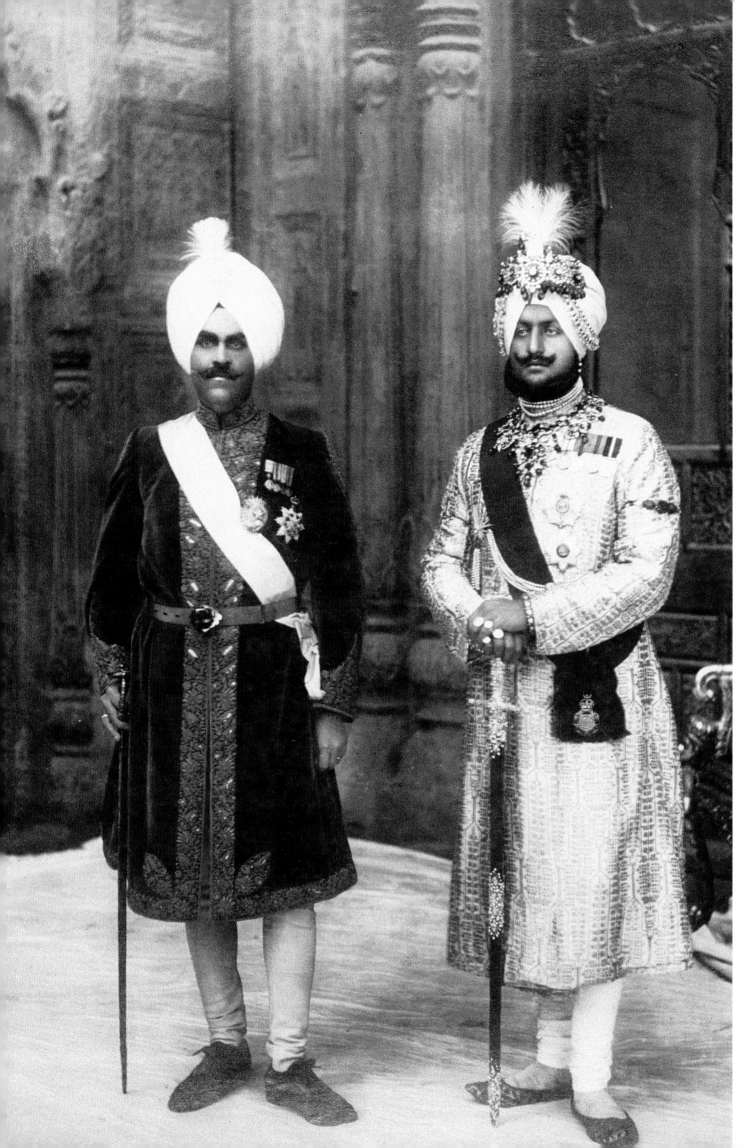

THE TWO LEADING
LIGHTS OF THE STATES
OF PUNJAB, MAHARAJA
BHUPINDAR SINGH OF
PATIALA AND MAHARAJA
JAGATJIT SINGH OF
KAPURTHALA, IN FULL
STATE REGALIA. THEY
WERE PROMINENT
MEMBERS OF THE
CHAMBER OF PRINCES.
BOTH THESE PRINCES
WERE VERY FOND OF
TRAVELLING ABROAD
AND STIRRED PUBLIC
INTEREST WITH THEIR
FLAMBOYANT LIFESTYLE
WHENEVER THEY DID SO.
BHUPINDAR SINGH, WHO
FAVOURED THE SAVOY
HOTEL IN LONDON,
TRAVELLED WITH 200
PIECES OF LUGGAGE,
NUMEROUS JEWEL CASES
AND EVEN A SILVER BATH
TUB MEANT FOR HIS
EXCLUSIVE USE. HE AND
HIS RETINUE OF 50
OCCUPIED 100 ROOMS IN
THE HOTEL. HIS STAFF
DELIGHTED IN USING THE
HOTEL'S LIFT (WHICH
THEY NICKNAMED THE
ASCENDING ROOM) AND
WENT UP AND DOWN IN
IT CARRYING OUT THE
MAHARAJA'S ORDERS.

MAHARAJA MOHINDAR
SINGH OF PATIALA
MARRIED THRICE AND HIS
HEIR, RAJINDAR SINGH,
WAS BORN IN 1872. IN
1870, MOHINDAR SINGH
VISITED LAHORE TO MEET
THE DUKE OF
EDINBURGH AND IN
1875, MET THE PRINCE
OF WALES IN PATIALA
TERRITORY. THE NEXT
YEAR, HE SUDDENY DIED
AT THE AGE OF 24. MANY
SUSPECTED FOUL PLAY.

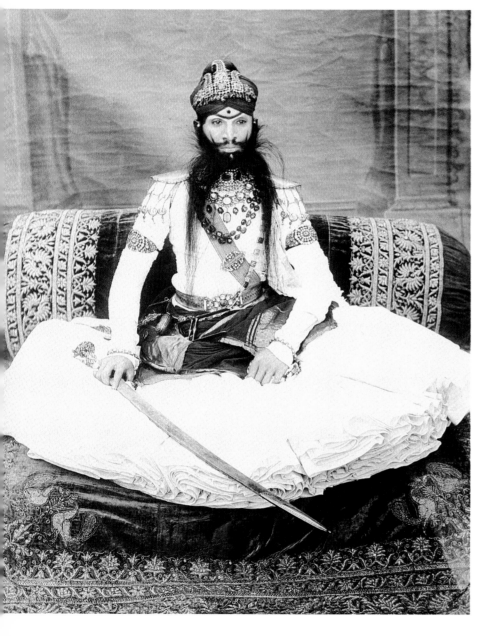
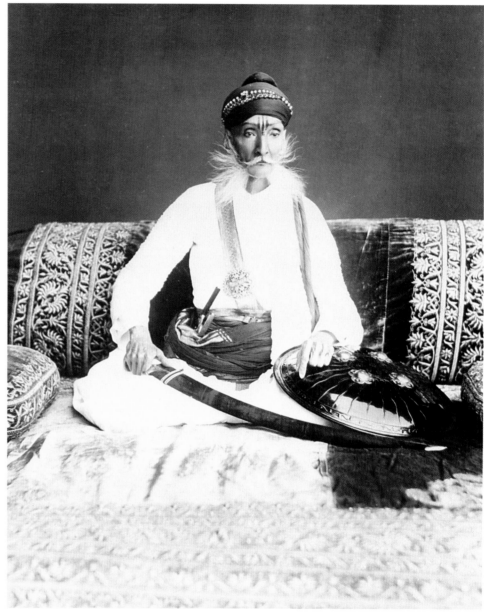

Even though by the time these photographs were taken the Indian princes were no longer the fierce warriors they once were, they were deeply attached to, and proud of, their weapons. There are hardly any portraits that do not show them carrying their ceremonial swords. Their arms were more than mere weapons; they signified the risking of their life for the protection of their country, ideals, honour, and justice. But other than these, arms were also a test of courage and a demonstration of manhood, pride, victory, and freedom.

As such, arms became invested with sacred power. They were worshipped by the rulers on special festivals, such as Dussera. On such occasions the ruler, dressed in ceremonial robes and carrying a sword and shield, would ride out in a procession through the state capital. Perhaps the most famous example of the deep reverence in which the rulers held their arms is that of the Maratha ruler and guerrilla leader Shivaji. He always used to worship his sword, said to be invested with the divine energy of the goddess, before a battle.

Indian arms and armour were also showcases of skilled craftsmanship. They were beautiful works of art. Studded with precious jewels and damascened or gilded with gold and etched, they were handed down from father to son, and some of them can be counted as valuable antiques. At the time of coronation, the ruler was ceremoniously handed the sword and shield of his father by the family priest. Most old forts still have a *toshkhana*, where the state armoury is housed.

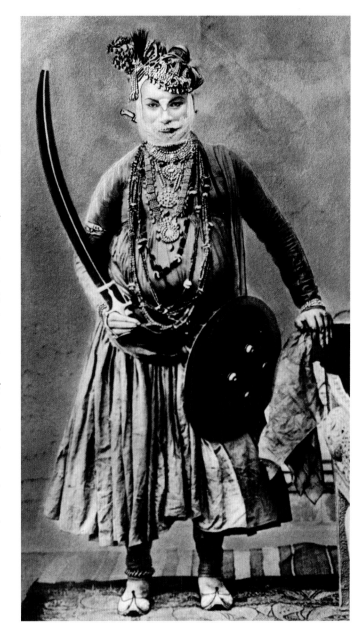

SIR BHANWAR PAL DEO BAHADUR, THE MAHARAJA OF KARAULI, C. 1911. SURROUNDED BY THE STATES OF BHARATPUR, JAIPUR, GWALIOR AND DHOLPUR, THE RULERS OF KARAULI TRACED THEIR ANCESTRY TO LORD KRISHNA.

FACING PAGE LEFT:
MAHARAO RAJA RAGHUBIR SINGH BAHADUR OF BUNDI, C. 1888. BUNDI, A RAJPUT STATE WAS RENOWNED FOR ITS FIERCE WARRIORS. THE MAHARAO, SITTING AGAINST THE TRADITIONAL *GADDI* (CUSHIONED THRONE), WEARS HIS BEARD AND SPLENDID MOUSTACHES IN THE TRADITIONAL STYLE OF HIS FAMILY.

FACING PAGE RIGHT:
MAHARAO SIR RAM SINGH, HIS FATHER, SITS AGAINST THE SAME *MASNAD*, C. 1880S.

MAHARAJA TAKHT SINGH
OF JODHPUR (1843–
1873). ADOPTED FROM
THE NEIGHBOURING
STATE OF IDAR BY
MAHARAJA MAAN SINGH,
HE PROVED TO BE AN
INDIFFERENT RULER,
AND SPENT HIS DAYS
SURROUNDED BY HIS
HAREM OF THIRTY WIVES
CHOSEN FROM VARIOUS
RAJPUT CLANS. SHIKAR
WAS HIS PASSION AND HE
ENCOURAGED HIS WIVES
TO ACCOMPANY HIM,
MUCH TO THE SHOCK OF
THE CONSERVATIVE
RAPJUT NOBLEWOMEN,
WHO PRACTISED STRICT
PURDAH.

FACING PAGE:
MAHARAJA RAGHURAJ
SINGH OF REWA, C. 1875.
THE EYES ARE FIERCE AS
IS THE BEARD, BUT
THERE IS AN AIR OF
DECAY AND DISSIPATION
ON THE FACE. REWA WAS
A RAJPUT STATE IN
CENTRAL INDIA FAMOUS
FOR THE ABUNDANT
TIGERS IN ITS DENSE
FORESTS. THE MAHARAJA
WEARS THE ROBE OF THE
MOST EXALTED ORDER
OF THE STAR OF INDIA,
AN HONOUR CONFIRMED
IN THAT YEAR BY THE
PRINCE OF WALES.

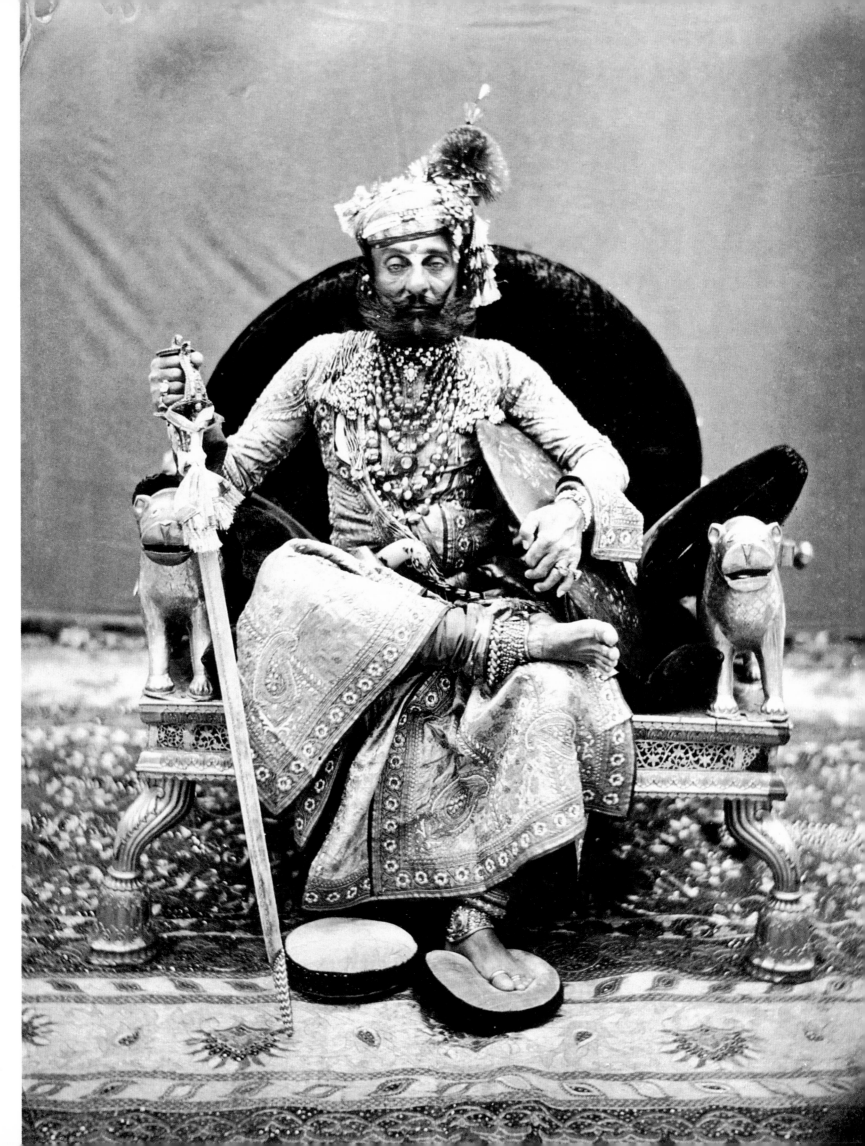

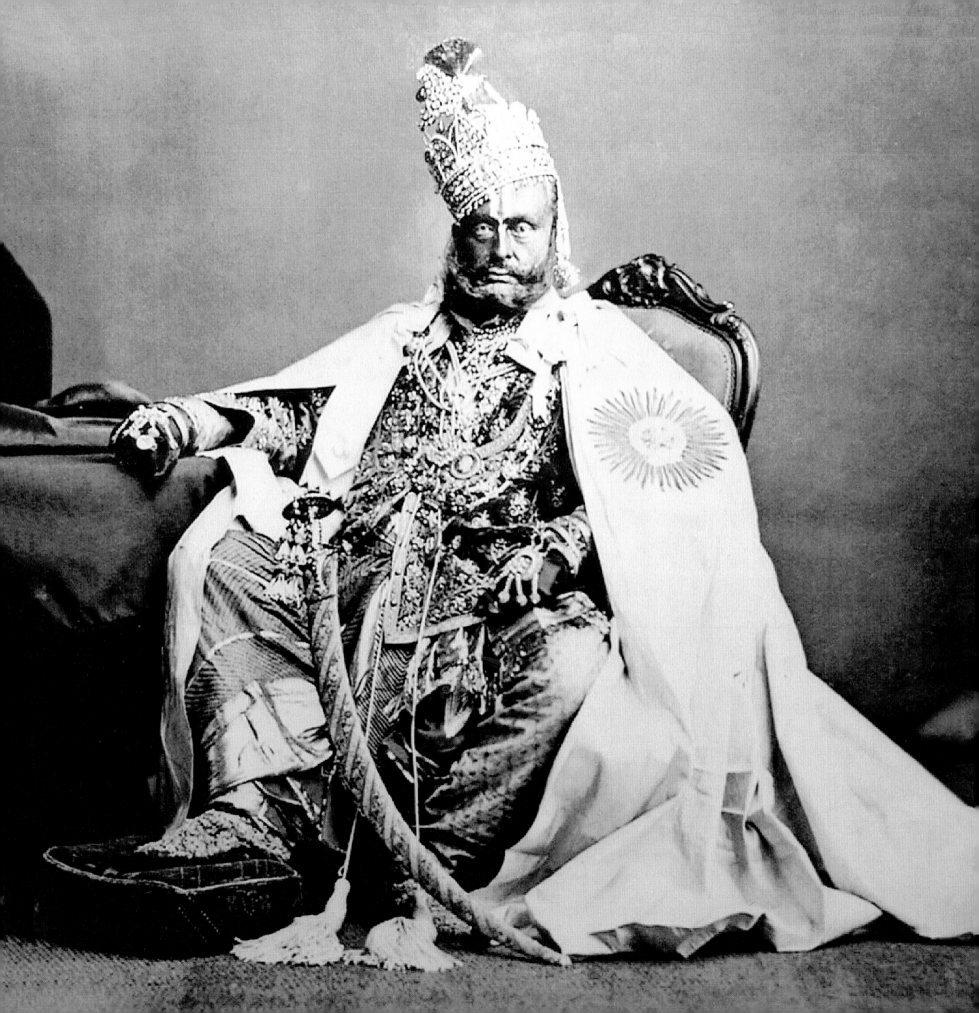

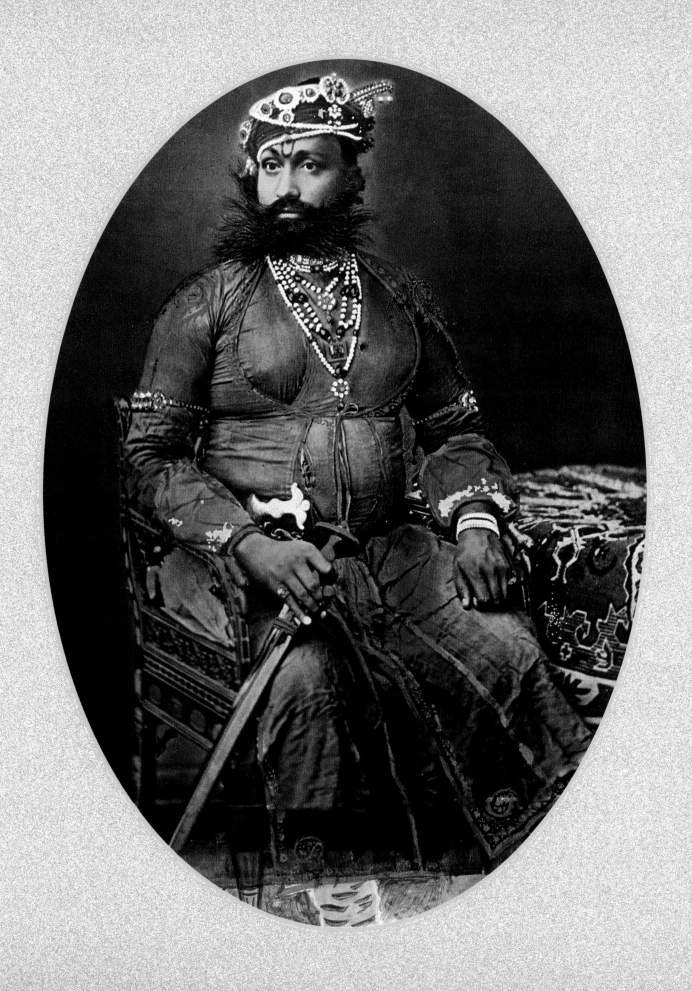

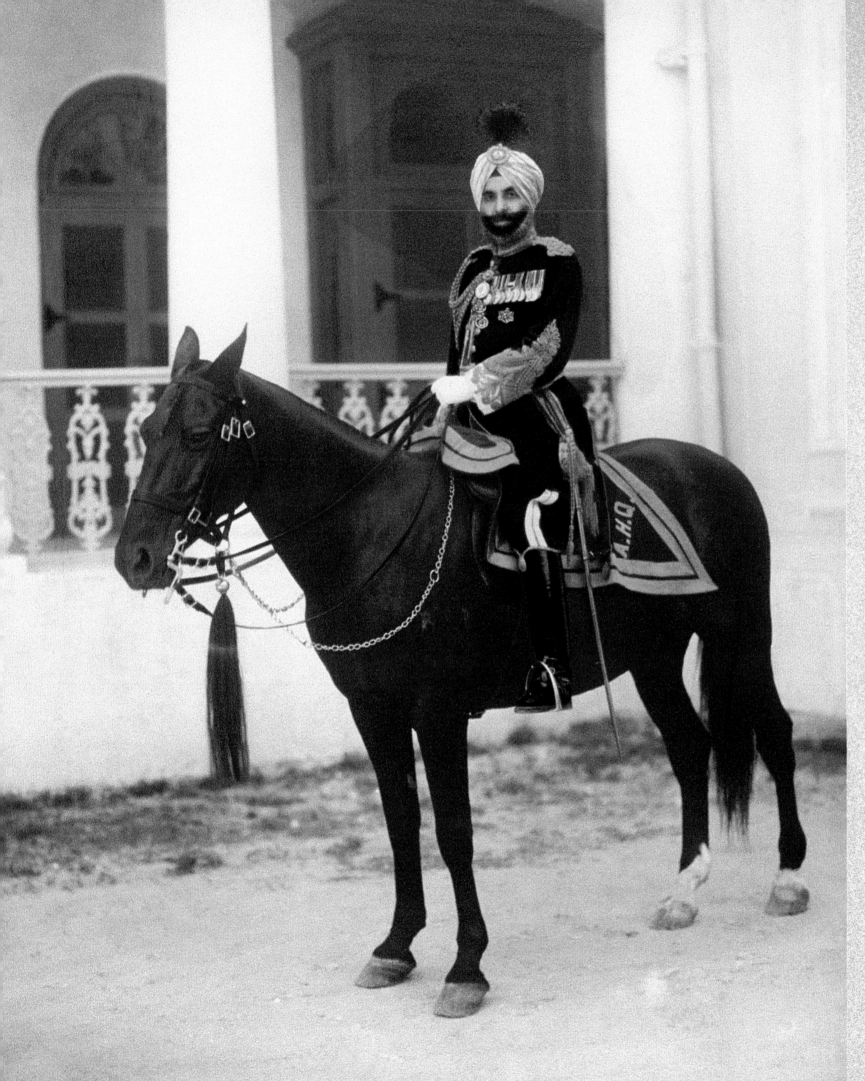

MAJOR GENERAL S. B.
GURDIAL SINGH HARIKA,
CHIEF OF THE GENERAL
STAFF OF PATIALA, WHO
WAS ALSO THE LAST
PRIME MINISTER OF THE
STATE. GENERAL HARIKA
WAS A *JAGIRDAR* (THE
CHIEF OF A MINOR
PRINCIPALITY) AND IS
CREDITED WITH TRAINING
THE FAMOUS PATIALA
CAVALRY REGIMENTS. AN
ACCOMPLISHED
HORSEMAN, IT IS SAID
THAT THE GENERAL
KNEW EVERY HORSE IN
THE PATIALA STABLES BY
NAME. HE WAS AWARDED
WITH THE PRESTIGIOUS
ORDER OF BRITISH INDIA
(O.B.I.), 1ST CLASS, AND
INDIAN DISTINGUISHED
SERVICE MEDAL
(I.D.S.M.).

FACING PAGE: MAHARAJA
PRITHVI SINGH OF
KISHANGARH, WAS BORN
IN 1837 AND RULED
FROM 1840–1880.
KISHANGARH, A RAJPUT
STATE, IS RENOWNED
FOR ITS EXQUISITE
COLLECTION OF
MINIATURE PAINTINGS
DONE IN A TYPICAL
STYLE, DEVELOPED BY
THE COURT PAINTERS.

TRICK PHOTOGRAPHY, AN
EXPERIMENT WITH
SUPERIMPOSED PLATES
POPULAR TILL TODAY
WITH RURAL FOLK WHO
GET THEMSELVES
PHOTOGRAPHED FOR THE
FIRST TIME AT VILLAGE
FAIRS, WAS TRIED OUT
EVEN BY THE ROYALS
WHEN THEY FIRST
ENCOUNTERED
PHOTOGRAPHY. HERE,
THE RULERS OF JAIPUR
ARISE FROM THE
SWIRLING SMOKE OF AN
ALLADIN'S LAMP: *FROM
THE BOTTOM*: RAM
SINGH; MADHO SINGH;
SAWAI MAN SINGH II.

IN ANOTHER TRICK
PHOTOGRAPH, THE YOUNG
RULER OF JAIPUR, SAWAI
MAN SINGH II IS
BLESSED BY A PANTHEON
OF INDIAN GODS. ON HIS
LEFT ARE SHIVA AND HIS
CONSORT PARVATI WHILE
ON HIS RIGHT, KRISHNA
AND RADHA. OVER THEM,
FRAMED BY THE SACRED
SYMBOL OF OM, WEARING
A GARLAND OF SKULLS,
IS BHAVANI, THE PATRON
GODDESS OF THE
RAJPUTS AND THE
FAMILY DEITY OF THE
HOUSE OF JAIPUR.

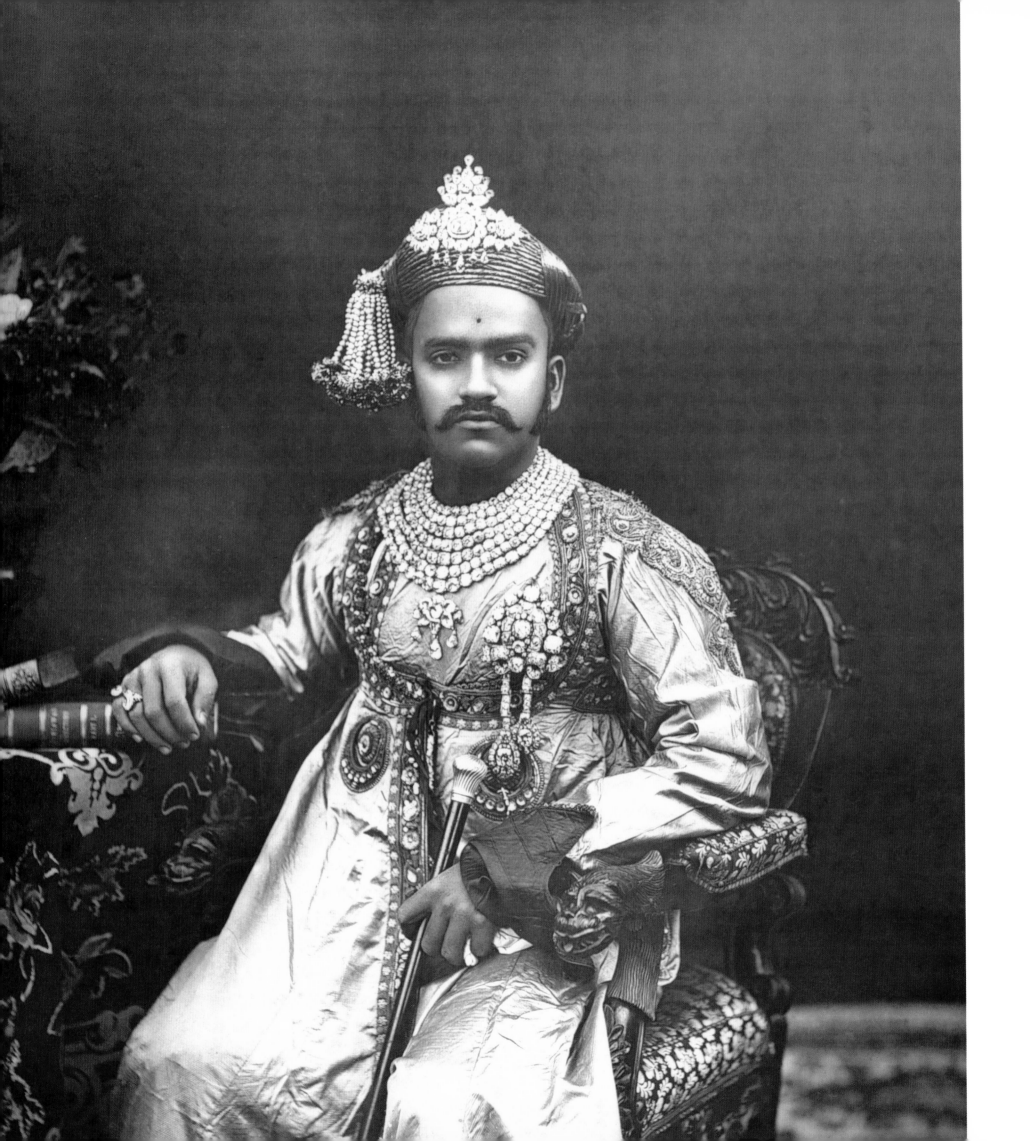

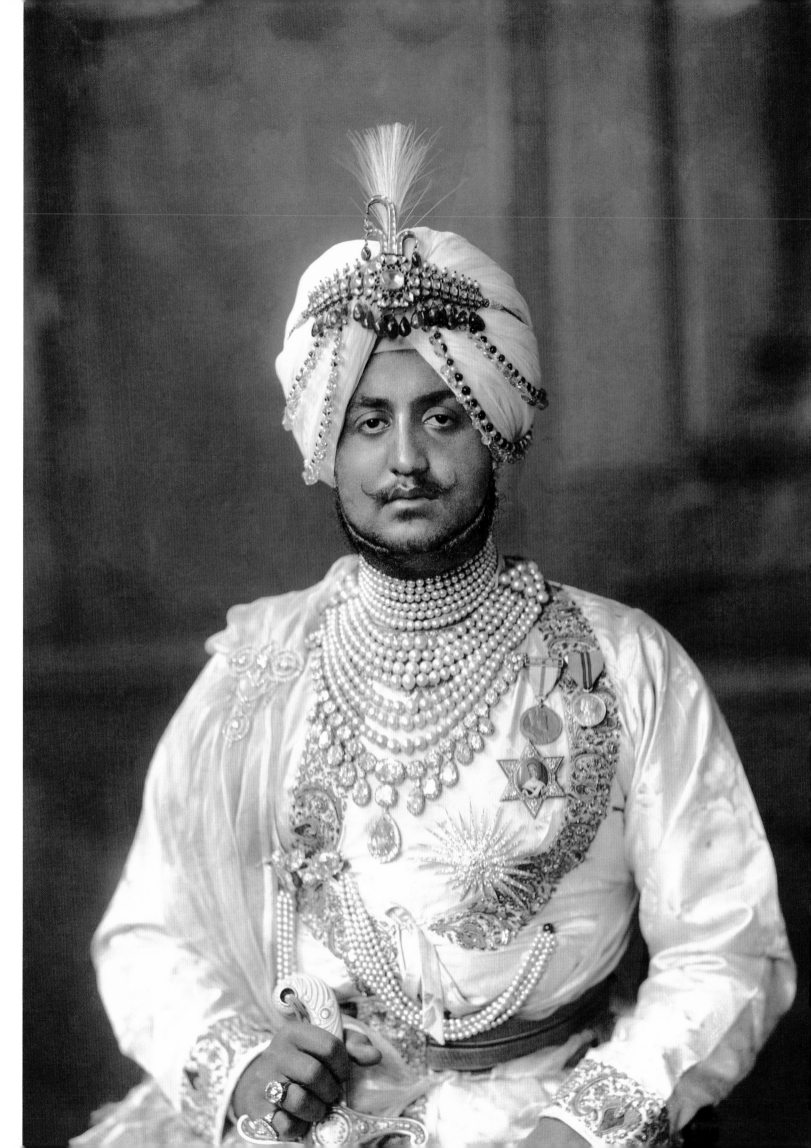

MAHARAJA BHUPINDAR SINGH OF PATIALA. FROM HIS ACCESSION IN 1909 TO HIS DEATH IN 1938, HE WAS ONE OF THE MOST COLOURFUL MEMBERS OF THE PRINCELY ORDER. HE WAS FAMED FOR HIS HOST OF BEAUTIFUL WOMEN, HIS MAGNIFICENT PALACES AND HIS JEWELS AND GOLD PLATE. ON HIS HEAD IS A MAGNIFICENT 'SARPECH' OF DIAMONDS AND PENDANT EMERALDS EXECUTED BY THE HOUSE OF CARTIER, PARIS. HIS TURBAN IS ORNAMENTED WITH AN EGRET CREST OR *KALGI*. AROUND HIS NECK IS A NECKLACE OF FOURTEEN STRANDS OF NATURAL MATCHED PEARLS, THE LOWEST HUNG WITH PENDANT EMERALDS AND A CENTRAL LARGE DIAMOND, POSSIBLY THE SANCY, WHICH HE IS REPORTED TO HAVE OWNED.

FACING PAGE: SIR SAYAJI RAO GAEKWAD, RENOWNED FOR HIS FABULOUS JEWELS, IS SEEN HERE WEARING A FAMOUS BARODA DIAMOND NECKLACE. ANOTHER FAMOUS BARODA PEARL NECKLACE WAS SET WITH PRICELESS DIAMONDS, SUCH AS THE STAR OF DRESDEN AND THE STAR OF THE SOUTH. IT HAD SEVEN STRINGS OF NATURAL PEARLS, EACH THE SIZE OF A MARBLE. AS PEARLS OF THIS SIZE WERE FOUND ONLY ONCE A YEAR, IT MUST HAVE TAKEN HUNDREDS OF YEARS TO ASSEMBLE SUCH A FABULOUS NECKLACE.

MAHARAJA JAI SINGH OF
ALWAR WITH MEMBERS
OF COUNCIL AND
COLONEL FAGAN, THE
POLITICAL AGENT IN
1903. MAHARAJA JAI
SINGH WAS THE RULER
OF ALWAR FOR OVER
FORTY YEARS. HE HAS
BEEN VARIOUSLY
DESCRIBED AS
'SINISTER', 'UNCANNY',
'BAFFLING', AND SO ON.
HE WAS ACCUSED,
STARTLINGLY, TO HAVE
USED YOUNG CHILDREN
AS BAIT FOR TIGERS.
HE, HOWEVER, EXCUSED
HIMSELF WITH THE
COMMENT THAT HE
NEVER MISSED A TIGER,
WHICH WAS TRUE, AND
NEVER LOST A CHILD.
PARADOXICALLY,
HIS CHARM WAS
OVERWHELMING AND
HIS CONVERSATION
GLITTERED AND
ENTRANCED. IN LATER
LIFE HE SEEMS TO HAVE
BECOME DERANGED AND
DROVE HIS TENANT
FARMERS TO
REBELLION. HE WAS
REMOVED FROM THE
ALWAR THRONE IN
1933.

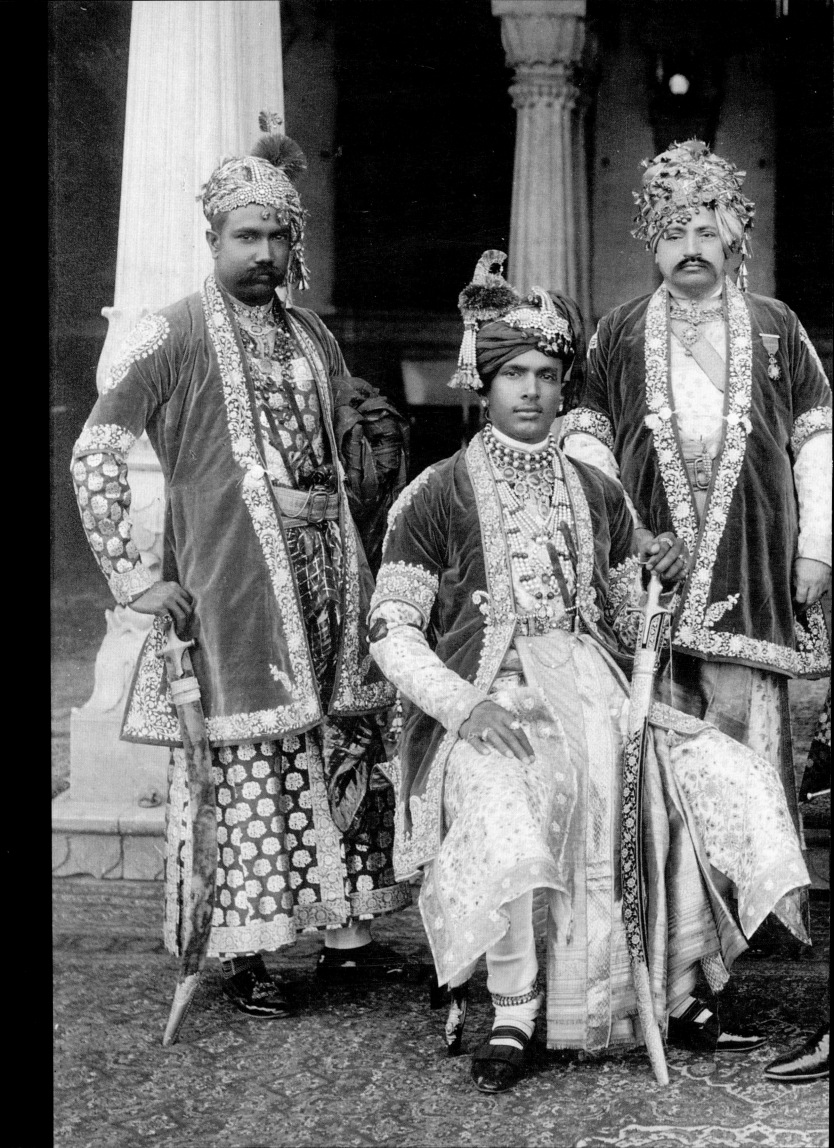

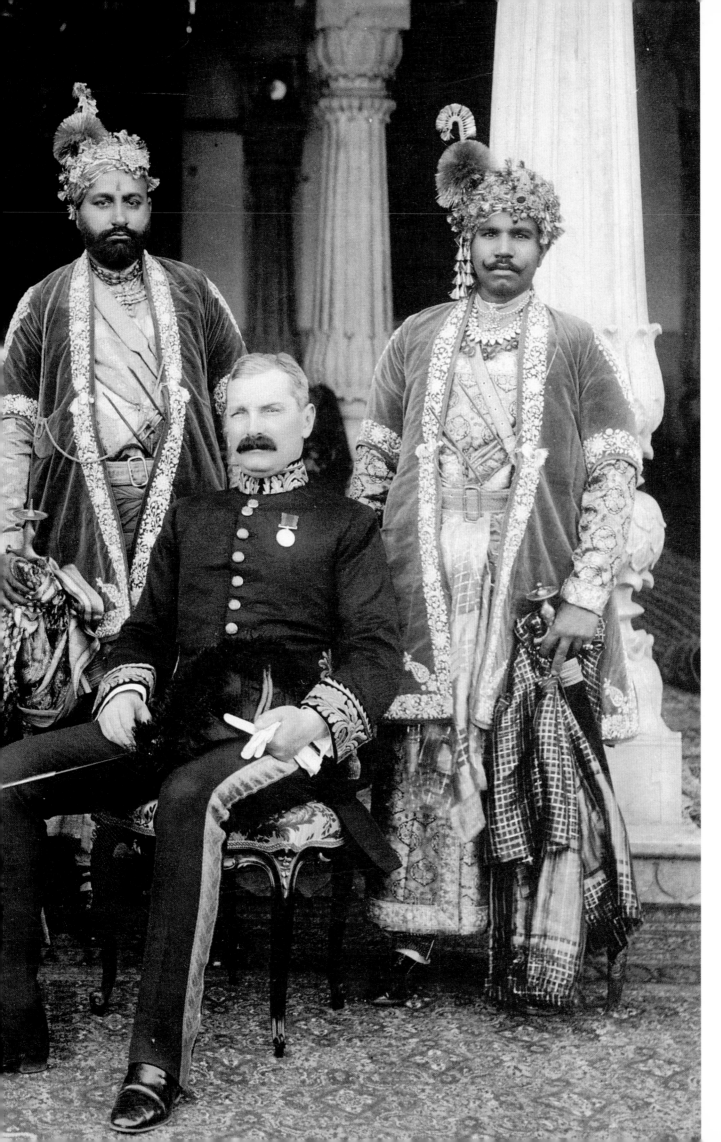

Most Indian Princes had an astounding collection of jewellery. Many of them had access to private diamond and gold mines and over the years, built up private hordes of jewels that would be the envy of collectors anywhere in the world. The Kohinoor, Hope and Jacob were names of diamonds that have interesting stories behind them and were once owned by Indian rulers.

The dazzling jewels were matched by the rich brocades and velvet costumes that Indian princes habitually wore. Turbans, festooned with ropes of pearls and studded with sparkling diamonds, emeralds and rubies outshone the conventional crowns of western royalty. Nor were these princes shy of wearing necklaces, armlets, bracelets and ornamental belts. Colourful scarves were tied to the ceremonial swords that were sheathed in scabbards sparkling with gems. With time, however, these traditional costumes were worn only on ceremonial occasions and most princes preferred to wear the more modern, and convenient, western attire. These, however, were custom-made for them by the finest drapers in the world.

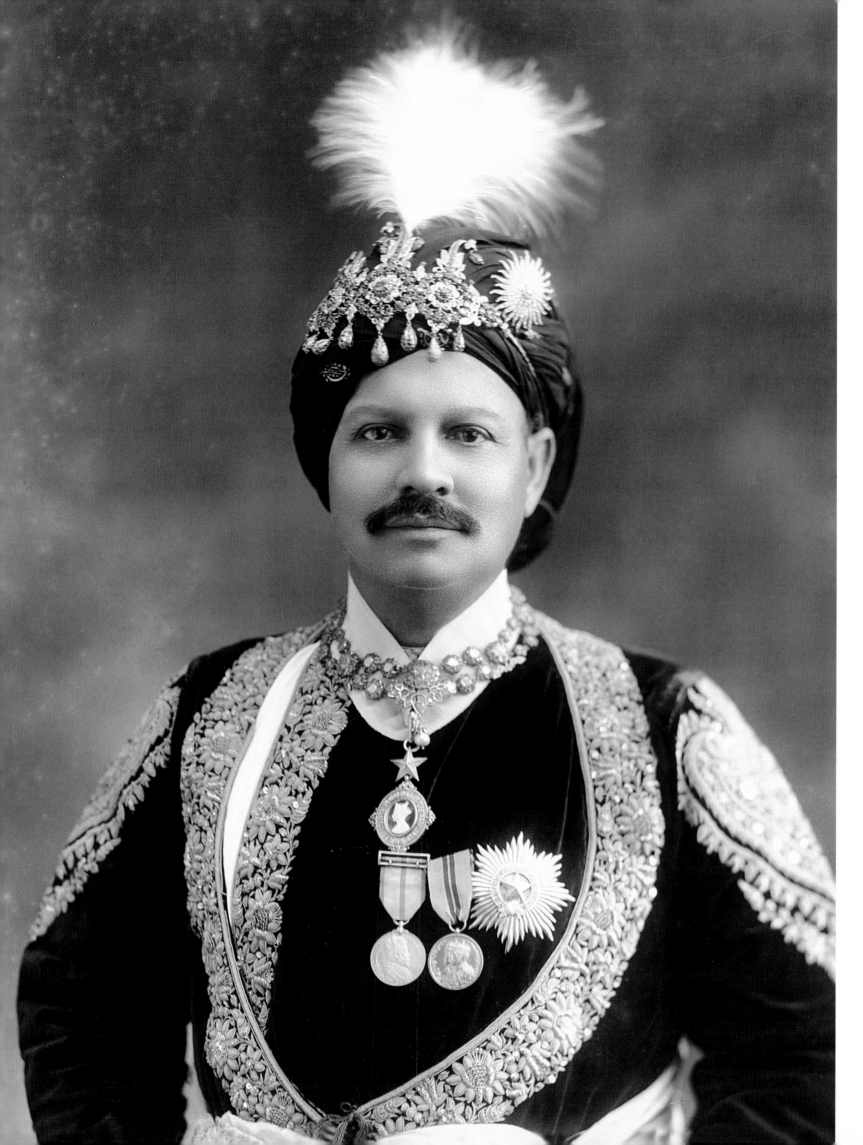

MAHARAJA RANA SIR
BHAWANI SINGH
BAHADUR OF JHALAWAR
(1874–1929). HE WAS
SUCCEEDED TO THE
THRONE BY MAHARAJA
RAJENDRA SINGH, WHO
WAS A KEEN CRICKETER
AND AWARDED MUCH
HOSPITALITY TO VISITING
TEAMS. THE PROBLEM,
HOWEVER, WAS THAT
THE LOCAL UMPIRES
COULD NOT DECLARE
HIM OUT TILL HE HAD
SCORED MANY RUNS AND
WAS A BIT TIRED.
JHALAWAR, ONE OF THE
SMALLER STATES OF
RAJASTHAN, HAD AN
AREA OF ONLY 810
SQUARE MILES AND
RATED 13-GUN
SALUTES.

FACING PAGE:
YUVARAJA SIR
NARASIMHARAJA
WODEYAR OF MYSORE
(1888–1940) WAS
THE SECOND SON OF
JAYACHAARAJENDRA
WODEYAR, THE LAST
MAHARAJA OF MYSORE.
MYSORE IN SOUTH INDIA
WAS ONE OF THE FIVE
LARGEST STATES IN
THE COUNTRY WITH AN
AREA OF ABOUT 20,000
SQUARE MILES AND
WAS ACCORDED THE
MAXIMUM SALUTE OF
21 GUNS.

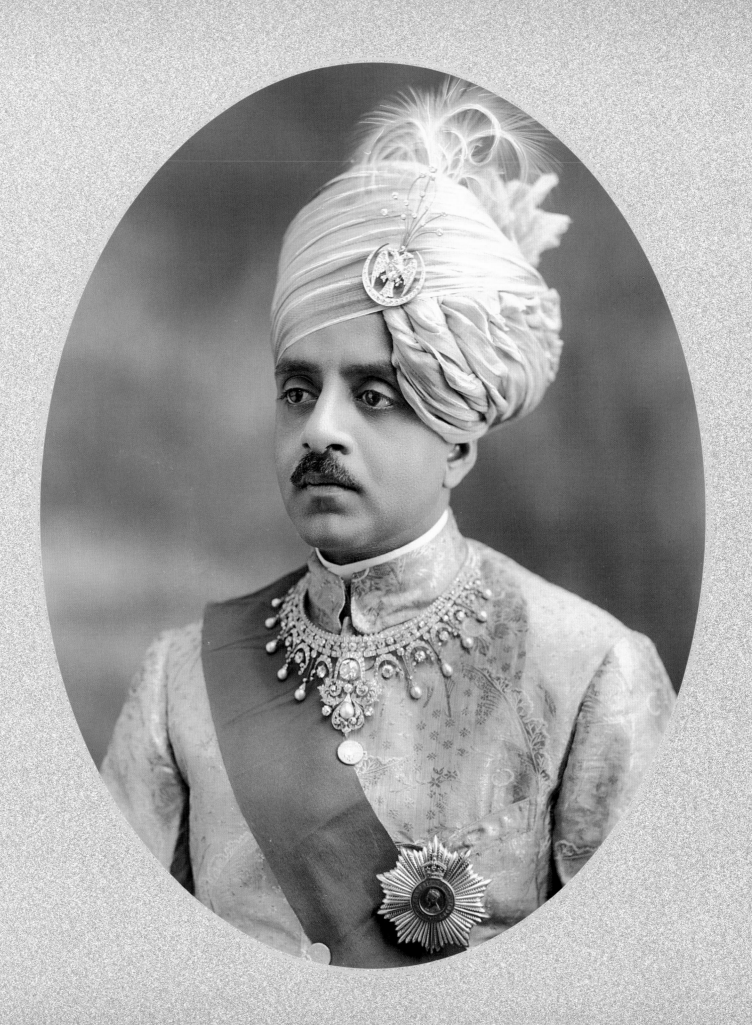

MAHARANI BAKHTAVAR
KAUR OF PATIALA, THE
SENIORMOST QUEEN OF
MAHARAJA BHUPINDAR
SINGH. SHE GAVE BIRTH
TO SEVEN CHILDREN, OF
WHICH ONLY TWO
SURVIVED. HER ONLY
SURVIVING SON,
YADAVINDRA SINGH,
SUCCEEDED HIS FATHER
IN 1938. THE MAHARANI
WEARS SOME OF THE
PRICELESS JEWELS THAT
THE TREASURY OF
PATIALA WAS REPUTED
TO OWN. AMONG THEM
WERE DIAMOND
NECKLACES, ROPES OF
PEARLS AND HEADPIECES
SET WITH EMERALDS,
SAPPHIRES AND RUBIES.
THE HOUSE OF CARTIER
HANDLED THE BIGGEST
COMMISSION OF ALL
TIMES WHEN THEY
CONVERTED CASKET
AFTER CASKET OF
PATIALA JEWELS INTO
EUROPEAN DESIGNS.
ONE OF THESE JEWELS
WAS THE VICTORIA OR DE
BEERS DIAMOND OF
234.69 CARATS.

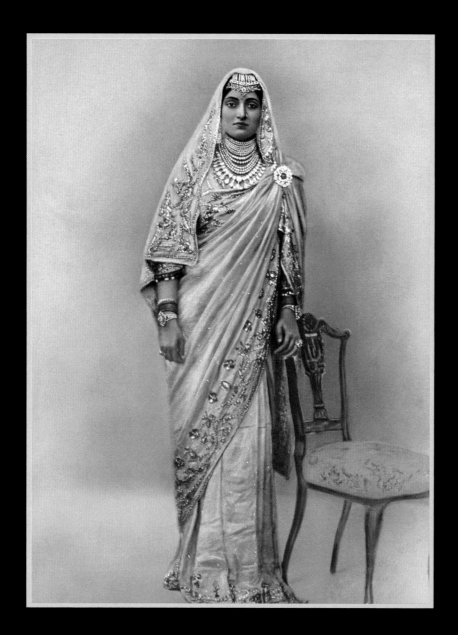

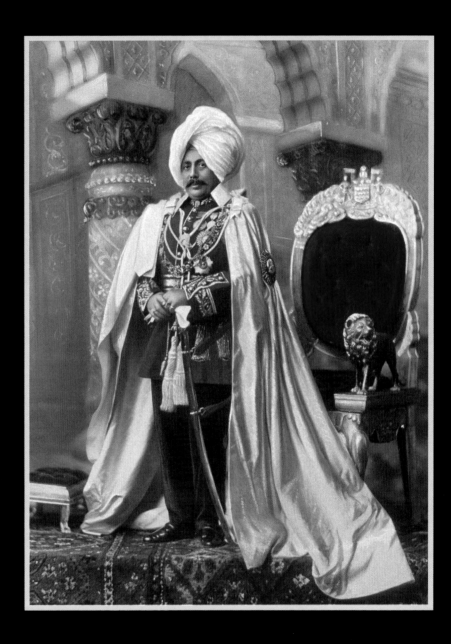

THE STATE OF JAMMU &
KASHMIR WAS FOUNDED
BY THE GREAT WARRIOR
AND STATESMAN
MAHARAJA GULAB SINGH
IN 1846. IT WAS THE
LARGEST INDIAN STATE
UNDER BRITISH
SUZERAINTY. HE PASSED
AWAY IN 1856 AND WAS
SUCCEEDED BY HIS SON
MAHARAJA RANBIR
SINGH, THE GREAT
TEMPLE BUILDER,
SCHOLAR AND
ADMINISTRATOR. HE
PASSED AWAY IN 1885,
AND WAS SUCCEEDED BY
MAHARAJA PRATAP
SINGH (LEFT), A PIOUS
AND DEVOUT MAN WHO
RULED THE STATE FOR
40 YEARS UNTIL 1925.
HE WAS SUCCEEDED BY
HIS NEPHEW MAHARAJA
HARI SINGH.
DURING HIS RULE,
MAHARAJA PRATAP
SINGH INSTITUTED
SEVERAL REFORMS,
AND DESPITE MANY
CONSPIRACIES AGAINST
HIM, HE WAS, BY AND
LARGE, ABLE TO
MAINTAIN PEACE AND
STABILITY IN THIS
HIGHLY SENSITIVE AND
MULTI-REGIONAL STATE.

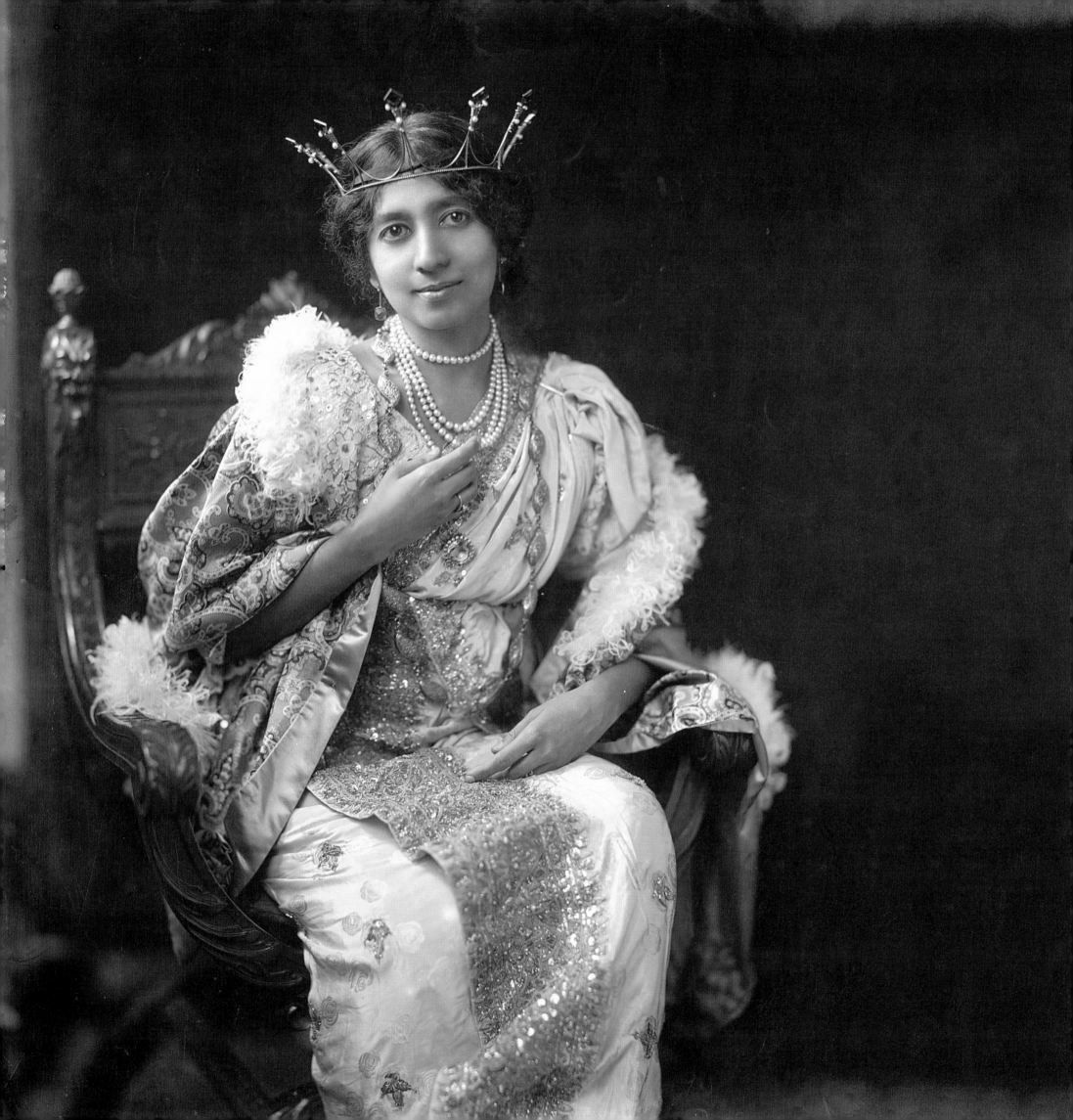

RANI AMRIT KAUR WAS THE
ONLY DAUGHTER OF MAHARAJA
JAGATJIT SINGH OF
KAPURTHALA. DURING HER
VISIT TO LONDON, KING
GEORGE V AND QUEEN MARY
RECEIVED THE RANI BEFORE
THE THIRD COURT OF THE
SEASON ON 26 JUNE 1924.
SHE WAS LATER MARRIED TO
THE RAJA OF MANDI, A HILL
STATE IN THE NORTH OF INDIA.

FACING PAGE: INDIAN
PRINCESSES OFTEN POSED FOR
LAFAYETTE STUDIO PORTRAITS
WEARING WESTERN-STYLE
CROWNS AND DRESSES. NOTICE
THE RUCHED BLOUSE AND
CLOAK. THIS PORTRAIT IS
PROBABLY OF A PRINCESS OF
THE VIJAYNAGARAM STATE IN
SOUTH INDIA.

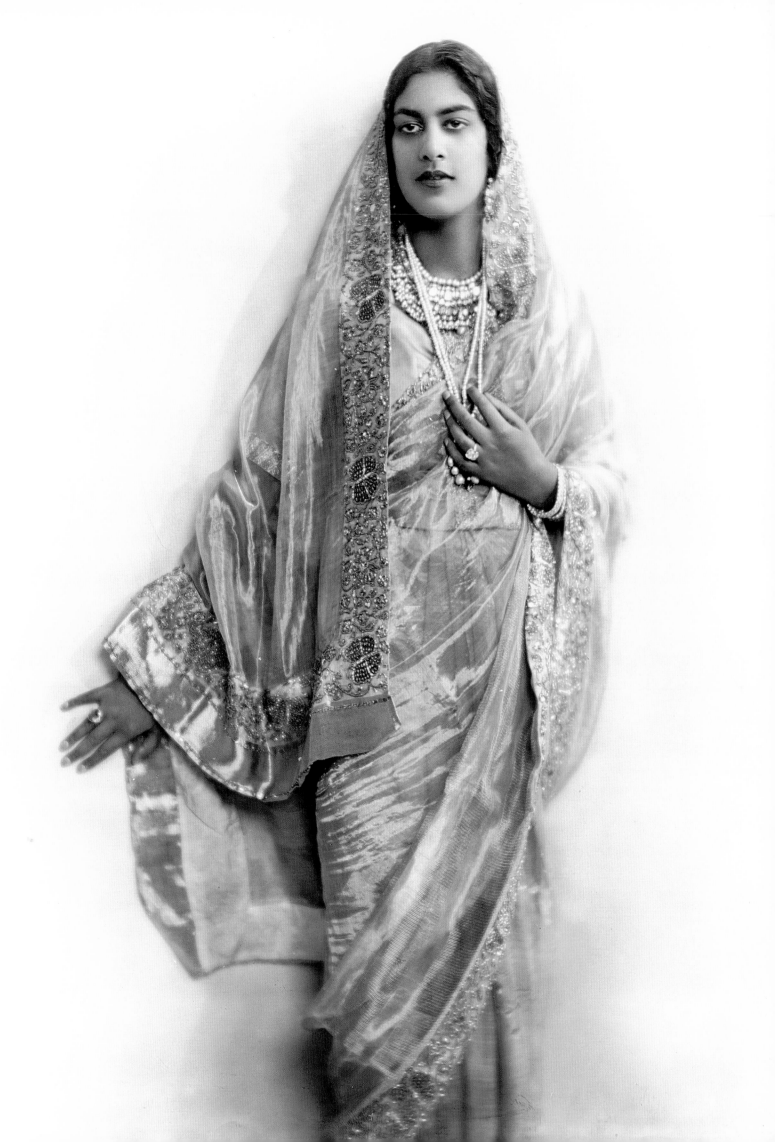

BEGUMS OF BHOPAL

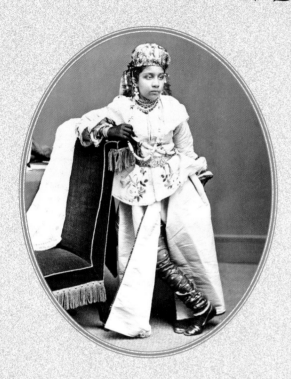

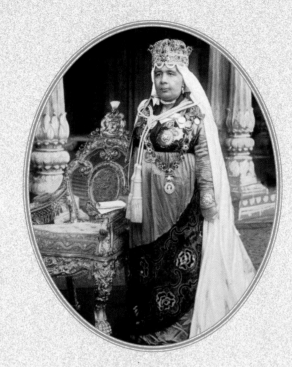

regency. When he fought for an early marriage, her forces triumphed and she had the match broken off on a false charge of impotence against him! But, her rival bribed the British Political Agent to now engage his youngest son, Jahangir, to Sikandar. They were married in 1835. Qudisia did not relinquish power easily and had to be retired off to a vast estate.

Jahangir failed as a ruler and husband. After an unsuccessful attempt at assassinating his wife Sikandar, he drank himself to death and the British made his 7-year-old daughter Shahjahan the ruler with Sikandar acting as regent. Sikandar, a strong and masculine person, reorganized the army, set up a nominated Parliament, and improved the judicial system. Shahjahan, the daughter, was married to the loyal if aged Commander-in-Chief, Baqi Khan.

During the 1857 Revolt, Sikandar Begum stood behind the British. She obtained the right to make

TOP LEFT: The sultana of Bhopal, Shahjahan.

TOP RIGHT: the Begum of Bhopal, Sultan Jahan.

BOTTOM: The begum of Bhopal in purdah makes her entry into the 1911 Durbar.

Bhopal was the second biggest Muslim state in British India after Hyderabad. An unscrupulous Pathan mercenary, Dost Mohammad Khan, grabbed the state after its beautiful and widowed ruler, who was his employer, died. Dost died in 1740 and four ineffective Nawabs allowed the widow of the second Nawab to rule from behind the throne. It became the ruling pattern.

Bhopal then came under the Marathas, but passed to Nawab Nazar Mohammad Khan who, harassed by the Marathas, accepted the East India Company's suzerainty in return for Bhopal's security. When Nazar died, the British made his widow, Qudisia Begum, regent in 1819. She was 19 years old, illiterate and in purdah. Yet she marks the beginning of the 'great century of women's rule in Bhopal.'

Qudisia, who had relinquished purdah, was a tall, thin, plain woman blessed with political acumen. She engaged her 15-month-old daughter, Sikandar, to the eldest son of her rival—it guaranteed her 16 years of

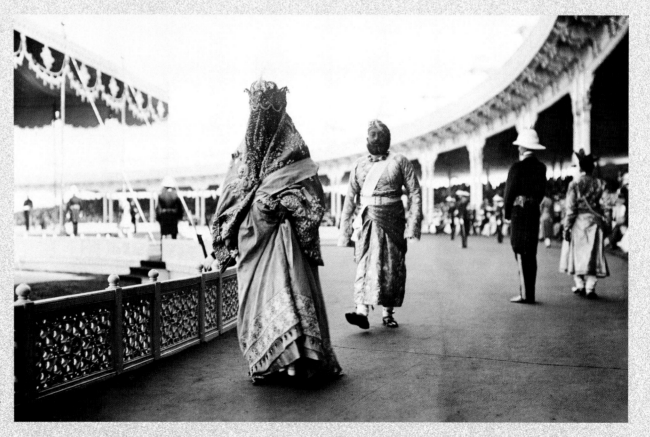

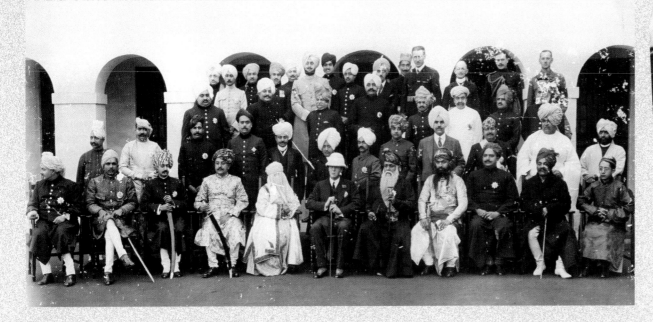

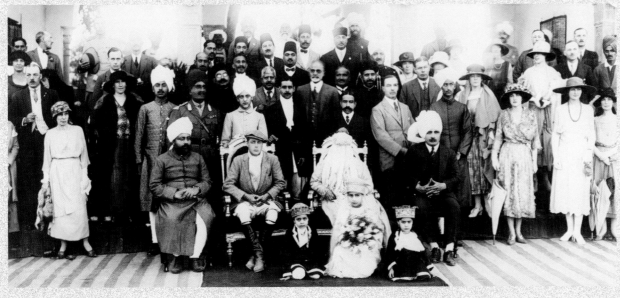

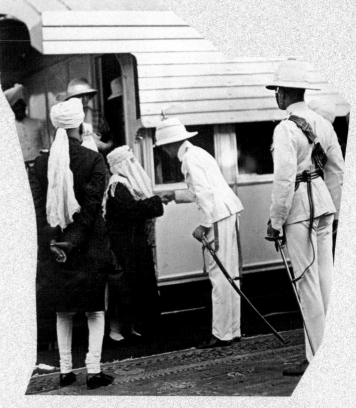

The Begum alights in a burka. Ruling over a Muslim state, the Queens had to remain in purdah and come before the public only in a burka, a veil that covered them from head to toe.

Top Left: Group photograph taken at one of the meetings of the Chamber of Princes. The burka-clad Begum of Bhopal (fifth from left, sitting) was the only woman ruler in this assembly.

Left: A group with the Begum during the Prince of Wales tour, 1922.

her daughter heir-apparent and herself titular ruler. Shahjahan also abdicated in favour of her mother. Sikandar became the first-ever Muslim ruler to perform the Haj, but died soon after in 1868. Meanwhile, Shahjahan's affairs had wrecked the marriage and her husband's death left Shahjahan 'a distinctly merry widow.'

Shahjahan an aspiring poetess at 30, enjoyed the company of young men in court and was besotted by one Siddiq Hasan. She married him in 1871, when her daughter Sultan Jahan was 13. Sultan Jahan, like Bhopal's gentry, disapproved of the 'impecunious non-Afghan clerk'. She also married against Shahjahan Begum's wishes and remained estranged from her mother. Hasan, a religious bigot, gained control and opposed the British, for which he was deposed. Power returned to a more mature Shahjahan, who ruled well, getting Bhopal linked to a railway line, till her death in 1901.

Sultan Jahan assumed power when she was a matronly 43 years of age. Within a year, she lost her husband and took to her duties. She brought about the electrification of Bhopal city and revived the Legislative Council. In 1903, she was the only woman to attend the Coronation Durbar and in 1911, went to George V's coronation in London—in a burka with medals worn outside. In 1924, she lost both her sons and abdicated in favour of her youngest son Hamidullah Khan. The Viceroy wanted the grandson to succeed her. But, Sultan Jahan Begum travelled to London and got the decision reversed.

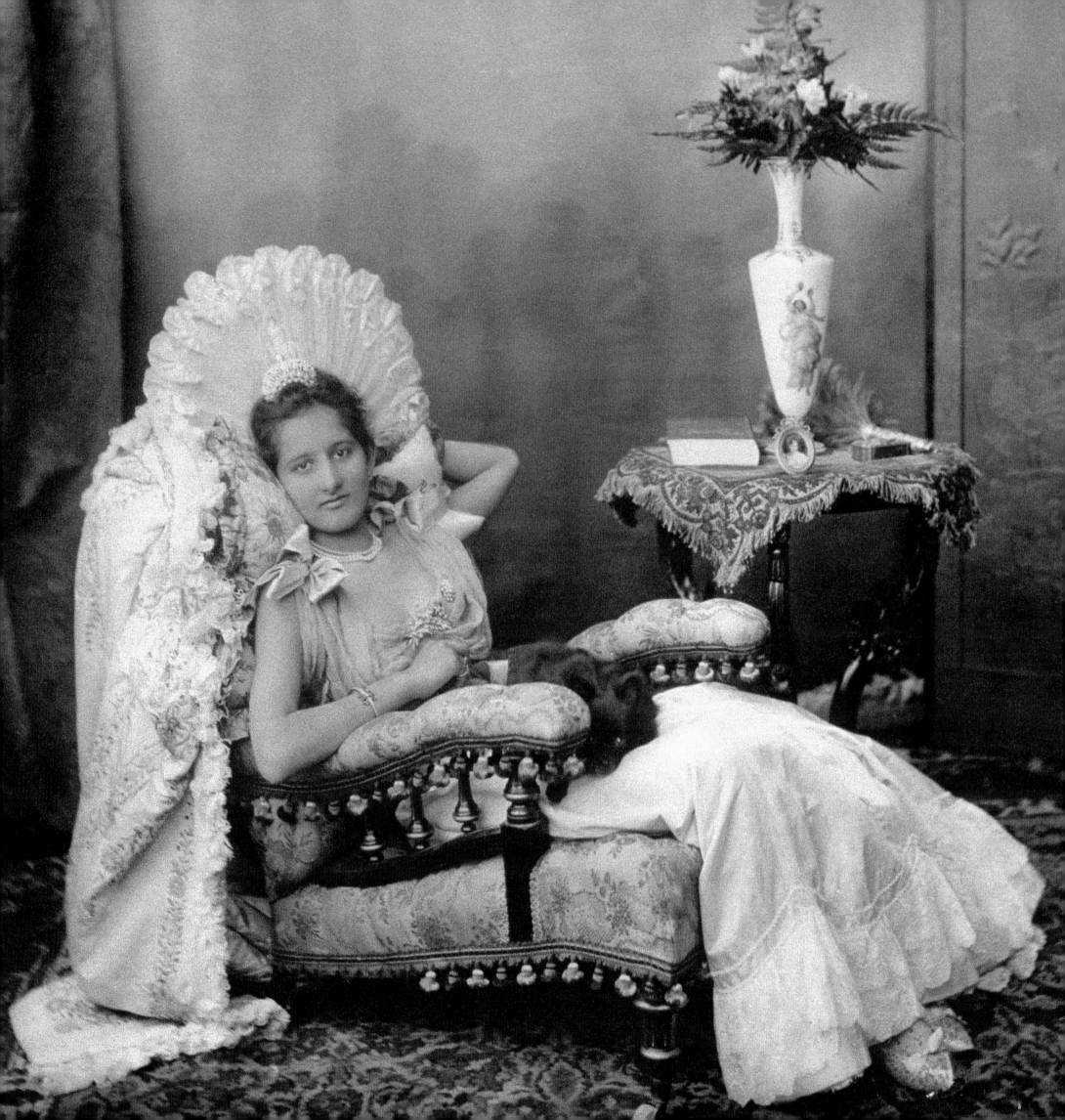

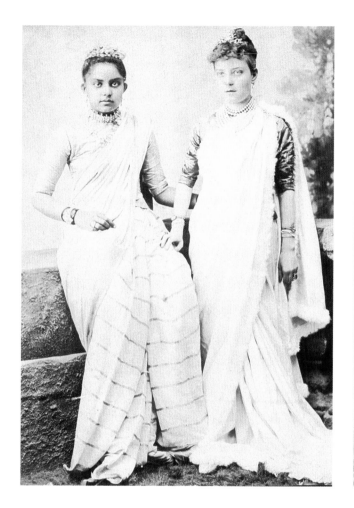

FACING PAGE: OFTEN, INDIAN PRINCESSES POSED IN FANTASTIC COSTUMES. A PORTRAIT OF RANI KANARI OF KAPURTHALA, TAKEN AT THE LAFAYETTE STUDIOS, SHOWS HER WEARING A HEADDRESS MADE OF OSTRICH FEATHERS AND A GOWN TRIMMED WITH LACE. A NOTICEABLE 'EUROPEANIZATION' OF SARTORIAL TASTES TOOK PLACE IN THE EARLY YEARS OF THE LAST CENTURY, AS INDIAN ROYALTY ADOPTED VICTORIAN FASHIONS.

TOP: AN INTERESTING COUNTERPOINT TO THIS WAS THE ADOPTION OF INDIAN DRESSES BY FOREIGN LADIES IN ROYAL HAREMS. THIS RARE PHOTOGRAPH IS ONE OF THE FEW OF 'MAHARANI FLORENCE' (FLORENCE BRYAN, THE ENGLISHWOMAN WHO RAJINDAR SINGH MADE HIS QUEEN) OF PATIALA, DRESSED IN A SARI. SHE IS SEEN HERE WITH THE MAHARANI OF PATIALA. NO SMILES WERE PUT ON FOR THIS PHOTOGRAPH!

ANITA DELGADO, A SPANISH FLAMENCO DANCER MARRIED JAGATJIT SINGH OF KAPURTHALA. GIVEN THE TITLE OF RANI PREM KAUR BY HER HUSBAND, SHE WAS REPUTED TO BE A DANCING PARTNER OF THE FAMOUS SPY, MATA HARI. HOWEVER, SUCH MIXED MARRIAGES WERE FROWNED UPON BY THE BRITISH AND INDIANS ALIKE AND OFTEN THESE 'QUEENS' LED SAD AND LONELY LIVES.

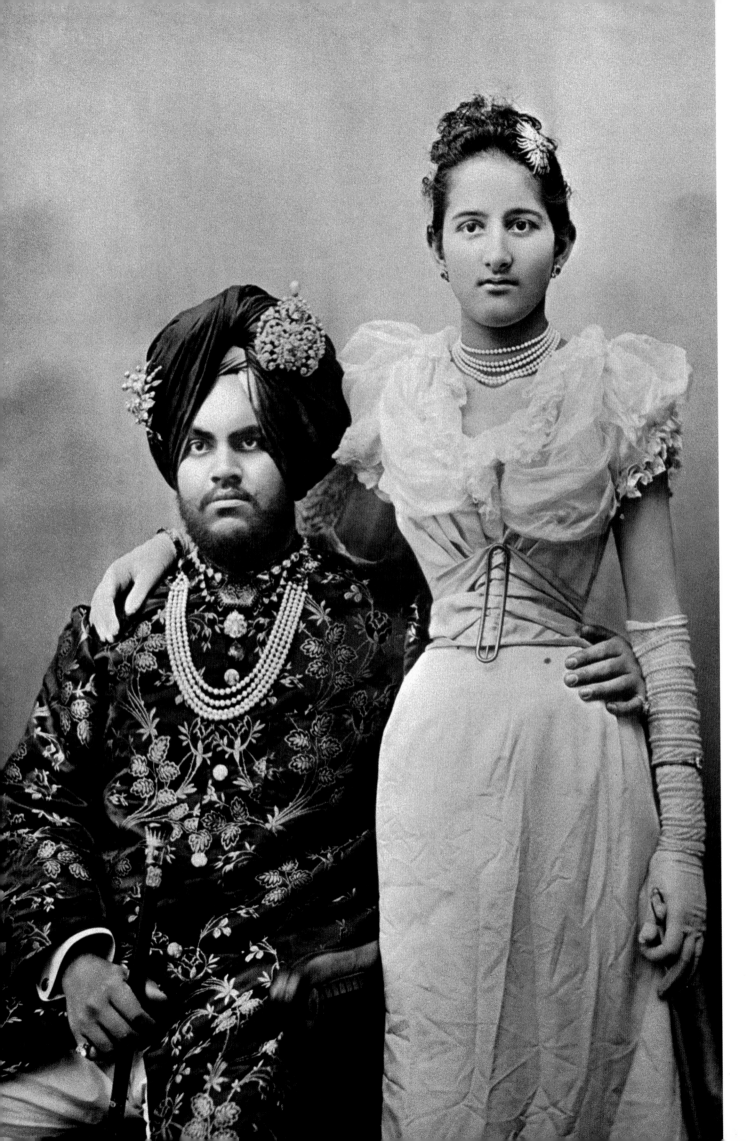

OF ALL THE PRINCES OF HIS TIME, MAHARAJA JAGATJIT SINGH WAS THE MOST FAMOUS FOR HIS ADMIRATION OF EUROPEAN CLOTHES AND TASTES. WHILE BUILDING PALACES, HE WENT THROUGH A FRENCH PHASE AND THEN A SPANISH ONE, AND HIS CHANGING WHIMS ARE CLEARLY VISIBLE IN THEIR ARCHITECTURE. HERE, HE IS SEEN IN A ROMANTIC POSE WITH HIS FOURTH QUEEN, RANI KANARI. SHE WAS SMUGGLED OUT TO ENGLAND BY HER BESOTTED HUSBAND DISGUISED AS A BOY SINCE ROYAL WOMEN WERE NOT ALLOWED TO TRAVEL ABROAD THEN. SHE IS SEEN WEARING AN EDWARDIAN COSTUME, AND HER WAIST, WHICH THE MAHARAJA HOLDS PROUDLY, IS TIGHTLY CORSETED. GLOVES, NEVER WORN BY INDIAN WOMEN, ARE ANOTHER INTERESTING FEATURE.

FACING PAGE:
BHUPINDAR SINGH OF PATIALA, AS A CHILD. A MINORITY COUNCIL TOOK CARE OF THE STATE WHILE HE WAS A MINOR. AMONG ITS MEMBERS WAS HIS LATE FATHER'S BROTHER, RAJA RANBIR SINGH (STANDING, *EXTREME RIGHT*). A DWARF, DRESSED IN THE STATE LIVERY, STANDS CLOSE TO HIM (*EXTREME LEFT*). CONSIDERED A LUCKY MASCOT, A PAIR OF DWARFS USED TO FOLLOW THE PRINCE WHEREVER HE WENT!

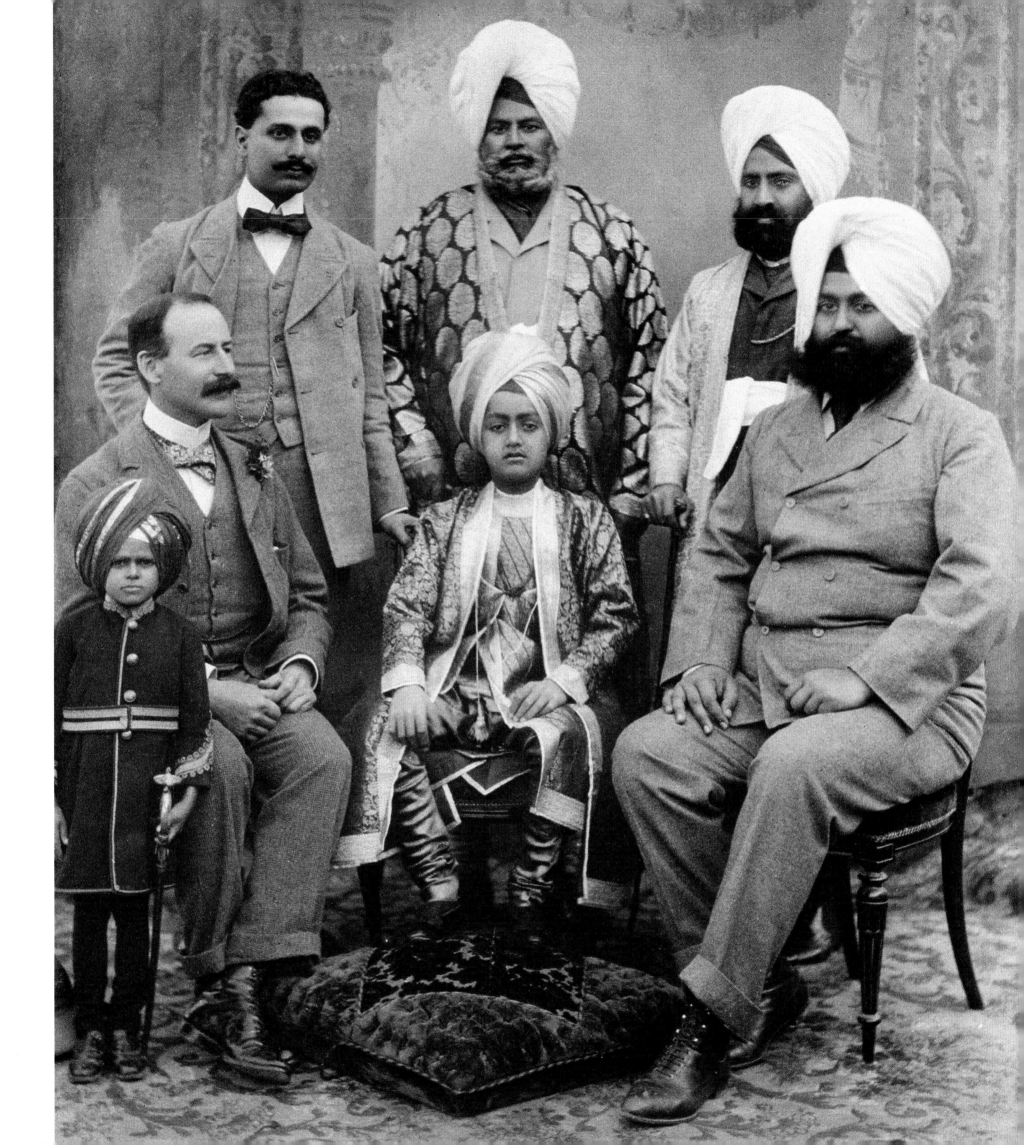

HIS HIGHNESS THE
PRINCE OF BERAR
(1907–1970), THE
ELDEST SON OF THE
NIZAM OF HYDERABAD,
AND THE BEAUTIFUL
TURKISH PRINCESS DUR-
I-SHAHVAR SULTANA, HIS
WIFE. ON HER LAP IS
PRINCE MUKKARAMJAH
BAHADUR, ELDEST SON
OF THE PRINCESS AND
THE LAST NIZAM OF
HYDERABAD, WHO IS NOW
SETTLED IN AUSTRALIA.
HYDERABAD WAS THE
LARGEST STATE IN INDIA.
THE NIZAM WAS FORCED
TO SIGN THE TREATY OF
ACCESSION TO INDIA
WHEN THE INDIAN ARMY
OVERWHELMED THE
STATE FORCES IN A
MATTER OF HOURS.
PRINCESS DURI-I-
SHAHVAR, WITH HER
STRIKING LOOKS,
REMARKED THAT IT WAS
TYPICAL OF HER
ESTRANGED HUSBAND,
THE PRINCE OF BERAR,
TO ABSENT HIMSELF
FROM THE BATTLE BUT
TO BE PRESENT AT THE
SURRENDER!

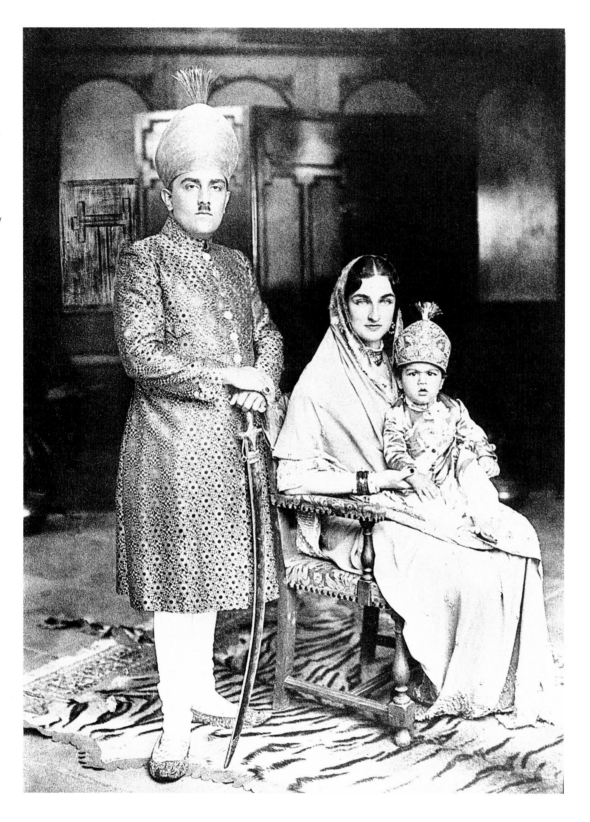

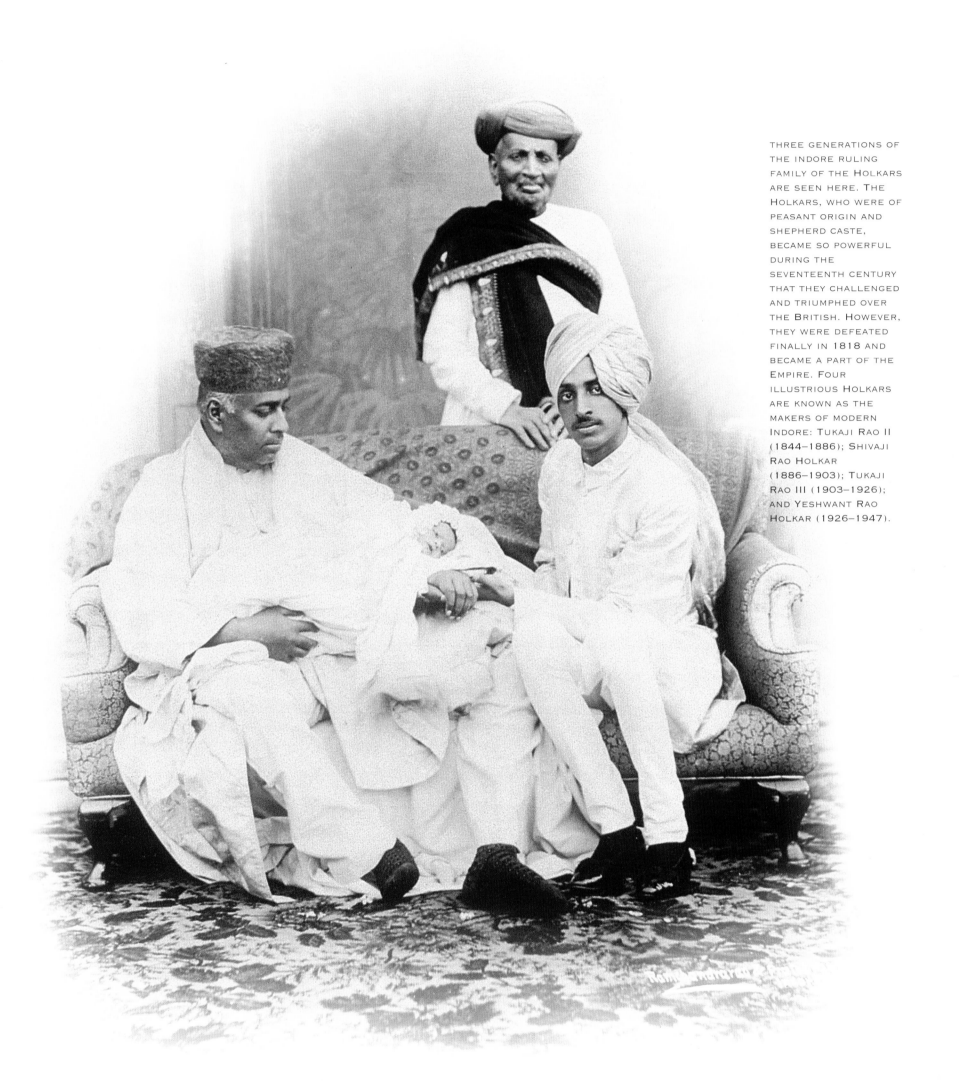

THREE GENERATIONS OF
THE INDORE RULING
FAMILY OF THE HOLKARS
ARE SEEN HERE. THE
HOLKARS, WHO WERE OF
PEASANT ORIGIN AND
SHEPHERD CASTE,
BECAME SO POWERFUL
DURING THE
SEVENTEENTH CENTURY
THAT THEY CHALLENGED
AND TRIUMPHED OVER
THE BRITISH. HOWEVER,
THEY WERE DEFEATED
FINALLY IN 1818 AND
BECAME A PART OF THE
EMPIRE. FOUR
ILLUSTRIOUS HOLKARS
ARE KNOWN AS THE
MAKERS OF MODERN
INDORE: TUKAJI RAO II
(1844–1886); SHIVAJI
RAO HOLKAR
(1886–1903); TUKAJI
RAO III (1903–1926);
AND YESHWANT RAO
HOLKAR (1926–1947).

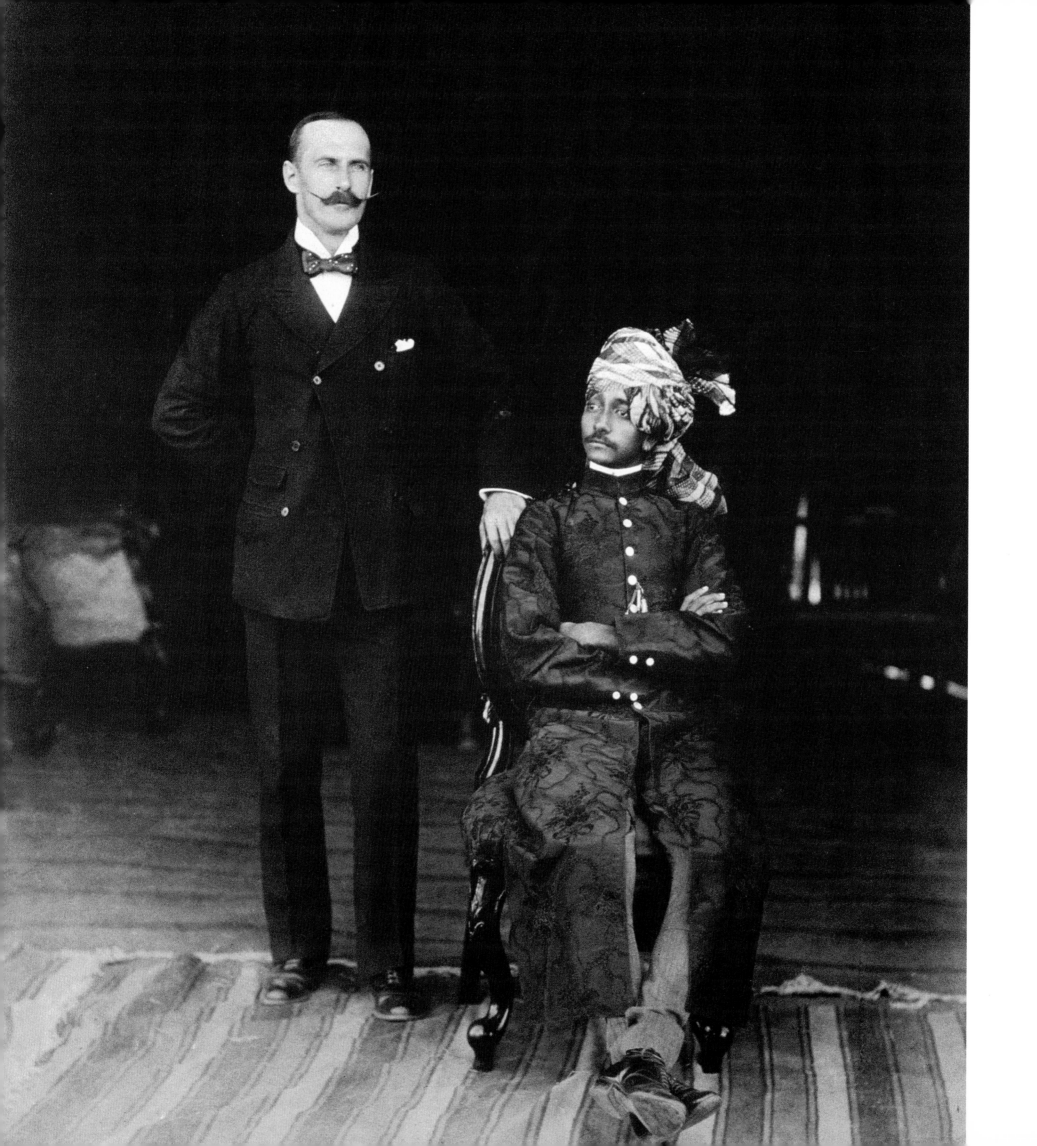

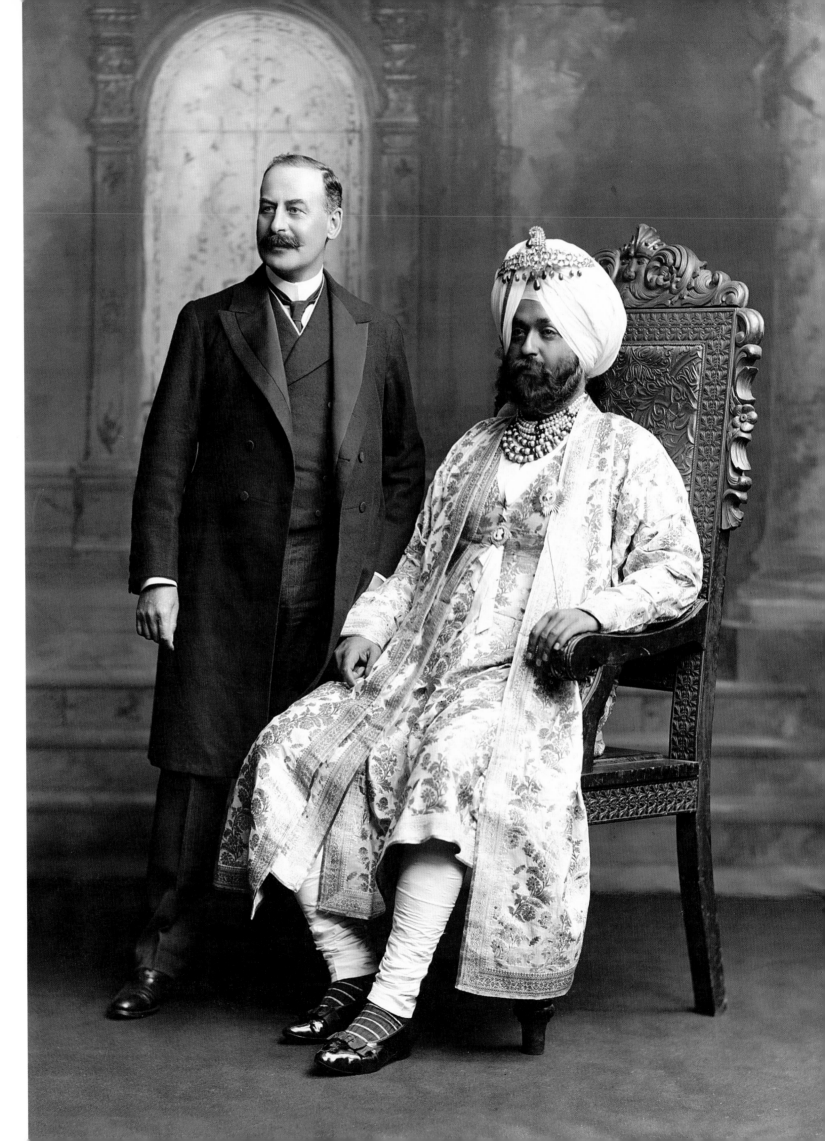

AFTER THE REVOLT OF
1857, THE BRITISH
REGARDED THE PRINCES
WITH DEEP SUSPICION,
FOR THEY WERE THE
TRADITIONAL RULERS
AND MILITARY GENERALS
WHO COMMANDED A
LOYAL FOLLOWING.
OBSESSED WITH THE
NECESSITIES OF
MILITARY DEFENCE,
THE BRITISH CROWN
CURTAILED THE
SOVEREIGNTY OF THE
PRINCELY STATES.
BRITISH POLITICAL
AGENTS WERE
APPOINTED TO OVERSEE
THE PRINCELY STATES.
THE SIZE OF STATE
ARMIES WAS RESTRICTED
AND THE PRINCES HAD
TO RELINQUISH CONTROL
ON POSTS AND
TELEGRAPHS IN THEIR
PRINCIPALITIES. THEIR
RIGHT TO MINT COPPER
AND SILVER COINS,
EXCEPT IN A FEW LARGER
STATES, WAS TAKEN AWAY
AND BRITISH INDIAN
CURRENCIES BECAME
LEGAL TENDER.
PARAMOUNTCY WAS
STERNLY THRUST DOWN
ON THE PRINCES. THIS
PHOTO SHOWS RAJA
RANBIR SINGH OF JIND
WITH THE POLITICAL
AGENT OF THE STATE.
THIS PHOTOGRAPH WAS
TAKEN AT THE LAFAYETTE
STUDIOS IN 1906.

FACING PAGE:

MAHARAJA MADAN SINGH
OF KISHANGARH, WHO
RULED FROM 1900
TO 1926, WITH HIS
ENGLISH TUTOR,
HUGH WILKINSON.

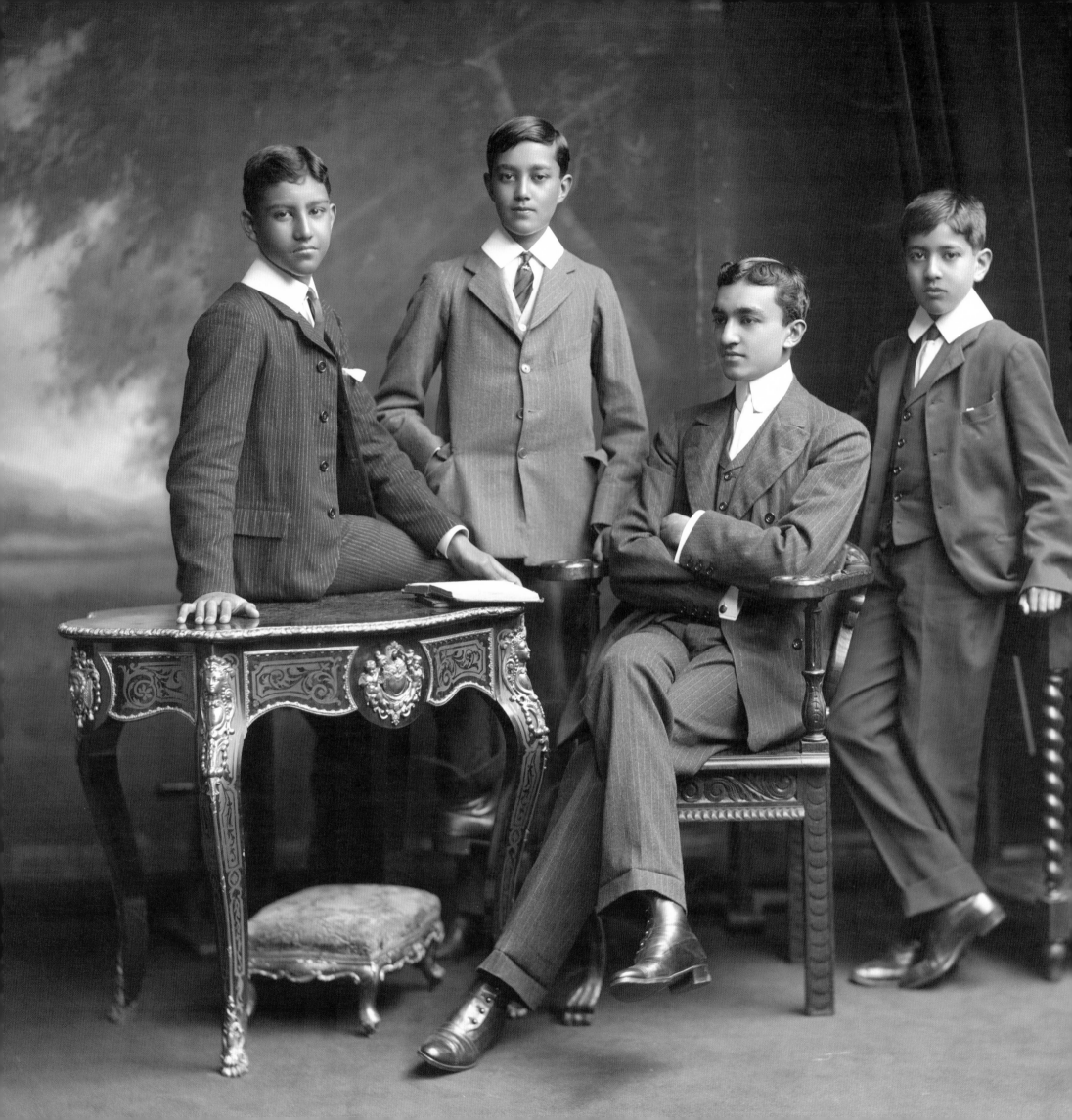

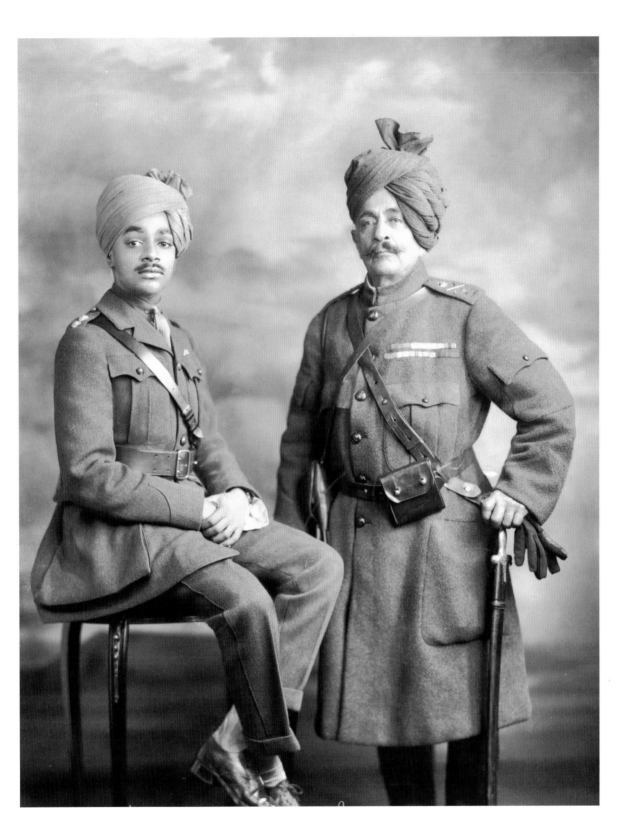

SIR PRATAP SINGH
(STANDING) WITH HARI
SINGH, 1910. SIR
PRATAP WAS THE THIRD
SON OF THE MAHARAJA
OF JODHPUR, BUT BY A
SPECIAL ORDER OF
QUEEN VICTORIA WAS
APPOINTED THE
MAHARAJA OF IDAR. HE
LATER ABDICATED TO
BECOME REGENT IN
JODHPUR. SIR PRATAP
FOUGHT IN MOST OF THE
BRITISH WARS AND HIS
LOYALTY TO THE BRITISH
WAS OFTEN THE BUTT OF
JOKES PLAYED ON HIM BY
HIS PEERS IN INDIA. A
DEDICATED SPORTSMAN,
HE IS CREDITED WITH
HAVING DESIGNED THE
FAMOUS JODHPUR
BREECHES.

FACING PAGE: THE
PRINCES OF COOCH
BEHAR. (*LEFT TO RIGHT*)
MAHARAJA SIR JITENDRA
NARAYAN BHUP
BAHADUR (1886–1922).
MAHARAJA KUMAR
VICTOR NITENDRA
(1887–1937), WHO DIED
IN A MOTOR ACCIDENT IN
ENGLAND; MAHARAJA
SHRI RAJENDRA
NARAYAN BHUP
BAHADUR (1883–1913);
AND MAHARAJA KUMAR
HITENDRA NARAYAN
(1890–1920). THEY
STUDIED AT ETON AND
WERE FLUENT IN
ENGLISH, GREEK AND
FRENCH, BUT FOUND
IT DIFFICULT TO
COMMUNICATE IN ANY
INDIAN LANGUAGE. THEY
ALL DIED VERY YOUNG.

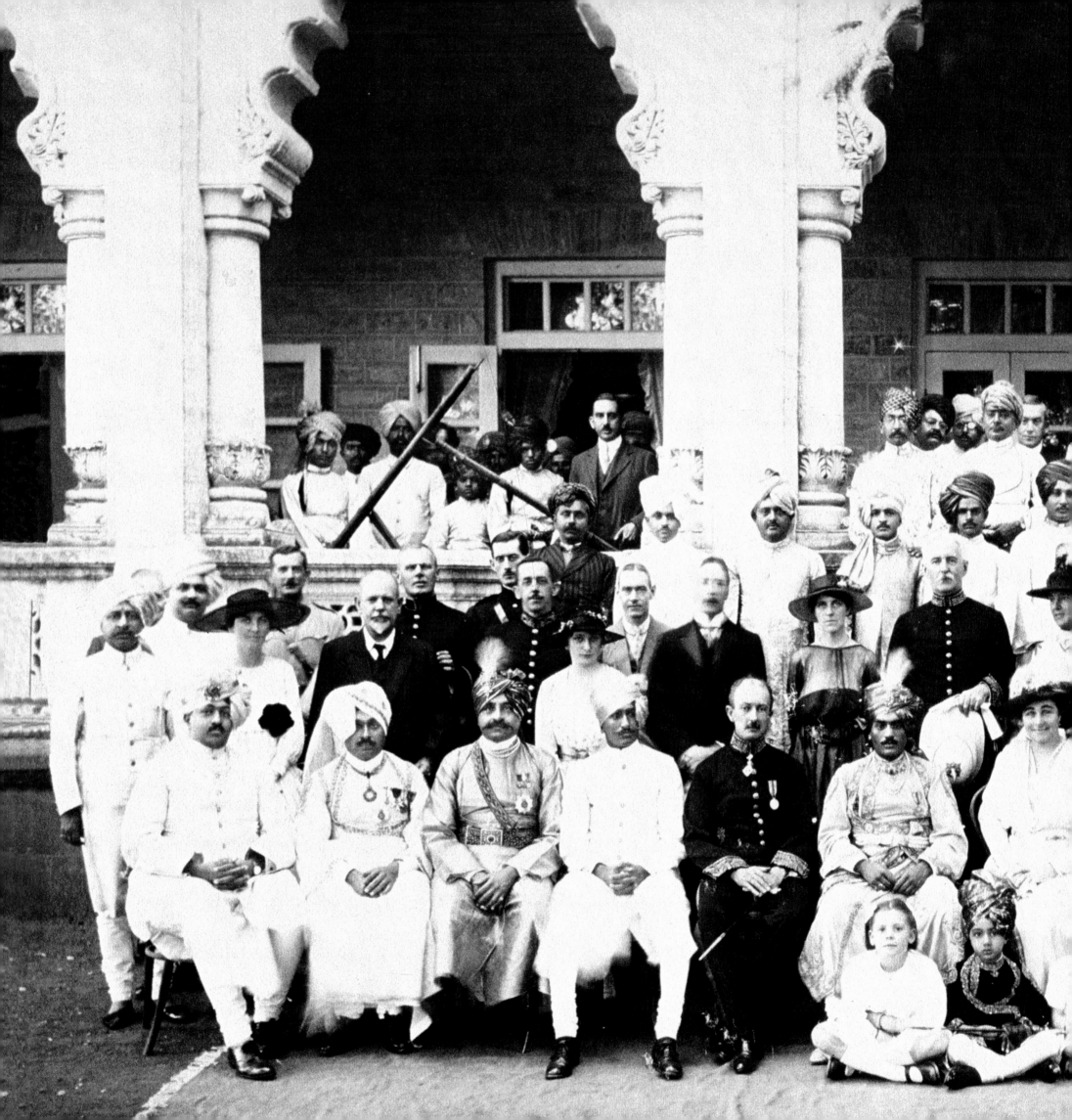

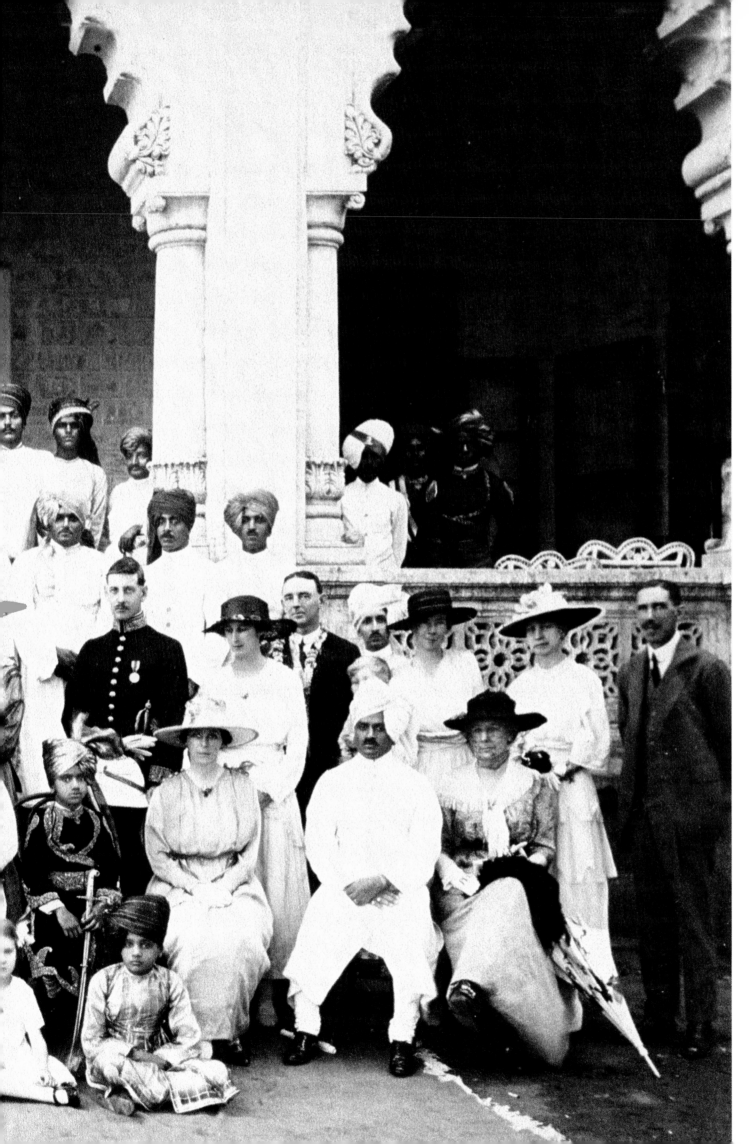

TAKEN ON THE OCCASION OF A ROYAL WEDDING IN THE 1920S, THIS PHOTOGRAPH SHOWS THE GROOM, MAHARAJA BAHADUR SINGH OF PALITANA, FLANKED BY SOME IMPORTANT WEDDING GUESTS. AMONG THEM ARE THE PRINCES OF WESTERN INDIA AND SEVERAL EUROPEANS. THE PALACE OF JUNAMAHAL IN PALITANA WAS THE VENUE OF THIS GROUP PHOTOGRAPH.

On ceremonial occasions, such as a durbar, the entry of the Maharaja, resplendent in brocade and jewels, was heralded by trumpets. He was ushered in by courtiers and retainers holding various symbols of kingship. These included gold and silver maces, emblems and insignia atop tall poles, peacock feathers and yak tails in embossed silver handles. The throne (GADDI) varied from a raised cushion covered with gold cloth on which he sat cross-legged, to a carved gold or silver throne.

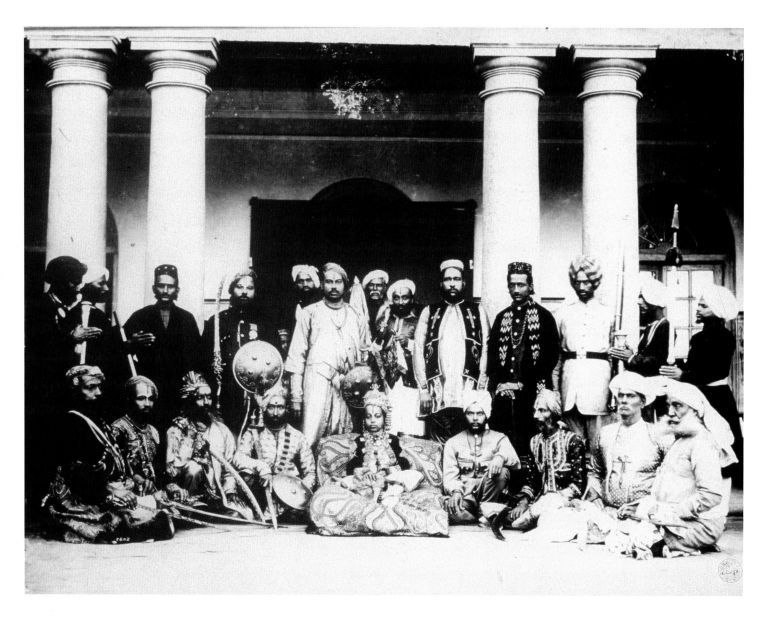

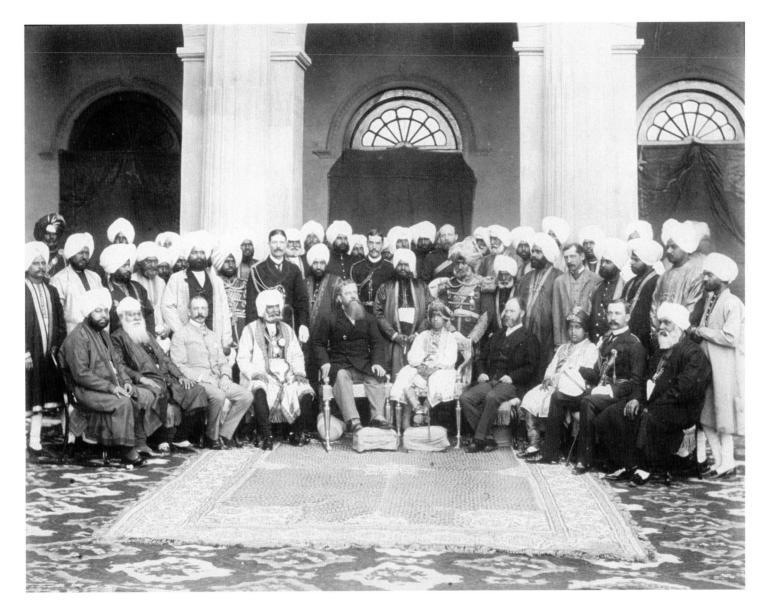

WHEN THE VICEROY,
LORD RIPON, VISITED
PATIALA IN 1884,
MOHINDAR SINGH WAS
JUST TWELVE YEARS OLD.
RUDYARD KIPLING THEN
ON THE STAFF OF *THE
CIVIL AND MILITARY
GAZETTE*, REPORTED THE
VISIT IN HIS PAPER AND
WROTE FOUR ARTICLES
ON THE SPLENDOURS OF
THE PATIALA COURT. HE
WROTE: 'IMAGINE A ROOM
SEVENTY YARDS LONG
AND THIRTY YARDS WIDE
LITERALLY CRAMMED
WITH CHANDELIERS AND
CRYSTAL FOUNTAINS OF
WHITE, RED AND GREEN
GLASS, THROW IN ACRES
OF MIRRORS, SCORES OF
STATUES, PERSIAN RUGS,
A GOLD KNOB CARPET
FIVE YARDS SQUARE, AND
TWO MASSIVE SILVER
GILT CHAIRS-OF-STATE,
AND IT IS POSSIBLE TO
OBTAIN SOME FAINT IDEA
OF THE DURBAR
CHAMBER.'

CHIEFS FROM WESTERN
INDIA POSE WITH THE
BRITISH POLITICAL
AGENT OF THEIR AREAS.
FROM LEFT TO RIGHT:
MANSINGJEE, RAJA OF
BARIA; GUMBHIRSINGJEE,
RAJA OF RAJPIPLA;
PURTABSINGRANAJEE,
RAJA OF SUNTH;
COLONEL BARTON,
POLITICAL AGENT;
WUKSINGJEE, RAJA OF
LUNAWARA; JITSINGJEE,
RAJ OF CHOTA UDAIPUR;
AND ZORAWARKHANJEE,
NAWAB OF BALASINOR, C.
MID-1870S.

FACING PAGE: THE
NAWAB OF TONK WITH
HIS SIRDARS. THE NAWAB
WAS THE RULER OF ONE
OF THE LESS WEALTHY
STATES AND ITS RULERS
FELL ON HARD TIMES
WHEN THE PRIVY PURSES
WERE CUT OFF IN THE
1950S. THE TONK
RULERS HAD A LARGE
ESTABLISHMENT TO LOOK
AFTER AND HUNDREDS OF
DEPENDENTS TO FEED.
THIS PICTURE WAS TAKEN
IN HAPPIER TIMES.

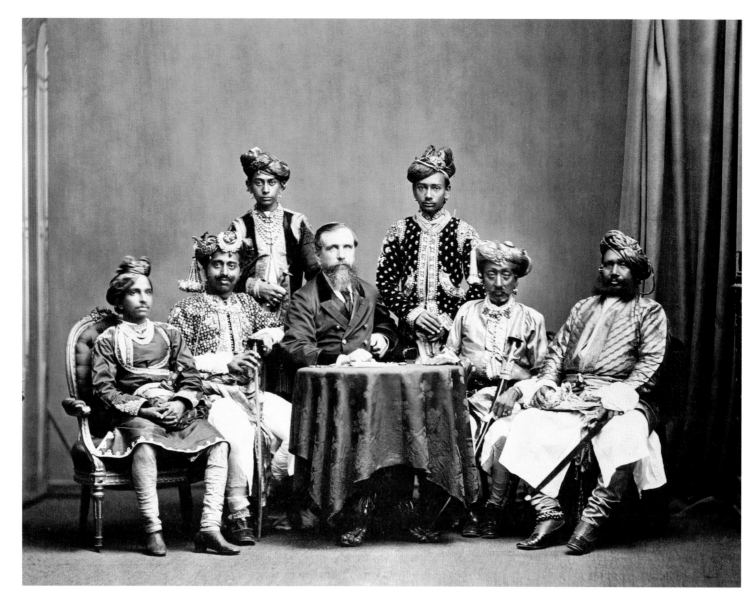

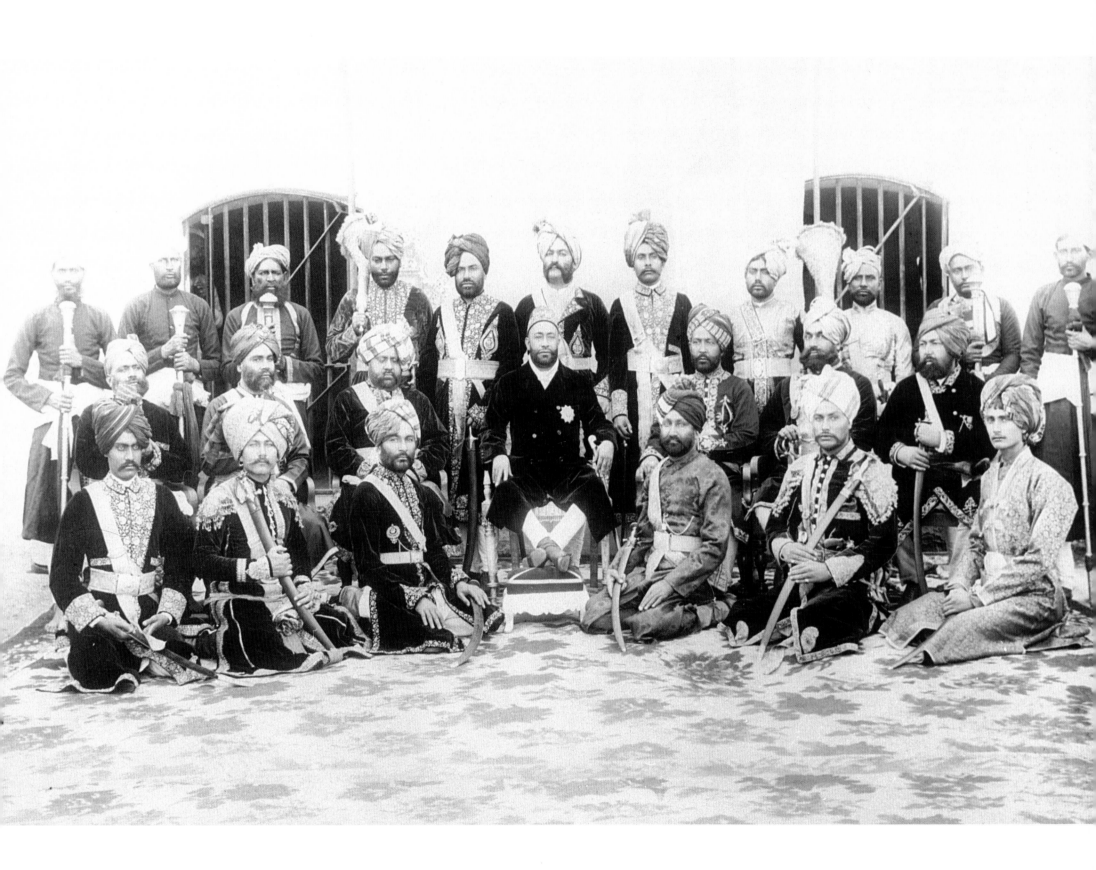

117

THE PRINCELY STATES OF
INDIA FOLLOWED A
STRICT CLAN HIERARCHY.
MANY RULERS WERE
REGARDED AS LIVING
GODS BY THEIR
CLANSMEN AND THEIR
LOYALTY TO THEIR RULER
WAS LEGENDARY. ON HIS
PART, THE RULER WAS
CALLED THE *MAI-BAAP*
(FATHER AND MOTHER)
OR *ANNADATA*
(PROVIDER) OF HIS CLAN
AND LOOKED AFTER HIS
PEOPLE AS A FATHER
LOOKS AFTER HIS
CHILDREN. MAHARAJA
MADHO RAO OF GWALIOR
SEATED WITH HIS
MINISTERS, C. 1875.

FACING PAGE: THE
MAHARAJA OF BIJAWAR
WITH HIS NOBLEMEN.
BIJAWAR WAS A RAJPUT
STATE IN BUNDELKHAND
(CENTRAL INDIA) WITH
AN AREA OF CLOSE TO
1000 SQUARE MILES AND
RATED AN 11-GUN
SALUTE.

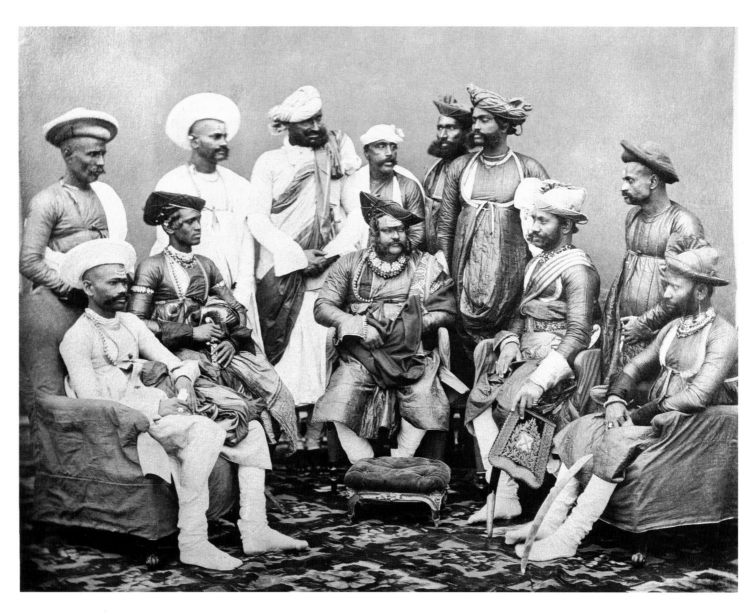

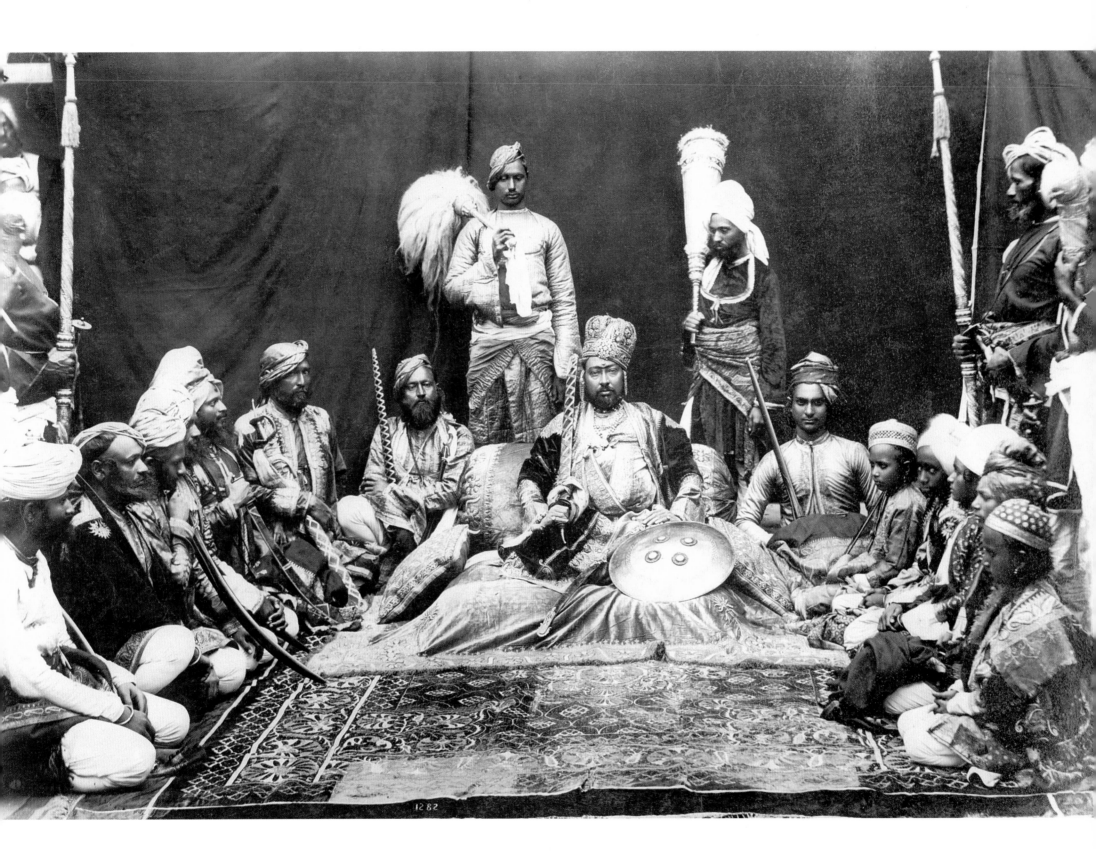

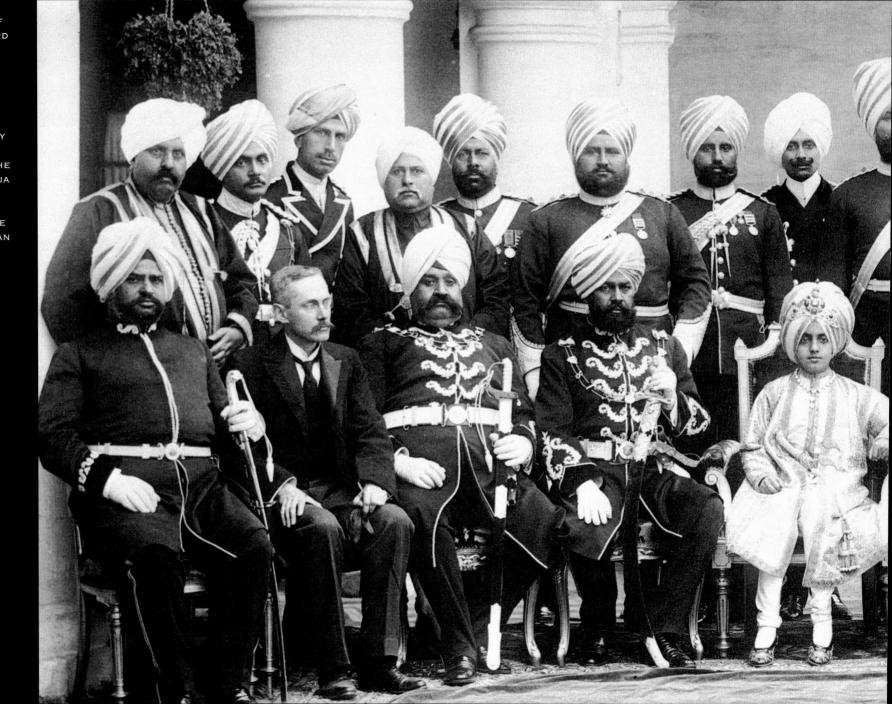

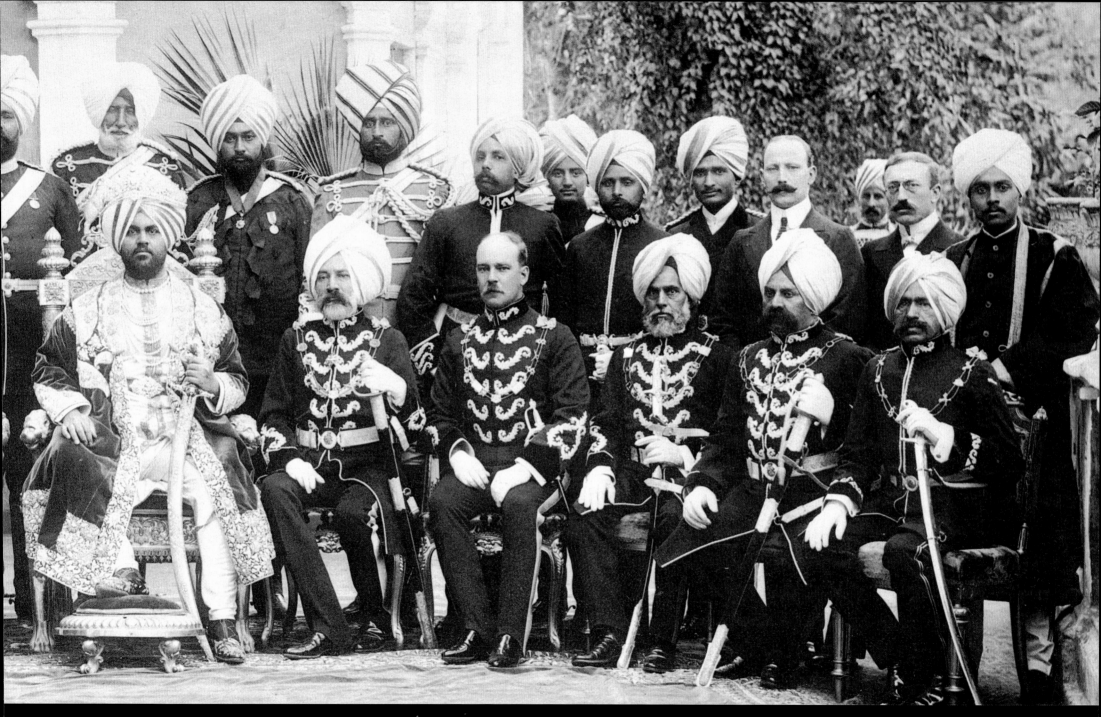

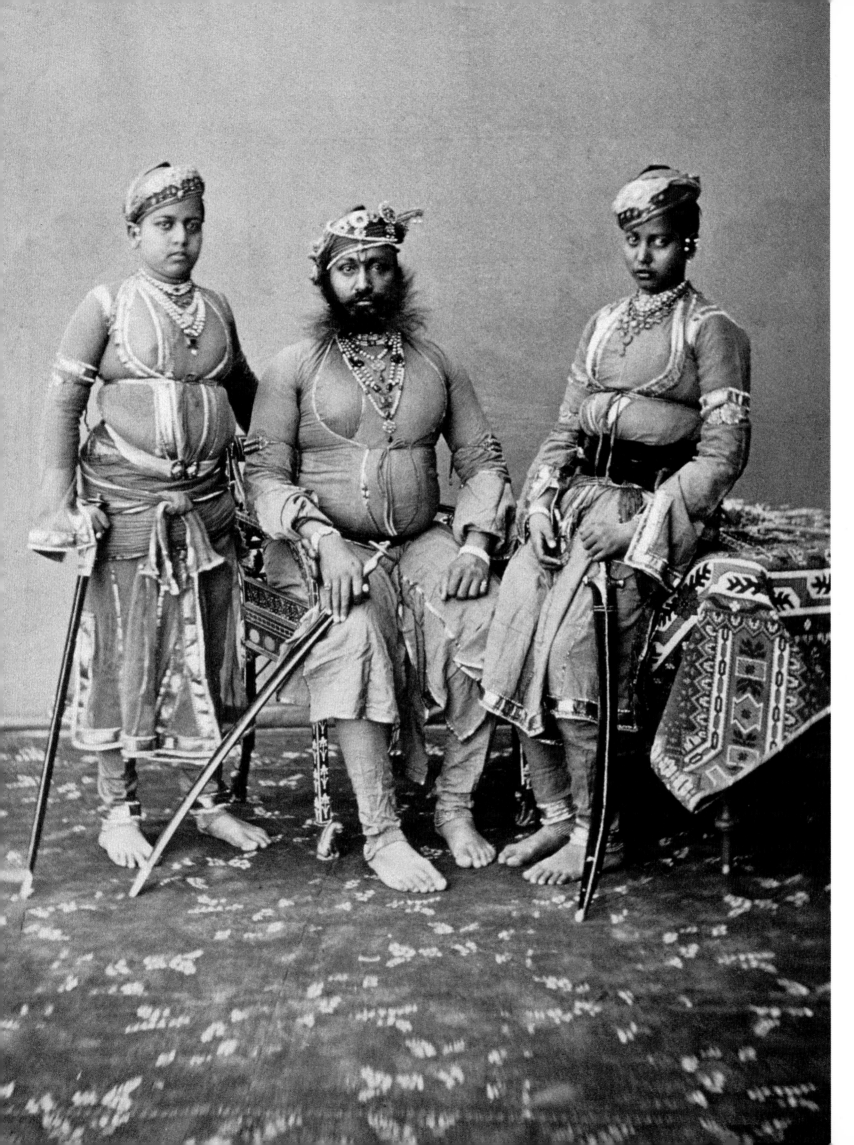

From the earliest times, the Indian raja (literally, one who rules) was looked upon as one who had the divine right to rule. The raja's title was hereditary and based on the principle of male primogeniture. This portrait from Kishangarh, a Rajput state, shows Maharaja Prithvi Singh flanked by his elder son and heir, Mahrajkumar Sardul Singh on the left and his younger son, Maharajkumar Jawan Singh, on the right.

Facing page: Maharaja Tukoji Rao Holkar of Indore, c. 1875. The most distinguished among the Holkars was their founder, Malhar Rao Holkar, who established the state of Indore in the 1750s. Under Peshwa Baji Rao's leadership he fought battles all over North India and planted the Maratha flag on the borders of Afghanistan and had even planned an attack on Khandahar. Maharaja Tukoji Rao was a descendent of Malhar Rao Holkar.

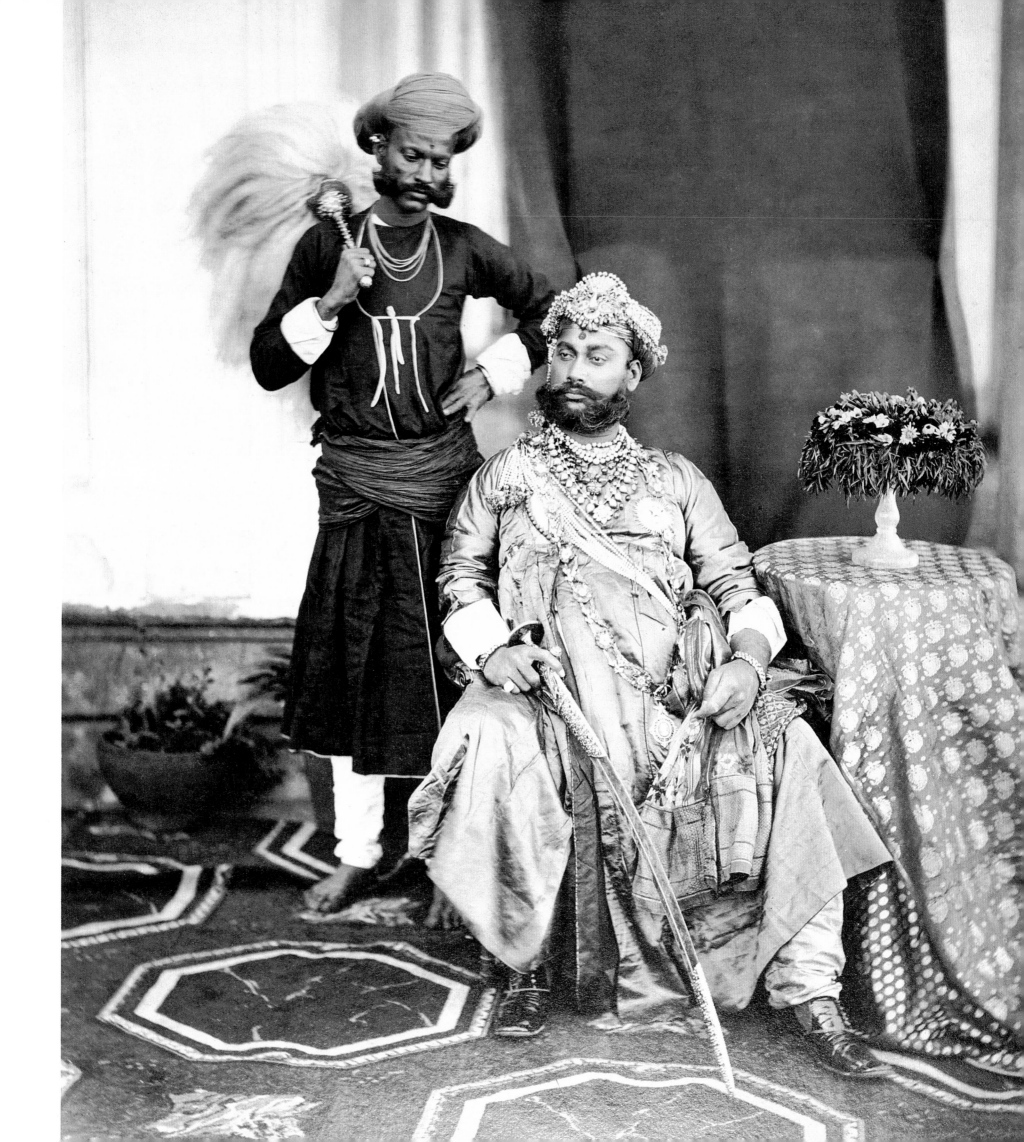

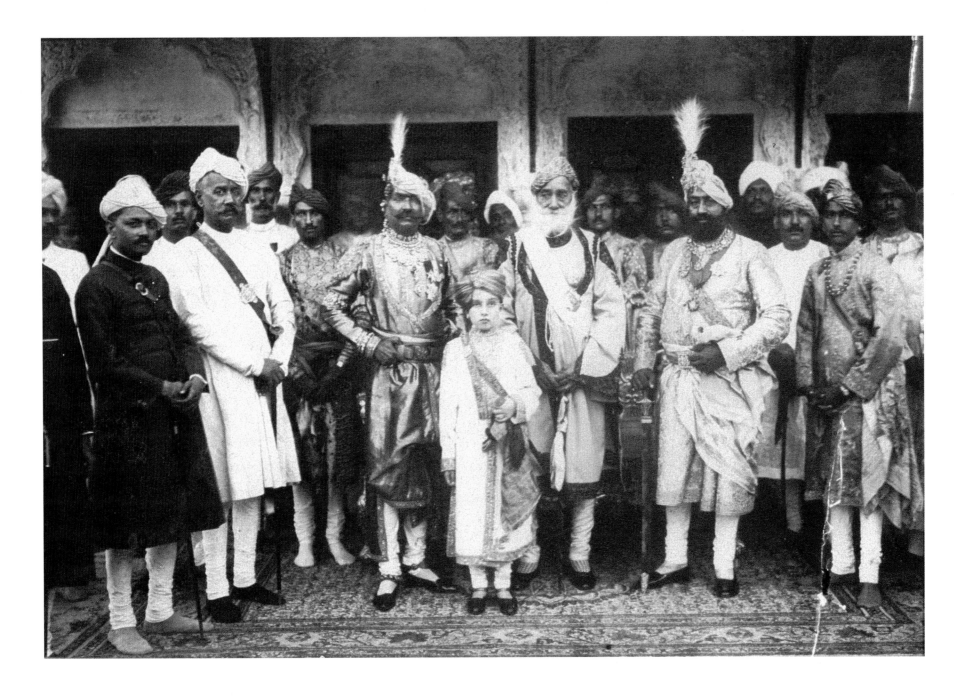

THE HEIR APPARENT WAS KNOWN AS THE RAJKUMAR IN THE HINDU STATES AND WALIHAD IN THE MUSLIM ONES. IN THE EVENT OF HIS LOSING HIS FATHER AT A YOUNG AGE, HE WAS LOOKED AFTER BY A GUARDIAN. MAHARAJA GAJ SINGH OF JODHPUR WAS MERELY FOUR YEARS OLD AND MAHARAJA BHUPINDAR SINGH OF PATIALA JUST NINE WHEN THEY BECAME THE RULERS OF THEIR STATES. BOTH WENT ON TO BECOME EXEMPLARY ADMINISTRATORS.

FACING PAGE: MAHARAJA PRATAP SINGH OF NABHA (CENTRE) AND SIBLINGS. BEHIND THE PRINCE IS A COURTIER HOLDING THE CEREMONIAL *CHANWAR* (YAK TAIL).

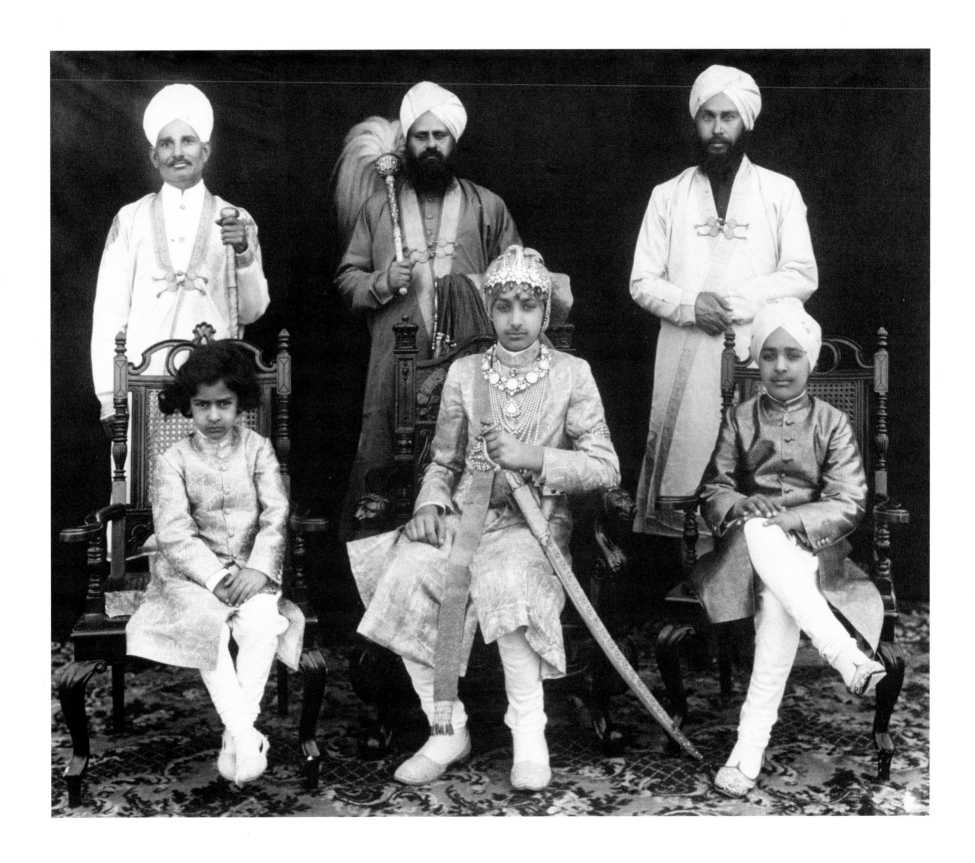

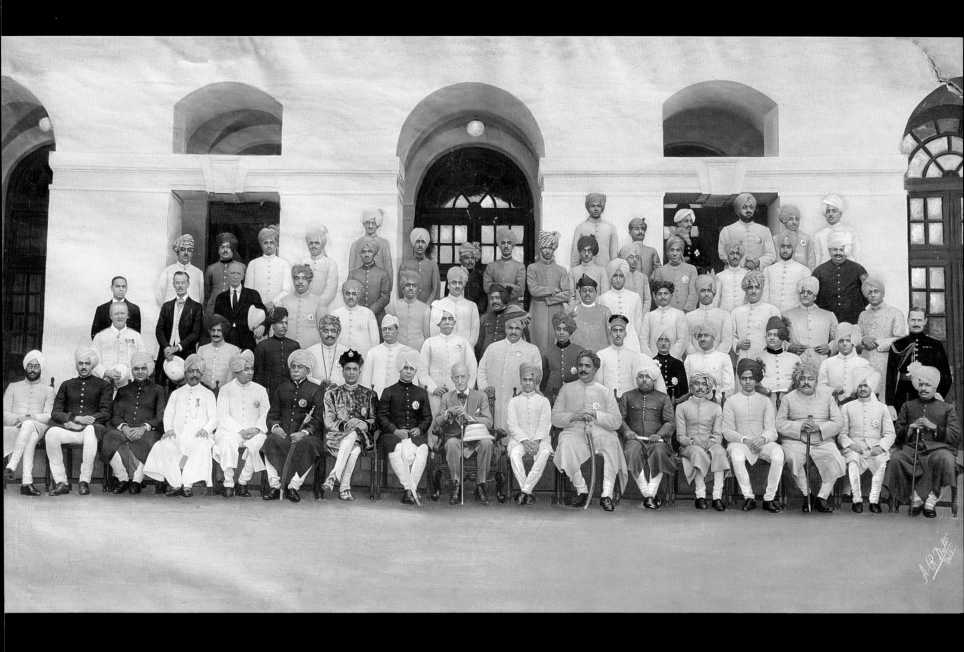

THE CHAMBER OF
PRINCES WAS SET UP TO
REPRESENT THE
POLITICAL INTERESTS OF
THE INDIAN PRINCES.
THE CHAMBER'S
MEMBERS MET EVERY
YEAR TO DISCUSS THEIR
PROBLEMS.

FACING PAGE: THOSE
WHO WERE NOT
MEMBERS OF THE
CHAMBER OF PRINCES
HAD OTHER FORUMS TO
MEET EACH OTHER FROM
TIME TO TIME. THIS
PHOTOGRAPH SHOWS
THE SHEKHAVATI

RAJPUTS AT SUCH
A CONCLAVE. NOTE
HOW THE ARTIST WHO
WAS ENTRUSTED
WITH TINTING THE
PHOTOGRAPH HAS
CHOSEN TO HIGHLIGHT
JUST A FEW CHOSEN
FEATURES.

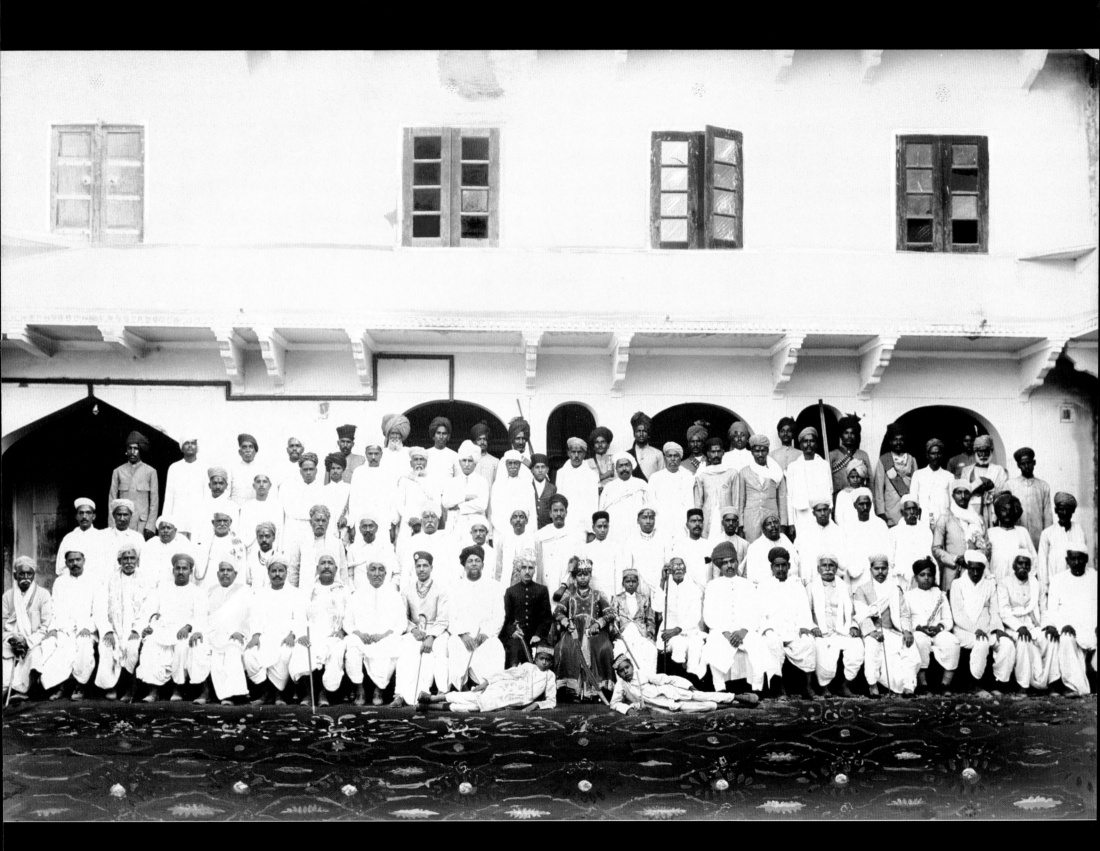

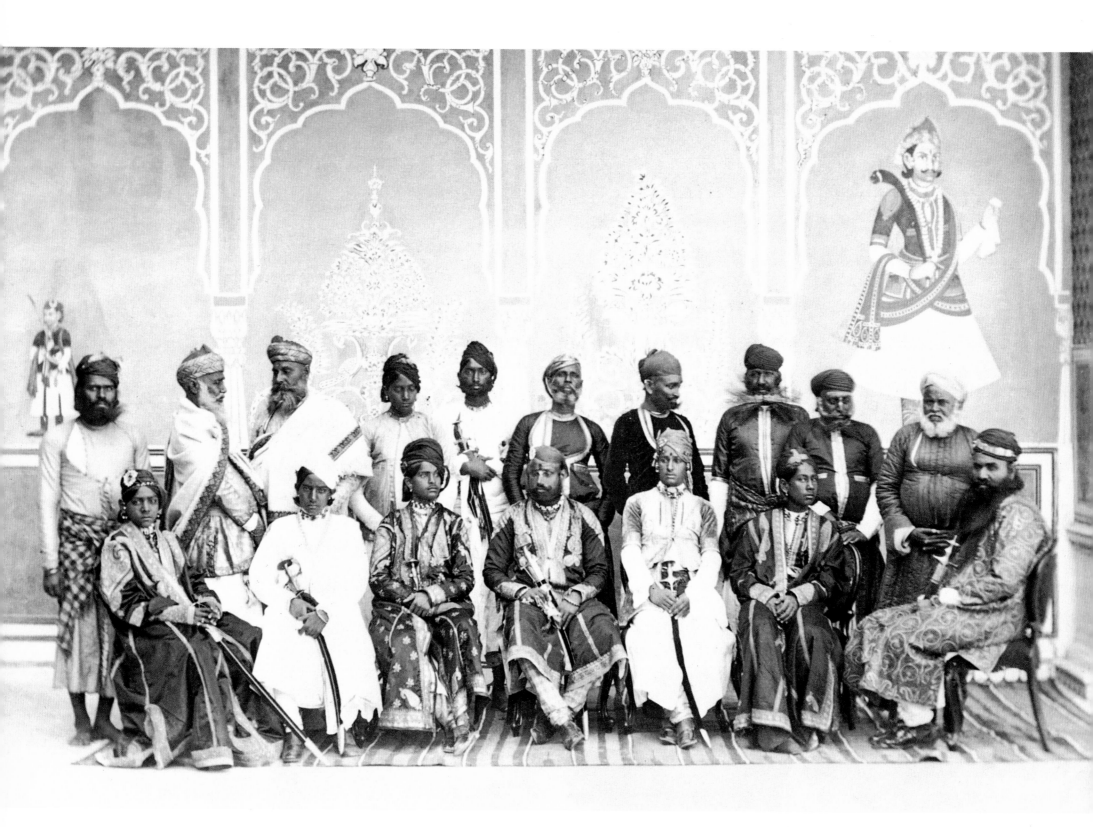

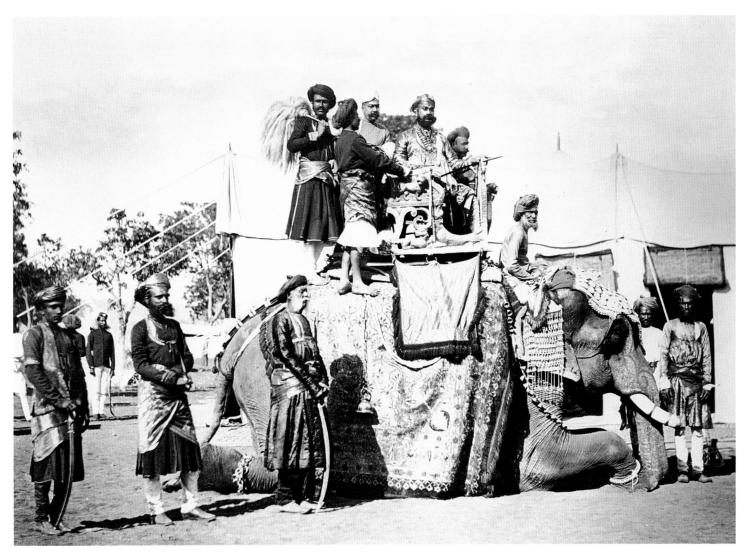

STATE CEREMONIAL WAS FOLLOWED WHETHER THE MAHARAJA WAS IN HIS PALACE OR OUT IN THE FIELD. THIS PHOTOGRAPH (C. 1875–76), SHOWS MAHARAJA HOLKAR OF INDORE MOUNTING AN ELEPHANT OUTSIDE A TENT. THE RICHLY CAPARISONED ELEPHANT, AND HIS MAHOUT WAIT PATIENTLY FOR THE MAHARAJA'S ORDERS.

FACING PAGE: THIS PHOTOGRAPH, ONE OF THE EARLIEST IN THE BOOK, DATES TO 1875. TAKEN IN JAIPUR, IT SHOWS A GROUP OF SIRDARS, OR NOBLEMEN FROM THE KACHCHAWA CLAN. THE KACHCHAWAS CONSIDERED THEMSELVES THE LEADING RAJPUT CLAN AND WERE FIERCELY WEDDED TO THEIR CODE OF HONOUR. THE CHIEF COMMANDED ABSOLUTE LOYALTY AND WAS REGARDED AS THE REPRESENTATIVE OF GOD ON EARTH.

THE INDIA OF ANCIENT
TRADITIONS—SOME
GOING BACK TO OVER A
MILLENNIUM—WAS
FOUND BEST IN THE
PRINCELY STATES
ALTHOUGH THE
CEREMONIALS VARIED
FROM STATE TO STATE.
THESE ANCIENT
TRADITIONS OF PRINCELY
INDIA WERE VISIBLE
MOST IN THE
CELEBRATION OF
FESTIVALS, BIRTHDAYS
AND MARRIAGES.
MARRIAGES BETWEEN
ROYAL FAMILIES WERE
OFTEN ARRANGED TO
FORGE POLITICAL
ALLIANCES. THEY WERE
ELABORATE AFFAIRS
THAT WENT ON FOR DAYS
AND INVOLVED
PREPARATIONS AND
FESTIVITIES.

FACING PAGE: THE
WEDDING PROCESSION OF
PRINCE KARNI SINGH OF
BIKANER EMERGES FROM
THE LALGARH PALACE IN
THE JUNAGADH FORT.
SEVERAL RAJPUT FORTS,
SOME OF WHICH ARE
OVER FIVE HUNDRED
YEARS OLD, HAVE
SPECTACULAR PALACES
WHERE THE FAMILY
TEMPLE IS LODGED.

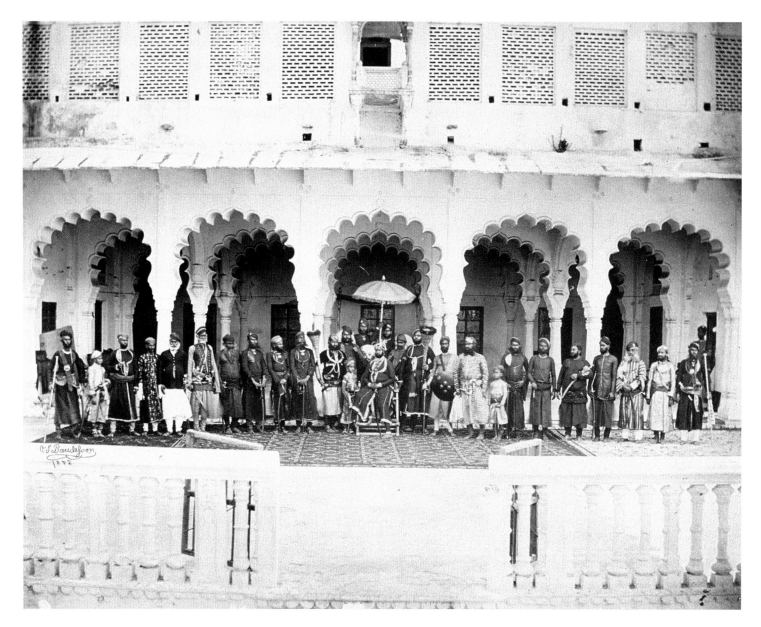

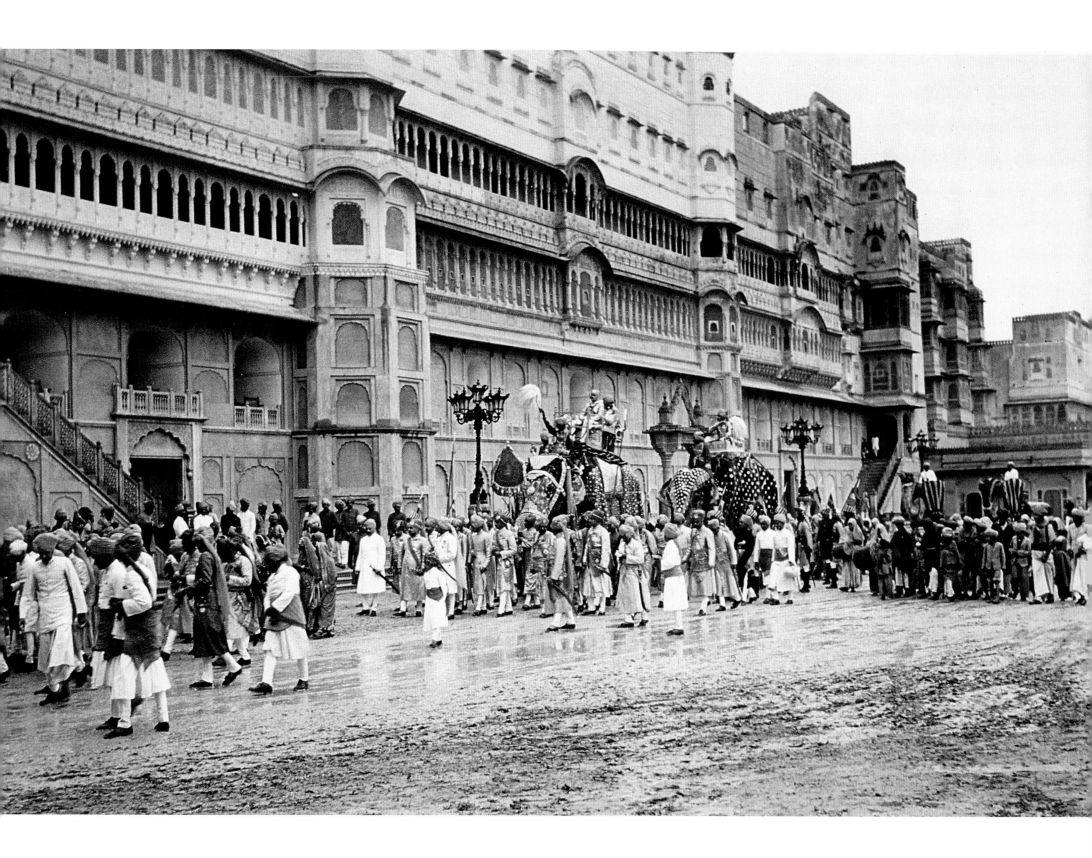

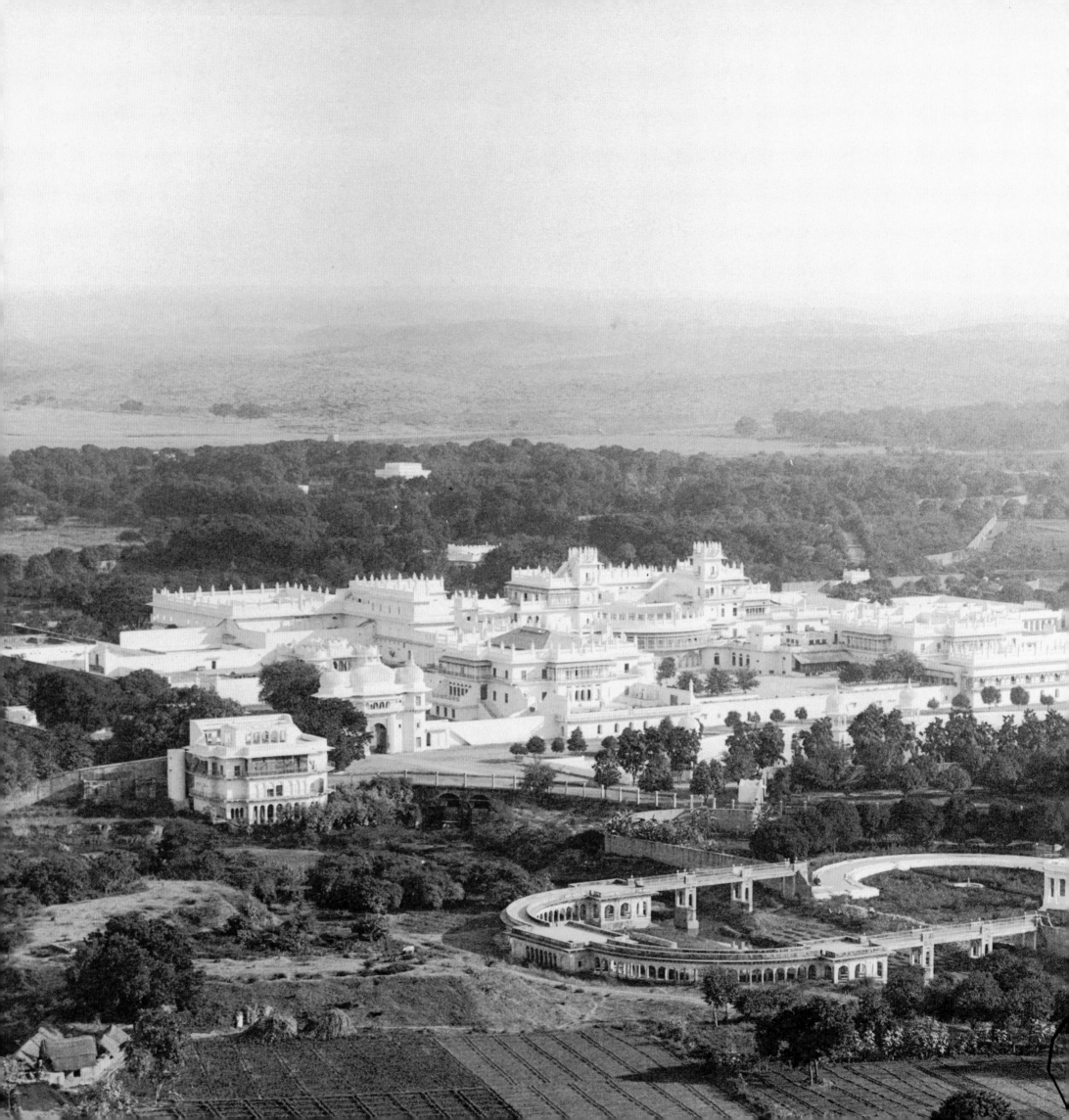

CITADELS OF POWER

In scale and grandeur, the palaces and strongholds of the erstwhile princely states must surely rank among the most impressive in the world. Although they span a range of styles, most Indian palaces can be broadly divided into two distinct categories: the classic or traditional Indian palaces, and the newer royal residences that reflect European architectural styles or features.

The classic Indian palaces, with some that go back nearly four hundred years, range from dainty pavilions in white marble that float lightly on lakes (Udaipur) to dramatic fortified retreats on bleak mountain tops (Gwalior), and desert fortresses (Jaisalmer). One suggests poetry and music, the other projects power and majesty. Often, these stylistic variations reflect the reason behind their construction: that is, whether they were built for a Maharaja's pleasure, or for self-defence. Built between the mid-1400s to mid-1800s, these palaces show considerable sophistication and imagination. They are imposing monuments with great domes, cusped arches and towering pillars, often liberally embellished with deep and crisp stone carvings, ornamental balconies (*jharokhas*), intricately latticed window screens (*jaalis*), wall paintings and elegant sculptures.

Although the palaces vary in style and size from region to region, they have some common features, since they followed the ancient laws laid down in the *Vastu Shashtra*, the sacred text followed by traditional artisans. Some of them (mainly in Rajasthan) are often a blend of the Hindu and Islamic architectural traditions, synthesizing the profusely ornamental Hindu style with the stately geometry of the Islamic architectural tradition, incorporating features such as the dome and arch that were introduced to India by the Islamic rulers of the north.

Most princely capitals had several palaces of which the largest and most opulent served as the main residence of the Maharaja and his

(AERIAL VIEW) UMAID BHAWAN PALACE, JODHPUR. BUILT BY THE BRITISH ARCHITECTS LANCHESTER AND LODGE, THIS WAS INDIA'S FIRST ART DECO PALACE. ITS DURBAR HALL HAS A CURVED GOLDEN CEILING AND FRESCOES EXECUTED BY A POLISH ARTIST, JULIUS STEFAN NORBLIN, WHO CHOSE THEMES FROM INDIAN MYTHOLOGY TO GIVE HIS WORK AN ORIENTAL TOUCH. THE BATHROOM ATTACHED TO THE MAHARANI'S BEDROOM HAS A BATHTUB AND A WASHBASIN IN ONYX WITH GILDED FITTINGS.

FACING PAGE: (AERIAL VIEW) JAI VILAS PALACE, GWALIOR. PERHAPS THE MOST AMBITIOUS OF INDIA'S ROYAL RESIDENCES, IT WAS BUILT TO CELEBRATE THE VISIT OF THE PRINCE OF WALES TO GWALIOR IN 1870. DESIGNED BY COL. SIR MICHAEL FILOSE, ITS DURBAR HALL HAS GILT AND GOLD FURNISHINGS. THE GIGANTIC CRYSTAL CHANDELIERS, EACH WITH 248 CANDLES PROTECTED BY GLASS CHIMNEYS, WEIGH AN ASTOUNDING 4,000 KG (9,000 LBS.). THE CARPET OF THE DURBAR HALL IS SAID TO BE THE LARGEST IN ASIA.

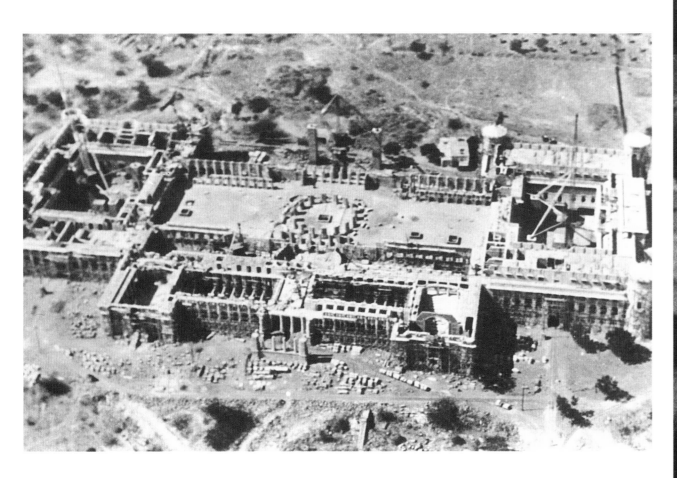

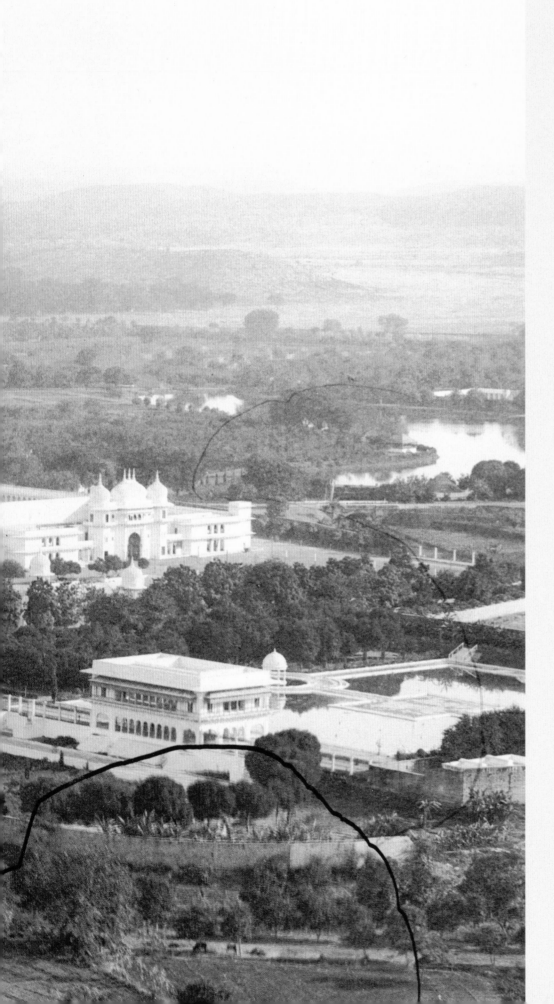

CITADELS OF POWER

In scale and grandeur, the palaces and strongholds of the erstwhile princely states must surely rank among the most impressive in the world. Although they span a range of styles, most Indian palaces can be broadly divided into two distinct categories: the classic or traditional Indian palaces, and the newer royal residences that reflect European architectural styles or features.

The classic Indian palaces, with some that go back nearly four hundred years, range from dainty pavilions in white marble that float lightly on lakes (Udaipur) to dramatic fortified retreats on bleak mountain tops (Gwalior), and desert fortresses (Jaisalmer). One suggests poetry and music, the other projects power and majesty. Often, these stylistic variations reflect the reason behind their construction: that is, whether they were built for a Maharaja's pleasure, or for self-defence. Built between the mid-1400s to mid-1800s, these palaces show considerable sophistication and imagination. They are imposing monuments with great domes, cusped arches and towering pillars, often liberally embellished with deep and crisp stone carvings, ornamental balconies (*jharokhas*), intricately latticed window screens (*jaalis*), wall paintings and elegant sculptures.

Although the palaces vary in style and size from region to region, they have some common features, since they followed the ancient laws laid down in the *Vastu Shashtra*, the sacred text followed by traditional artisans. Some of them (mainly in Rajasthan) are often a blend of the Hindu and Islamic architectural traditions, synthesizing the profusely ornamental Hindu style with the stately geometry of the Islamic architectural tradition, incorporating features such as the dome and arch that were introduced to India by the Islamic rulers of the north.

Most princely capitals had several palaces of which the largest and most opulent served as the main residence of the Maharaja and his

133

extended family. Called the 'city palace', such a palace was usually divided into two main areas: the zenana (the women's quarters) and the *mardana* (the men's quarters). The zenana was further divided into separate chambers so that each queen had a private apartment. Partly because of the necessity of providing ventilation and also due to the practice of purdah, intricate *jalis* embellished the windows and arches of these royal quarters. Moved by the plight of the royal ladies in his zenana, Sawai Pratap Singh of Jaipur created the Hawa Mahal (literally, the Palace of the Winds) in 1799. This splendid pink 'palace', with tier upon tier of windows, is a baroque composition of projecting *jharokhas* just one-room deep to enable the royal ladies in purdah to view processions pass in the street below without being observed themselves.

The *mardana* contained the private apartments of the ruler as well as spaces designated for the conduct of state business. The latter included a *diwan-e-khas* (hall of private audience) and a *diwan-e-aam* (hall of public audience where the Maharaja met his ministers and high officials. In keeping with the Hindu tradition, most 'old' palaces had large courtyards, used for entertainment such as a *nautch* (dance performance) or for celebration of festivals, such as *holi,* by the royal family or on other festive occasions, such as birthdays and anniversaries. The *mardana* also included the picture gallery, armoury and the treasury.

In addition to these enclosures, there were pavilions, sometimes named romantically Sawan Bhadon (the months when the monsoon hits north India), where musical soirees were held. Then there were halls studded with mirrors (called the Sheesh Mahal), where the light of a single candle danced off the mirrors on the ceiling and walls to the delight of viewers. The walls were often embellished with gorgeous paintings, done by the court painters in the characteristic style of the state.

Many ancient forts contained palaces as well, which were known as *garh* palaces, or fort-palaces. Merged as a single structure with the fort with private temples or mosques attached to the royal quarters, *garh* palaces were also an expression of power and enviously eyed by neighbouring rulers. Such palaces had fortified walls and gates with narrow corridors that connected various apartments with secret passages. This ensured that any rebel or enemy forces would have to enter single file and their use of weapons would be restricted.

The 'old' palaces were built slowly and continuously over a long period, sometimes over a hundred years or more. The continual alteration and addition occasionally led to a degree of asymmetry in structure but it was seldom unpleasing and introduced an element of charming whimsicality. The Bharatpur kings built a 'water palace' in Deegh, their summer capital. A lyrical composition of marble and sandstone, the complex owes its existence to an eighteenth-century ruler, Suraj Mal, who wished to capture the magic of the monsoons for his harem. Since Deegh receives little rain, he created special effects here to simulate thunder and showers. The Sawan Bhadon pavilions in Deegh were vantage points from where the royal viewers savoured the delights of a cooling shower (from concealed fountains on the roof) whenever they so fancied!

Constantly modified by successive rulers, most Indian palaces were enormous structures: some with over 400 rooms. It was not uncommon for a prince to lose his way around in his own home and there were actually portions of palaces that remained unvisited for decades. Accustomed to this scale and grandeur, it was hardly surprising that many Maharajas on their first visit to England were shocked to see how small Buckingham Palace is and for them 'it paled in comparison' to their own royal residences. European visitors, on the other hand, were simply overawed by the gigantic scale of the Indian palaces.

By the late nineteenth century, a new style of palace building became fashionable in India. The old fortified palaces became irrelevant as treaties with the British ensured the Indian princes security from mutual hostilities and war. Many rulers amassed considerable wealth through taxes and revenues that they did not now need to spend on war. Above all, they had discovered European architectural styles since travelling abroad became a popular royal pastime. Initially, royal fancies consisted of isolated vulgarities, such as the carving of trains and horse carriages in palace sculpture. But soon this influence became more pervasive and in the later decades of the 1800s, the traditional Rajput or Mughal styles were cast aside and Indian palaces began to not merely incorporate European architectural features, but to actually replicate English stately homes and French chateaux. Located incongruously in the desert sands of Rajasthan or the dusty plains of the Punjab and the tropical

landscapes of South India, these European chateaux and English country houses were also seen as a measure of the ruler's sophisticated tastes and his closeness to the English rulers.

While some of the 'new' palaces were distinctly European in appearance, others were built in a hybrid style that came to be called Indo-Saracenic. Looking at some of its examples, though, it might be more appropriate to call this style Indo-Gothic or Indo-Baroque. The main palaces at Jodhpur and Mysore are good examples of this, as is the overwhelming Laxmi Vilas at Baroda, built in 1890 by Charles Mant. The Jagatjit Palace at Kapurthala built in 1908, and named the Elysee Palace by the Francophile ruler Maharaja Jagatjit Singh, has a startling resemblance to Versailles and was designed by a French architect, M. Marcel. All over the country one can locate these fanciful and grand residences. The Indian princes were encouraged by the British rulers to spend their time and attention on creating palaces that were radically different from the traditional residences. This not only bred a lifestyle that was more in keeping with the British image of a profligate Indian prince, it also kept the princes out of mischief. Hunting, shooting and fishing—the mindless preoccupations of the English nobility—came to dominate the lifestyle of the once-proud Rajput and Maratha warriors who now played polo and went on shikar when they were not occupied with travelling on the Continent.

A point often forgotten is that where the old palaces had evolved over years, built lovingly by a team of anonymous master craftsmen, the newer palaces were built swiftly under the supervision of one European architect who stamped his name upon the palace as surely as the ruler's. Landscaped gardens in the European tradition replaced the charming groves of the older palaces, often planted with roses and such 'English' flowers. With these palaces, it seemed as if the European conquest of the Indian landscape was complete.

Equally significant were the changes that took place in the interiors of Indian palaces in the nineteenth century. The old divans, *pidhis* (cushioned stools), bolsters and cushions gave way to objects d'art imported from Europe in shiploads. Victorian bric-a-brac, classical French, or carved silver furniture were eagerly bought to furnish royal homes now. The rich embroideries of an older era and Indian miniature paintings were swept away and in their place came porcelain vases from China and Japan and oil paintings by European masters. Swords and daggers studded with precious stones and gold damascene had to make way on the walls for hunting trophies and royal crests. Silver photograph frames littered every French pier table. Mirrors and stained glass from Belgium, cut-glass chandeliers from Venice and Bohemia, silk carpets from Persia and marble statues from Europe became the raging fashion. The very badges of Indian royalty were now European: every carriage and cigar box was stamped with a crest that could pass for English but for its motto that was still inscribed in Sanskrit, not Latin. Naturally, this hybrid Indo-European lifestyle had several hilarious outcomes: the Nizam of Hyderabad had a smoking room set aside in his opulent Falaknuma Palace which had hookahs for his Indian guests.

In the last few decades of the twentieth century, a sea change took place in the fortunes of the erstwhile princely states. With their privy purses snatched away, running these palaces became a nightmare for many royal families. Today, most Indian palaces are in a pathetic state. The harsh climate of the land and years of poor maintenance have taken a heavy toll on their exteriors that are cracked and peeling. The manicured gardens of those years are now a tangle of weeds where stray cattle come to graze. The interiors have suffered no less: in palace after palace one encounters draperies that are tattered or threadbare, clumsily repaired rickety furniture and chipped or cracked chandeliers and cut-glass objects. Many palaces, even forts, have crumbled, others have been sold off although some still remain private residences. Several royal families have converted their properties into heritage hotels or leased them to hotel chains and private entrepreneurs. The Government of India has taken over many properties and converted them into museums, educational institutions or offices. The beautiful Ratlam Palace is now a post office. The elegant Elysee Palace of Kapurthala is now an army school and its dainty French interiors overtaken by the rough and ready efficiency of the state government that runs it. Patiala's Moti Bagh Palace, once considered the largest royal residence anywhere in the world, is now a sports academy. The marble pool where beautiful ladies cavorted with the Maharaja is now a wrestling pit filled with sand.

What remains now are the memories, preserved in faded sepia and in tales written by travellers and royal biographers.

(AERIAL VIEW) UMAID BHAWAN PALACE, JODHPUR. BUILT BY THE BRITISH ARCHITECTS LANCHESTER AND LODGE, THIS WAS INDIA'S FIRST ART DECO PALACE. ITS DURBAR HALL HAS A CURVED GOLDEN CEILING AND FRESCOES EXECUTED BY A POLISH ARTIST, JULIUS STEFAN NORBLIN, WHO CHOSE THEMES FROM INDIAN MYTHOLOGY TO GIVE HIS WORK AN ORIENTAL TOUCH. THE BATHROOM ATTACHED TO THE MAHARANI'S BEDROOM HAS A BATHTUB AND A WASHBASIN IN ONYX WITH GILDED FITTINGS.

FACING PAGE: (AERIAL VIEW) JAI VILAS PALACE, GWALIOR. PERHAPS THE MOST AMBITIOUS OF INDIA'S ROYAL RESIDENCES, IT WAS BUILT TO CELEBRATE THE VISIT OF THE PRINCE OF WALES TO GWALIOR IN 1870. DESIGNED BY COL. SIR MICHAEL FILOSE, ITS DURBAR HALL HAS GILT AND GOLD FURNISHINGS. THE GIGANTIC CRYSTAL CHANDELIERS, EACH WITH 248 CANDLES PROTECTED BY GLASS CHIMNEYS, WEIGH AN ASTOUNDING 4,000 KG (9,000 LBS.). THE CARPET OF THE DURBAR HALL IS SAID TO BE THE LARGEST IN ASIA.

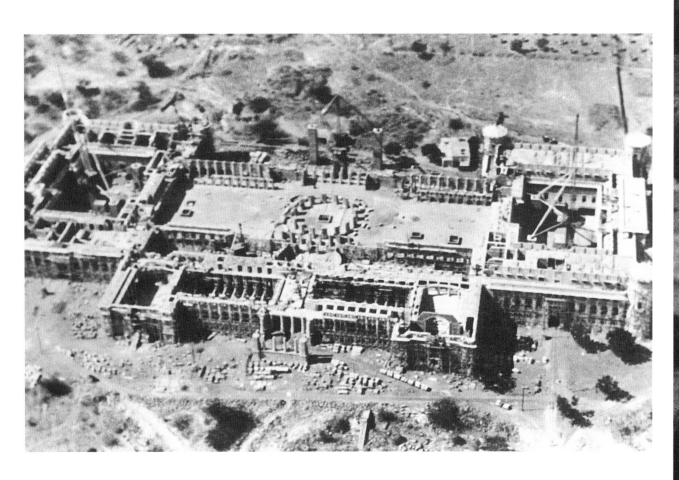

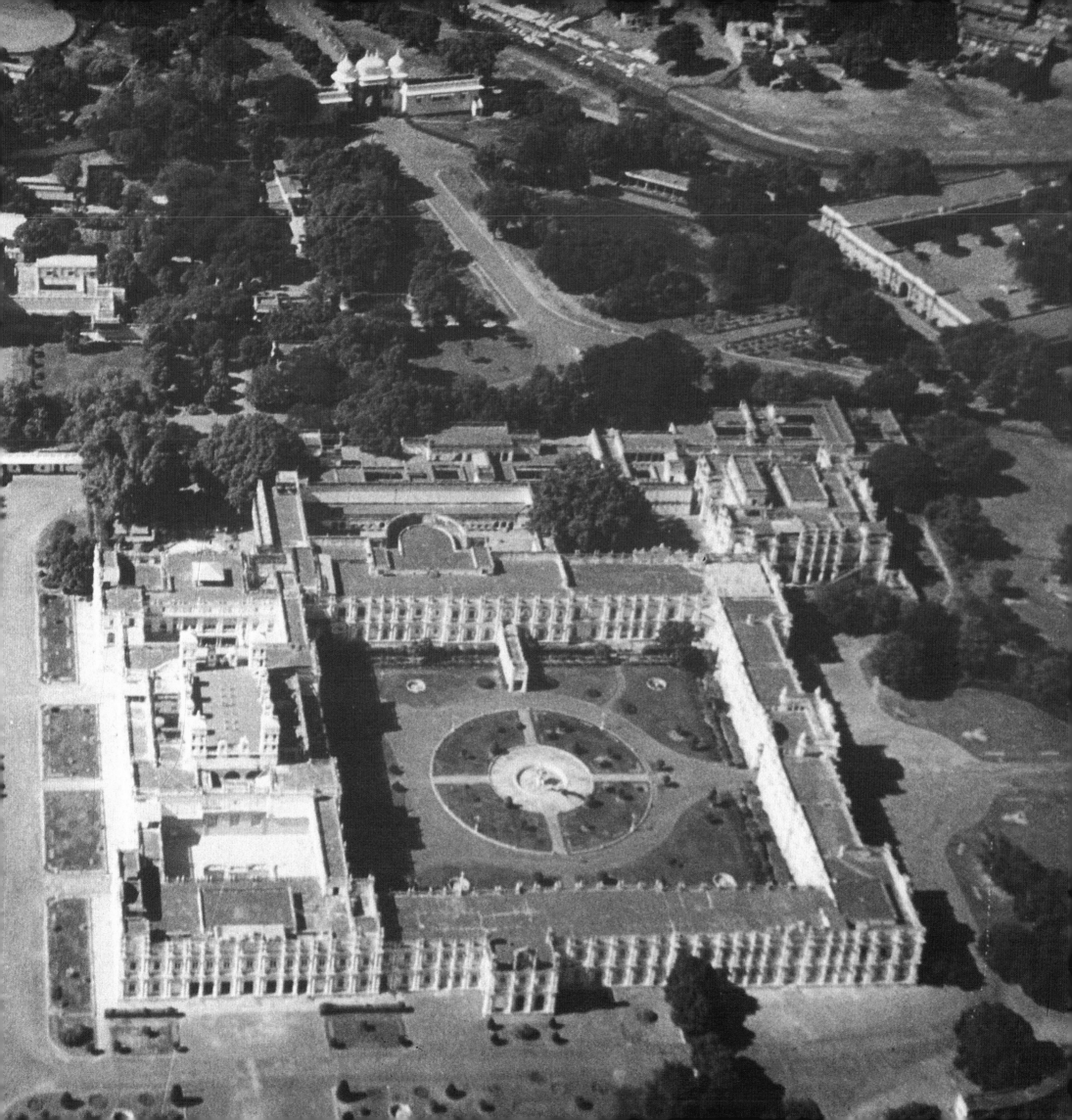

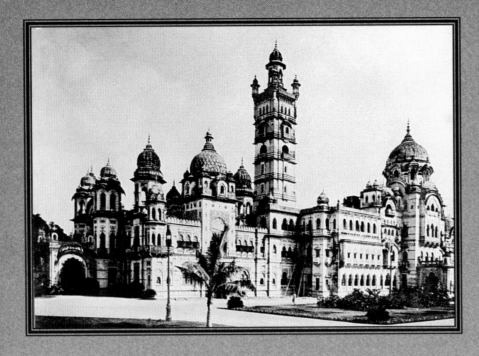

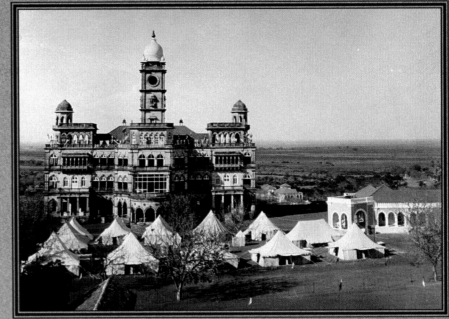

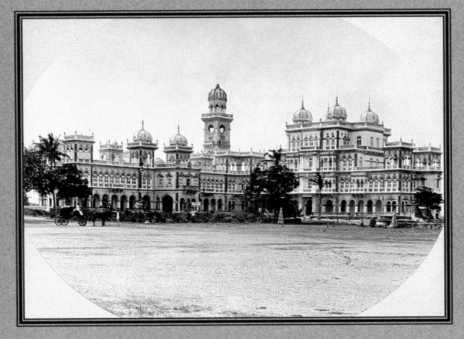

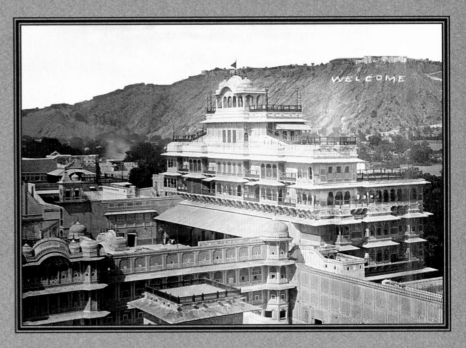

TOP LEFT: THE NABHA PALACE.

TOP RIGHT: RANJIT VILAS PALACE, WANKANER. DESIGNED BY MAHARAJ AMAR SINHJI IN A BOLD SYNTHESIS OF STYLES WITH GOTHIC ARCHES, A DUTCH ROOF AND RAJPUT BALCONIES. THE PALACE ALSO BOASTS A EUROPEAN STYLE CLOCK TOWER.

BOTTOM LEFT: JAMNAGAR PALACE. ALSO KNOWN AS NAWANAGAR, OR 'THE NEW CITY'. JAMNAGAR WAS ONE OF THE LARGER STATES OF SAURASHTRA. IT HAS SEVERAL PALACES, WHICH INCLUDE: DARBARGARH, PARTS OF WHICH GO BACK TO THE SIXTEENTH CENTURY.

BOTTOM RIGHT: CITY PALACE, JAIPUR. SITUATED IN THE HEART OF THE CITY, THIS HUGE COMPLEX WAS HOME TO THE RULERS OF JAIPUR FROM THE EIGHTEENTH CENTURY. THE WELCOME SIGN WRITTEN ACROSS THE HILLSIDE WAS IN HONOUR OF THE VISITING PRINCE AND PRINCESS OF WALES.

FACING PAGE: THE PALLADIAN FACADE OF THE IMPOSING PALACE AT PORBANDAR SHOWS THE IMPACT THAT ENGLISH STATELY HOMES HAD UPON PALACE ARCHITECTURE IN INDIA. THE FORMAL GARDENS ARE LAID OUT WITH FOUNTAINS AND STATUES AND GEOMETRIC FLOWER BEDS.

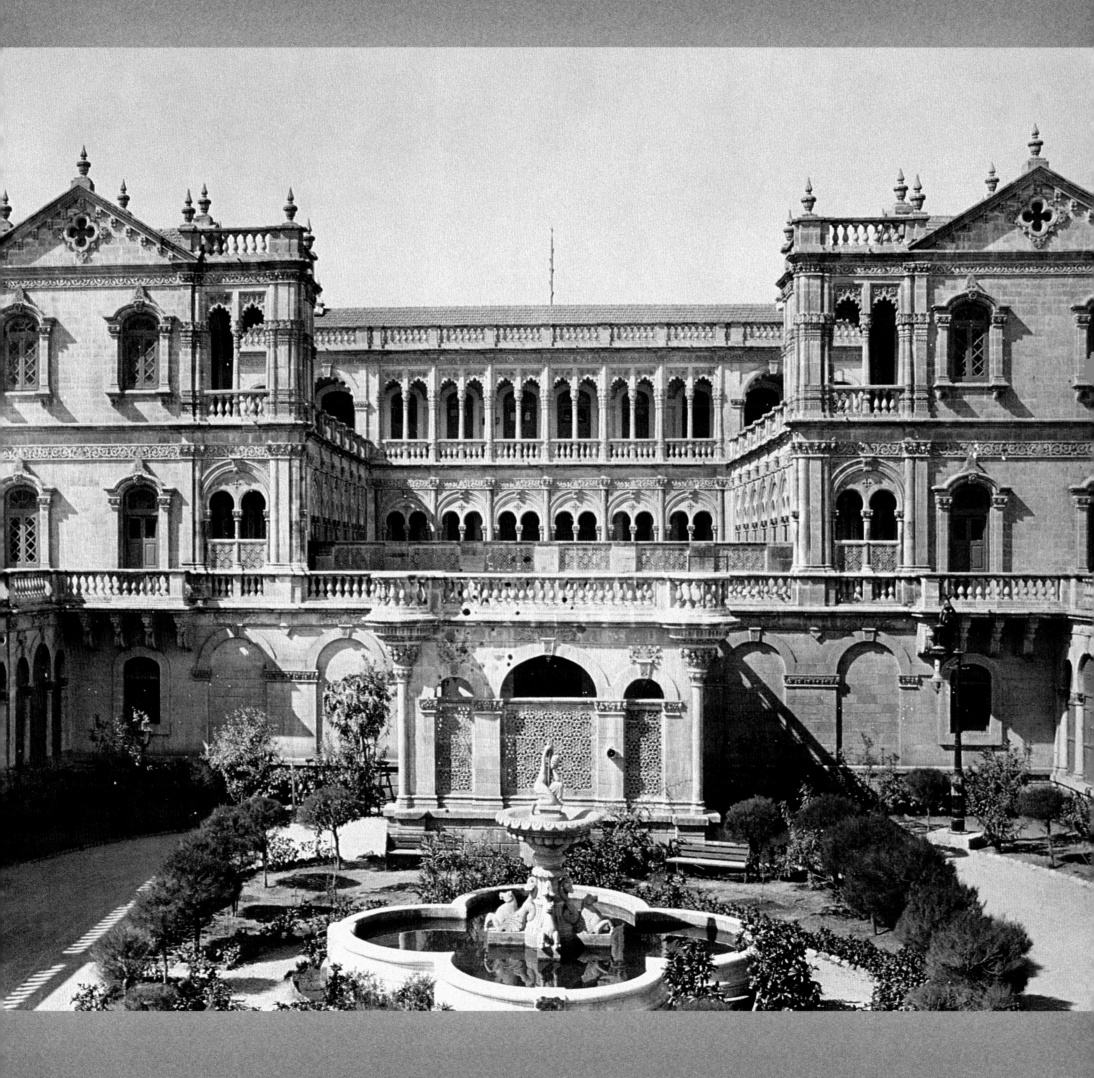

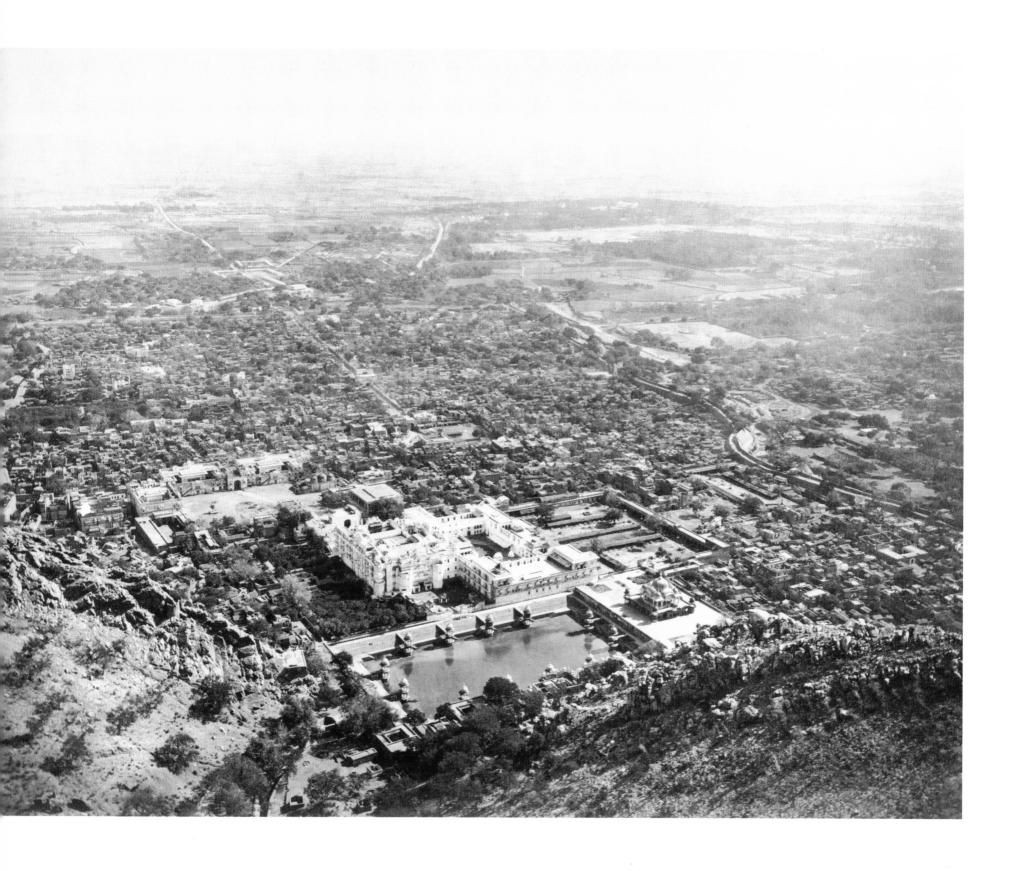

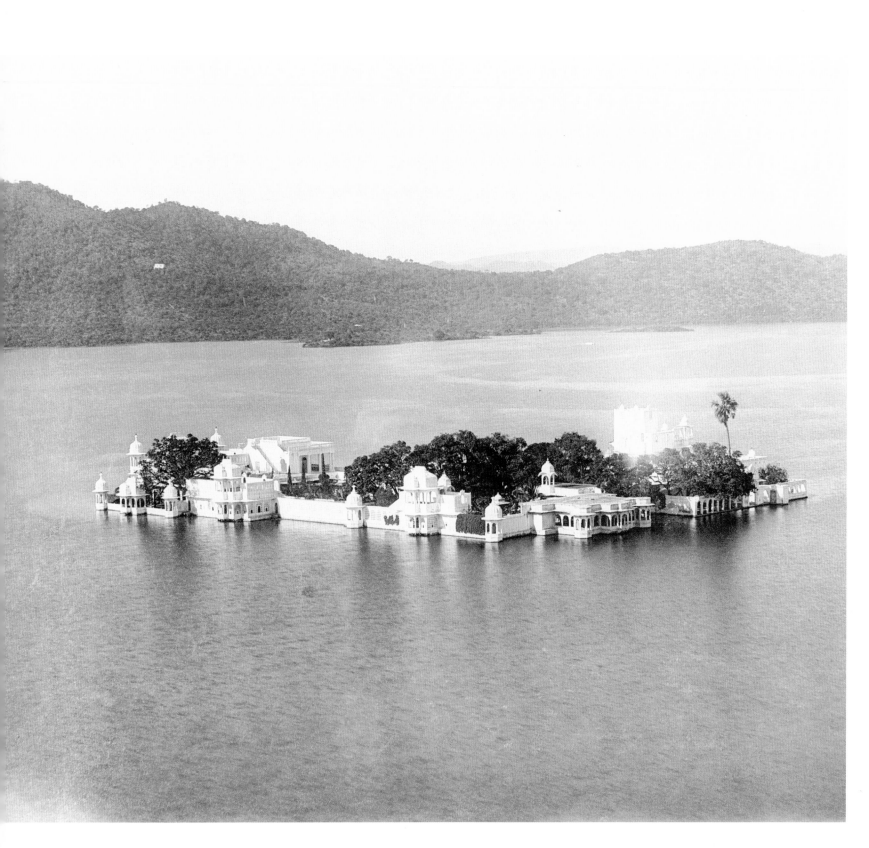

THE JAG MANDIR, UDAIPUR, WAS BUILT IN 1620. AT ITS ENTRANCE ARE EIGHT STONE ELEPHANTS, INSIDE ITS MARBLE CHAMBERS ARE INLAID WITH COLOURED STONE. THE PALACE IS SURROUNDED BY THE WATERS OF LAKE PICHOLA. THE MUGHAL EMPEROR SHAH JAHAN WAS DEEPLY IMPRESSED BY IT AND SOME OF THE WATER FEATURES USED IN THE TAJ MAHAL ARE SAID TO HAVE BEEN INSPIRED BY THIS PALACE.

FACING PAGE: A BIRD'S EYE VIEW OF THE ALWAR PALACE COMPLEX BUILT IN THE EIGHTEENTH CENTURY. THE CLASSIC INDIAN PALACES RANGE FROM DAINTY PAVILIONS IN WHITE MARBLE THAT FLOAT LIGHTLY ON LAKES TO SPRAWLING PILES. ONE SUGGESTS POETRY AND MUSIC, THE OTHER PROJECTS POWER AND MAJESTY. OFTEN, THESE STYLISTIC VARIATIONS REFLECT THE REASON BEHIND THEIR CONSTRUCTION: THAT IS, WHETHER THEY WERE BUILT FOR A MAHARAJA'S PLEASURE, OR FOR SELF-DEFENCE. BUILT BETWEEN THE MID-1400s TO MID-1800s, THEY ARE IMPOSING MONUMENTS.

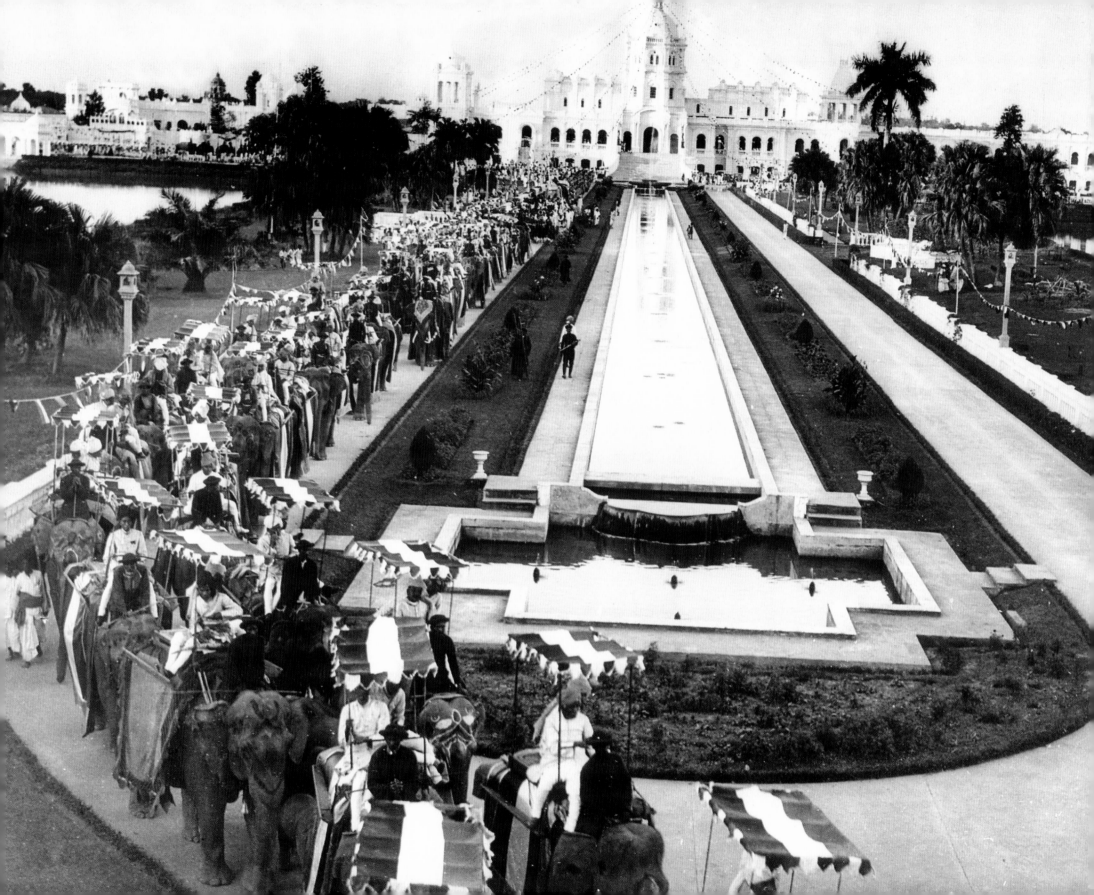

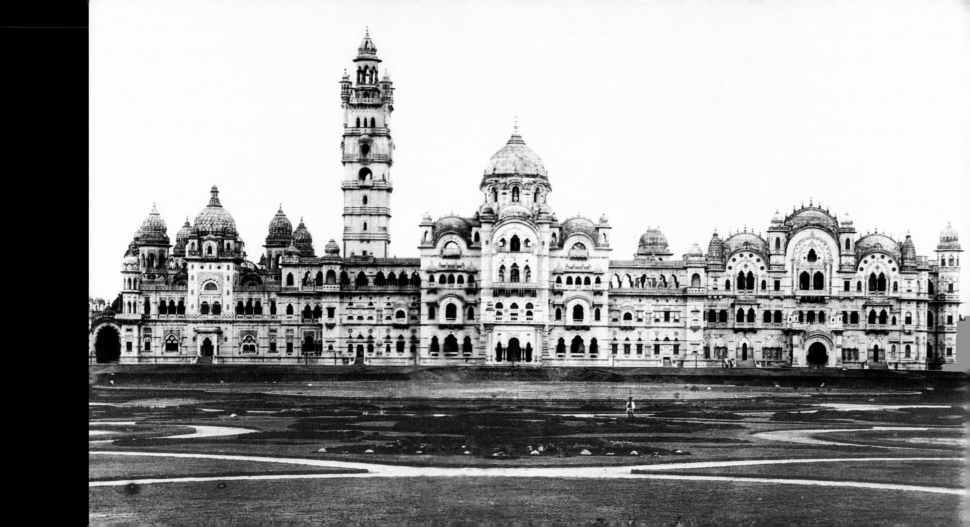

INTERIOR OF THE
DURBAR HALL AT
MYSORE, C. 1921–1922.
ARCHITECT HENRY IRWIN
DESIGNED THE PALACE
WHICH WAS THE FIRST TO
MAKE USE OF CAST-IRON
CONSTRUCTION.
COLUMNS AND ROOF
FRAMES WERE
MANUFACTURED BY
MACFARLANE'S OF
GLASGOW, THEN SHIPPED
TO INDIA. THE
OCTAGONAL KALYANA
MANDAPA OF THE PALACE
HAS A DOME OF STAINED
GLASS WITH PEACOCK
MOTIFS, AND A SPLENDID
TILED FLOOR. IN THE
AMBA VILAS (HALL OF
PRIVATE AUDIENCE), A
STAINED GLASS CEILING
FLOATS ABOVE A MASSIVE
HALL OF PAINTED
COLUMNS.

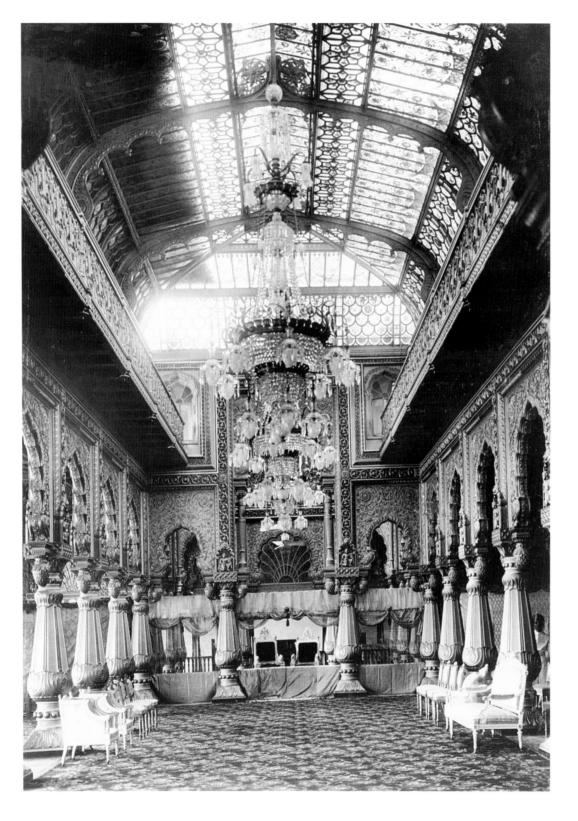

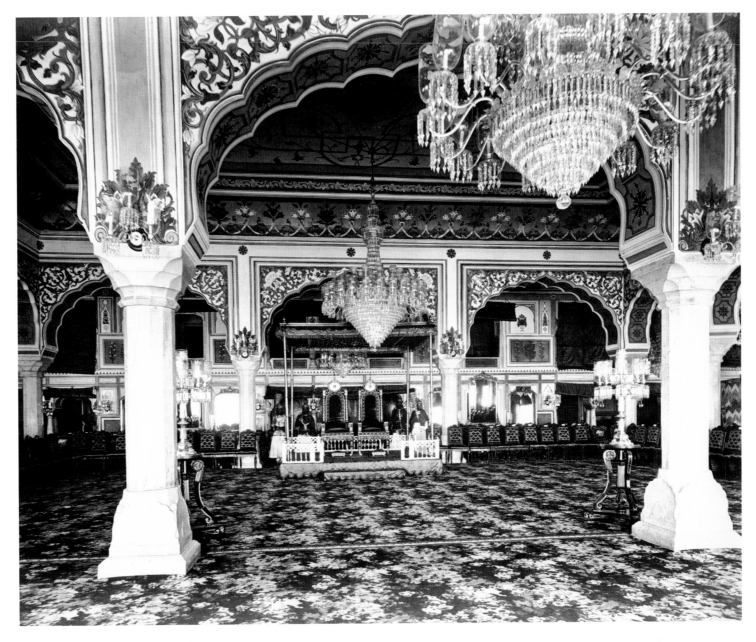

THE DURBAR THRONES IN JAIPUR, C. 1875. JAIPUR WAS ONE OF THE MOST GLAMOROUS STATES OF PRINCELY INDIA. GAYATRI DEVI RECORDS IN HER MEMOIRS THAT A STAFF OF OVER FOUR HUNDRED WAS NEEDED TO RUN THE PALACE. FOOD AND WINE WERE PROCURED FROM THE LONDON FIRM OF FORTNUM AND MASON'S. MANAGING THIS ARMY OF SERVANTS, MANY OF WHOM PILFERED FREELY, WAS A HUGE TASK. WHEN GAYATRI DEVI TOOK AFFAIRS IN HAND TO CHECK THE EXTRAVAGANT SPENDING, SHE WAS VIEWED AS A STRANGE NEW PHENOMENON—A MAHARANI WHO ASKED FOR ACCOUNTS!

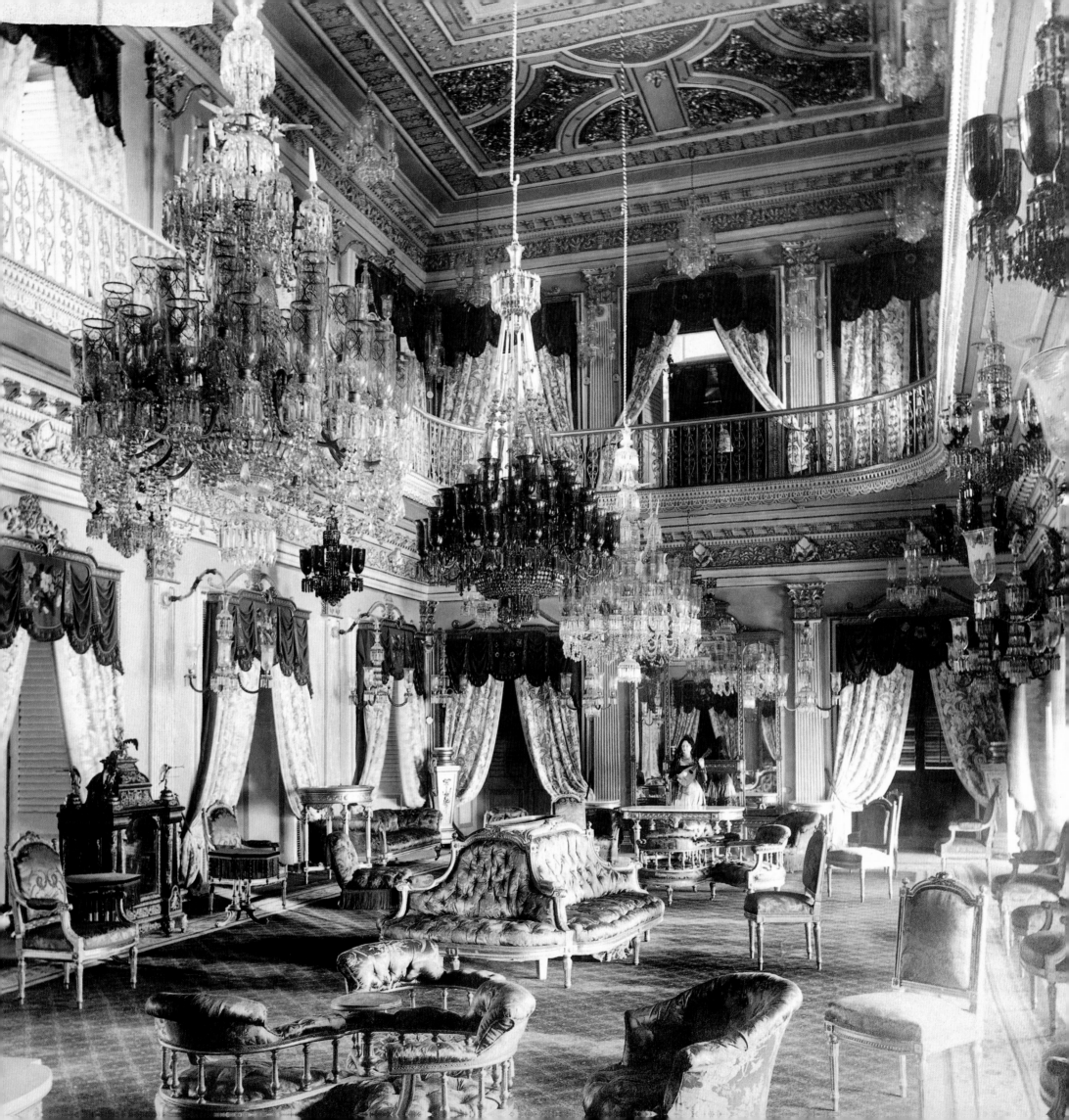

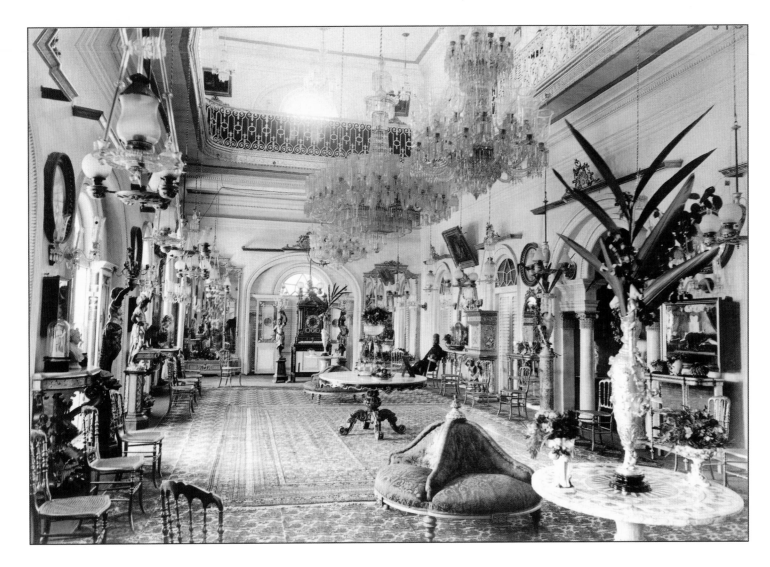

FEW PALACES IN THE
WORLD COULD MATCH
THE ORNATE INTERIORS
OF THE NIZAM'S PALACES
IN HYDERABAD. AMONG
THEM WAS THE
FALAKNUMA, LITERALLY
THE MIRROR OF THE SKY,
A GLITTERING ARRAY
OF CHANDELIERS AND
RICH TAPESTRIES. ITS
ELABORATE ROOMS AND
SUITES WERE DONE UP
IN A VARIETY OF STYLES.
THESE RANGED FROM
CLASSIC FRENCH TO
ENGLISH AND OFTEN
HAD SOME INTERESTING
ADDITIONS, MORE SUITED
TO INDIAN LIFESTYLES,
SUCH AS A SMOKING
ROOM WITH HOOKAHS.

FACING PAGE: THE
CHOWMAHELA PALACE,
HYDERABAD.

THIS THRONE IS ONE OF
THE ARTICLES OF
INTEREST IN THE
MYSORE PALACE DURBAR
HALL. THE ORIGINAL
STRUCTURE, OF FIG-
WOOD OVERLAID WITH
IVORY, IS SAID TO HAVE
BEEN SENT BY
AURANGZEB TO CHIKKA
DEVA RAJA IN 1699.
THE PALACE LEGEND,
HOWEVER, RUNS THAT IT
HAD ONCE BEEN THE
THRONE OF THE PANDUS.
AN ASCETIC REVEALED
THAT IT LAY BURIED AT
PENUGONDA TO THE KING
OF THE VIJAYNAGAR
DYANSTY. THEREAFTER,
IT WAS HANDED DOWN
FROM DYNASTY TO
DYNASTY TILL IT
REACHED THE HANDS
OF THE WODEYARS
OF MYSORE.

FACING PAGE: HAMID
MANZIL WAS THE
RESIDENCE OF THE
NAWABS OF RAMPUR.
BUILT BY NAWAB HAMID
ALI KHAN BAHADUR,
IT HAD A FANTASTIC
COLLECTION OF
PAINTINGS AND
ILLUSTRATED
MANUSCRIPTS. AMONG
ITS MANY SPLENDOURS
WAS THIS BED WITH
SILVER NYMPHS INSTEAD
OF BEDPOSTS, AND A
CURVED CANOPY. NOTICE
THE EROTIC PAINTINGS
ON THE WALL.

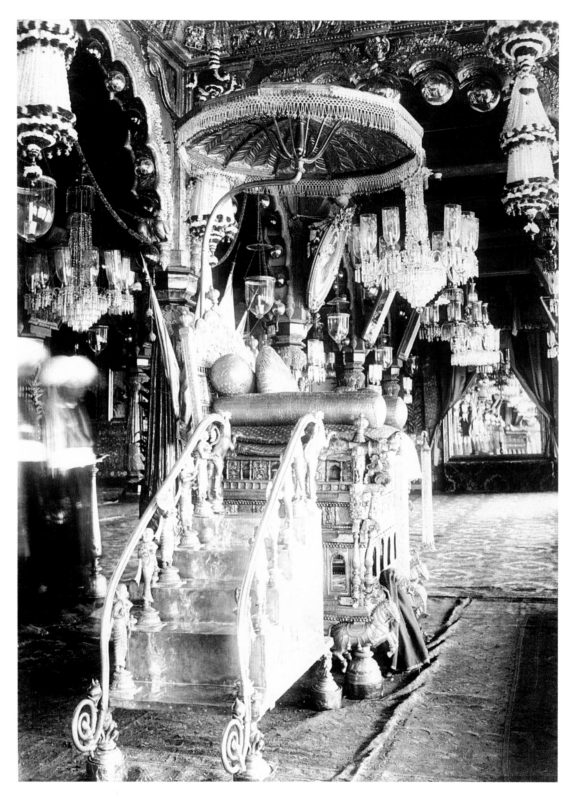

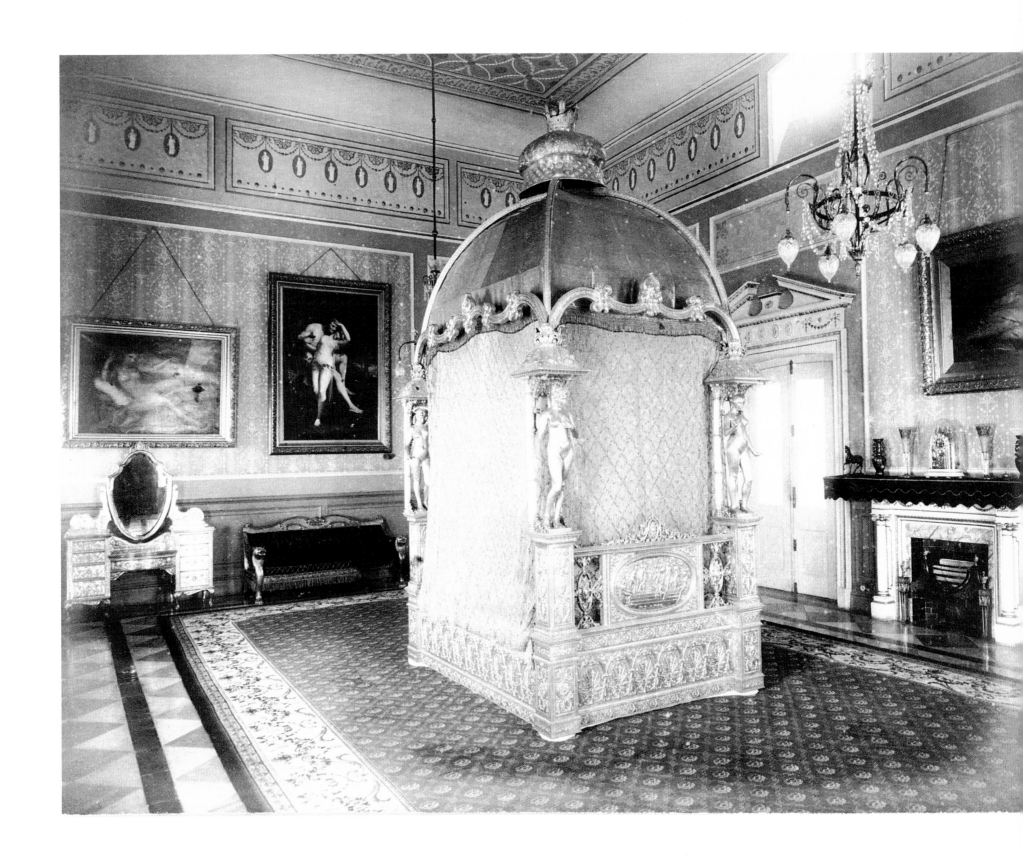

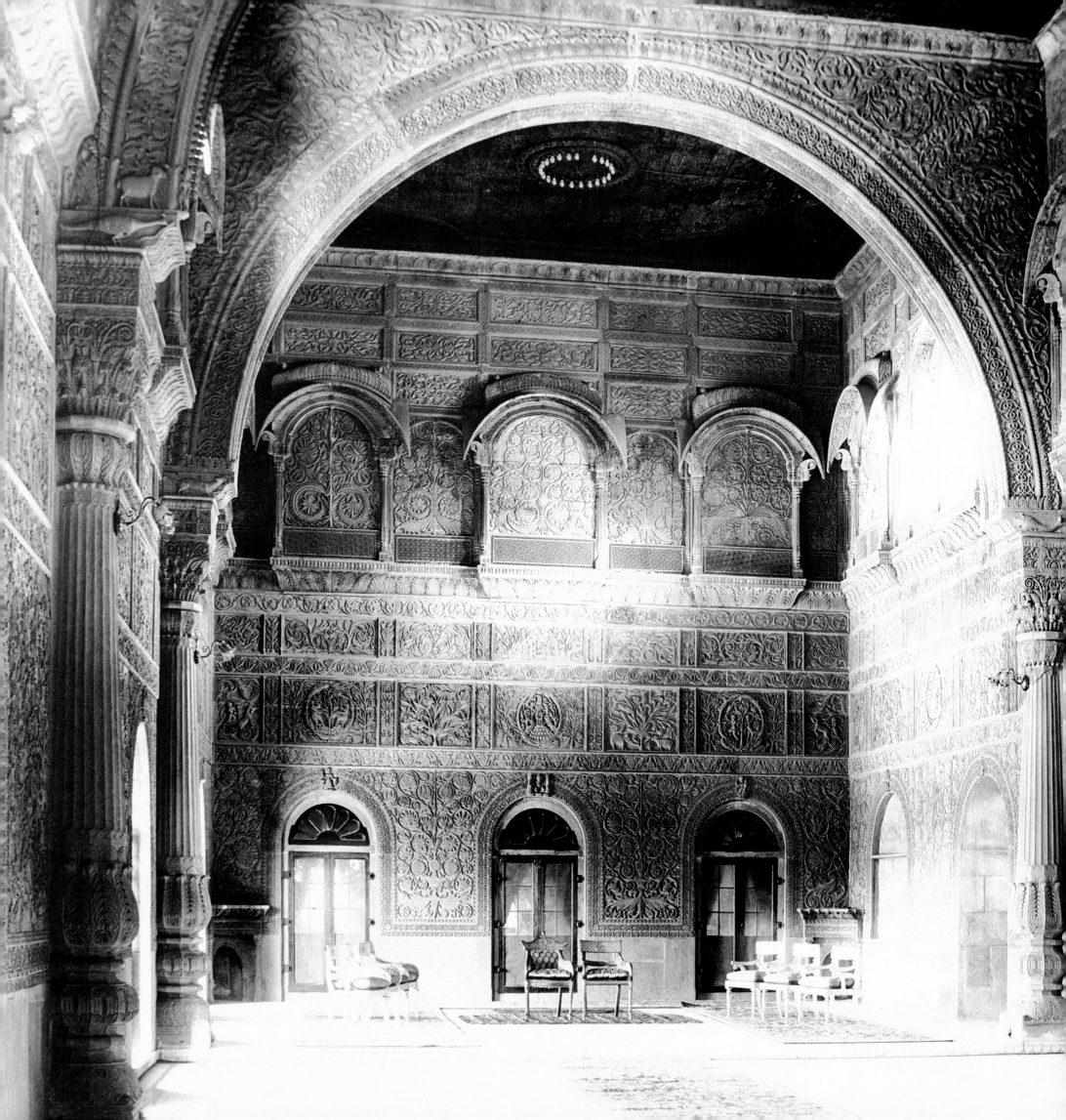

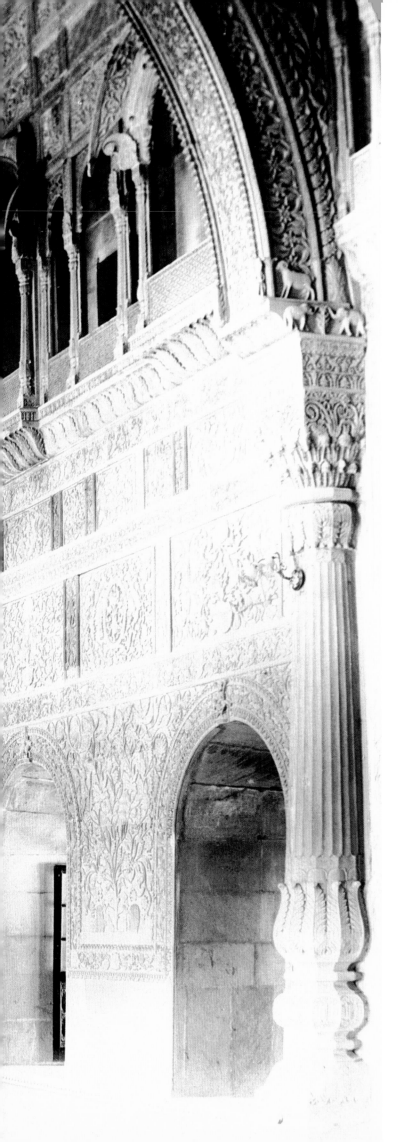

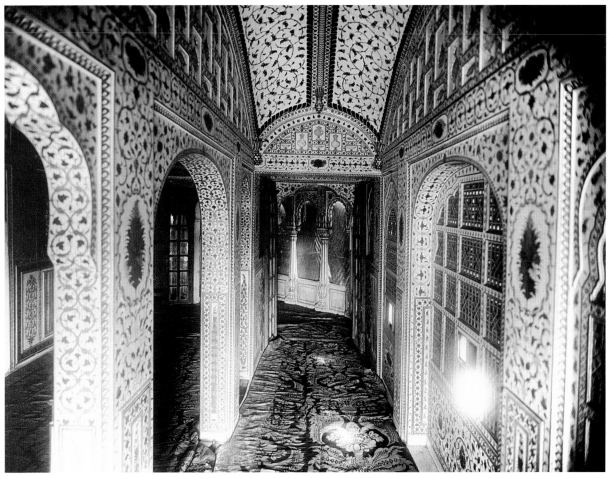

THIS PASSAGE IN THE JUNAGADH FORT IS RICHLY EMBELLISHED WITH LACQUER AND MIRROR WORK AND GOES BACK TO THE SIXTEENTH CENTURY. SUCH ORNAMENTAL WORK IS A HALLMARK OF THE ZENANA QUARTERS OF THE FORT.

FACING PAGE: LAXMI NIWAS WING OF LALGARH PALACE, BIKANER. THIS RED SANDSTONE PALACE HAS INTERIORS THAT ARE RICHLY ORNAMENTED WITH STONE CARVINGS WHILE ITS CEILING IS MADE OF APRICOT WOOD. THE ARCHITECTS OF NEW DELHI, LUTYENS AND BAKER, VISITED THIS PALACE FOR IDEAS TO INCORPORATE IN THEIR BUILDINGS.

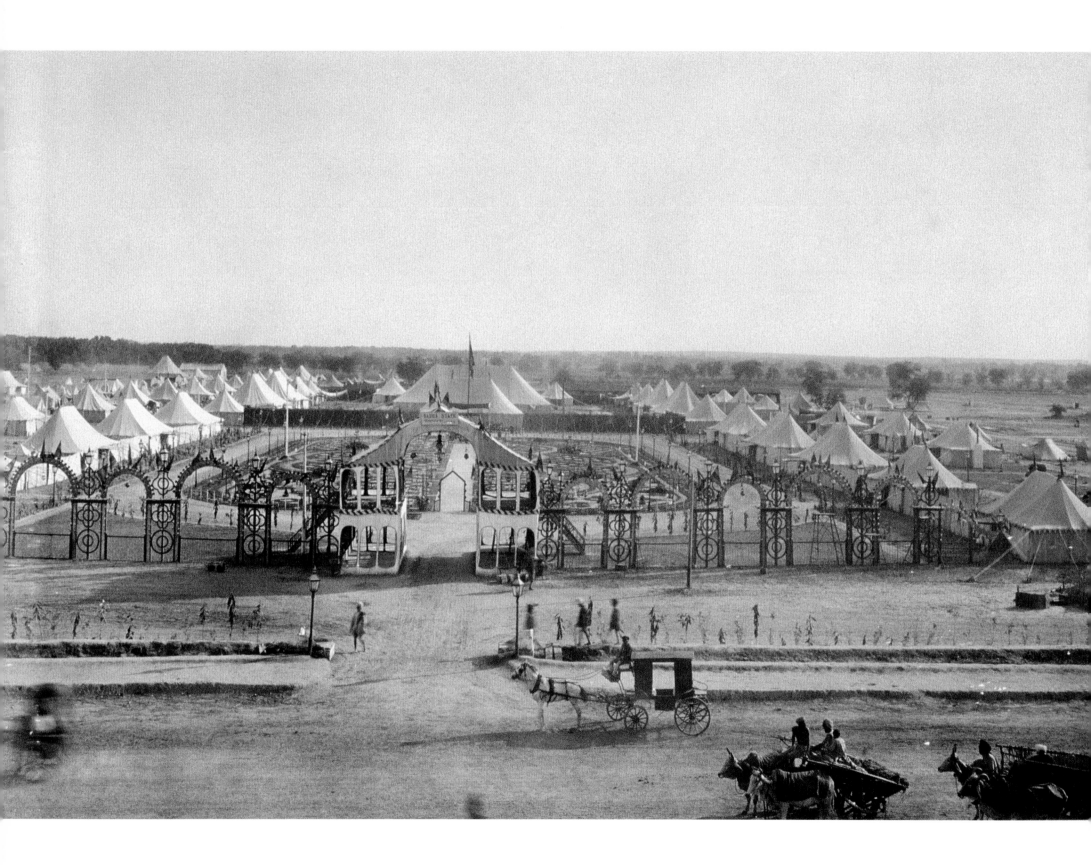

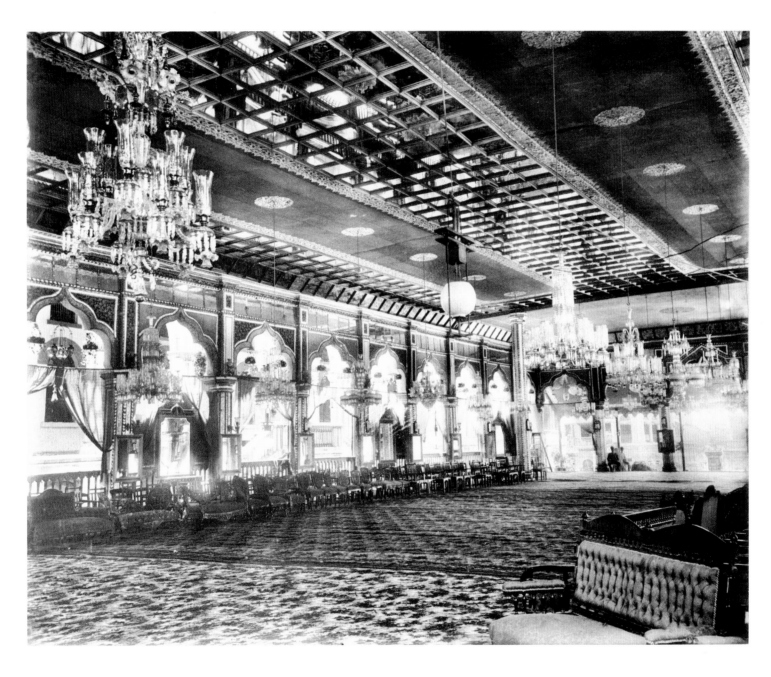

THE *MANDAPA* ERECTED FOR THE MARRIAGE OF THE HEIR APPARENT OF JUNAGADH, PRINCE SHERJAMA KHAN, C. 1900. THE MIRRORED CEILING IS DECKED WITH CHANDELIERS AND THE FLOOR COVERED WITH RICH CARPETS. INDIAN ARTISANS WERE SKILLED IN ERECTING BAMBOO SCAFFOLDINGS FOR TEMPORARY BUILDINGS. CALLED *MANDAPS* OR *SHAMIANAS*, THESE TENTED 'TOWNSHIPS' WERE CREATED TO ACCOMMODATE HUNDREDS OF GUESTS AND THEIR ATTENDANTS ON OCCASIONS SUCH AS WEDDINGS AND STATE DURBARS.

FACING PAGE: PREPARATIONS FOR THE IMPERIAL DURBAR OF 1903. THE BRITISH AIM WAS TO CELEBRATE THEIR COMING OF AGE IN INDIA IN THE STYLE OF THE IMPERIAL MUGHALS.

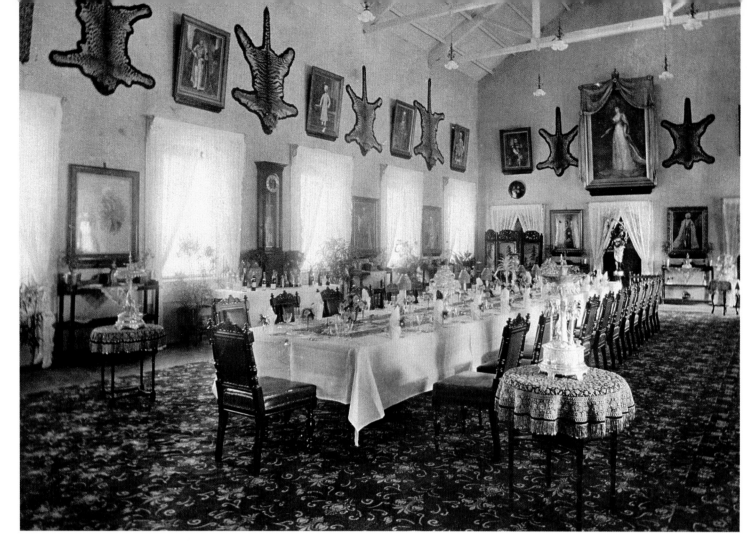

JAMNAGAR—THE
BANQUET HALL OF ONE
OF THE PALACES.
JAMNAGAR WAS ALSO
CALLED NAWANAGAR, OR
'THE NEW CITY.' THE CITY
WAS FOUNDED IN 1540.

BOTTOM: THE STUDY OR
'DEN' OF MAHARAJA
GANGA SINGH OF
BIKANER. PRIDE OF
PLACE IS GIVEN TO A
PAIR OF TIGER SKINS
ARTISTICALLY ARRANGED
OVER THE MANTELPIECE.

FACING PAGE: THE
INTERIOR OF BASHIR
BAGH PALACE,
HYDERABAD, 1892.

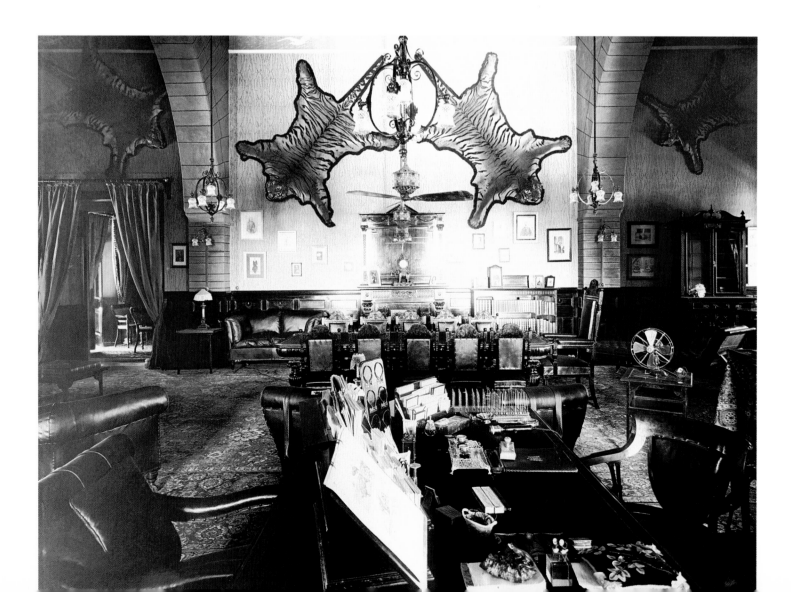

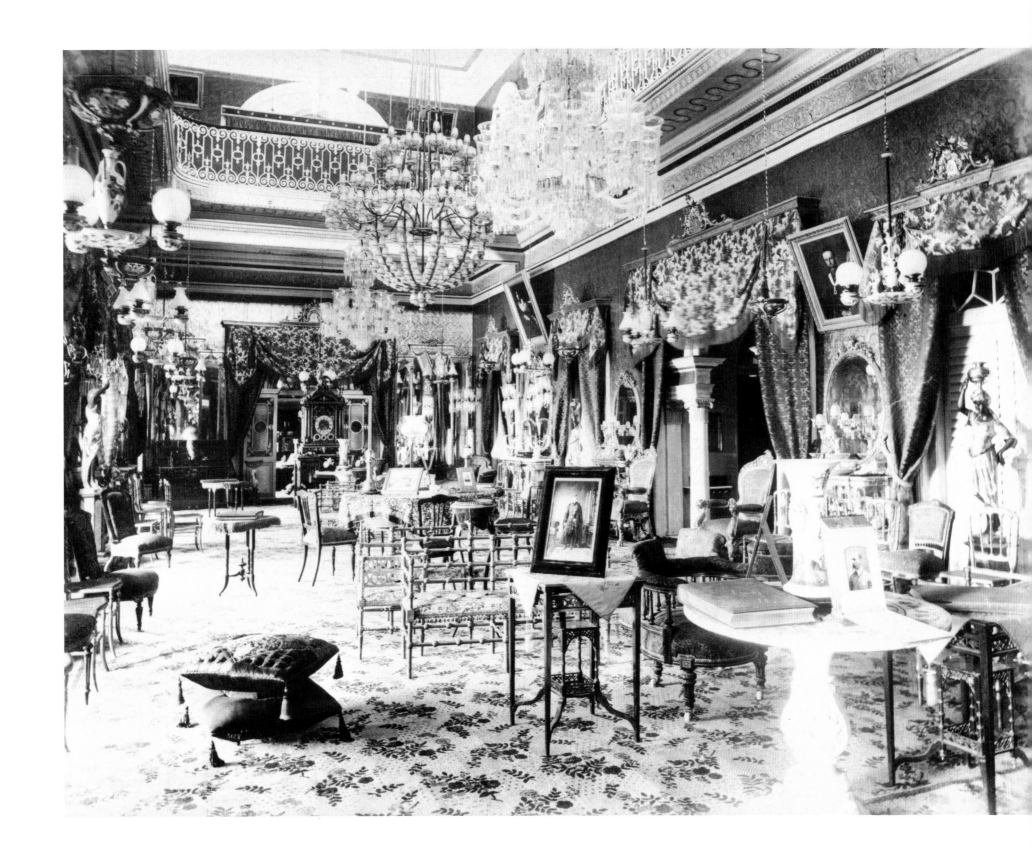

DUSSERA DURBAR AT
THE LAXMI VILAS
PALACE, MYSORE. THE
SPLENDID DURBAR HALL
OF THE PALACE WAS
RICHLY DECORATED IN
THE TRADITONAL SOUTH
INDIAN STYLE. THE
MAHARAJA SAT ON A
GOLD THRONE THAT WAS
ORIGINALLY MADE OF FIG
WOOD OVERLAID WITH
IVORY. LATER THIS WAS
PLATED WITH GOLD AND
SILVER LEAF.

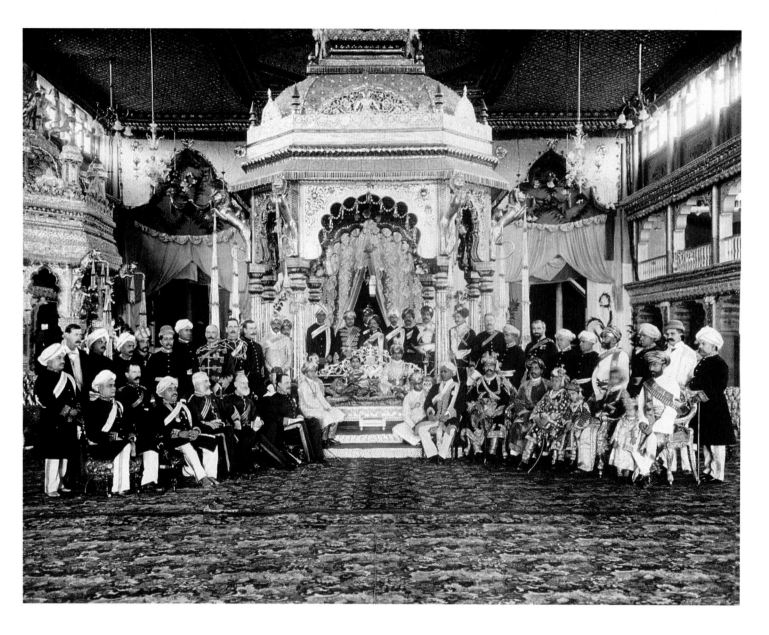

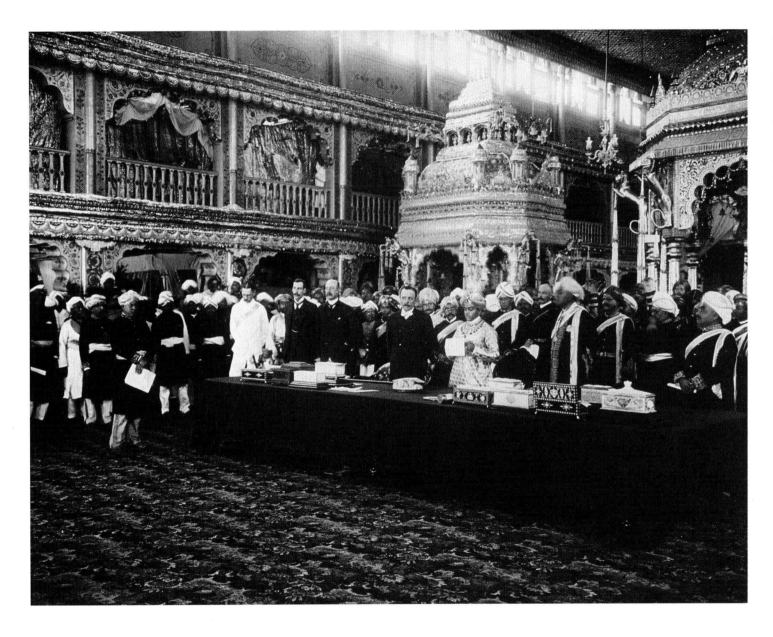

A STATE DINNER AT
MYSORE. THE WODEYARS
OF MYSORE WERE STRICT
VEGETARIANS AND THEIR
MEALS WERE PREPARED
BY ORTHODOX *LINGAYAT*
COOKS. MEAT WAS,
HOWEVER, SERVED ON
SOME OCCASIONS BUT
THE MAHARAJA WOULD
THEN REFRAIN FROM
SHARING THE 'POLLUTED'
TABLE WITH HIS GUESTS.

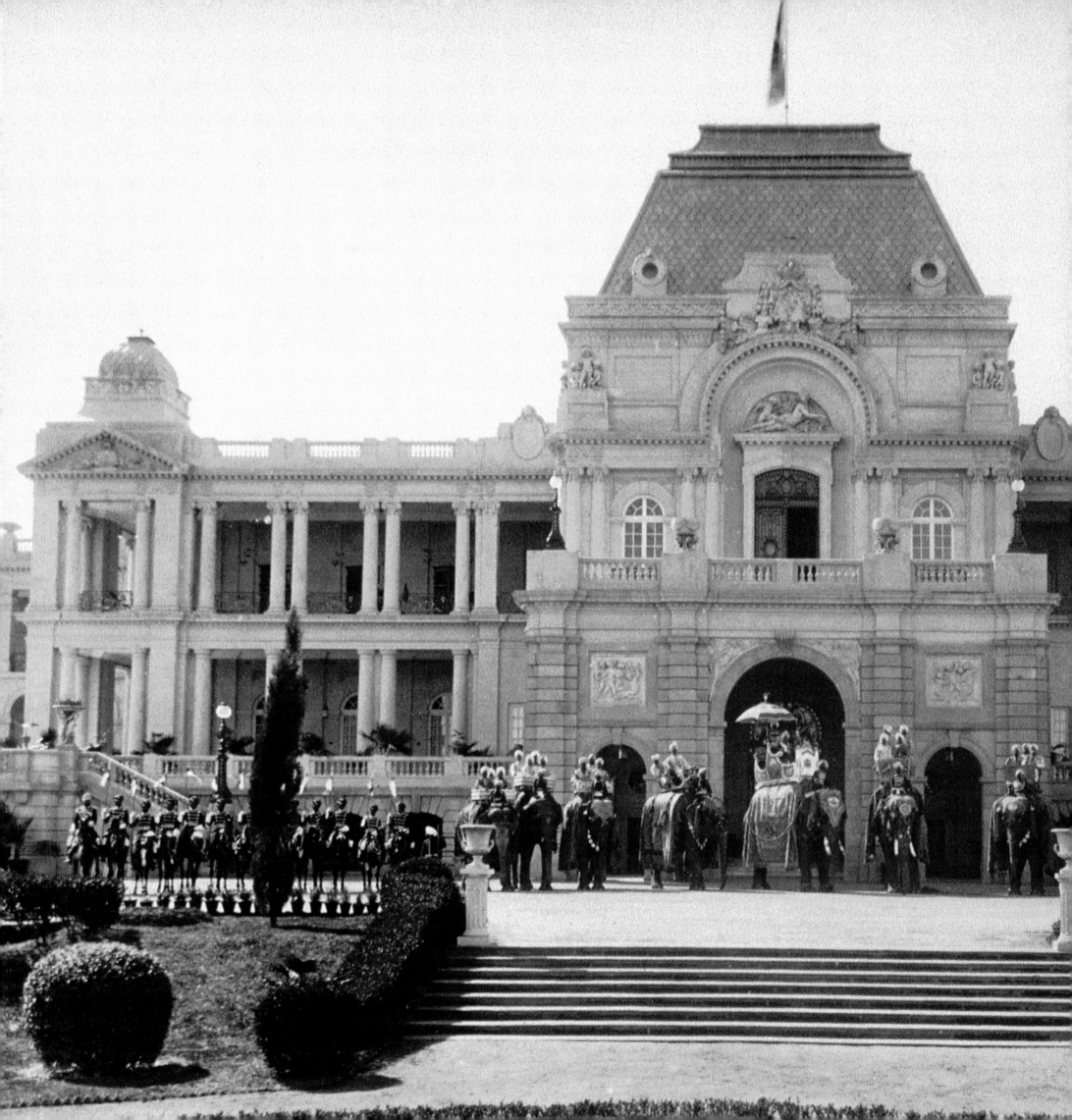

CELEBRATING
AN ERA

Indian India was a frequently used term to distinguish Princely India from 'British India'. Curiously apt, it distinguished the two halves of the subcontinent perfectly from each other for they were almost two separate worlds.

The India of ancient traditions—some going back to over a millennium—was found best in the princely states although the ceremonials varied from state to state. These ancient traditions of princely India were visible most in the celebration of festivals, birthdays and marriages, ceremonial processions and, most importantly, in the Durbars that were held from time to time. For the common people such events provided entertainment and glamour, even if it meant goggling at a pale and moist-faced political agent in his ubiquitous sola topi driving in a car.

The most important festival celebrated in the princely states was Dussera, traditionally regarded by Rajputs and Marathas as an auspicious day for the start of their winter war campaigns. In many states, brilliant processions were taken out on Dussera day. Led by a bejewelled Maharaja on a caparisoned elephant, the royal procession went through the main streets of the capital with the state's noblemen and ministers on elephants and horses, retainers with all the state insignia, followed by the state cavalry in colourful uniforms and glinting spears. Grand kettle-drums (*nakkaras*) were sounded, the sword, shield and the spear worshipped and a buffalo sacrificed by a stroke of the sword.

The most majestic of all the Dussera processions were held in Mysore, Gwalior, and Baroda. The illuminations of the palaces and

main state buildings were quite spectacular. The state of Kashmir had a different pageant consisting of a procession of stately boats on the river that meanders through the capital city, Srinagar.

Yet another splendid celebration was the Gangaur festival of Udaipur. The Maharana arrived at the beautiful Pichhola Lake on a caparisoned elephant, accompanied by the cavalry bearing the state insignia. He then boarded one of the two royal barges, each of which could seat a hundred guests, with raised platforms at the rear and front for the musicians and dancers who entertained the guests.

The Viceregal visit, an important part of British ceremonial and pageantry, evolved its own ceremonial but much of it was based on the older etiquette handed down from the time of imperial Mughal visits. The Viceroy usually arrived in a special white-and-gold train. The Maharajas of the big five states with 21 gun salutes, would receive him at their palaces. However, the other princes had to await him at the railway station, bejewelled and in ceremonial robes along with the leading nobles and ministers in Durbar dress and military officers in a blaze of uniforms. British political officers were also present on the occasion.

On the Viceroy's arrival, he and the prince would lead a procession in a carriage through the crowded main streets of the city to the Viceregal residence. Later, a reception was held at which the nobles and high officials were introduced to the visitor and perfume and betel leaves (*ittr* and *paan*) were ceremoniously offered. The Viceroy than paid a return visit to the Maharaja's palace and the same ceremonial was strictly observed.

The State banquet that followed was a glittering affair. The prince proposed a toast to the health of the Viceroy and reviewed the administration and developments of the state. The Viceroy usually offered some advice and made some political announcements. Not all visits, however, proceeded smoothly. Gwalior had a famous silver toy train that ran on silver rails round the vast dining table carrying the most delectable liqueurs for the guests The Maharaja, who was

inordinately proud of this toy, operated it himself by pressing buttons. However, during a State banquet at Gwalior for King George V and Queen Mary something went horribly wrong. The train braked suddenly right in front of the King and toppled all the liqueur into the royal lap. The King, it seems, was not amused.

Viceregal visits were also an occasion for tiger and other big game shooting, polo tournaments, and pig sticking. Shikar, a favourite royal pastime was a poor substitute for war and often used by the Maharajas to meet members of the Political Department informally. As it was always useful to have friends there, many an advantage was won for the state by organizing a shikar party for an important British officer. It has often been said, generally by the Maharajas themselves, that they were 'the greatest conservationists of game.' This is partly true, as all game was the exclusive preserve of the ruler and the leading noblemen of the state. Therefore there were only a handful of people who would shoot in the reserved hunting grounds. Despite the Maharajas competing to bag 500 or 1000 tigers each, no species was endangered then and the tiger population actually grew.

Of all the pageantry associated with the princely states, the royal Durbar was without doubt the grandest. Durbars were held to mark an official occasion such as the birthday of the Maharaja, his accession and the assumption of powers on coming of age, and festivals. The main purpose of this was to provide the public, as well as the nobles and state officials an opportunity to declare their allegiance and loyalty to the ruler. Held in India from about the sixteenth century on, Durbars were probably introduced by the Mughal Emperors who considered them a crucial part of state ritual and necessary for the conduct of state business. The great durbar halls of the palaces, hung with shimmering chandeliers and rich tapestry, provided a scene of true oriental splendour. In the more opulent states these halls were big enough to hold about a thousand people.

Durbar procedures and etiquette worked out over centuries to the minutest detail, were scrupulously followed

and became not just an opportunity to display the wealth and pomp of a ruler but a means to overawe both the participants and the general public. Outside the palace stood lines of painted and caparisoned elephants, and bodyguards on horseback in brilliant uniforms.

The Maharaja would arrive at an auspicious hour determined by the court astrologer, resplendent in brocade and jewels, heralded by trumpets and ushered in by courtiers and retainers holding various symbols of kingship. These included gold and silver maces, emblems and insignia atop tall poles, peacock feathers and yak tails in embossed silver handles. The royal umbrella (*chattri*) was sometimes held over the ruler's head. The throne (*gaddi*) varied from a raised cushion covered with gold cloth on which he sat cross-legged, to a carved gold or silver throne.

The assembly of noblemen and officials would be magnificently turned out as well. Dressed usually in an *angarkha*, a long coat worn over *churidar* pajamas, they were required to carry their swords. The headgear varied from state to state, but was always colourful. In the Rajasthani states, it was the nine-yard long turban (*safa*) or the narrower and much longer *pagri*. In the Maratha states, it was the red *shindeshahi*, three cornered *pagri*, worn at a dashing slant and hung with ropes of pearls. The hall was a sea of turbans and *pagris*, brilliant tied and dyed stripes or solid yellow, red and blue or a spectacular magenta pink. In Hyderabad, courtiers wore distinctive caps called *dastars*.

The assembly usually sat on the cushioned and well carpeted floor with both legs tucked on the right side and the sword resting free on the left. The seating in the hall was strictly in keeping with the hierarchy of the nobles of the respectful state: the *Jagirdars* and *Sardars* sat in the front row closest to the Maharaja. In other Durbars, chairs were arranged for the courtiers (*darbaris*) in long lines along the sides of the hall.

Gun salutes were fired as soon as the Maharaja sat on the *gaddi*. The *darbaris* would then approach the ruler individually to pay homage and obeisance. They would bow low, salute three times and present a ceremonial offering (*nazar*) of a gold or silver coin on a white silk handkerchief, which the ruler would touch lightly. They would then retire backwards, as no courtier could turn his back to the ruler.

The women and children of the palace would watch this spectacle from the balconies provided above the main hall, from behind bamboo screens (*chiks*). The presentation of *nazar* was followed by a speech or presentation of awards by the ruler. Finally, the ruler would rise and mingle with the crowd. Court musicians provided the music and perfume and betel leaf (*ittr-paan*) were offered. Beautifully wrought and carved silver flagons (*gulab pash*) were used to lightly sprinkle rose water on the audience. The ruler would then depart accompanied by the family and retainers.

In the outlying district headquarters of the larger states, Durbars were occasionally held on important state occasions, although the ruler could not be present. A marquee (*shamiana*) would be erected to substitute the durbar hall and the whole formal procedure and presentation of *nazar* took place in front of the ruler's portrait. This ensured that the subjects in the distant districts could pay homage and so get a sense of participation despite the absence of the Maharaja.

Surely, the most unique Durbar was the kind held by His Highness Sir Sayyed Mohammad Hamid Ali Khan Bahadur (1875-1930), the Nawab of Rampur, The Nawab preferred to hold an 'unofficial durbar' in a large, well-appointed bathroom. Perhaps a permanent victim of irritable bowel syndrome, he had his chief engineer specially design his toilet seat, not only for comfort, but to give the impression that he was formally enthroned. He spent part of the day dispensing justice and advice from this unique 'throne'.

A Luncheon being held at Sultanpur Lodi, February 1941. (*LEFT TO RIGHT*): Raja Sir Daljeet Singh of Kapurthala, Sir Joginder singh, Maharajkumar Ajit Singh of Kapurthala, Raja Bhalindra Singh of Patiala, Tikka Raja paramjit SIngh of Kapurthala, maharajadhiraj Yadavindra SIngh of Patiala, Maharaja Jagatjit SIngh of Kapurthala, Raja Ravi Singh of Kalsia, Maharajkumar Amarjit Singh of Kapurthala, Raja Pratap Singh of Patiala, Kunvar Jasjit Singh of Kapurthala, Kunvar Sahib of Khairagarh, and A guest.

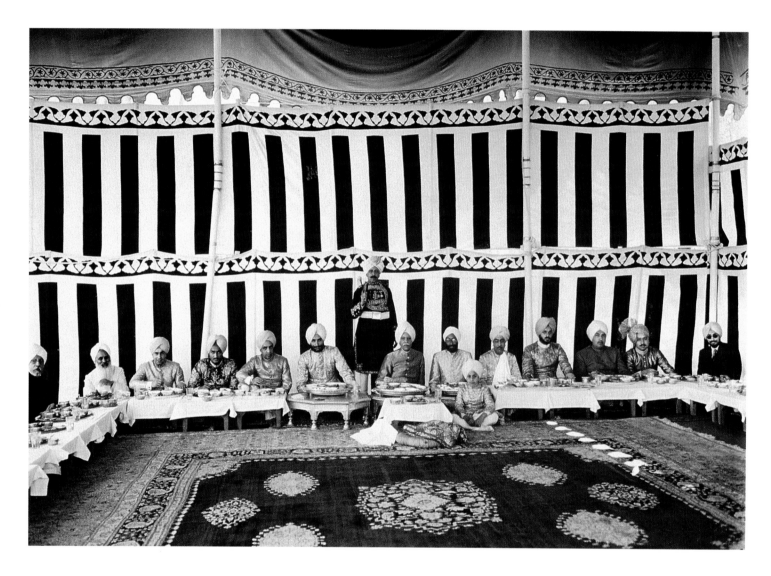

162

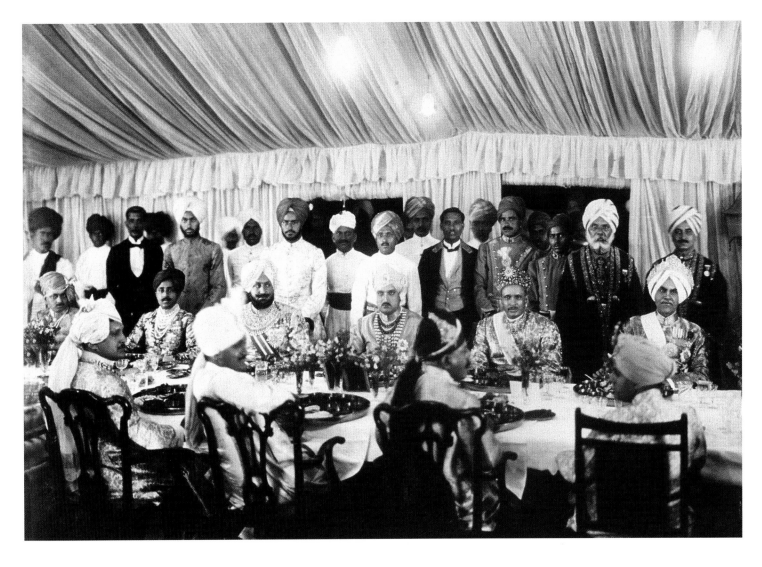

A CORONATION DURBAR
BANQUET TO MARK THE
ACCESSION OF HIS
HIGHNESS HARI SINGH
OF KASHMIR, JAMMU,
C. 1926. (*SEATED RIGHT
TO LEFT*): MAHARAJA
JAGATJIT SINGH OF
KAPURTHALA, THE
MAHARAJA OF ALWAR,
MAHARAJA OF KASHMIR
HARI SINGH, AND
MAHARAJA BHUPINDAR
SINGH OF PATIALA.
(*RIGHT TO LEFT*): WITH
THEIR BACKS TO THE
CAMERA, PARAMJIT
SINGH AND THE NAWAB
SAHEB OF PALANPUR
AMONG OTHERS.

THE *TULA DAAN*
CEREMONY OF MAHARAJA
GANGA SINGH OF
BIKANER (B. 1880;
R. 1887-1943) ON HIS
GOLDEN JUBILEE.
THE *TULA DAAN* IS A
TRADITIONAL RITUAL
SAID TO CONFER
GREAT MERIT TO THE
BENEFACTOR. DURING
THIS CEREMONY, THE
RULER IS ACTUALLY
WEIGHED AGAINST GOLD
AND SILVER COINS. FOR
THIS EVENT, A PAIR OF
LARGE SCALES WAS SET
UP IN A BEAUTIFUL
SANDSTONE PAVILION,
WHICH STILL STANDS IN
THE GROUND OF THE
LALGARH PALACE. GOLD
TO THE VALUE OF 3,021,
915 RUPEES WAS
BALANCED AGAINST THE
MAHARAJA'S WEIGHT
OF 14 STONES AND 8
POUNDS. THEN, THE
CASH EQUIVALENT OF
THE GOLD AND OTHER
SUMS OF MONEY WERE
DONATED TO THE
GOLDEN JUBILEE FUND,
AND USED FOR CHARITY
WITHIN THE STATE. THE
MAHARAJA'S WORKS
WERE NO LESS
MERITORIOUS. IN 1899-
1900, WHEN A FAMINE
RAVAGED THE BIKANER
REGION, HE TOOK
CHARGE OF RELIEF WORK
TO BRING CANALS TO THE
DESERT REGION. THE
MAHARAJA ESTABLISHED
AND SPONSORED THE
BHAKRA NANGAL
PROJECT, THAT PROVIDES
RELIEF TO THIS DESERT
AREA TILL TODAY.

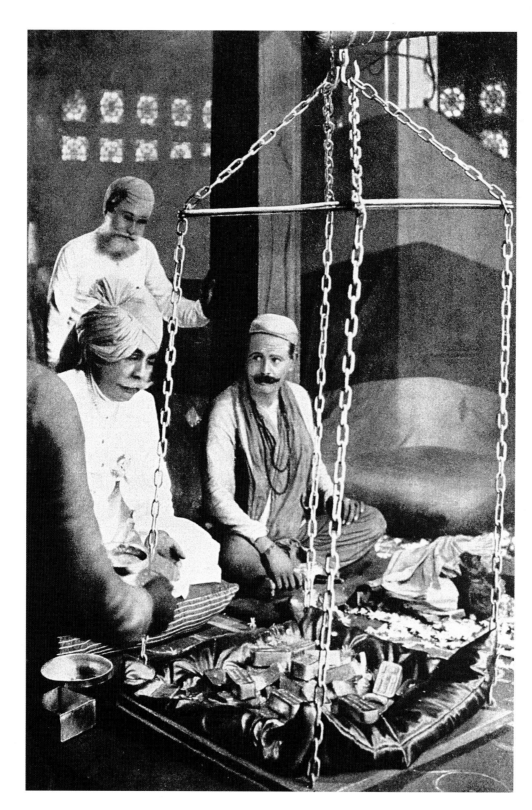

FACING PAGE:
MAHARAWAL SAHAB
LAKSHMAN SINGH OF
DUNGARPUR AT A PUBLIC
TULA DAAN. DUNGARPUR
CLAIMS DESCENT FROM
THE SENIOR BRANCH OF
THE SISODIA CLAN OF
THE RAJPUT HOUSE
OF MEWAR. LEGENDS
ASSOCIATED WITH
THE FOUNDING OF
DUNGARPUR RELATE
THE DISCORD CREATED
BETWEEN THE RANA OF
MEWAR AND HIS ELDEST
SON, SAMANT SINGH.
THE SON WAS TO BE
MARRIED AND THE
AUSPICIOUS COCONUT
WHICH HAD TO BE
ACCEPTED BY THE
BRIDEGROOM WAS
MISTAKENLY ACCEPTED
BY THE FATHER. THE
HEIR-APPARENT INSISTED
THAT THE RANA MARRY
THE GIRL AND LEFT THE
STATE. THE SON BORN
OF THIS MARRIAGE
SUCCEEDED MEWAR
WHILE SAMANT SINGH
ESTABLISHED HIS
KINGDOM AT DUNGARPUR.
ACCORDING TO ANOTHER
LEGEND, SAMANT SINGH
WILLINGLY GAVE UP HIS
THRONE FOR THE
YOUNGER BROTHER WHO
HAD SAVED HIS LIFE IN
BATTLE.

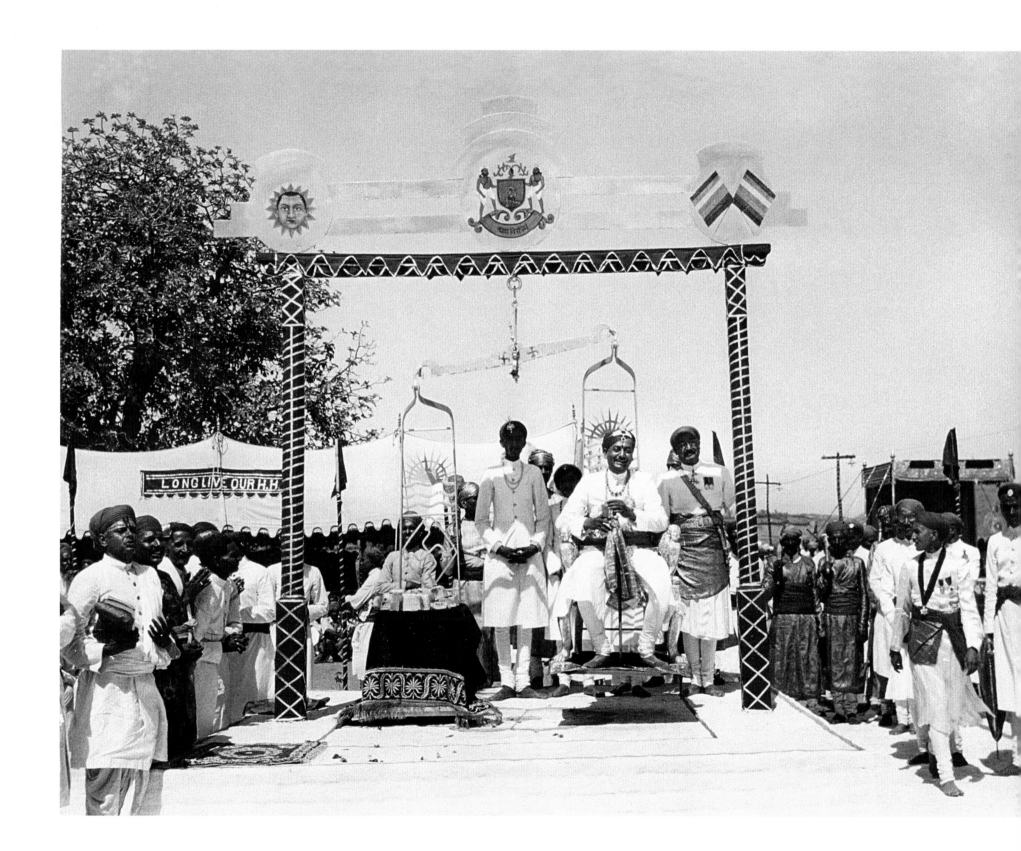

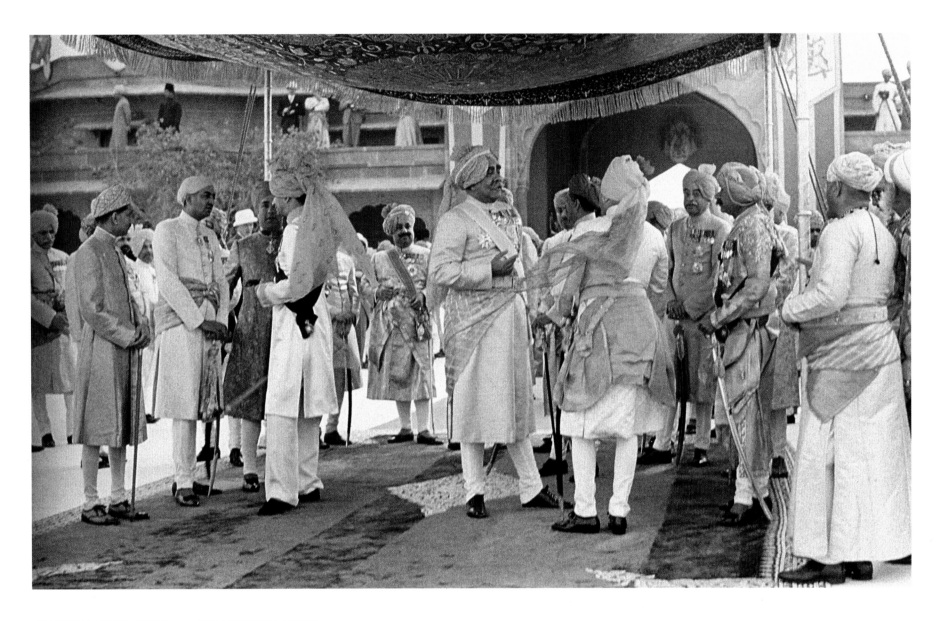

MAHARAJA GANGA SINGH
OF BIKANER AT THE
WEDDING OF HIS GRAND-
DAUGHTER, PRINCESS
SUSHILA KUMARIJI TO
MAHARAJKUMAR
BHAGWAT SINGHJI OF
UDAIPUR, SON OF
MAHARAJA BHOPAL
SINGH, MAY 1939.

THIS WEDDING, WHICH
BROUGHT TOGETHER TWO
OF THE MOST IMPORTANT
RAJPUT STATES, WAS
WIDELY REGARDED AS
ONE OF THE LANDMARK
OCCASIONS OF ITS TIME.

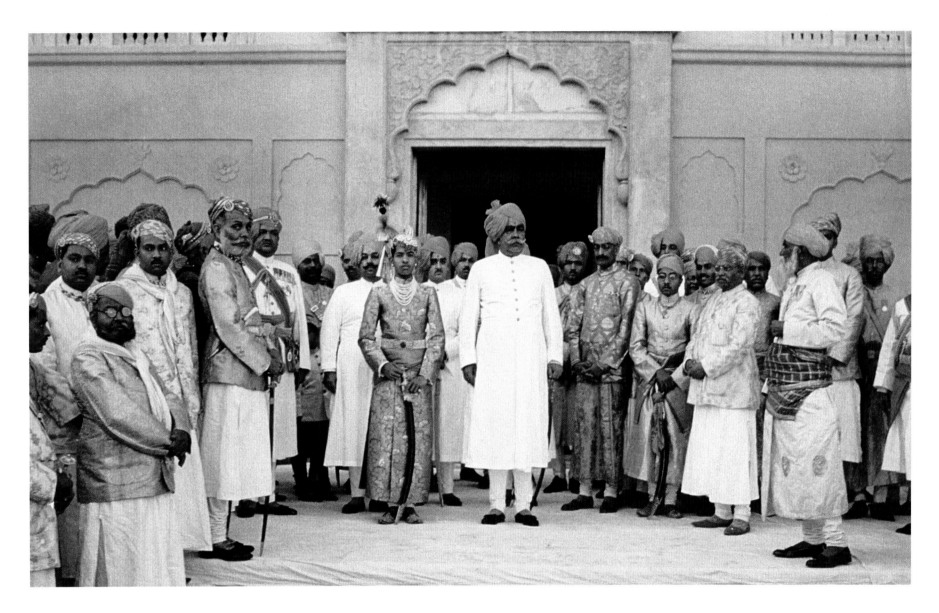

INDIAN MARRIAGE CEREMONIES BRING COMMONERS AND THE ROYALS TOGETHER. NO ONE CAN FAIL TO BE MOVED BY THE OPULENCE, AND FRENETIC PREPARATIONS. TRADITIONALLY, AN INDIAN BRIDE LEAVES HER HOME AND FAMILY AND IS ADOPTED INTO HER HUSBAND'S HOME, WHICH SHE CONSIDERS HER OWN FOREVER. SUSHILA KUMARIJI, THE PRINCESS OF BIKANER, BROKE DOWN WHEN IT WAS HER TIME TO LEAVE HER FAMILY. AS A TRAIN WAITED TO TAKE THE WEDDING PARTY TO UDAIPUR, THE PRINCESS ASKED TO SEE HER OLD ENGLISH NANNIE, MRS DENT. THE TRAIN WAITED FOR A FULL 20 MINUTES WHILE A CAR FETCHED MRS DENT TO THE RAILWAY STATION. IT LEFT ONLY AFTER THE PRINCESS HAD TAKEN LEAVE OF HER BELOVED NANNIE, WHO LATER LOOKED AFTER SUSHILA KUMARIJI'S CHILDREN.

PRINCE KARNI SINGH OF BIKANER RIDES TO HIS WEDDING IN A CEREMONIAL PROCESSION (1944). HIS WEDDING TO A PRINCESS FROM DUNGARPUR WAS CELEBRATED WITH GREAT FANFARE. THE BRIDE'S PALACE, AN EIGHTEENTH-CENTURY EXTRAVAGANZA, WAS BUILT OF THE GRANITE QUARRIED IN THE STATE. THE GROOM IS ACCOMPANIED ONLY BY MEN AS RAJPUT WOMEN PRACTISED STRICT PURDAH AND COULD NOT UNVEIL THEMSELVES. THE BRIDE WAS GIVEN A LAVISH DOWRY THAT INCLUDED A VAST RETINUE OF PERSONAL MAIDS WHO ACCOMPANIED THEIR ROYAL MISTRESS TO HER NEW HOME. KARNI SINGH, A RENOWNED SHOT, LATER REPRESENTED INDIA AT THE OLYMPIC GAMES AND WAS THE CHAIRMAN OF THE INDIAN OLYMPIC COMMITTEE.

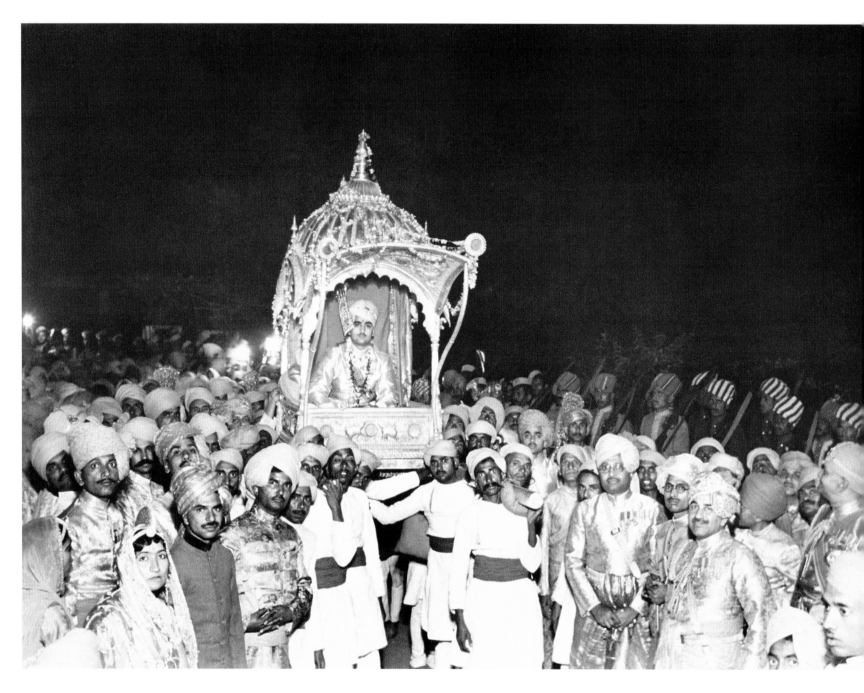

THE WEDDING
PROCESSION OF A
RAJPUT PRINCE. THE
ROYAL GROOM IS SEATED
ON THE CEREMONIAL
HOWDAH ATOP A RICHLY
CAPARISONED ELEPHANT.
AMONG THE ATTENDANTS
IS A MUSICIAN WHO
CARRIES HIS STRINGED
INSTRUMENT AND A
WOMAN WHO CARRIES A
SILVER PLATTER (*THALI*)
TO STREW ROSE PETALS
ON THE WAY.

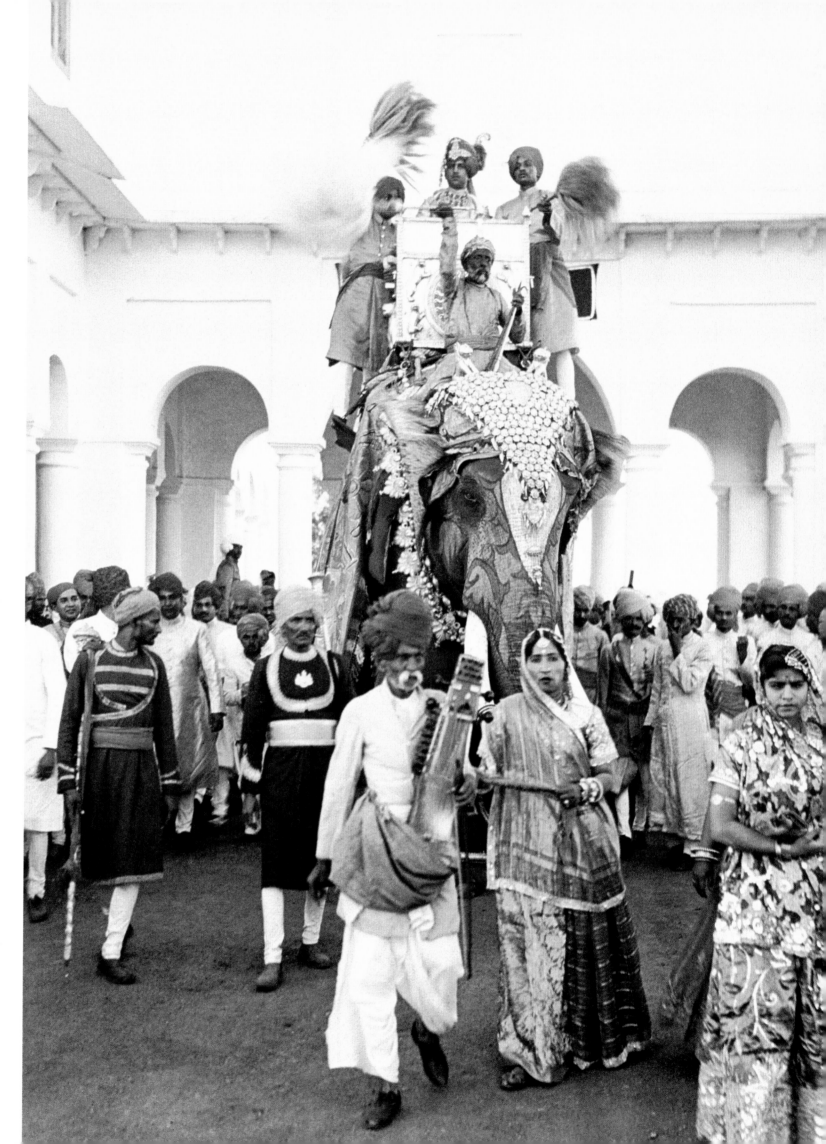

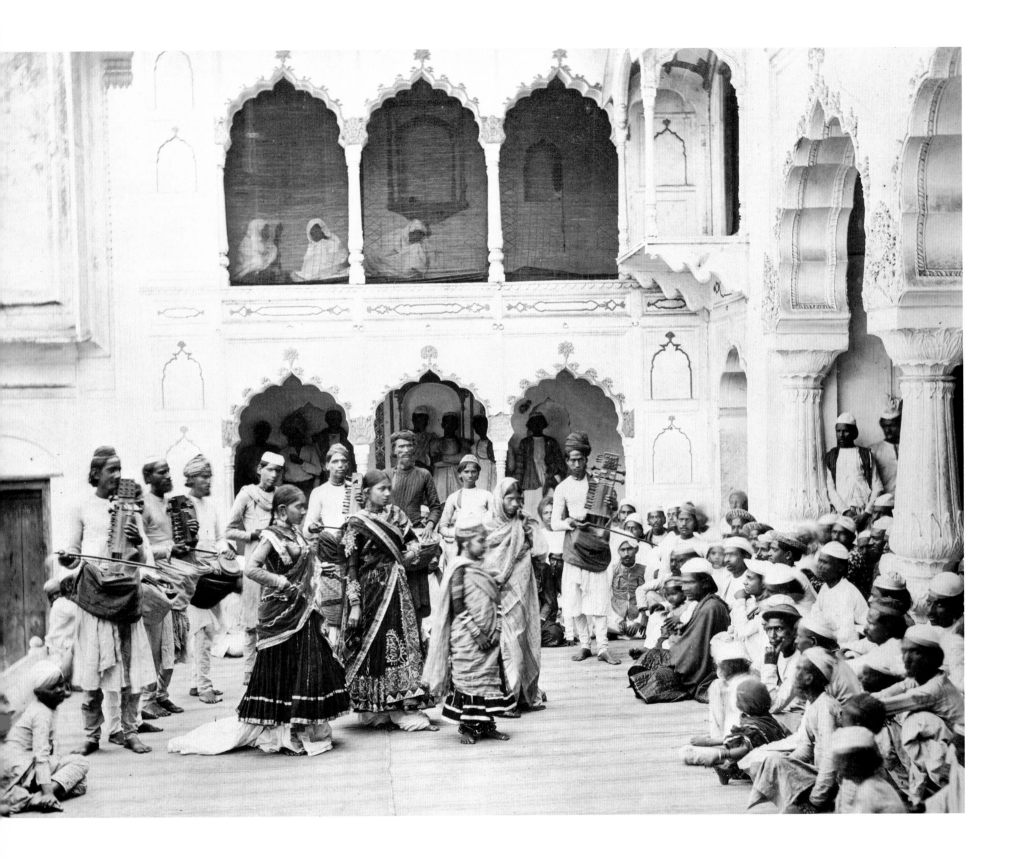

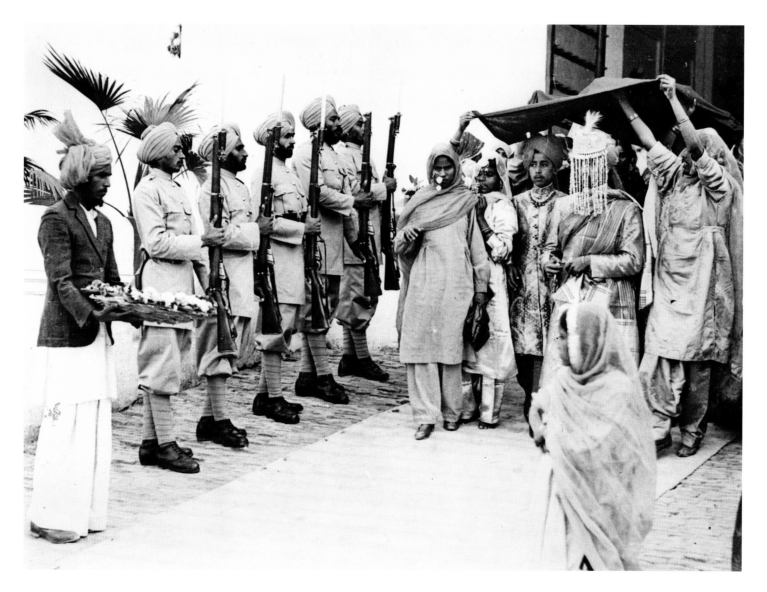

THE WEDDING OF THE PRINCE AND HEIR OF JIND, ON 7 FEBRUARY 1939. YUVRAJ RAJBIR SINGH MARRIED THE DAUGHTER OF NAWAB SARDAR UMRAD SINGH, THE CHIEF OF MANAULI AT SANGRUR. THE BRIDEGROOM, SURROUNDED BY ATTENDANTS, IS SEEN HERE LEAVING HIS PALACE TO ATTEND THE MARRIAGE DURBAR.

FACING PAGE: SINGERS AND NAUTCH DANCERS ENTERTAINING IN A PALACE COURTYARD IN JAIPUR (C. 1875). BEHIND BAMBOO SCREENS ARE THE LADIES OF THE ZENANA IN PURDAH. THE ZENANA WAS AN EXCLUSIVE, LADIES-ONLY ZONE WHERE THE ROYAL LADIES LIVED WITH THEIR CHILDREN AND WHERE THE MAHARAJA WAS OCCASIONALLY ENTERTAINED.

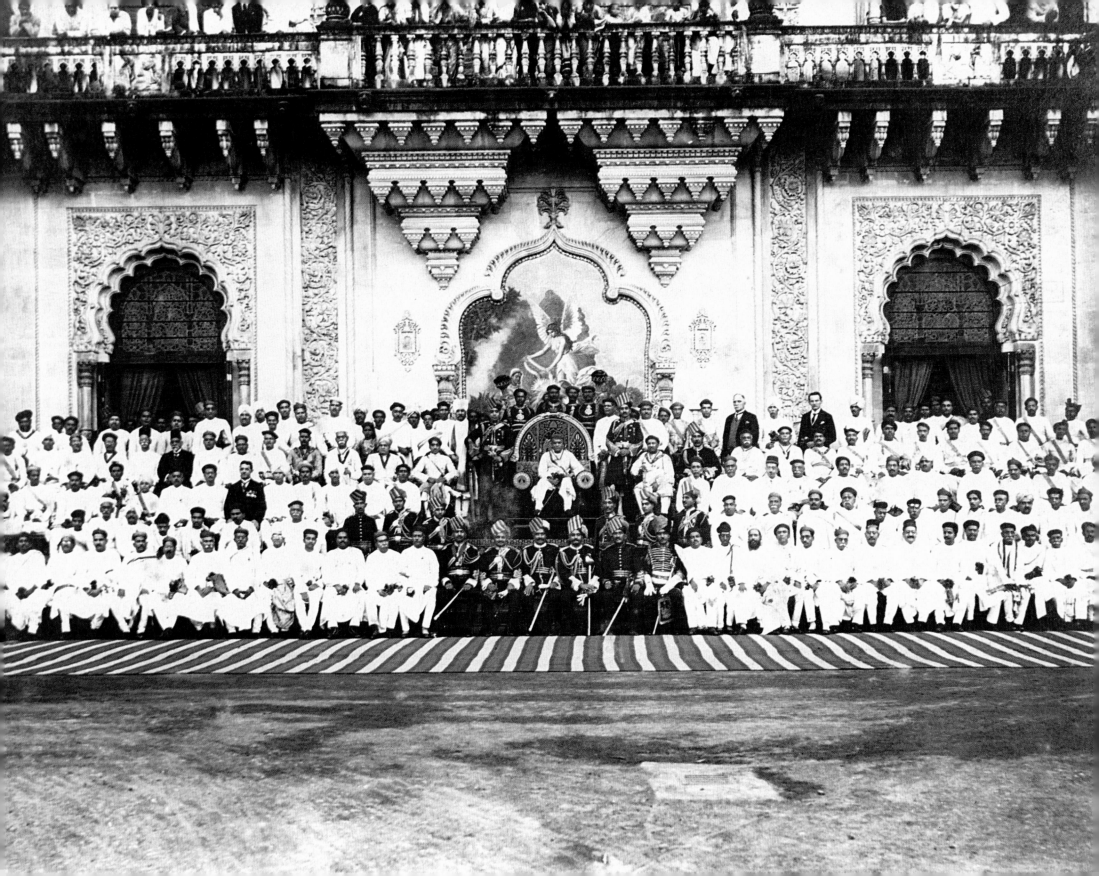

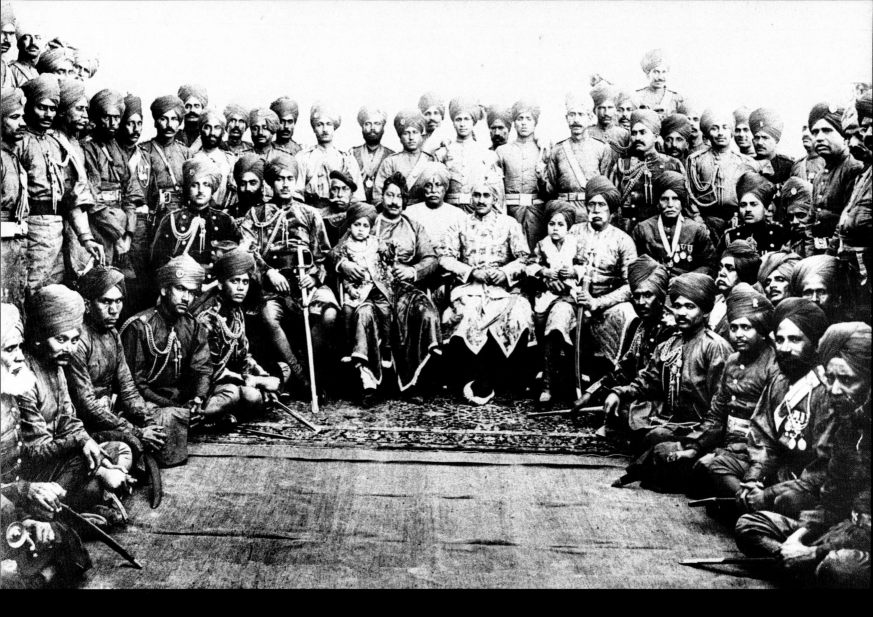

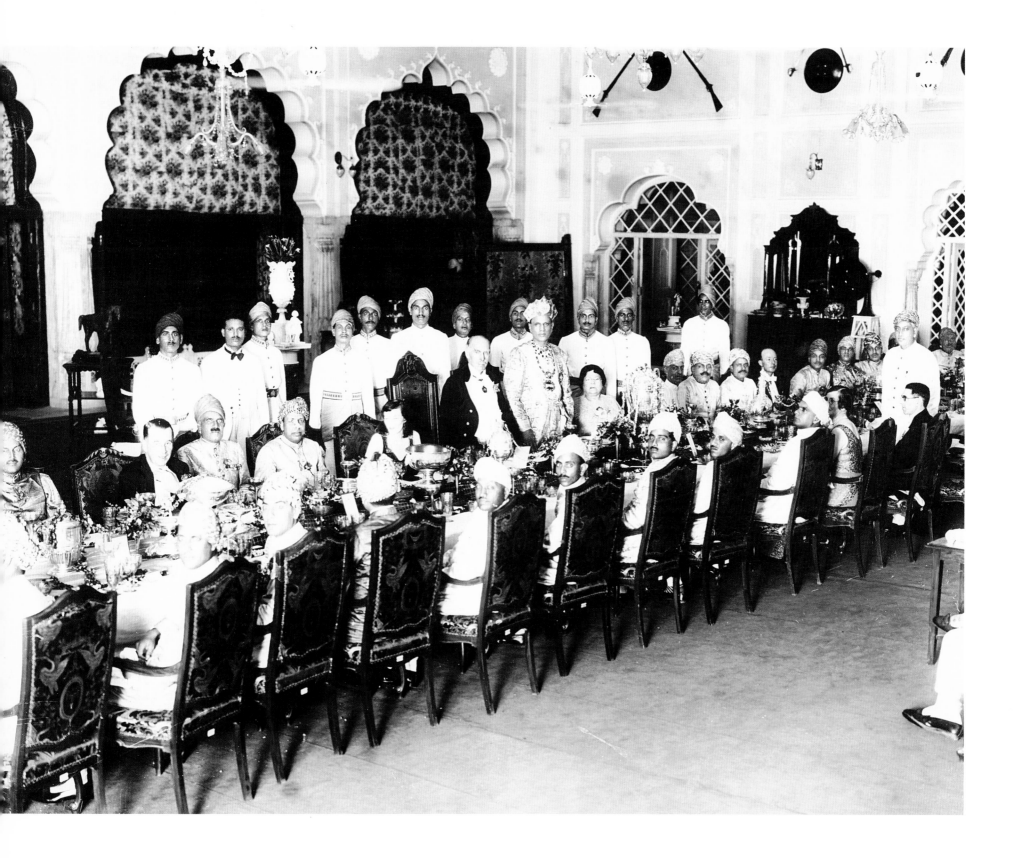

174

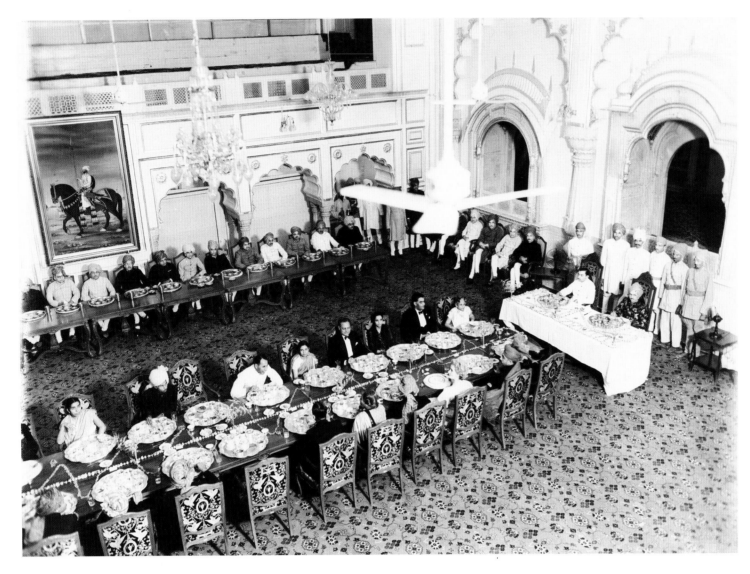

BANQUETS AND DINNERS WERE AN IMPORTANT PART OF STATE VISITS AND GREAT CARE WAS TAKEN TO PLEASE EUROPEAN GUESTS. SIT-DOWN MEALS WERE A LATER ADDITION TO ROYAL PARTIES, AS THE TRADITIONAL INDIAN METHOD OF SERVING FOOD WAS DIFFERENT. LARGE PLATTERS (THALIS) MADE OF GOLD AND SILVER INSTEAD OF CHINA PLATES, WERE THE ONLY RELICS OF AN EARLIER AGE IN THIS BANQUET. THE GUESTS LATER SIGNED THE MENU (BELOW). AMONG THEM WAS LORD WAVELL, THE GOVERNOR-GENERAL.

FACING PAGE: A STATE BANQUET IN ALWAR. THE STATE RENOWNED FOR ITS SHIKAR PARTIES WAS OFTEN THE VENUE OF GLITTERING DINNERS.

A MENU FOR ONE OF THE DINNERS AT THE PALACE IN BHARATPUR. A FRUIT COCKTAIL, FRIED POMFRET, PLAT DE BHARATPUR, HAM, CHICKEN, VENISON, SALAD, FRUIT COMPOTE ARE TOPPED BY CHEESE, COFFEE, AND DESSERT.

MAHARAWAL SAHAB
LAKSHMAN SINGH OF
DUNGARPUR RIDING AN
ELEPHANT THROUGH THE
STREETS. DUNGARPUR
CLAIMS DESCENT FROM
THE SENIOR BRANCH OF
THE SISODIA CLAN OF
THE RAJPUT HOUSE
OF MEWAR.

FACING PAGE: THE GRAND
WEDDING PROCESSION OF
DUNGARPUR SAW ALMOST
EVERY NOBLE MAHARAJA
IN ATTENDANCE. SEEN
HERE ARE MAHARAJA
MAN SINGH OF JAIPUR,
THE MAHARAJA OF KOTA,
AND SARDUL SINGH,
THE MAHARAJA OF
KISHANGARH.

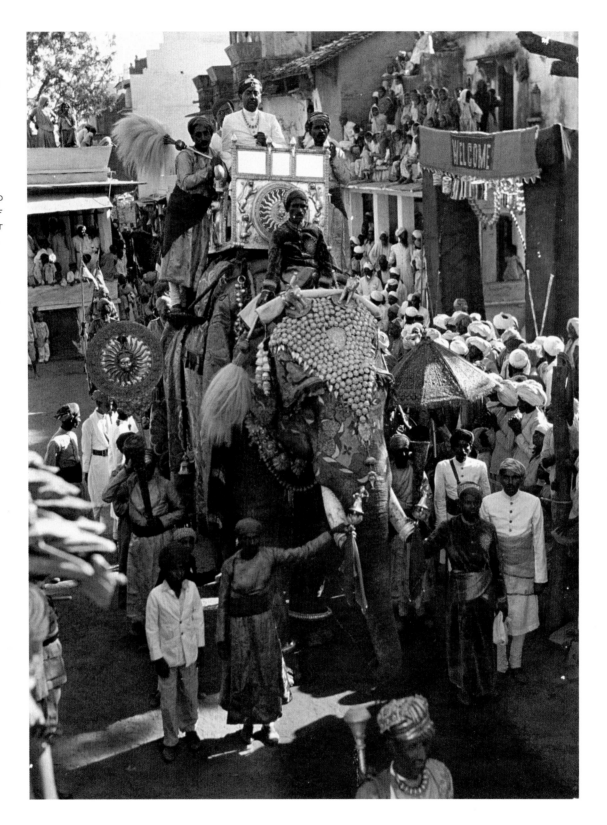

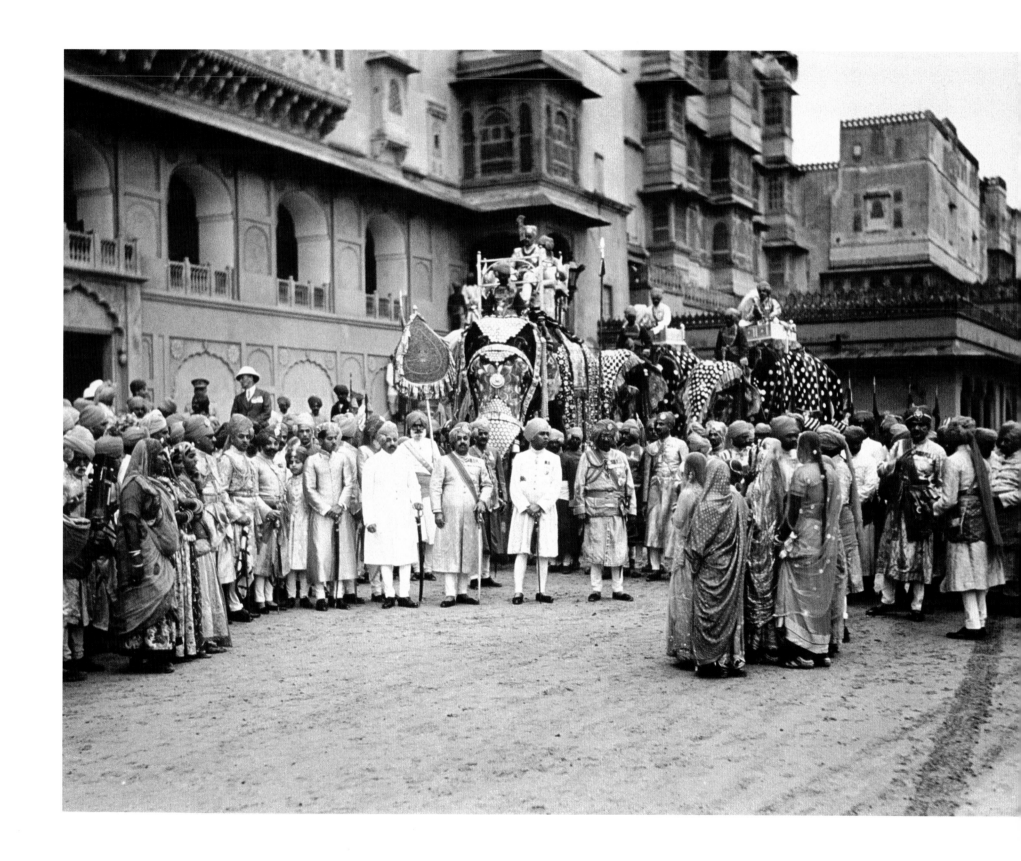

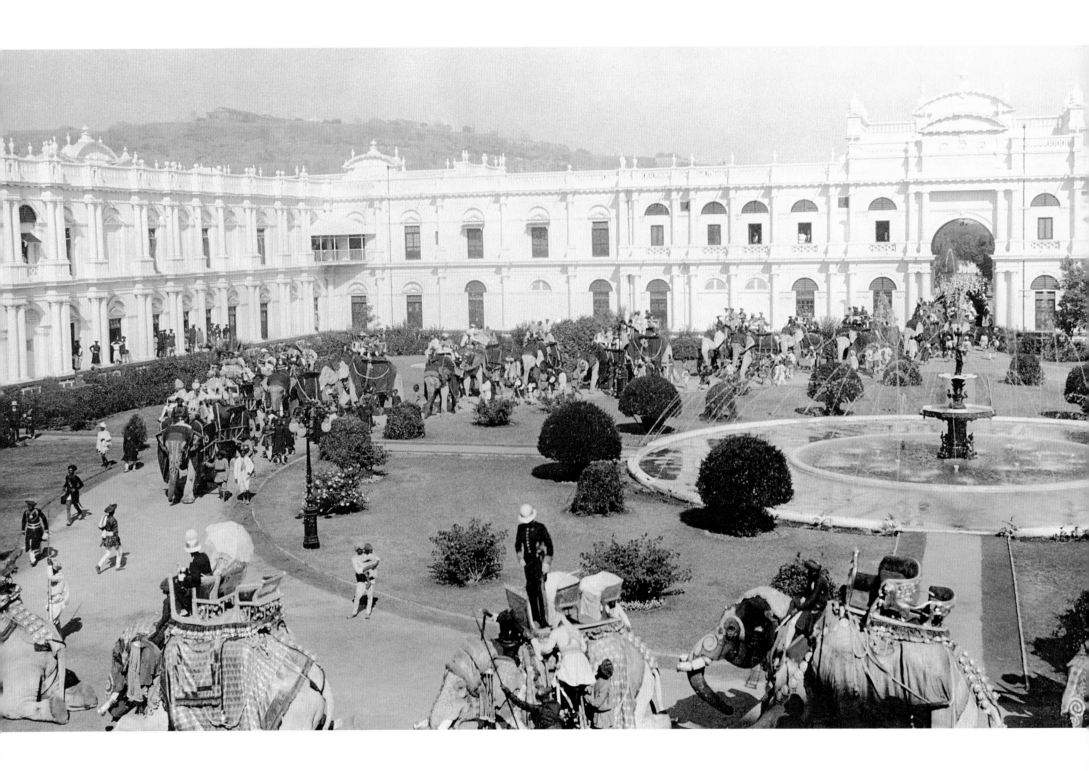

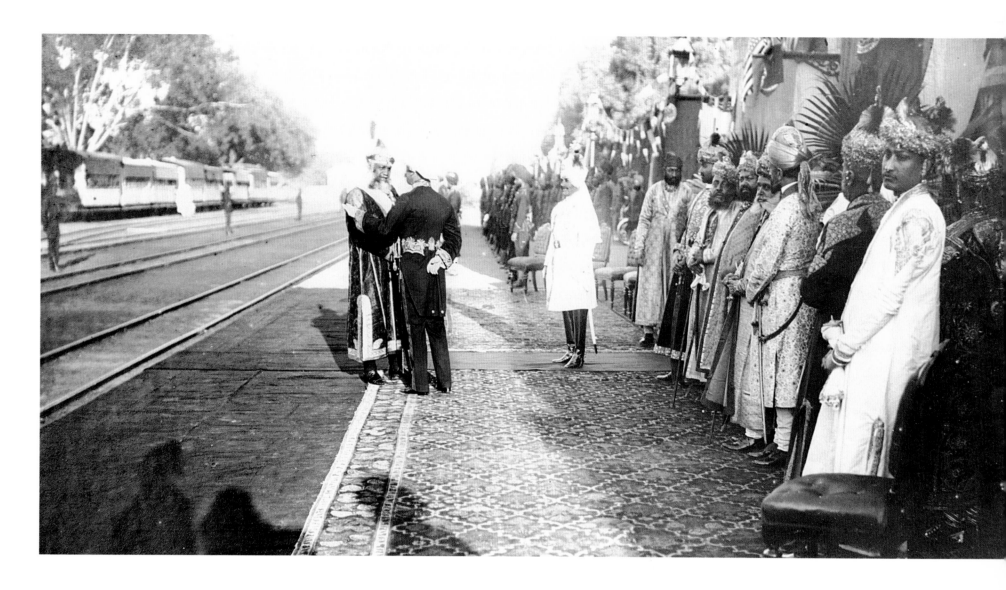

FACING PAGE: THE
IMPOSING GARDENS OF
THE JAI VILAS PALACE IN
GWALIOR. CONSIDERED
ONE OF THE MOST
MAGNIFICENT PALACES
OF THE WORLD, JAI VILAS
WAS THE OFFICIAL

RESIDENCE OF THE
SCINDIAS. MAHARAJA
MADHAVRAO SCINDIA, A
GREAT FAVOURITE OF
LORD CURZON, OFTEN
HOSTED SHIKAR PARTIES
AND ENTERTAINED HIS
GUESTS LAVISHLY.

ABOVE: SAWAI MADHO
SINGH OF JAIPUR AWAITS
THE VICEROY, WHO
ALWAYS TRAVELLED IN
A SPECIAL WHITE-AND-
GOLD TRAIN. WHEN
VISITING JAIPUR, THE
VICEROY'S TRAIN RAN

ON THE PRIVATE RAIL
TRACK OF THE MAHARAJA
THAT LED STRAIGHT TO
RAMBAGH PALACE.

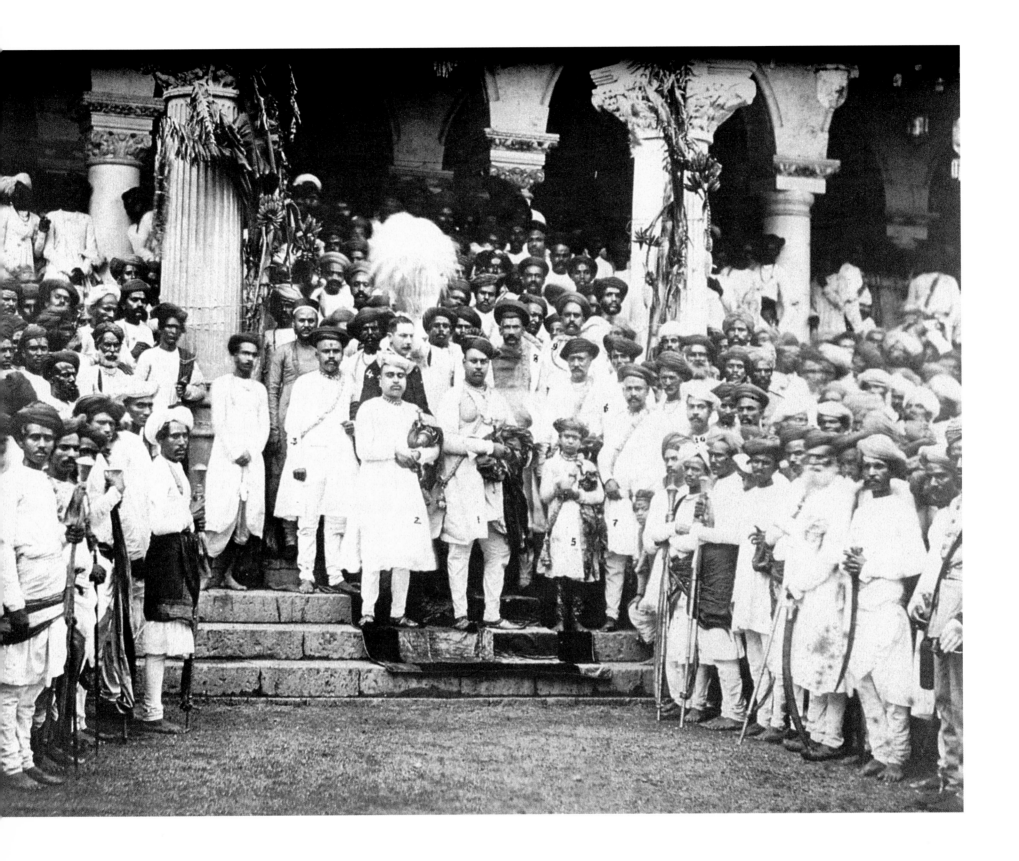

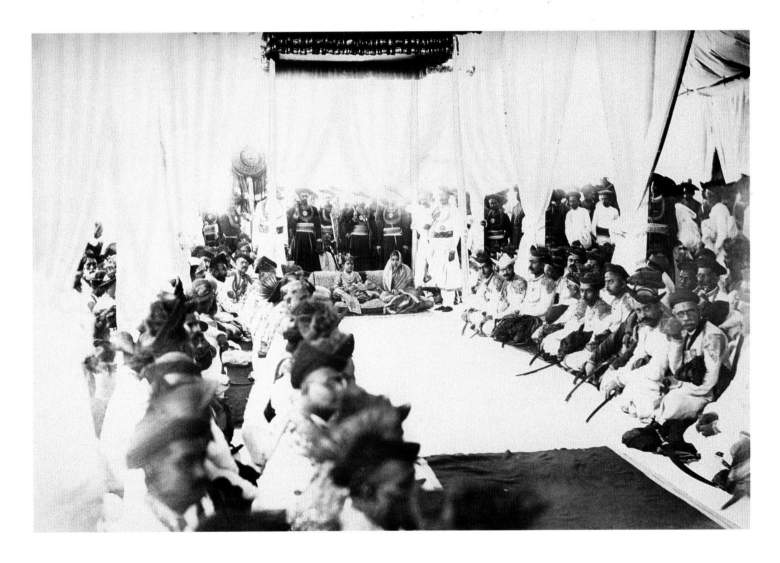

ALL IMPORTANT
OCCASIONS COULD MERIT
A DURBAR. HOWEVER,
THE MAIN PURPOSE OF A
DURBAR WAS TO PROVIDE
THE PUBLIC AS WELL AS
THE NOBLES AND STATE
OFFICIALS WITH AN
OPPORTUNITY TO DECLARE
THEIR ALLEGIANCE AND
LOYALTY TO THE RULER
—AS WAS CUSTOMARY
SINCE THE DAYS OF THE
MUGHALS. JIWAJI
'GEORGE' SCINDIA AND
HIS SISTER 'MARY' GIVE
AN AUDIENCE TO THEIR
SENIOR COURTIERS.

FACING PAGE: THE
ACCESSION OF MAHARAJA
SHIVAJI RAO HOLKAR TO
THE GADDI ON 3 JULY
1886.

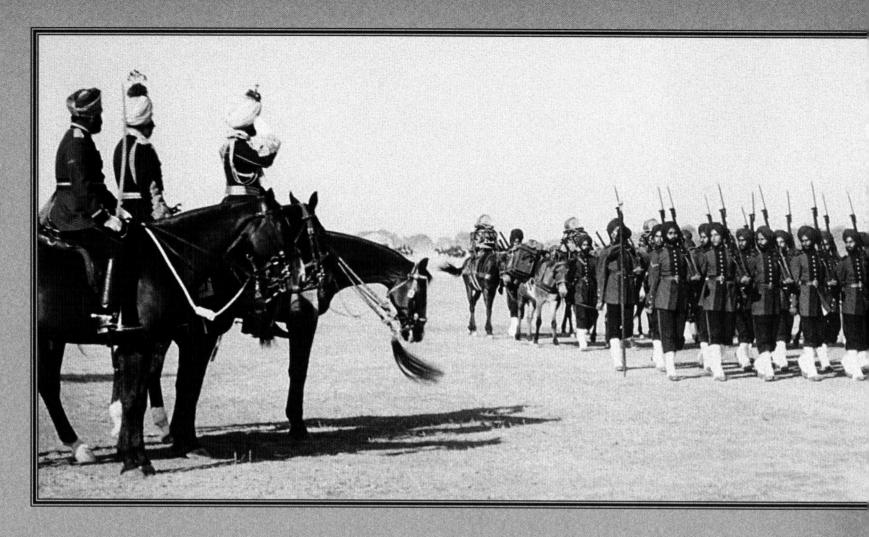

MOST PRINCELY STATES MAINTAINED THEIR OWN
TROOPS WHICH WERE TRAINED AND MANAGED BY
BRITISH OFFICERS. AMONG THE PRINCELY STATES OF
NORTH INDIA, THE STATE OF PATIALA BOASTED THE
BEST CAVALRY REGIMENT IN THE COUNTRY. ITS
SUPERVISION WAS HANDLED BY GENERAL GURDIAL
SINGH HARIKA, WHO KEPT AN EAGLE EYE ON EVERY
HORSE AND RIDER IN THE STATE ARMY. IT IS SAID
THAT WHEN HE RETIRED, GENERAL HARIKA WAS
GIVEN A FAREWELL MARCH PAST AND HE COULD
NAME EVERY PASSING MOUNT. HE IS SEEN ABOVE
WITH MAHARAJA YADAVINDRA SINGH OF PATIALA,
REVIEWING A SIKH STATE INFANTRY REGIMENT.
THE PATIALA REGIMENTS WERE NAMED AFTER THE
RULING PRINCES, SUCH AS THE FIRST RAJINDRA
TROOPS. THE SPLENDID GALLOP PAST OF ANOTHER
SIKH REGIMENT FROM PATIALA (*BELOW*) BRINGS OUT
VIVIDLY THE POWER AND GRACE OF THE CAVALRY
REGIMENTS OF THE STATE.

THE SIKHS HAD BEEN A MARTIAL RACE FOR
CENTURIES. TRAINED BY THEIR GURUS IN THE
MARTIAL ARTS, SIKHS WORSHIPPED THEIR ARMS
AND LOOKED AT WAR AS A SACRED DUTY. IT WAS
THIS SPIRIT ALONG WITH THEIR SUPERIOR CAVALRY
THAT EARNED THE PATIALA RULERS SEVERAL
DECORATIONS FROM THE BRITISH GOVERNMENT FOR
THEIR PARTICIPATION IN THE TWO WORLD WARS.
SIKH SOLDIERS FOUGHT SHOULDER TO SHOULDER
AT SEVERAL IMPORTANT BATTLES WITH THE ALLIED
FORCES IN AFRICA AND THE MIDDLE EAST.

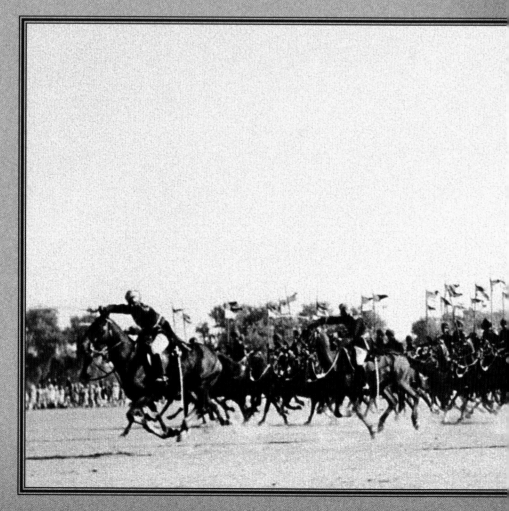

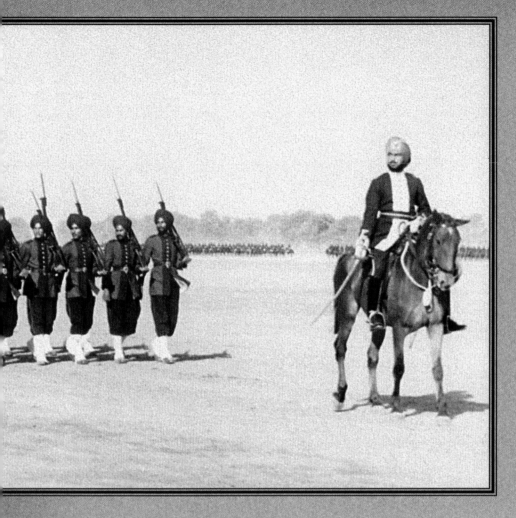

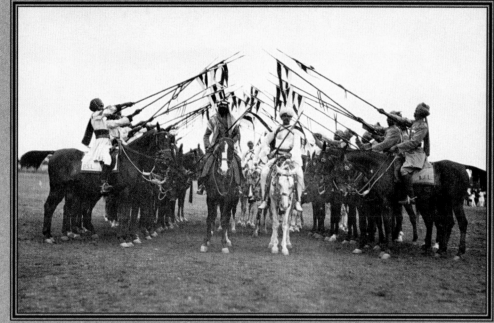

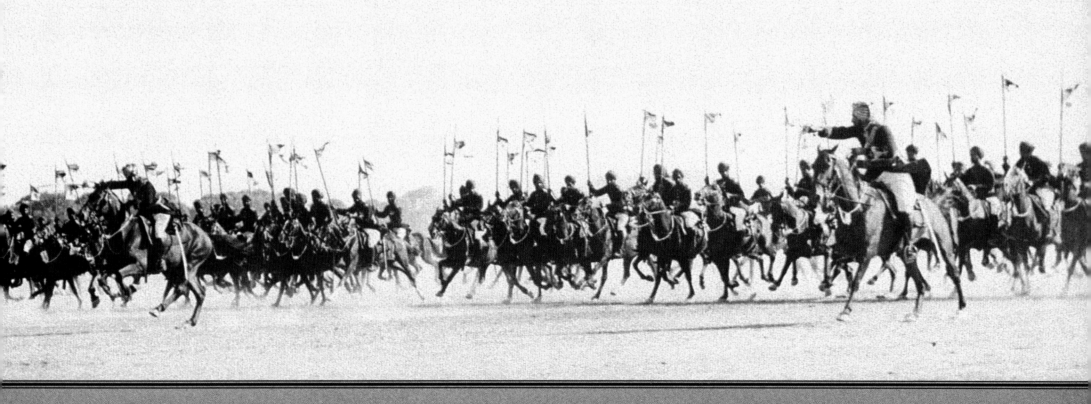

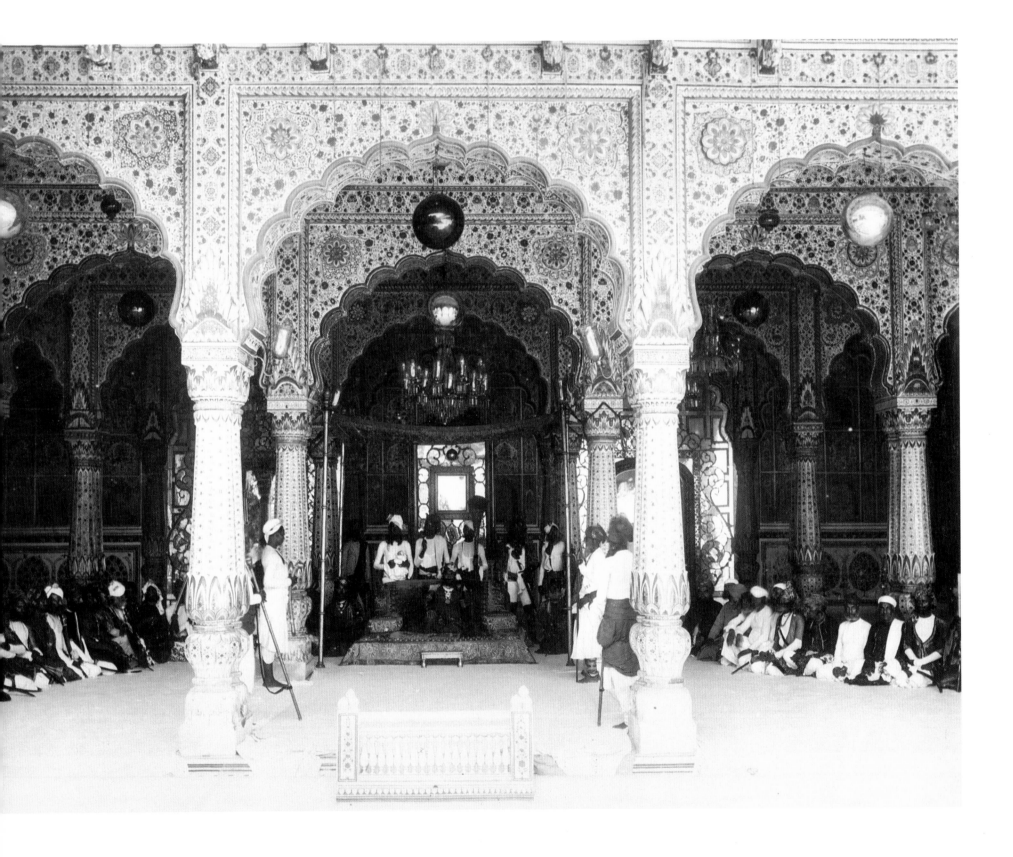

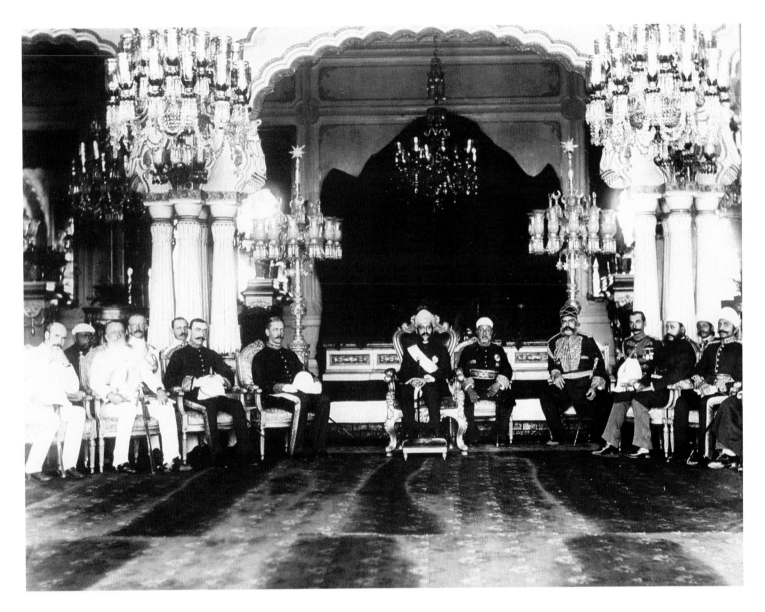

MIR OSMAN ALI, THE
NIZAM OF HYDERABAD,
SITS SURROUNDED BY
MEMBERS OF HIS STAFF
IN THE FALAKNUMA
PALACE. THE GLITTERING
FALAKNUMA (LITERALLY,
MIRROR OF THE SKY) WAS
THE MOST SUMPTUOUS
PALACE IN HYDERABAD.
ITS LAVISH INTERIORS
WERE PAVED WITH
ITALIAN MARBLE AND
GLITTERED WITH CUT
GLASS CHANDELIERS AND
FRENCH FURNITURE.

FACING PAGE: A DURBAR
IN ATTENDANCE AT THE
COURT OF SIR BHANWAR
PAL, MAHARAJA OF
KARAULI. THE KARAULIS
HEAD THE JADON CLAN
OF RAJPUTS AND TRACE
THEIR ANCESTRY
DIRECTLY TO LORD
KRISHNA. LEGEND SAYS
THAT A MAHARAJA
ON SHIKAR HERE
DISCOVERED A LAMB
HOLDING A WOLF AT
BAY. HE THEN RENAMED
HIS KINGDOM AFTER
LORD KALYANJI; THE
NAME WAS LATER
CHANGED TO KARAULI.

ABOVE: SAWAI MAN SINGH II OF JAIPUR PRESIDES OVER THE MERGER OF JAIPUR STATE WITH THE INDIAN UNION. NEXT TO HIM SITS SARDAR VALLABHBHAI PATEL, THE HOME MINISTER AND IRON MAN OF INDEPENDENT INDIA, WHO WAS RESPONSIBLE FOR GETTING NEARLY 600 PRINCELY STATES TO SURRENDER THEIR HEREDITARY PRIVILEGES. SAWAI MAN SINGH SIGNED THE INSTRUMENT OF ACCESSION ON 12 AUGUST 1947. THE MAHARAJAS WERE GIVEN A PRIVY PURSE THAT WAS LATER ABOLISHED.

FACING PAGE: SOON AFTER INDEPENDENCE, IN DECEMBER 1947, SAWAI MAN SINGH II CELEBRATED THE SILVER JUBILEE OF HIS ACCESSION TO THE THRONE. INDIA'S LEADING PRINCES CAME TO JAIPUR TO ATTEND THE EVENT. STANDING OUTSIDE THE CHINESE ROOM IN RAMBAGH PALACE ARE, *(IN THE FIRST ROW, LEFT TO RIGHT):* SARDUL SINGH OF BIKANER, PAMELA MOUNTBATTEN, HANWANT SINGH OF JODHPUR, LORD AND LADY MOUNTBATTEN, AND SAWAI MAN SINGH II HIMSELF.

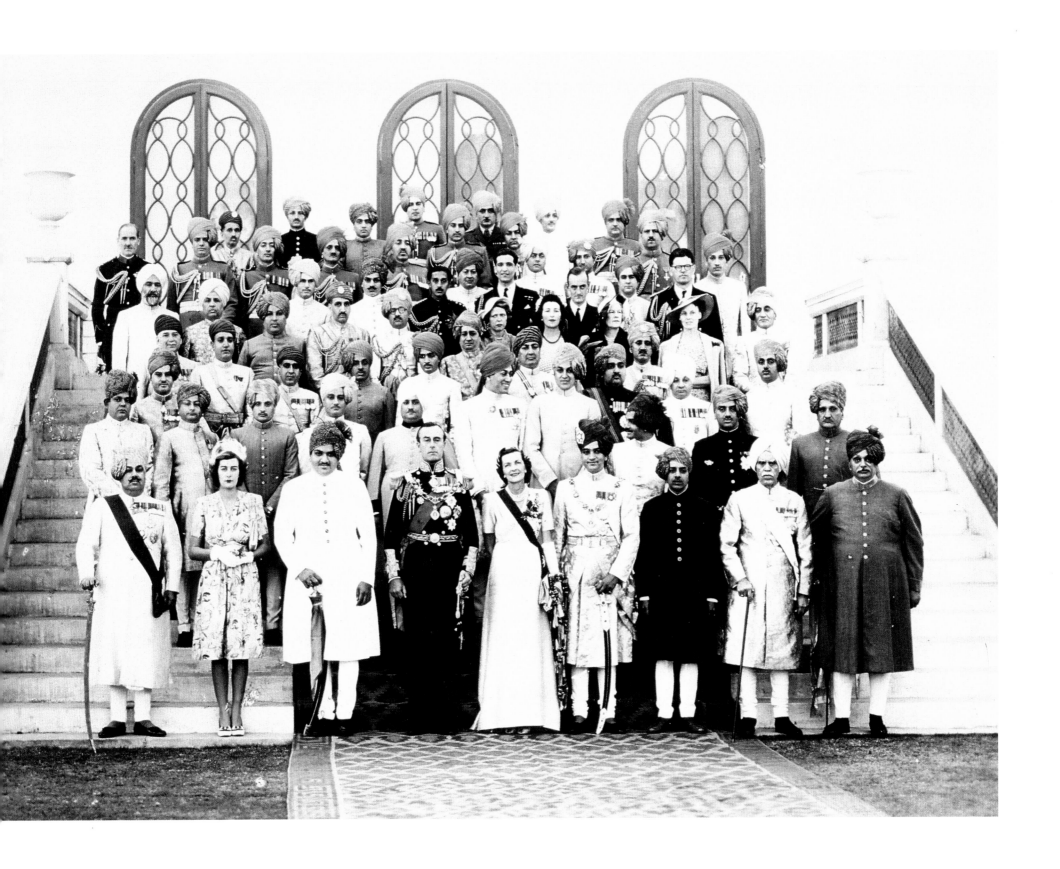

THE BRITISH
INTRODUCED THE INDIAN
PRINCES TO NEW WAYS
OF ENTERTAINING
THEMSELVES. BALLS AND
FANCY DRESS PARTIES
WERE THE RAGE AMONG
THE PRINCELY STATES.
DRESSES WERE
SPECIALLY ORDERED
FROM LONDON AND
GREAT SECRECY
GUARDED THEIR CHOICE.
THIS GROUP OF
REVELLERS IS DRESSED
IN A BEWILDERING
VARIETY OF COSTUMES.

FACING PAGE: LADY
CLARK IN BHAVNAGAR.
THE PHOTOGRAPH
COMMEMORATES A
VISIT MADE TO A GIRLS'
SCHOOL IN GUJARAT.
MANY PROGRESSIVE
RULERS SET UP
'PURDAH' SCHOOLS
FOR THE EDUCATION
OF GIRLS IN THEIR
KINGDOM.

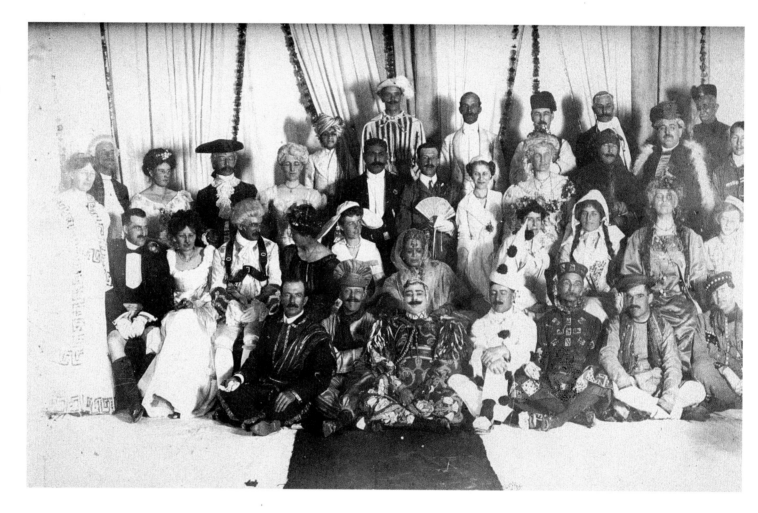

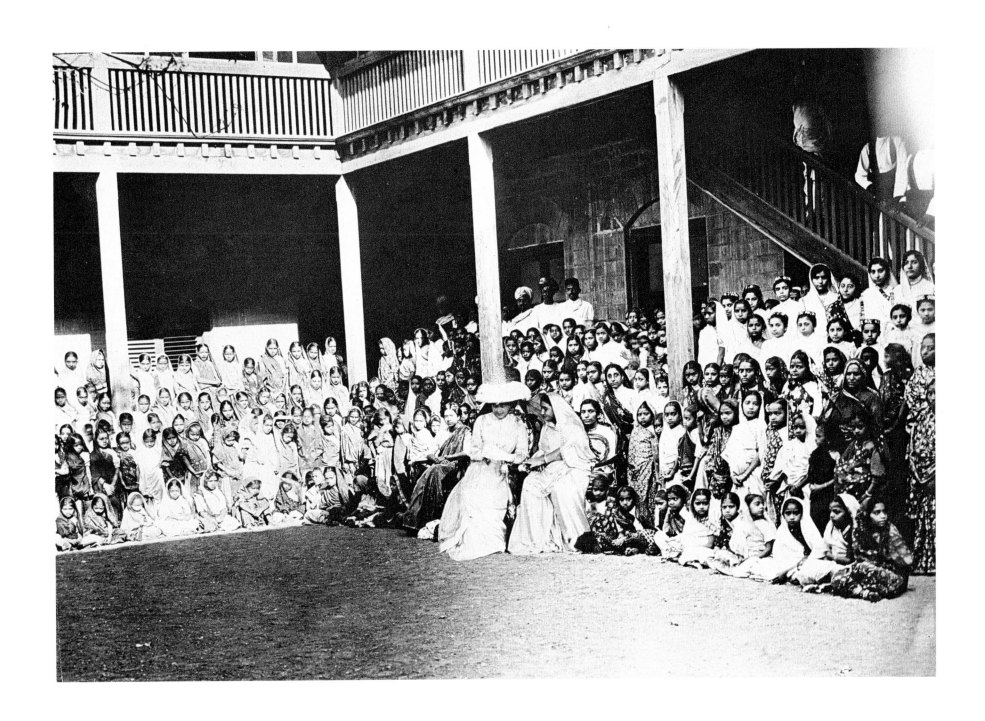

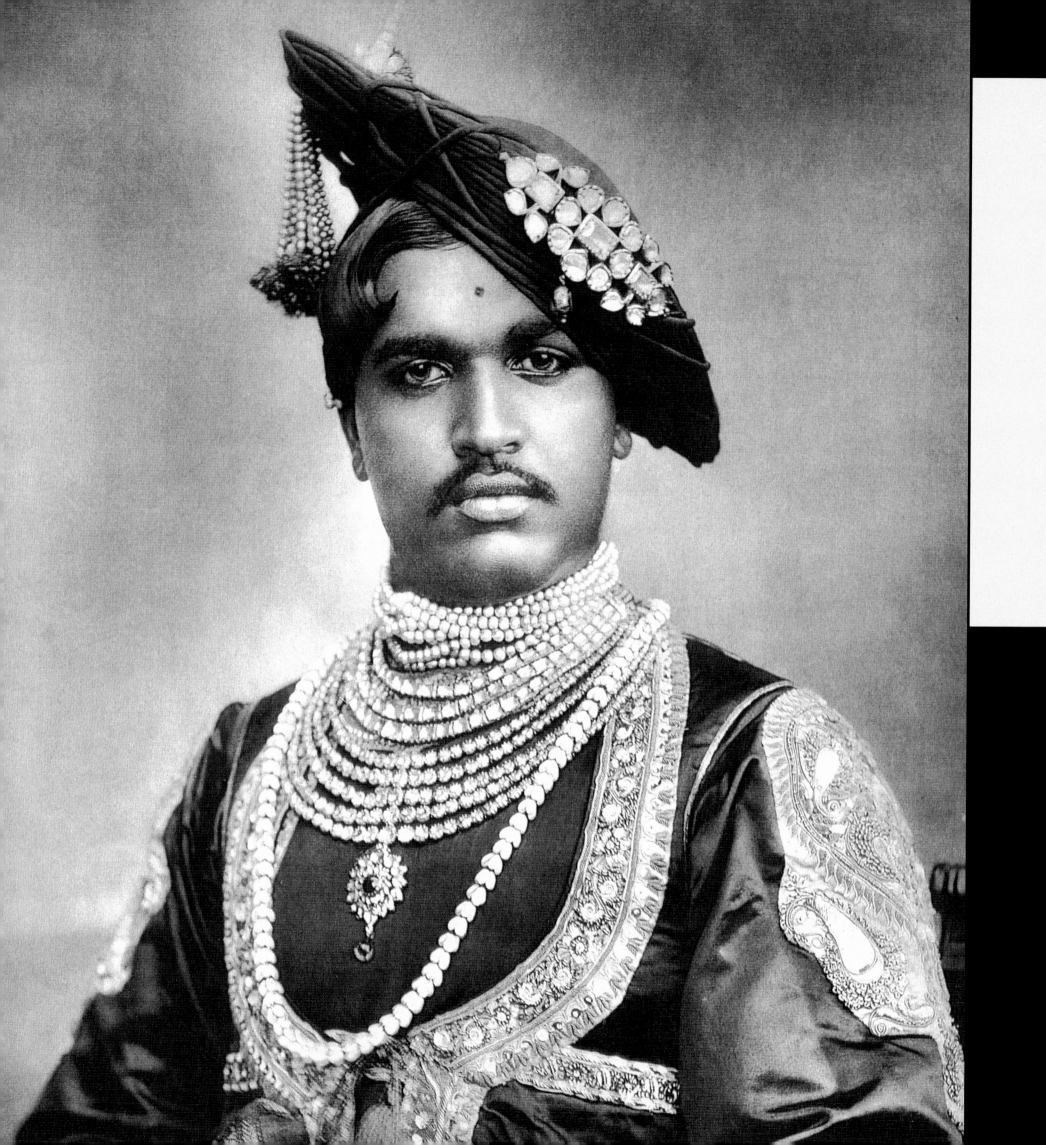

YES, YOUR HIGHNESS

Kohlapur was an important princely state in western India. Its rulers called themselves Chhatrapati, after their ancestor, the warrior-king, Shivaji. In his time, Shivaji had carved out an independent kingdom for himself and held out against the mighty Mughal Emperor, Aurangzeb. However, Shahuji Maharaj (1874–1922), was a sad contrast to this doughty ancestor. So eager was he to curry favour with the British rulers that he had a series of statues erected in 1912 to their 'sacred' memory. His sycophancy paid him rich dividends for the British decorated him with a number of titles. He proudly displayed all these on state occasions. However, he was by no means the only slave of the empire.

In another instance, the Maharaja of Gwalior named his son and daughter George and Mary and asked the Viceroy to convey his sincere desire to the ruling monarchs of England that they become their godparents. Needless to add, Lord Curzon approved most heartily. For Maharaja Sir Pratap Singh of Jodhpur devotion to the British Crown was almost a religion. He was born in 1845 and even as a child did not seem to have a sense of physical fear. At the age of nine, Pratap Singh tried to dispatch his first leopard with a sword. In later years Maharaja Pratap Singh and Sir Fredrick Roberts, Commander-in-Chief in India were out pig sticking. The dumpy Sir Fredrick speared a pig without killing it and the animal turned and ripped open the horse's belly with his tusks. Seeing the Commander-in-Chief in deep trouble, Pratap Singh jumped off his horse and held the wild boar by his hind legs until Sir Fredrick could collect himself and spear the boar. They were lifelong friends after that and met often during the course of several wars they fought together.

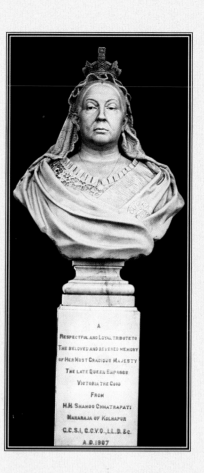

TOP RIGHT: THE BUST OF QUEEN VICTORIA.

BELOW, LEFT TO RIGHT: BUSTS OF KING EDWARD VII, QUEEN ALEXANDRIA, KING GEORGE V, QUEEN MARY, AND THE DUKE AND DUCHESS OF CONNAUGHT PRESENTED BY THE MAHARAJA IN 1912.

FACING PAGE: THE MAHARAJA OF KOLHAPUR.

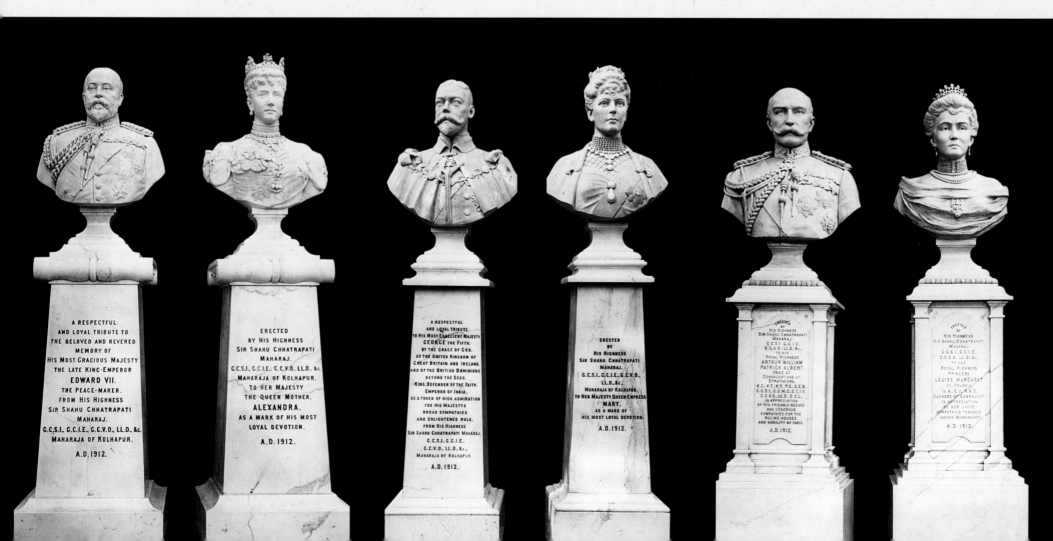

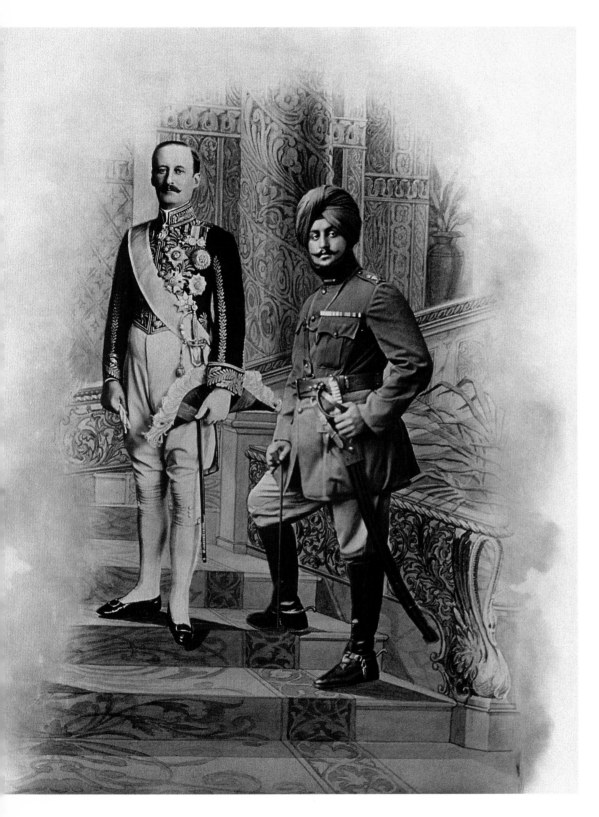

'There is also that rising Dictator, Herr Hitler, and it would afford me so much pleasure to see him and . . . judge him on his merits or otherwise.' Thus wrote the Maharaja of Patiala to the Indian Government arranging for a meeting with Hitler in Berlin. The Maharaja, however, botched the meeting that lasted 30 minutes. He began by telling Hitler how he had to pay extraordinarily high medical fees in Germany earlier. Hitler did not respond. Talk soon turned to Germany's effort at reconstruction and Italy's policies. Hitler said that Germany was not interested in Italy's conflicts, only happy that it could sell more coal to that country. The next day Hitler sent the Maharaja the photograph seen below. That is reputed to have the longest dedication Hitler ever wrote.

MAHARAJA JAGATJIT SINGH OF KAPURTHALA (1872–1949) WAS AMONG THE MOST GLAMOROUS OF INDIAN ROYALS. HE WAS AN EARLY VARIANT OF THE GLOBETROTTER, A LOVER OF ALL THINGS FRENCH, AND CARRIED FORWARD THAT PASSION FOR BUILDING MONUMENTS WHICH HAS BEEN THE HALLMARK OF SO MANY OF INDIA'S RULERS. THIS PHOTOGRAPH WAS PRESENTED TO PRINCESS SITA (*SEE PAGE 58*) IN 1926.

FACING PAGE LEFT:
MAHARAJA BHUPINDAR SINGH OF PATIALA POSES AGAINST A PORTRAIT OF LORD HARDINGE.

FACING PAGE BOTTOM:
MAHARAJA BHUPINDAR SINGH OF PATIALA MET ADOLF HITLER, AN EVENT WIDELY REPORTED IN THE GERMAN PRESS. HITLER, WHOM THE MAHARAJA HAD DESCRIBED IN A LETTER AS 'THAT RISING DICTATOR', IN BERLIN LATER SENT HIM AN AUTOGRAPHED PHOTOGRAPH. DATED 10.9.1935, IT IS SAID TO HAVE THE LONGEST DEDICATION (FIVE LINES) THAT HITLER EVER WROTE TO ANYONE.

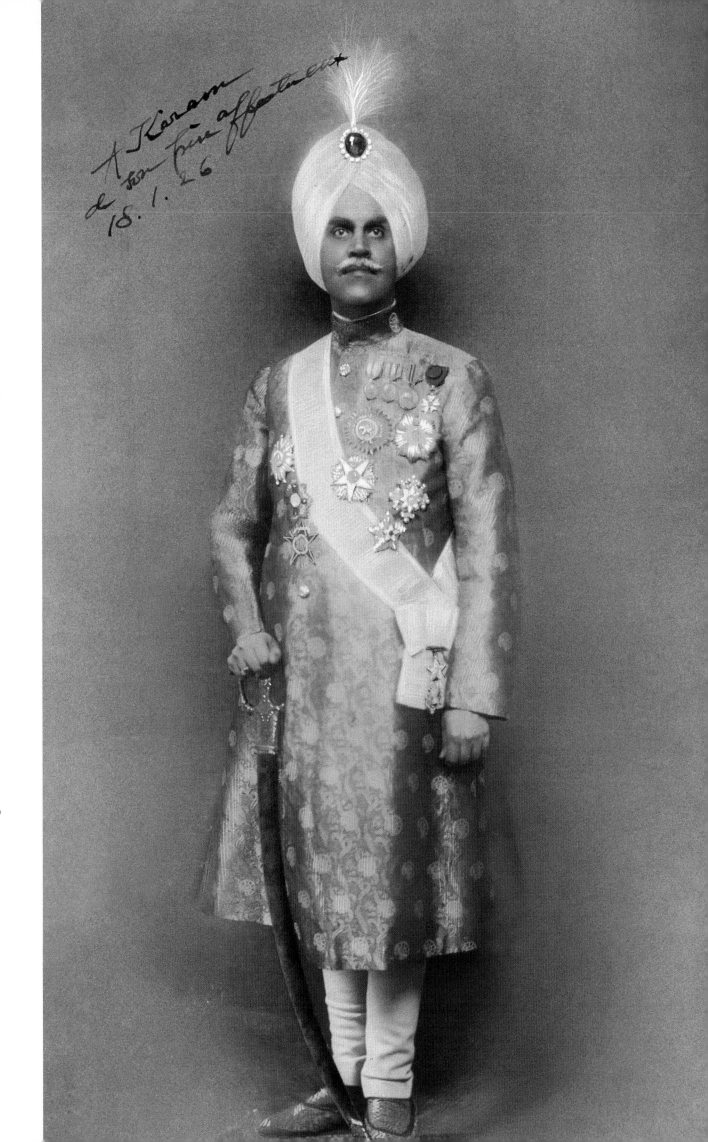

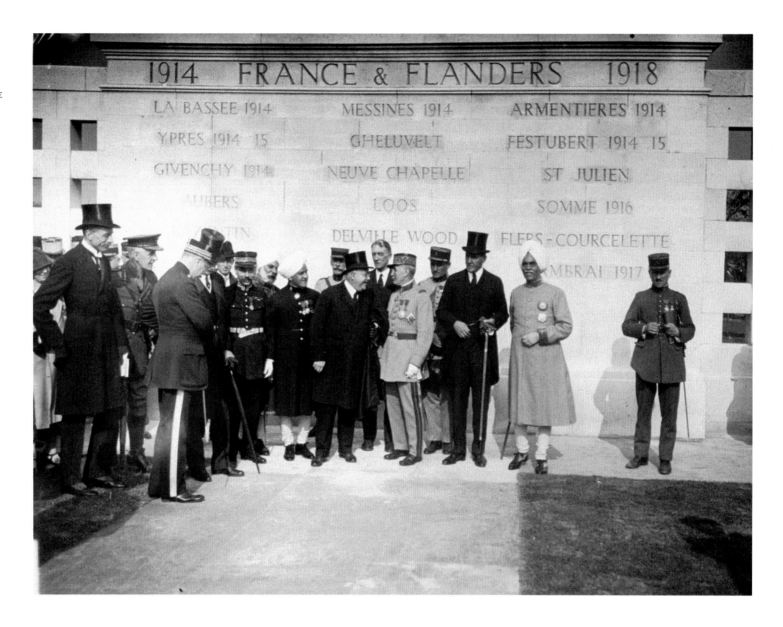

THE KING OF SPAIN
WITH MAHARAJA
JAGATJIT SINGH OF
KAPURTHALA AND THE
TIKKA SAHIB, THE
CROWN PRINCE OF
KAPURTHALA, AT
ESCURIAL, IN 1928. HIS
HIGHNESS KAPURTHALA
LOVED TO TRAVEL AND
SAW MORE OF THE
WORLD THAN MOST
OF HIS PEERS.
HE WAS THE PROUD
POSSESSOR OF
GRANDIOSE TITLES
AND WAS OFFICIALLY
ADDRESSED AS HIS
HIGHNESS FARZAND-I-
DUBAND RASIKH-UL-
ILIKAD DAULAT-I-
INGLISHIA RAJA-I-
RAJGAN MAHARAJA
SIR JAGATJIT SINGH
BAHADUR, GCSI, GCIC,
GBE, THE MAHARAJA OF
KAPURTHALA.

PATIALA WAS AT THE
FOREFRONT OF THE
INDIAN CONTRIBUTION
TO BRITAIN'S FIGHTING
STRENGTH DURING
WORLD WAR II. (NOTE
THE SIKH SOLDIER
PLANTING A FLAG IN THE
PHOTOGRAPH ON THIS
PAGE). THE MAHARAJA
HIMSELF ORGANIZED
RECRUITING DURBARS
AND BY THE END OF
1917, HAD ENROLLED
ALMOST 11,000 OF
PATIALA'S BRAVE MEN IN
ADDITION TO HIS OWN
IMPERIAL SERVICE
TROOPS. WHEN THINGS
WERE NOT GOING SO
WELL FOR THE ALLIES,
PATIALA WAS ABLE TO
PUT THREE INFANTRY
BATTALIONS
AT THEIR DISPOSAL.

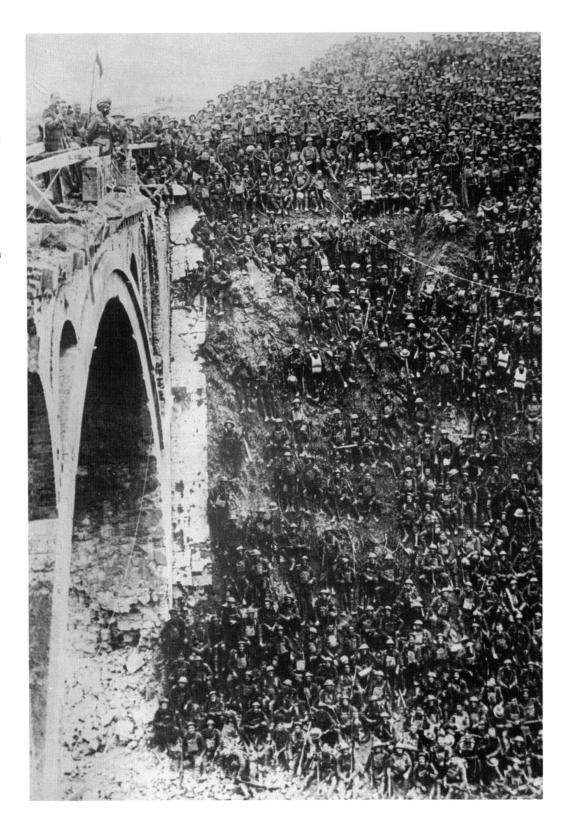

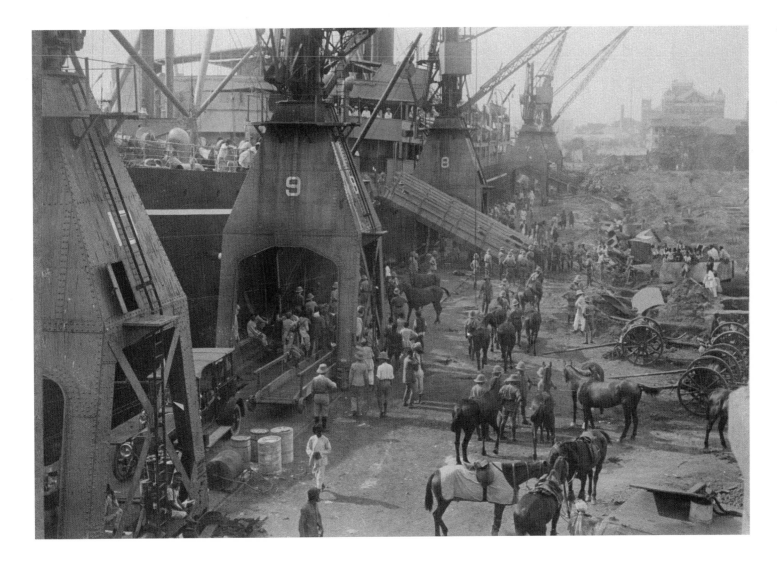

THE TROOPS OF PATIALA
FOUGHT BRAVELY IN
FLANDERS, GALLIPOLI,
ITALY, EGYPT, GAZA AND
MESOPOTAMIA. WHEN
VICTORY CAME, PATIALA
DECLARED A PUBLIC
HOLIDAY AND
CELEBRATED: A MONTH'S
SALARY WAS GIVEN AS
A BONUS TO STATE
EMPLOYEES, GUN
SALUTES WERE FIRED,
PRISONERS GIVEN
AMNESTY, AND FOOD
DISTRIBUTED FREE TO
THE POOR.

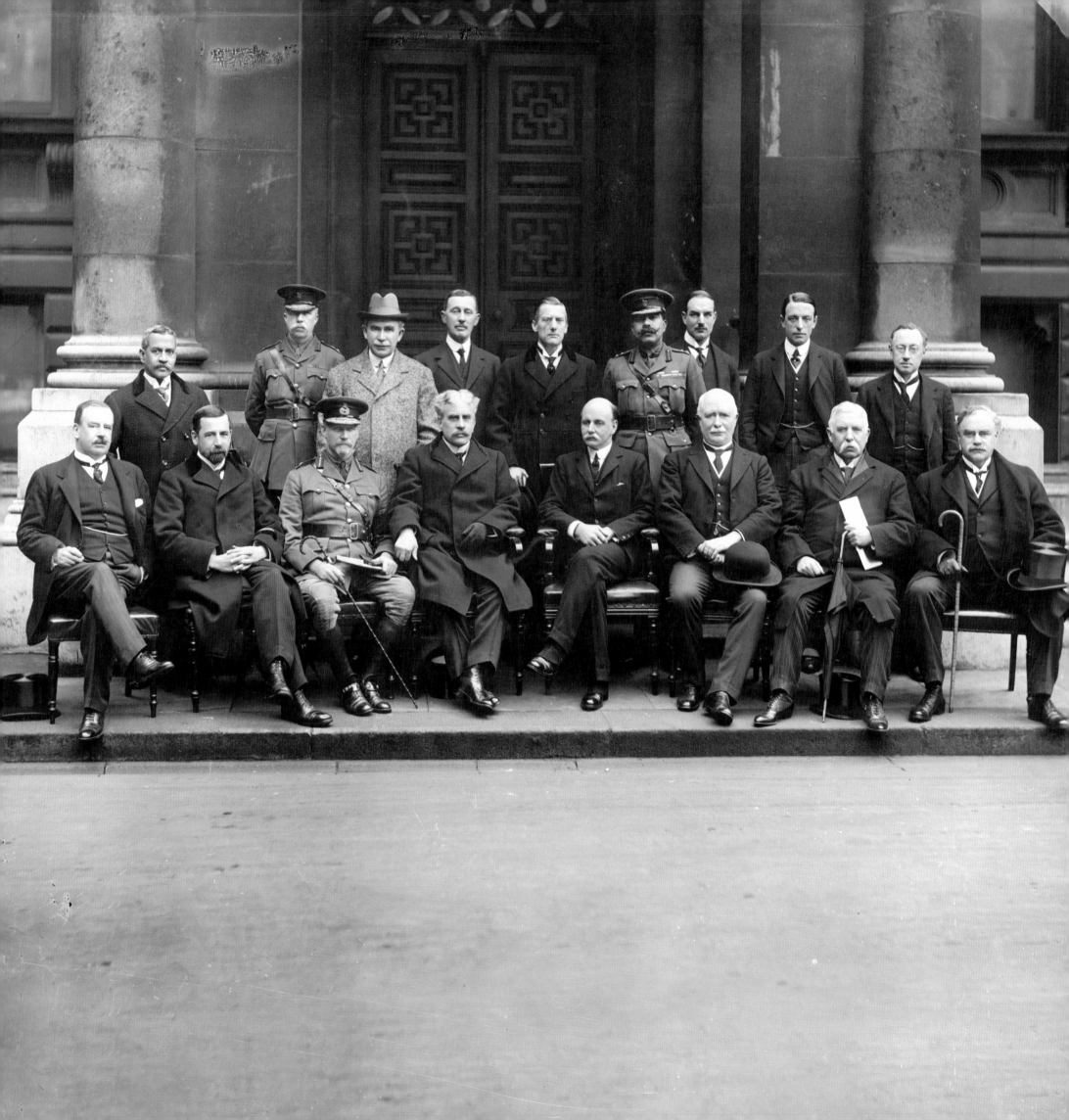

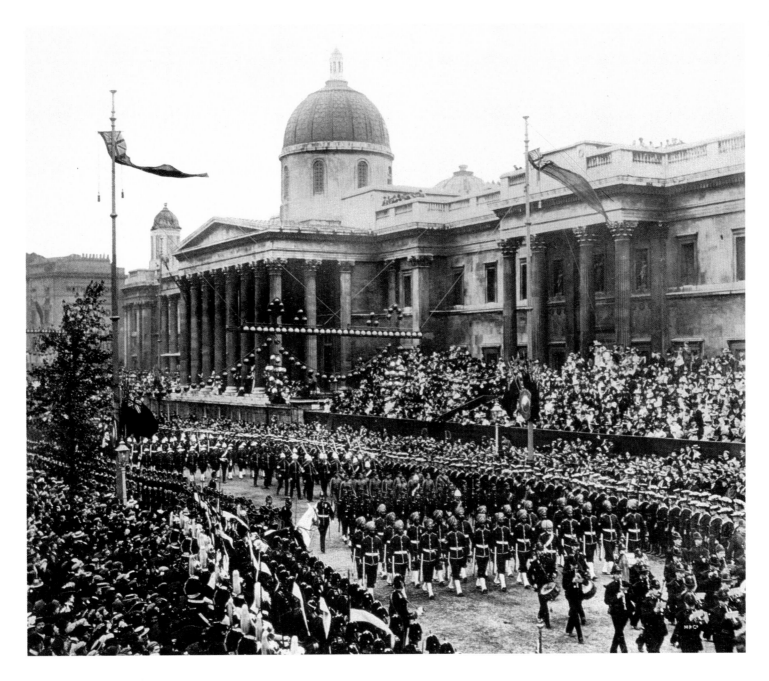

THE VICTORY DAY PARADE IN LONDON TO CELEBRATE THE END OF WORLD WAR II. IN FRONT IS A CONTINGENT OF INDIAN SOLDIERS WHO PARTICIPATED IN THE WAR.

FACING PAGE: A GROUP IMAGE TAKEN AT THE 'AMBASSADOR'S DOOR' OF THE FOREIGN OFFICE, LONDON. THESE REPRESENTATIVES OF THE SELF-GOVERNING MEMBERS OF THE BRITISH EMPIRE, WHO HAD FIRST COME TOGETHER IN 1887, MET EVERY FOUR YEARS; THEIR GATHERINGS WERE CALLED COLONIAL CONFERENCES. THE MAJOR EVENT OF THIS 1917 CONFERENCE WAS THE ADMISSION OF INDIA INTO THE CONFERENCE. INDIA WAS REPRESENTED BY MAHARAJA GANGA SINGHJI OF BIKANER *(BACK ROW, THIRD FROM RIGHT)* AND SATYENDRA PRASSANO, FIRST BARON SINHA OF RAJPUR *(BACK ROW, FIRST LEFT).*

THE BRITISH DURBARS

The concept of the durbar, or the imperial court, has a long history. In Indian mythology, the king of the gods, Indra, held a glittering heavenly assembly where lesser gods and courtiers were regaled by celestial dance and music.

In almost every palace in India, there is a separate hall marked for the holding of durbars. It was the Mughal emperors, however, who took the durbar to its most glittering height. Under them, the durbar became both a means of administering the business of the day and an occasion to enforce the might of the ruler. Ritual, etiquette, dress and position were carefully put in place with a deep emphasis on ceremony and pomp. Even after the Mughals vanished, the durbar continued to be held in royal courts. In the early years of the twentieth century, the last king of Jaisalmer held mock courts in a small part of the palace after the British had left Jaisalmer a ghost town. He received meagre tributes ranging from eight annas to a rupee from the tribes loyal to the king till as late as the 1960s.

The British made full use of the glory of the Mughal durbar and its grip over the Indian mind. In 1877, 1903, and 1911 the British organized three grand durbars in India. In doing so, they had three objectives in mind: First, to showcase British power and its trappings, underlining the fact that here was a sovereign on whose ever-extending realms the sun never set. Secondly, to imply a historical continuity from Mughal to British rule, with the further aim of papering over the brute force and deceit by which India was colonized. And finally, to establish the relationships of fealty and obedience between the Queen in England and her Indian subjects.

Benjamin Disraeli, the Prime Minister of England, masterminded the first Durbar of 1877, twenty years after the Indian rebellion of 1857 had challenged and shaken British power. The Durbar was an undisguised

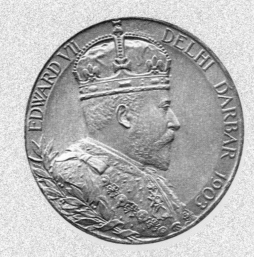

attempt to show the world the permanence of British power in India. Disraeli and Lord Lytton, the Viceroy, decided to revive the Mughal tradition in the grand manner and remind Indians that the British had inherited the mantle of the Mughals.

The occasion was also used to formally declare Queen Victoria the Kaiser-e-Hind, or Empress of India. Over 400 Indian princes with vast retinues converged on Delhi for a dazzling display of 'imperial theatre' and pageantry. Almost all contemporary accounts noted that 'the size and organization of the great camp beside the Jamuna was overwhelming.'

However, 1877 was a modest affair compared to the Durbar of 1903. This Durbar was supposed to mark the accession of King Edward VII. However, it became very much a celebration of Lord Curzon's Viceroyalty and was labelled 'the greatest show on earth.'

The Durbar was held in Delhi rather than in Calcutta, then the capital of British India. The venue was chosen because of Delhi's more deep-rooted associations with India's past. Curzon was happy to enlist these in service of his vision of a contented land unified under British rule at last. The British empire was projected as a civilizing force, bringing morality, education, and technical knowledge to hasten the progress and advance the prosperity of the land it had occupied.

The Durbar area, thus, was appropriately vast. It measured roughly the same as the grounds for the 1877 function, and a five-mile long railway track had to be laid to convey and ferry people within the camp. The central amphitheatre was the focal point of the Durbar. Curzon insisted that it have an Indo-Saracenic dome with small kiosks and ornaments borrowed from Mughal architecture embellishing the structure. As the Viceroy proudly proclaimed, the entire area was 'built and decorated exclusively in the Mughal or Indo-Saracenic style'. Curzon thought it appropriate to emphasize an Indian flavour as the British now sought 'to step into the shoes of the Great Mughal.'

Encampments of the Viceroy, the Commander-in-Chief, and the various Maharajas and their entourage were spread out neatly at intervals around the railway circuit. There was a huge marquee containing the biggest display of Indian art and craftsmanship ever assembled in one place: carpets, silks, pottery, enamels, works in precious metals, paintings and priceless antiquities were on show. The complexity of the Durbar site was bewildering, but every detail had been meticulously planned before—an admirable British characteristic. A special Police Act had also come into

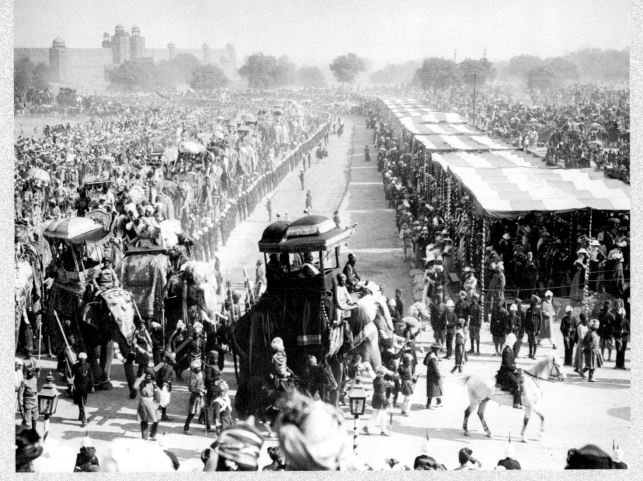

another detail, Curzon departed acutely from tradition: in place of the presentation of the *nazar*, Curzon simply shook hands with each ruling chief. However, he did not forget to reward those faithful to the Raj and both Indians and Britons were decorated in an investiture ceremony.

The review of troops was a three-hour affair where 34,000 British and Indian soldiers marched past the Viceroy. He stood at a safe distance, away from the dust the soldiers kicked up, and acknowledged their salutes. There was also a review of soldiers from the princely states. Once-proud rulers had provided contingents of warriors, camel corps, *palki*-bearers, elephants, caparisoned horses and the like.

Above all there was the grand state entry to the Durbar area. It was preceded by a long procession through the streets of Delhi, which more than a million

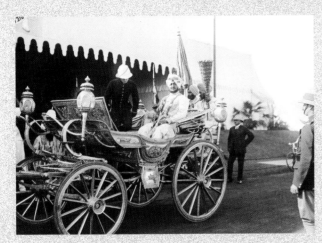

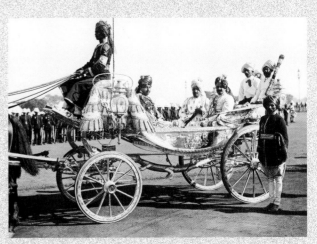

force. It threatened fines of up to fifty rupees (quite a sum in those days) or eight days imprisonment for a variety of infringements, which included soliciting for prostitution and committing a nuisance 'by performing the offices of nature in other than the appointed places'. Clearly, nothing could be allowed to spoil the show or the image of the Raj as a benign influence.

Curzon was anxious to secure the active participation of the leading princes in the ceremony. He managed this without ruffling any feathers. Each prince was asked to mount the dais by turn and offer a message of congratulations to the King Emperor. In

TOP: THE DURBAR WAS AN ASSEMBLY OF ALL LEADING MEN IN INDIA AND THE CONCENTRATION OF WEALTH AND POWER IN THE DURBAR WAS UNEQUALLED. THE MAHARAJAS MADE THEIR ENTRIES IN SHINING CARRIAGES AND ROYAL ELEPHANTS. THE STATE ENTRY INTO THE 1903 DURBAR SHOWING THE MAHARAJAH OF KAPURTHALA, THE MAHARAJA OF SIRMUR, AND THE NAWAB OF MALERKOTLA PASSING THROUGH CHANDNI CHOWK. THE BRITISH DURBARS IMITATED THE MUGHAL IDEA OF THE DURBAR WHERE FEUDATORIES PAID HOMAGE TO THE RULER AND RECREATED THE SPLENDOUR OF THE MUGHAL COURT.

FACING PAGE: THE MEDALS SPECIALLY MINTED FOR THE DELHI DURBAR; THE TOP ONE CARRIES THE PROFILE OF EDWARD VII.

people watched. Here were ambassadors from all over the world in their frock coats and cocked hats, Arab sheikhs in white robes and the Indian Maharajas in splendid attire dripping with jewellery, brocades and silks. They rode on elephants and horses and were easily the most spectacular of the whole assemblage. Contrasting with the blue blood collected from all continents were the common soldiers in brilliant uniforms, their spears and swords glinting in the sunlight.

Contemporary reports say that the most striking of all were the Indian cavalry, 'big men with forked beards carrying pennoned lances and wearing ochre, green

201

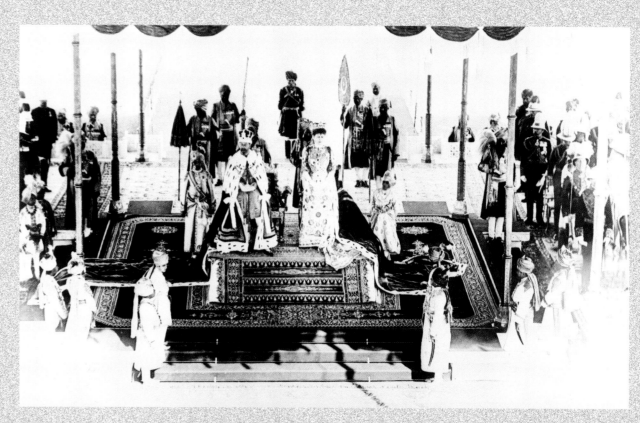

RIGHT: KING GEORGE V AND QUEEN MARY, WEARING THEIR CROWNS AND ERMINE-LINED ROBES OF IMPERIAL PURPLE, SAT ON GOLDEN THRONES WITHIN A CRIMSON PAVILION TOPPED WITH A GOLDEN CANOPY.

BELOW: IN THE AMPHITHEATRE AT THE DURBAR, BLOCKS D (FIRST THREE PILLARS) AND E. IN BLOCK D ARE THE MAHARAJA OF DHAR, THE MAHARAJA OF DEWAS, THE MAHARAJA OF SAMTHAR, THE NAWAB OF JAORA, AND THE MAHARAJA OF RATLAM. BLOCK E SEATS LORD AND LADY NORTHCOTE AND THE BOMBAY CHIEFS.

and blue tunics and brightly coloured cummerbunds and turbans . . . No one who saw them could have doubts that India's martial traditions are flourishing and vibrant.'

The spectacle emblazoned with Oriental ceremony was a great setting for the Viceroy.

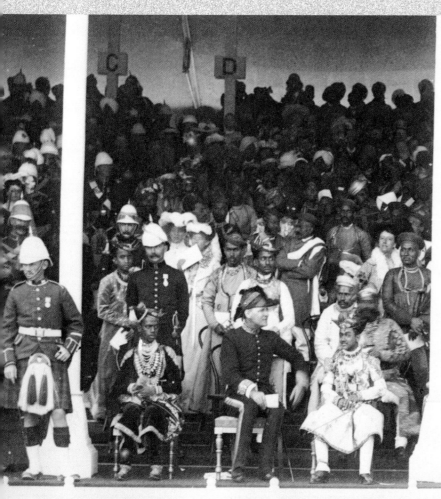
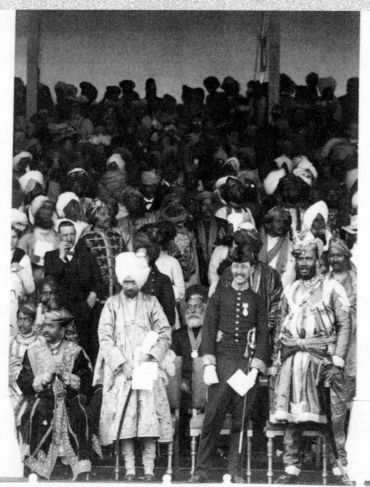
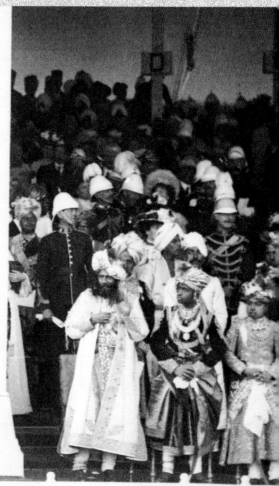

After trumpeters had sounded flourishes, Curzon ascended the throne and proclaimed the new king's coronation (though, it had taken place about six months earlier!) This was followed by 'the ultimate in ceremonial bombardment, a full Imperial Salute of 101 guns.' The ten days of celebrations, an Olympics of Ostentation, were interspersed with football and hockey, a polo tournament, cricket matches, tent pegging, and Indian-style wrestling. Performances by massed military bands of close to 2,000 men provided background music.

The sight was of a solid empire in masterful control over its dominions. The message was that India's future was secure as long as the paramount power was unchallenged. But the first rumblings of the national movement were being heard and for most Indians it was a heartening sound.

Yet another Durbar, as magnificent as Curzon's, was held in Delhi in December 1911. This commemorated the visit of the reigning King Emperor and was unprecedented in scale and extravagance. Much of the pageantry and celebrations were like Curzon's Durbar and do not bear repetition. The 1911 Durbar began with a cascade of decorations and orders for princes. The highlight of the celebrations came when King George V and the Queen, wearing their crowns and ermine-lined robes of imperial purple, received the homage of the princes. They sat on golden thrones within a crimson pavilion topped with a golden canopy. The Maharajas attired in full regalia and laden with jewels approached the King and Queen, bowed three times and stepped backwards. Maharaja Sayaji Rao of Baroda was different. Dressed in simple white and wearing no jewellery or British decorations, he walked forward, inclined his head once, turned about, and walked away casually waving his swagger stick. The onlookers were scandalized.

The incident had been filmed by newsreel cameras. When the film was shown in England, the public and the Press went into hysterics. However, Viceroy Hardinge played down the snub.

At the Durbar, King George, standing under the golden dome, announced the transfer of the capital from Calcutta to Delhi. The audience of some 100,000 people stood in stunned silence. Any blow to Bengali pride was mitigated by the reunification of Bengal, which had been divided a few years earlier. There was much rejoicing at this news; the protests were yet to come.

The grand show of 1911 was different from the other two Durbars, however. Behind its vast façade, the British edifice was showing early cracks. Independence was to come three dozen years later, but the Raj was on its last legs. The age of the Durbars was buried, curtly and without ceremony, in 1947.

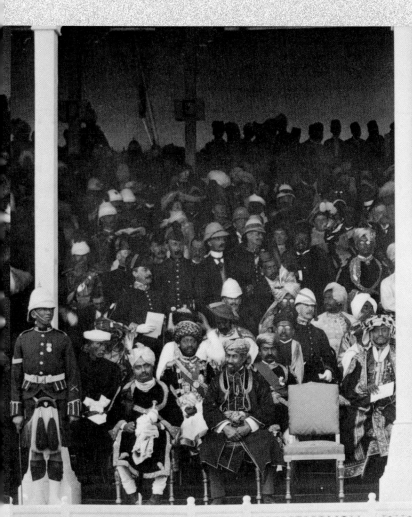
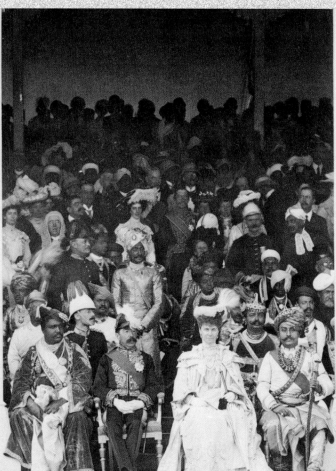
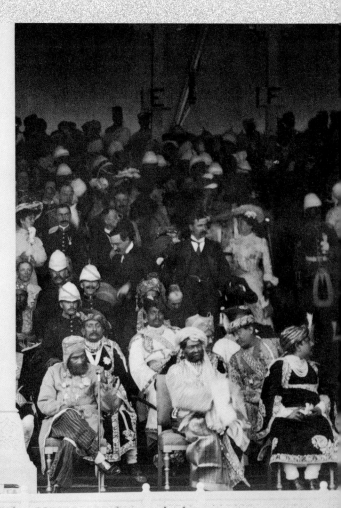

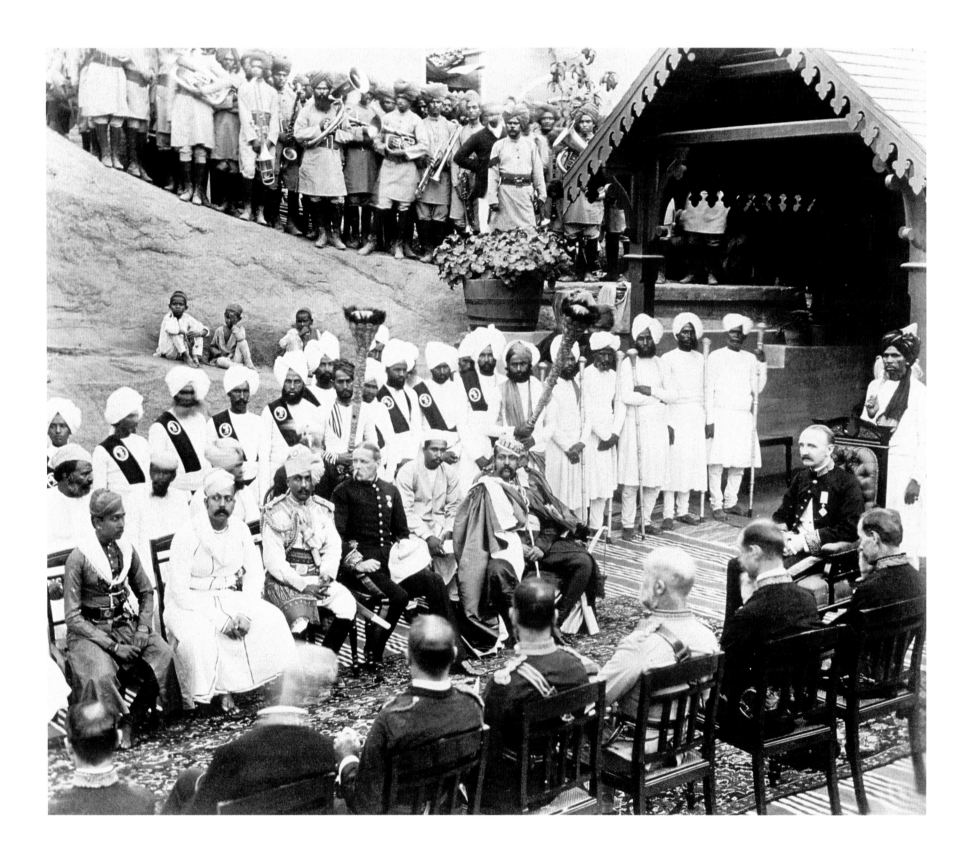

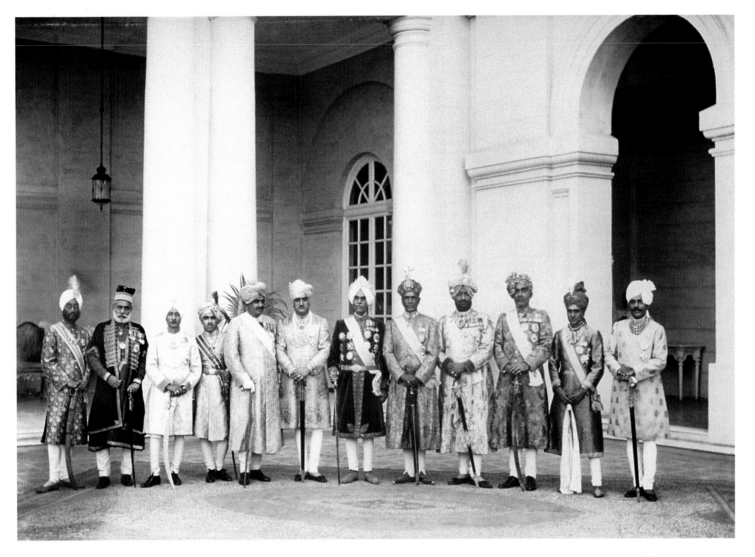

THE GOLDEN JUBILEE GROUP AT THE JAGATJIT PALACE IN KAPURTHALA, C. 1957. (*LEFT TO RIGHT*): RAJASAHEB KALSIA, NAWAB OF LOHARU, NAWAB OF MALERKOTLA, RAJA OF MANDI, JAMSAHIB OF JAMNAGAR, MAHARAJA HARI SINGH OF KASHMIR, MAHARAJA JAGATJIT SINGH OF KAPURTHALA, MAHARAJA OF ALWAR, MAHARAJA BHUPINDAR SINGH OF PATIALA, MAHARAJA GANGA SINGH OF BIKANER, MAHARAJA OF BHARATPUR, AND THE NAWAB OF PALANPUR.

FACING PAGE: MAHARAJA SARDUL SINGH OF KISHANGARH RECEIVING THE TITLE OF GCIE (GRAND COMMANDER OF THE INDIAN EMPIRE). INDIAN PRINCES WERE DECORATED FOR THEIR LOYALTY TO THE RAJ WITH SUCH TITLES. SIR PRATAP SINGH, WHOSE LOYALTY TO THE BRITISH WAS LEGENDARY, IS THIRD FROM THE LEFT IN THE FIRST ROW.

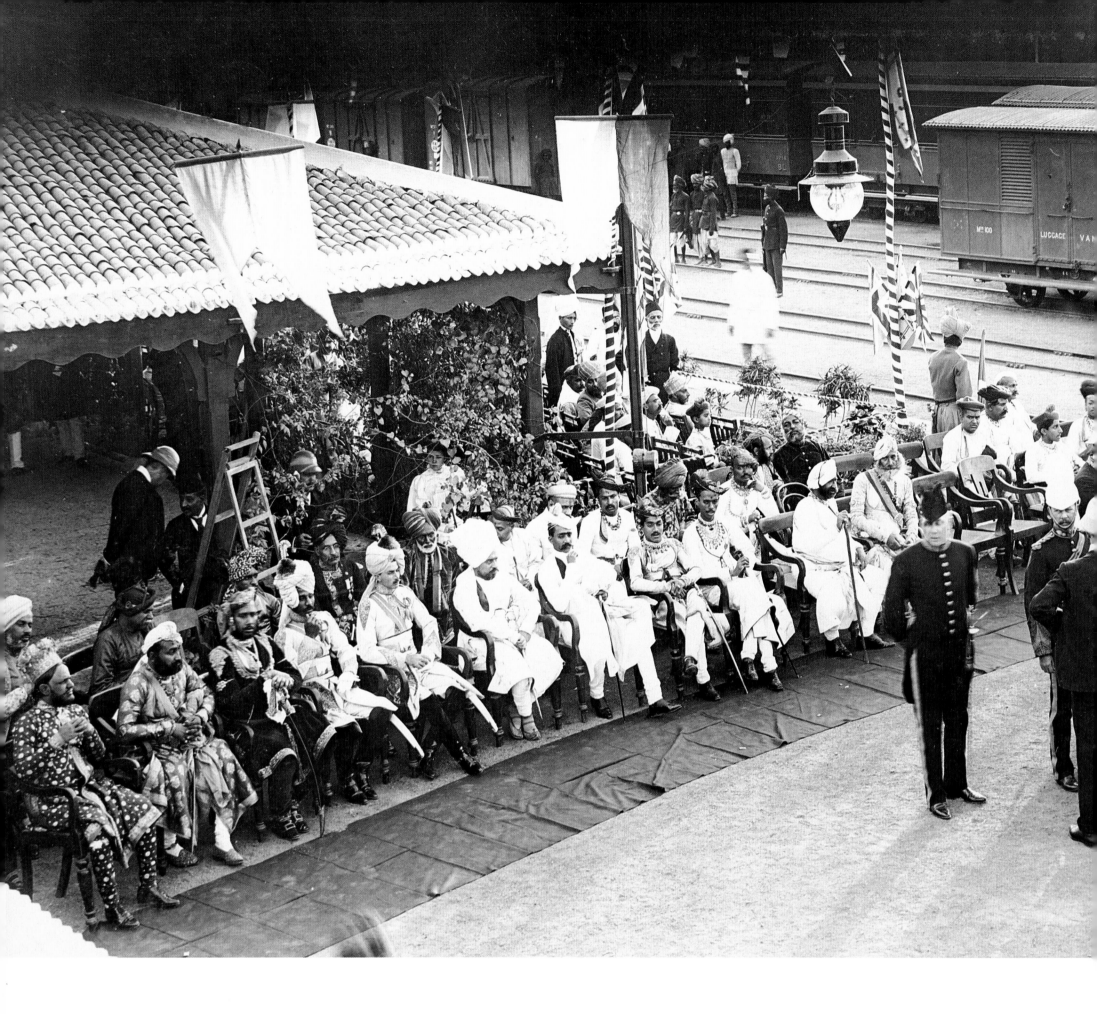

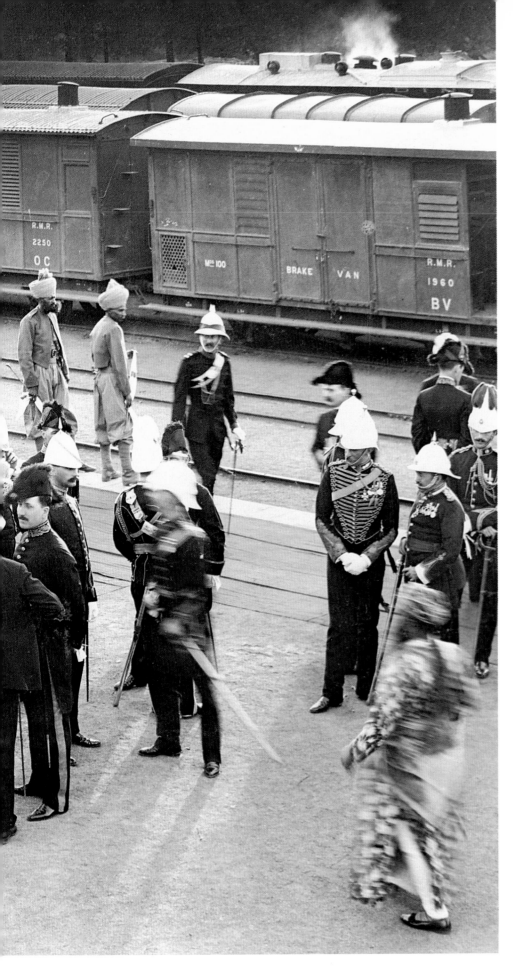

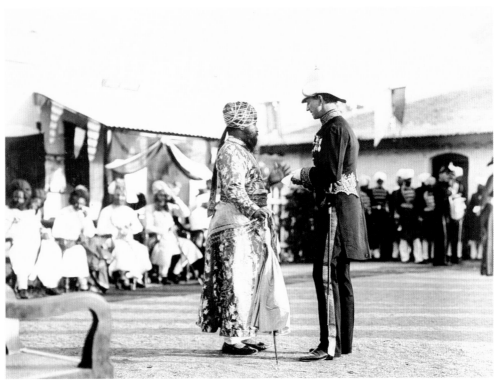

TOP: THE DIFFERENCE IN THE FORMAL COSTUMES OF THE MAHARAJA AND THE VICEROY IS STRIKING.

BOTTOM: A PURDAH IS RIGGED IN UDAIPUR AS A PRINCESS BOARDS A TRAIN. ARMED GUARDS KEEP THE INQUISITIVE AT BAY.

FACING PAGE: INDIAN PRINCES LINE UP TO RECEIVE THE VICEROY AT A RAILWAY STATION. FOURTH FROM THE LEFT IN THE FIRST ROW IS SAJJAN SINGH OF RATLAM, WHO WAS APPOINTED ADC TO THE KING-EMPEROR ON HIS STATE VISIT TO INDIA.

INDIAN PRINCES WERE
CHOSEN TO BE PAGE
BOYS FOR THE IMPERIAL
BRITISH COUPLE DURING
THEIR 1911 STATE VISIT,
AMONG THEM WERE: THE
PRINCES OF BHARATPUR,
IDAR, JODHPUR, ORCHHA,
BIKANER, FARIDKOT,
PALITANA, SAILANA,
BHOPAL, AND REWA.
THEY ARE DRESSED IN
THEIR TRADITIONAL
COURTLY ATTIRE WITH
SWORDS AND JEWELS.

FACING PAGE: PRINCE
ALFRED *(RIGHT)* AND
PRINCE ARTHUR
WEARING SIKH DRESSES,
SEPTEMBER 1854.
PRINCE ALFRED LATER
BECAME DUKE OF
EDINBURGH AND SAXE-
COBURG-GOTHA AND
PRINCE ARTHUR BECAME
DUKE OF CONNAUGHT.
THE INDIAN CLOTHES
WERE PROBABLY GIVEN
TO THEM BY MAHARAJA
DULEEP SINGH, SON OF
THE LEGENDARY SIKH
RULER, RANJIT SINGH.

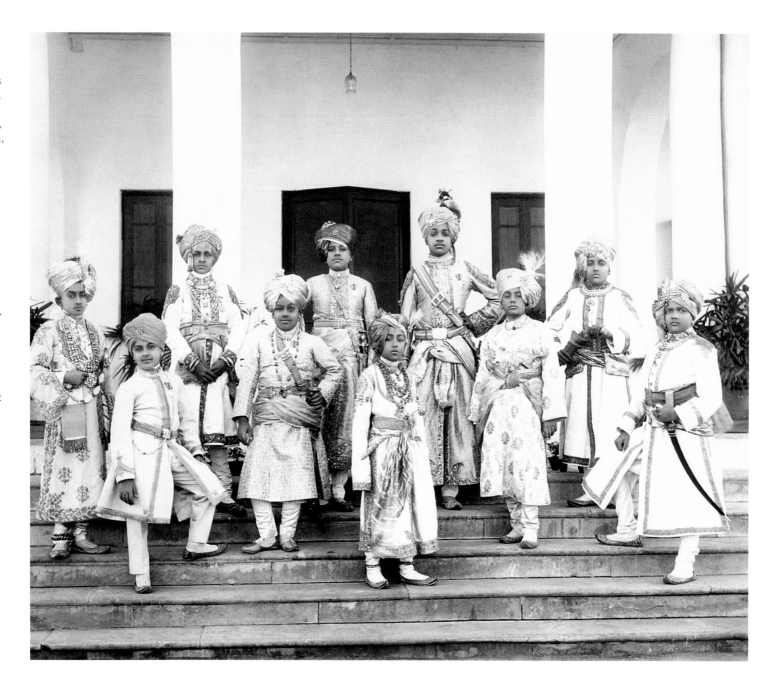

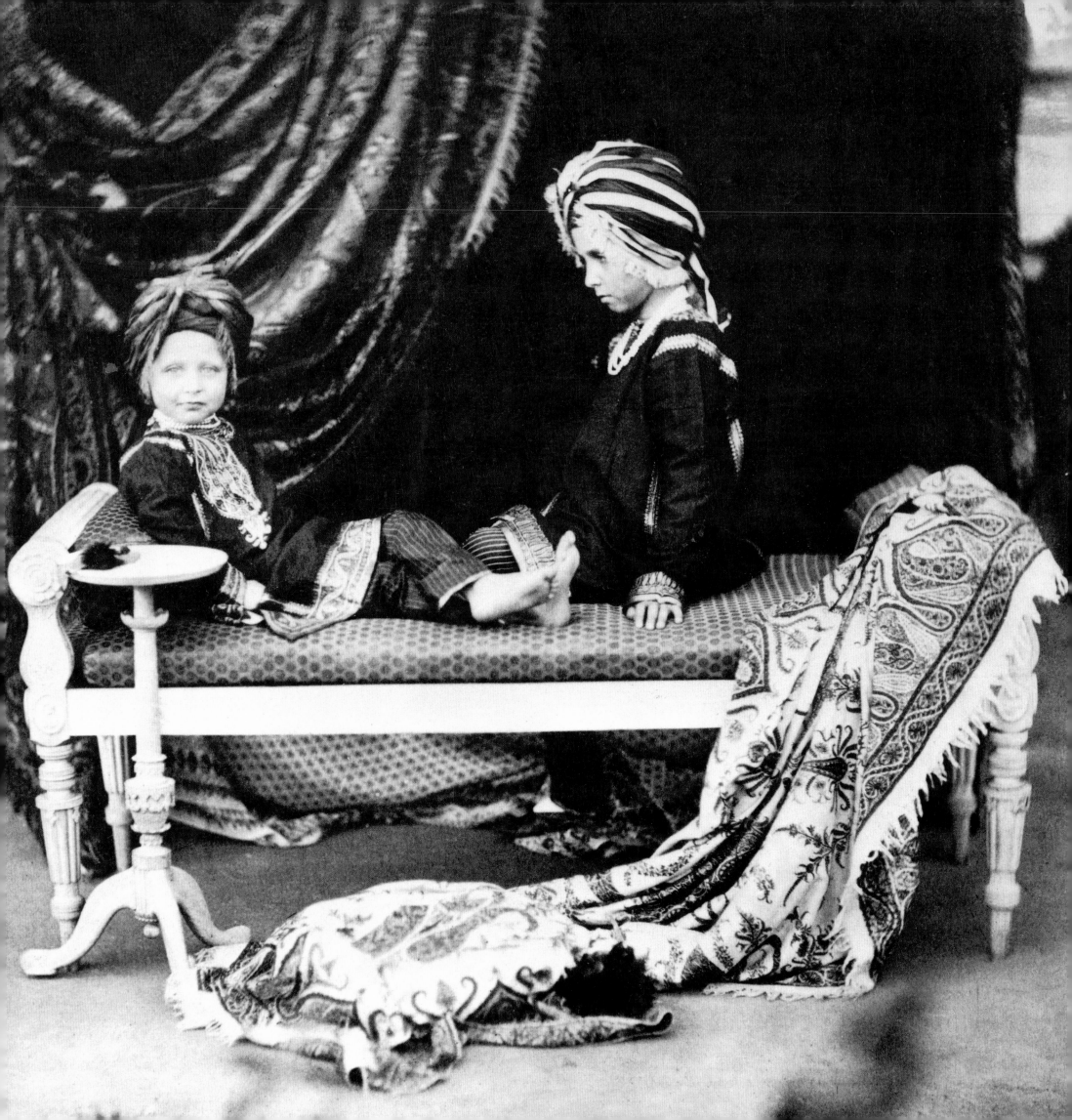

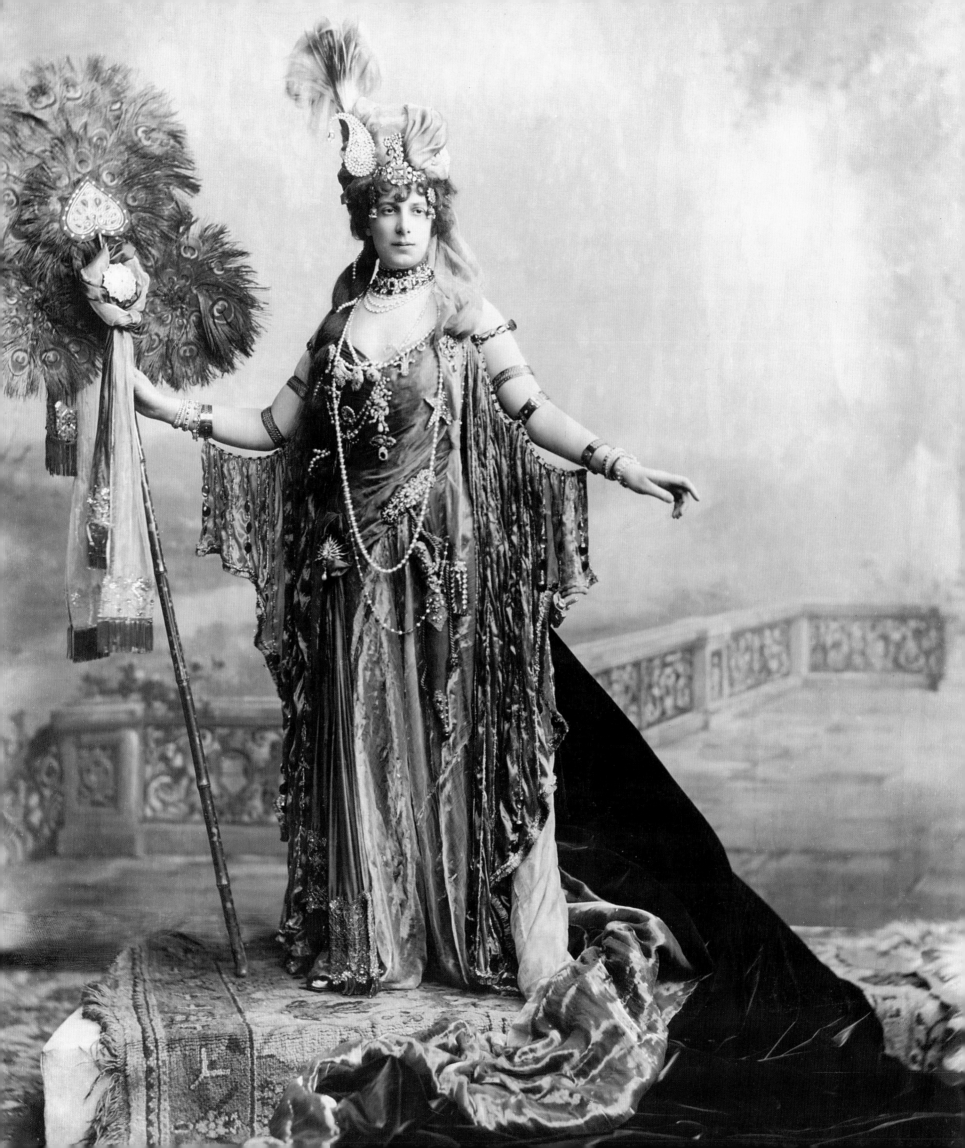

To His Royal Highness
The Prince of Wales

As the wishes of
Your Royal Highness, are a
command to me, I beg to
forward my Photograph, as
Your R. H. did me the honor,
of requesting it.

I have the honor to be,
Your Royal Highness's faithful Serv.
Nelgemma Gujputee Rao.

Madras
December 17th 1875.

FACING PAGE: LADY FEODOROWNA STURT IS PHOTOGRAPHED AS 'INDIA' IN 1900 FOR THE BENEFIT OF THE GUARDS WAR FUND DURING THE ANGLO-BOER WAR OF 1899-1902. 'SHE WAS DRESSED IN APRICOT COLOUR AND BORE BRANCHES OF HIBISCUS,' A NEWSPAPER WROTE. THE PICTURE WAS PUBLISHED IN AT LEAST THREE ILLUSTRATED NEWSPAPERS OF THE DAY.

TOP (L TO R): INDIAN ROYALTY WAS SIMILARLY BEWITCHED BY ITS WESTERN COUNTERPART. THIS YOUNG PRINCESS FROM SOUTH INDIA, NELGEMMA GUJPUTTEE RAO, WROTE A LETTER TO THE PRINCE OF WALES ON 17 DECEMBER 1875. SHE WRITES, IN FINE COPPERPLATE HAND, THAT SHE IS FORWARDING HER PHOTOGRAPH ALONG WITH IT AS THE PRINCE 'DID ME THE HONOUR OF REQUESTING IT.'

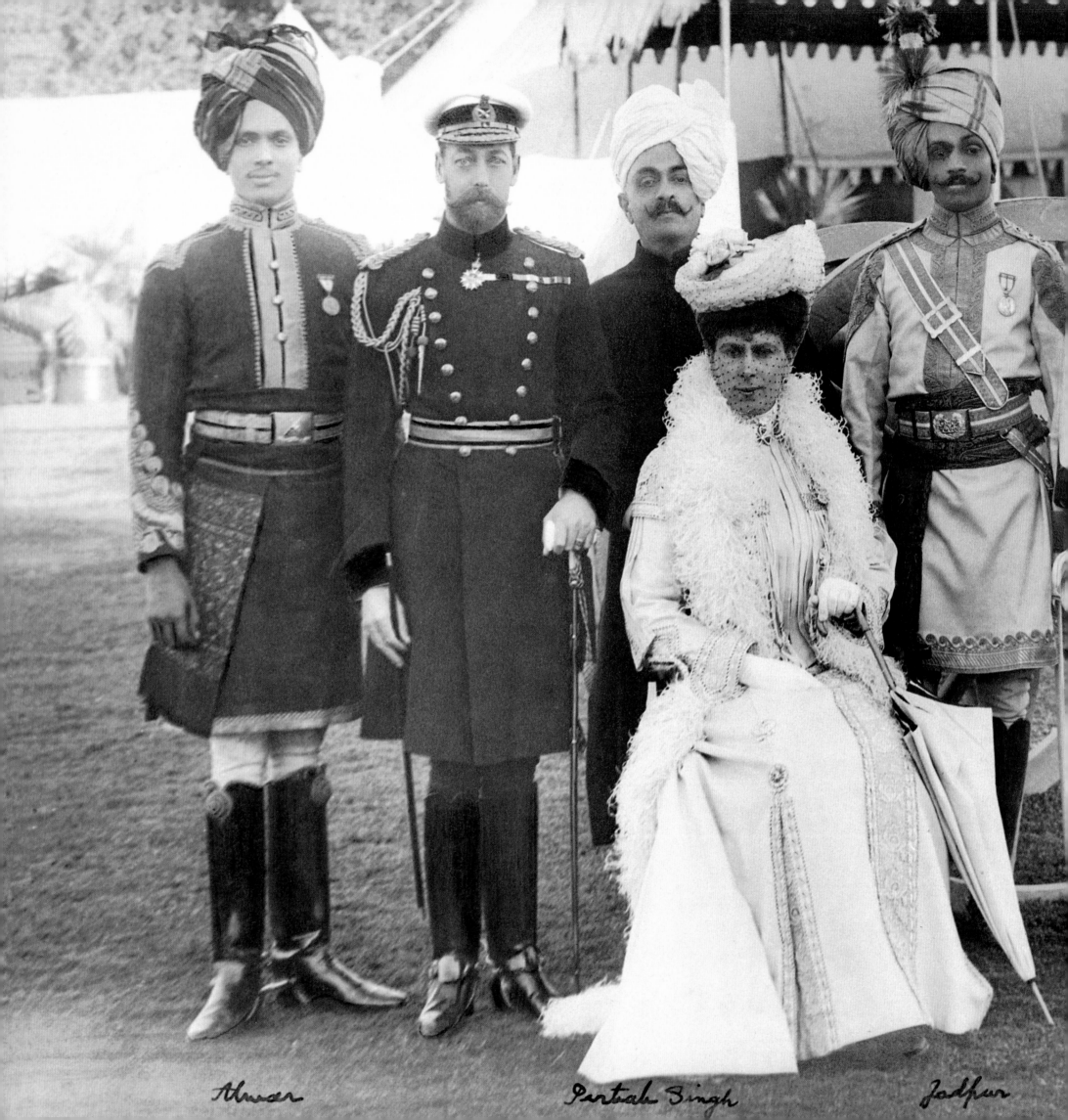

Alwar Partab Singh Jodhpur

Bikaner

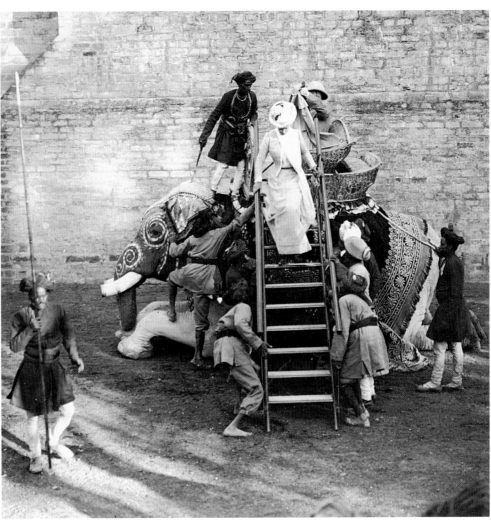

LEFT: MAHARAJA JAI SINGH OF ALWAR; SIR PRATAP SINGH, THE MAHARAJA SARDAR SINGH OF JODHPUR; AND THE MAHARAJA OF BIKANER, GANGA SINGH, WITH QUEEN MARY AND KING GEORGE V IN 1911. JAI SINGH POINTEDLY WASHED HIS HANDS WITH GANGES WATER TO 'PURIFY' THEM AFTER SHAKING HANDS WITH THE QUEEN. THIS INDISCRETION COST HIM DEAR AND HE WAS LATER FORCED TO STEP DOWN BY THE BRITISH CROWN.

TOP: THE ARRIVAL OF THE PRINCE AND PRINCESS OF WALES IN THE STATE OF GWALIOR, DECEMBER 20-25, 1905.

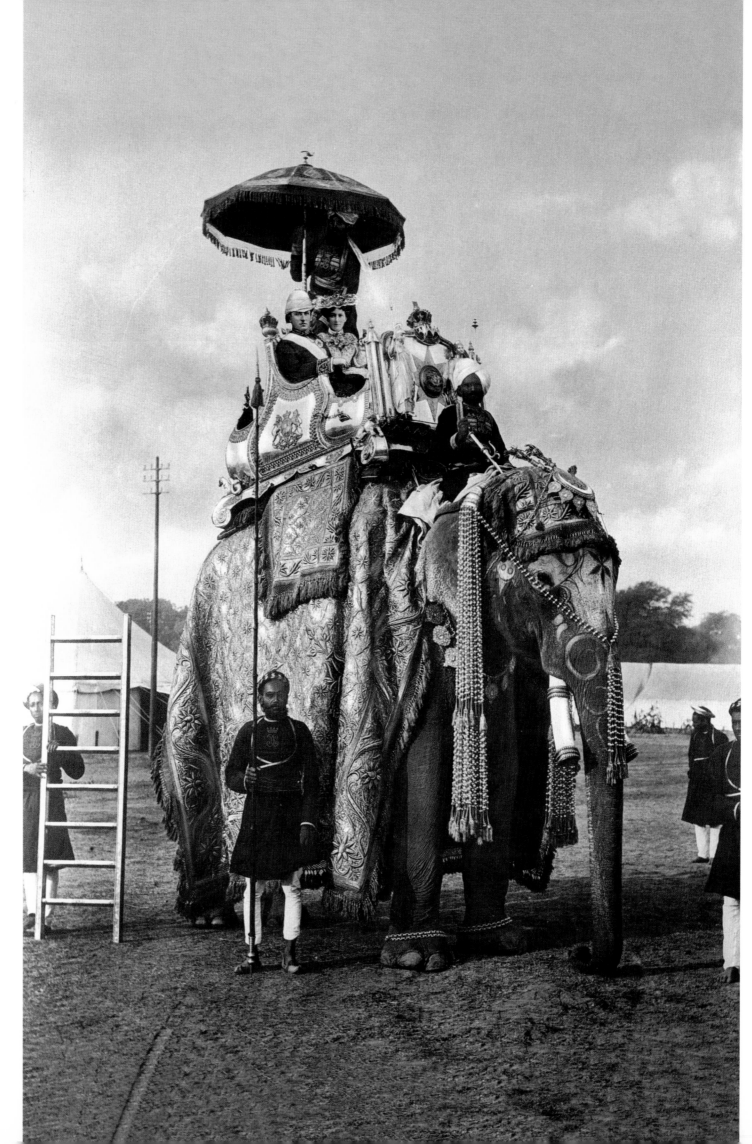

LUCHMAN PRASAD HAD
THE WEIGHTY HONOUR
OF CARRYING THE
VICEROY AND LADY
CURZON TO THE DURBAR
ARENA. OVER HIS BACK,
WAS MOUNTED A HOWDAH
OF BURNISHED SILVER
AS AN UMBRELLA OF SILK
AND GOLD HUNG OVER
THE CRIMSON, VELVET
SEATS. A SCARLET
VELVET HOUSING (JHUL),
HEAVY AND STIFF WITH
GOLD EMBROIDERY,
SWEPT TO THE GROUND.
CURZON, EVER AWARE OF
THE ROLE HE HAD IN
LIFE, HAD CHOSEN TO
RIDE AN ELEPHANT TO
EMPHASIZE THAT THE
POMP OF THE MUGHALS
WAS NOW THE PRESERVE
OF INDIA'S BRITISH
RULERS.

214

Bahadur Shah Zafar, the last of the Mughals, c. 1858. A puppet of the British, a king without a kingdom, he was asked to assume command by the *sipahis* of the revolt of 1857 who had marched to Delhi. By then a feeble old man in his eighties, Bahadur Shah was reluctant to do so but the rebels would not be deterred. The Mughal Empire was then resurrected but only for four short months. When the British reoccupied the capital, Bahadur Shah was taken prisoner and his sons murdered in cold blood. Banished to Rangoon, Bahadur Shah died a few years later in exile, unknown and unsung. He was a poet of some merit and one of the elegies he composed says:

> *'The tempest of misfortune has overwhelmed me. It has scattered my glory to the winds And dispersed my throne in the air'*

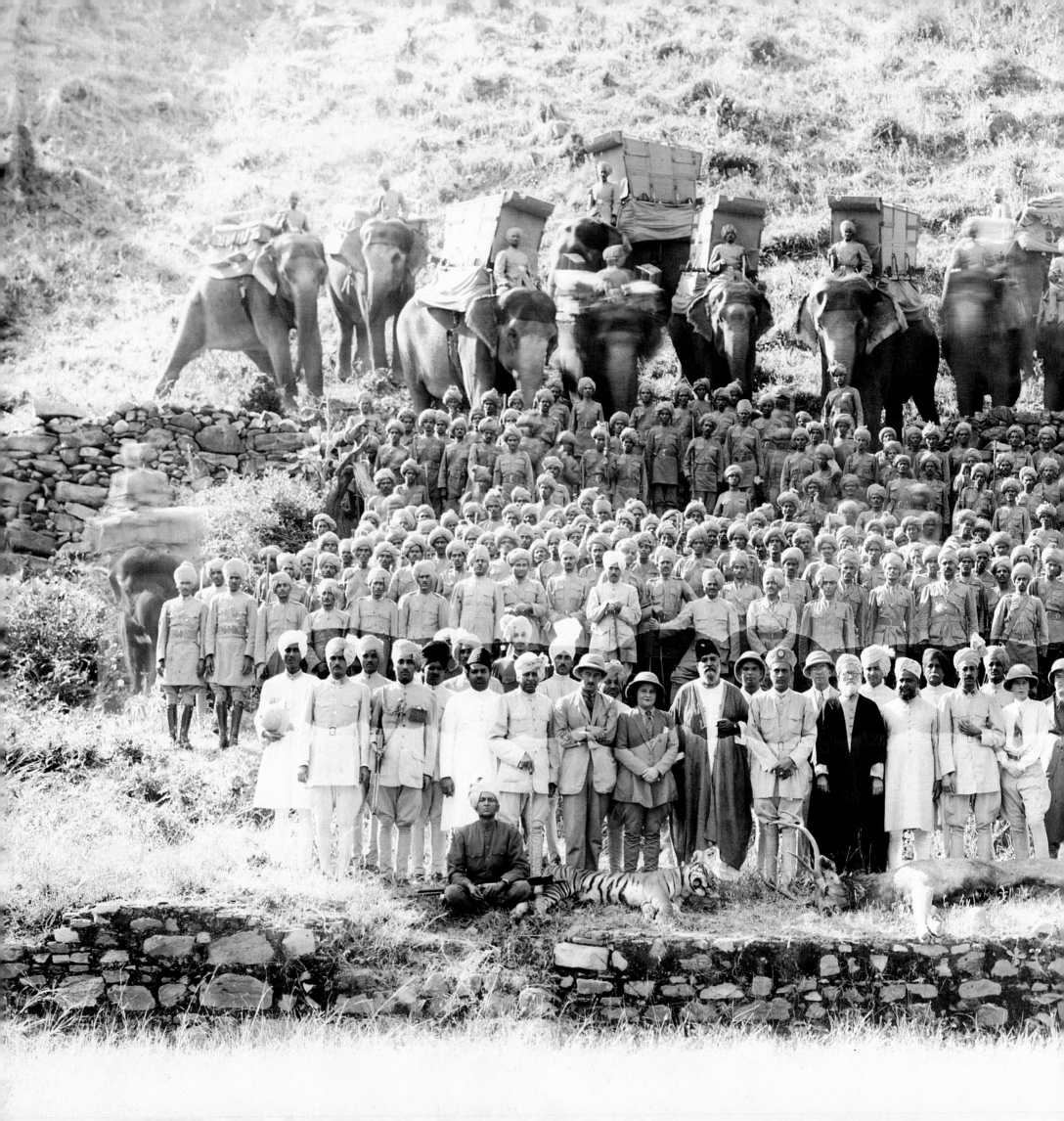

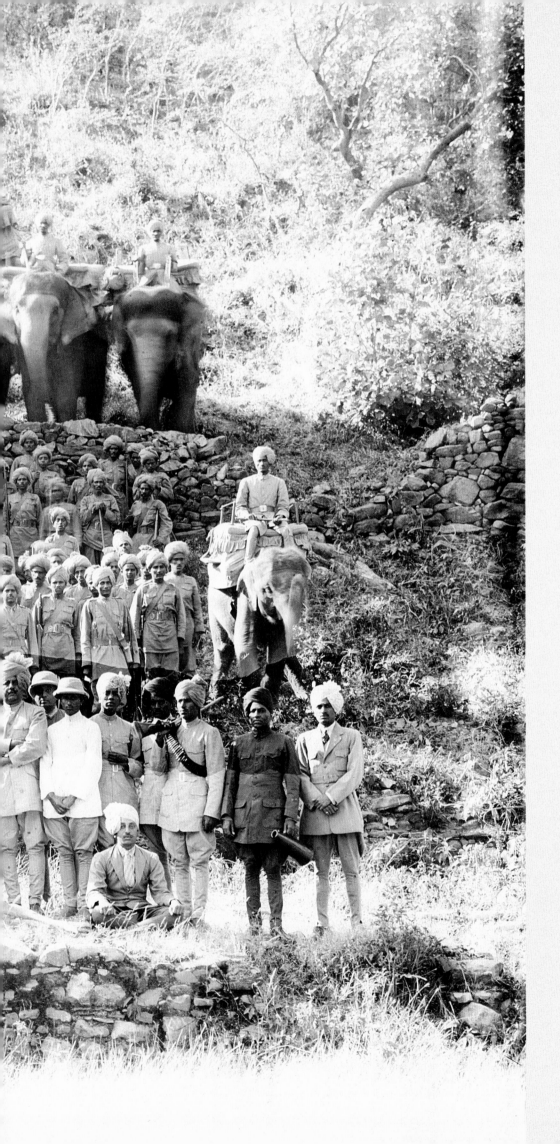

PRINCES AT PLAY

The Maharajas were the symbol and voice of authority in the subcontinent. But they quickly found themselves exercising a nominal role when the British, by trade and force, rolled over India. The Maharajas' rule had been unquestioned and supreme for so long; and now they had to bow and take their place in durbars, play host to visiting political agents and be, in their own land, subservient if noble lords.

Yet they remained overwhelmingly rich and flamboyantly ostentatious. The Raj, when it met India, got a taste of its fabled wealth (which it appropriated), its unspoilt landscapes and lush jungles. Represented in the person of the Viceroy, British suzerainty was treated to holidays where its 'love of the outdoors' was provoked and fulfilled.

Such outings took place when the Viceroy made his customary visit to the capitals of the princely states at least once a year. It was excuse enough for the Maharajas to take up an exercise in lavish catering known as the *shikar*.

Of course, the *shikar* primarily meant a hunt, but the burden of securing the graces of the Viceroy gave it a diplomatic thrust that took the adventure out of the game. For the *shikar* now had to be a *successful* hunt. The Maharajas could not afford a Viceroy who botched a shot. So, *shikar* lent itself to such mischief that favoured the hunter over the prey.

The British too had a game afoot. They encouraged *shikar*, believing it provided an outlet for the aggressive and rebellious impulses of Indian royalty. *Shikar,* in other words, was a substitute for

war. The Indian royals were set running after game less destructive to the foundations of the Raj.

The scale of the *shikar* was majestic. The shooting was always done in style: carpeted tents, champagne and caviar, Rolls-Royces on jungle paths, elephants and retainers, and thunder boxes with seats upholstered in velvet. The latest weapons were imported from the firm, Holland and Holland. The rifles and guns were laid with ivory and pearl; the gun cases were no less splendid.

The finery made the hunt into a spectacle, reducing it into nothing more than a holiday in the forest. The game was plentiful: tigers, cheetahs, pigs, ducks, and birds. Gwalior was considered great for tiger shoots, while Gajner near Bikaner was unrivalled for sand grouse, and duck shooting at Bharatpur was legendary.

In Gwalior, the best tiger country was at Shivpuri, 75 miles south of the capital. Shivpuri in fact accounts for many amusing anecdotes of the imperial *shikar* days.

In 1923, Maharaja Sir Madhavrao Scindia and the Viceroy were being taken on the narrow gauge railway belonging to the State for the hunt. The tiny train was chugging along with the Viceroy and the Maharaja ensconced in their plush saloon when it came to a sudden halt. There was commotion among the staff, and people were seen running helter-skelter. Unknown to the Viceroy, the semi-drugged tiger that was to be his trophy the next day was being taken to the hunting site in the last bogey. It had suddenly woken up and jumped off the train!

Shivpuri featured again when Lord Reading shot a tiger measuring 11 feet 5 inches—missing the world record by an inch. The ignorant applauded the feat, but the experts were sceptical. A dead tiger was measured between pegs driven into the ground at the muzzle and tip of the tail. Experts noted that only tigers shot by Viceroys had managed to extend over eleven feet. Moreover, the Viceroy's tigers were measured at Shivpuri with a special tape. It had 11 inches to a foot, so that a 10-ft imperial tiger grew to be 11 feet in front of everyone! When the trick was pointed out, Maharaja Scindia, astutely

diplomatic, grandly declared that he was answerable only to the King Emperor!

Such guile, however, was necessary. The entire prestige of the Raj and the political stake of the Maharaja concerned were at risk. The Maharaja's guests could not be seen to be novices at shooting. So, Viceroy Lord Reading learnt shooting at a rifle range—unheard of in those days—when he came to know that his state visits included *shikar* expeditions.

The British, perhaps the most avaricious hunters to set foot on Indian soil, found it full of tigers. At one time there were 40,000 tigers in India—quite a hazard. The numbers were conserved, paradoxically enough, during the *shikar* rage, as all game was the exclusive preserve of the ruler and the leading *jagirdars*. Only a handful of people could shoot in the reserved hunting grounds. No species was endangered and, in fact, the tiger population grew despite Maharajas competing to bag 500 or 1000 tigers each.

They employed two methods to kill tigers: the beat and the bait. In the first, the *shikar* party would take their positions while beaters would encircle the tiger. Drumming constantly, they would drive the tiger to the guns by closing in on the prey in decreasing circles.

The other method was to tie the bait, usually a buffalo, deep in the jungle. The hunters would sit on *machans*, or platforms tied on trees, within sight of the bait. They would wait till the tiger appeared, and then go for the kill. Occasionally, the beat and bait methods were combined.

An unusual proponent of the bait method was the Maharaja of Alwar, Jai Singh. Described as 'sinister beyond belief', he reputedly used children as bait for tigers. He even bragged that he had never lost a child, since he always got the tiger before the child came to harm.

For the connoisseurs, however, there was nothing like following the tiger on foot and under grave risk in daylight. The tiger would be sleeping in the shade or near a waterhole. The *shikari* approached it silently on foot, went down on his belly and crawled near. He waited till the cat got up and offered him a good sight, after which he took a careful shot. Here the

shikari met the tiger on fairly even terms: it was either him or the tiger. No second chances.

A century or more ago, a variant of big game hunting—hunting deer with cheetahs—was as popular. Cheetahs were captured in pits or wicker cages and trained to obey their masters. With their eyes hooded, they were carried in carts to the hunting ground. After being un-hooded and released, they used to chase and bring the deer to the ground. The hunters would ride up to the spot and coax the cheetah to loosen its grip by dangling raw meat before it. Today, the cheetah is extinct. But some states pursued the sport right up to the early 1900s.

Small game hunting was no less exciting for the British. Bharatpur and Kashmir were famous for duck shooting. At the Bharatpur lake, 40 shooting butts were built at the water's edge for the *shikaris* to take aim at the ducks coming in during their seasonal migration. A bugle signalled the shooting, with hundreds of ducks rising from the water 'with a noise like thunder'. After Independence, the Bharatpur lake was converted into a bird sanctuary—one of the finest in Asia.

The imperial grouse shoots at Bikaner were also legendary. They took place at Gajner, an enchanting lake surrounded by green forest, all in the middle of the desert. Gajner, like much else in Bikaner, was the creation of Maharaja Ganga Singh. He had butts laid out in lines 'so that the *shikaris* did not shoot each other'. It is said that the sky would turn black with birds coming at a time to drink at the lake. With two score shooters having a go, a morning's bag of 3,000 to 4,000 birds was not unusual.

The British also took, like a duck to water, to some Indian sports. They discovered polo and pig sticking, indigenous to India, and, in turn, introduced cricket and tennis.

Polo had been popular for several centuries in Manipur. In medieval times, it was played with zest in Mughal Delhi and the Rajput states. In these states even women patronized the sport. From the nineteenth century on, the princely houses of Rajasthan and the cavalry regiments promoted polo in India. In the 1930s, world-class players came from Jodhpur, Jaipur, and Ratlam. In addition Bhopal, Patiala, and some Saurashtra states produced illustrious polo players. Polo was also introduced from India into the British Isles in 1860. There it became popular with the army and the gentry.

Pig sticking, like polo, also required skilled horsemanship, strength and guts. Galloping at breakneck speed after a fast disappearing wild boar was thrilling. A sportsman of the time writes: 'I have seen some accidents from mismanagement of the spear. I have seen a man heavily thrown as a consequence of his running his spear into the ground; I have seen a rider spear his own horse and that of his companion; and any one of these accidents may occur to him who is inexpert or careless…' A boar in his prime, he adds, is 'quick and intrepid in attack; each charge it makes home to its object may leave a wound in horse or rider.' Pig sticking was extremely popular with the nobility in Jodhpur and in Kathiawar states.

What really caught the fancy of the princes however, was, cricket. In the 1920s and 1930s, there was no money in the game and sportsmen could not support themselves. The princes encouraged the game considerably by employing cricketers in the state army, police or as full-time coaches. Col. C.K. Nayudu and Mushtaq Ali worked for Holkar State, and V.S. Hazare for Baroda. Among the princes themselves there were three outstanding cricketers. The ruling family of Nawanagar produced the great 'Ranji' and his nephew Duleep Sinhji. The Nawab of Pataudi was another great cricketer. All three played for England and all scored centuries on their Test debut. Besides the Nawab of Pataudi, Iftikhar Ali Khan and his son, Mansur Ali Khan, captained India. Many princes were also enthusiastic about tennis, which was more of a social game, with tennis parties being the norm.

Thus, British culture crept slowly into the tradition of Indian hospitality with innocuous tennis tea parties, cricketing etiquette, and grand *shikars*. Indian sports and sportsmen owe a debt to these princely traditions.

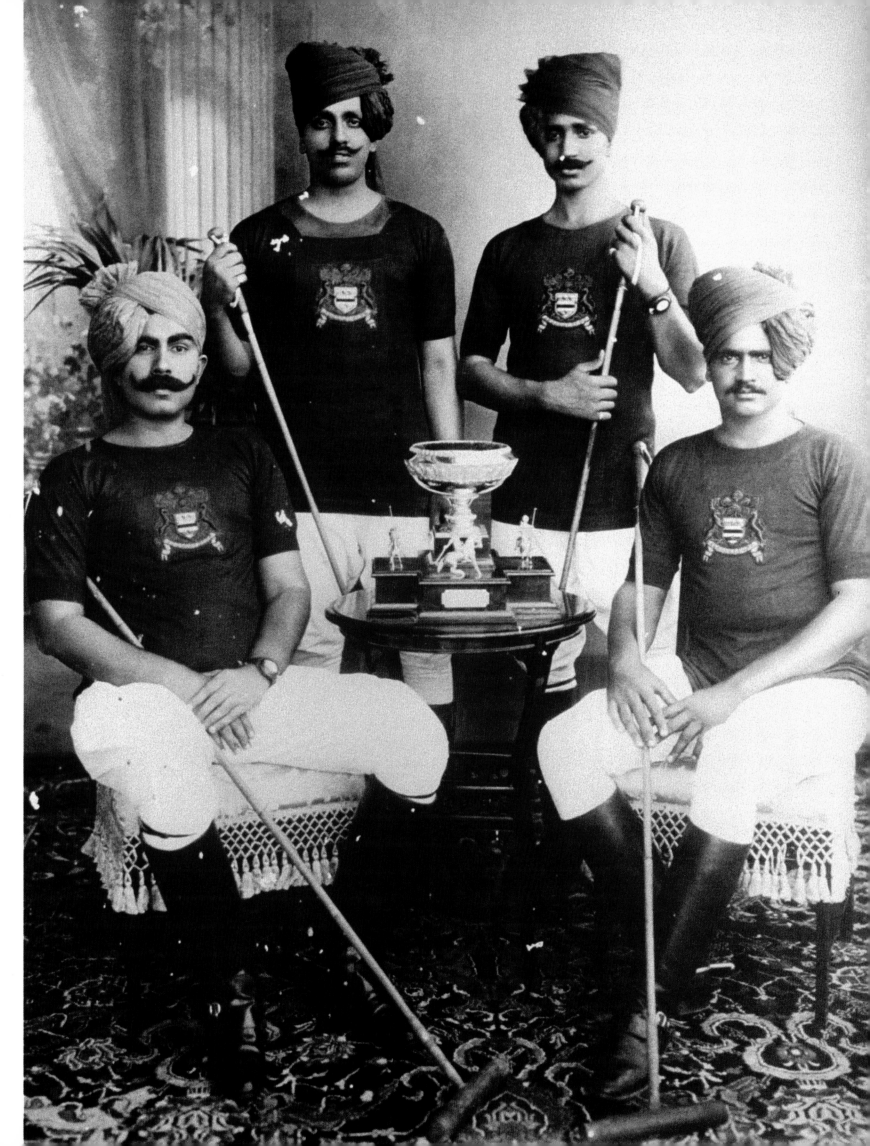

MAHARAJA GANGA SINGH OF BIKANER (SEATED LEFT) IN HIS TWENTIES WITH THE BIKANER POLO TEAM. SPORTSMAN, STATESMAN AND SOLDIER, GANGA SINGH WAS ONE OF THE MOST DISTINGUISHED RULERS OF HIS TIME (DIED 1943). POLO WAS INDIGENOUS TO INDIA, AND HAD BEEN PLAYED IN EASTERN INDIA FOR CENTURIES. IN MEDIEVAL TIMES IT WAS PLAYED WITH ZEST IN MUGHAL DELHI AND THE RAJPUT STATES, WHERE EVEN THE WOMEN PATRONIZED THE SPORT. POLO WAS INTRODUCED FROM INDIA INTO THE BRITISH ISLES AROUND 1860.

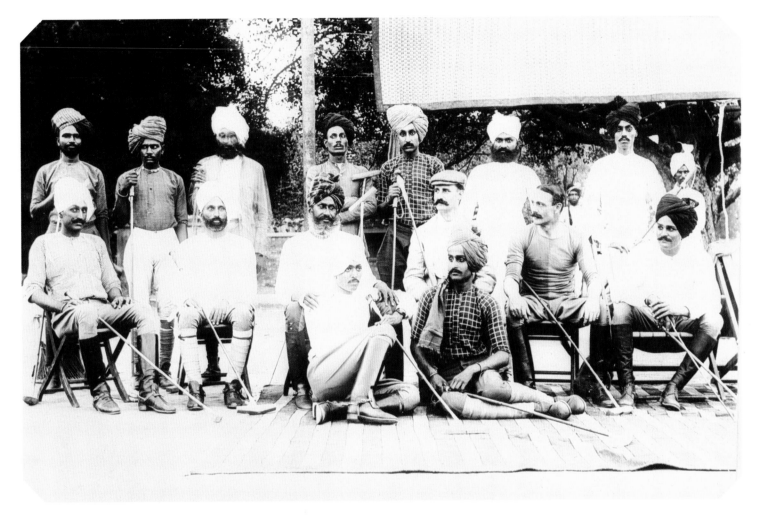

AN 1898 CLUB
PHOTOGRAPH OF
UNIDENTIFIED POLO
PLAYERS. (*FRONT ROW,
FROM LEFT TO RIGHT*):
MAHTAB, RUPJI, NARAIN,
FRANK, COOKSOM, AND
BHOORJI. SEATED ON
THE GROUND ARE DEVAJ
AND PARTAB.

BELOW: MAHARAJA
UMAID SINGH OF
JODHPUR *(SEATED
CENTRE)*, SAWAI MAN
SINGH OF JAIPUR
(SECOND FROM LEFT),
PRITHVI SINGH OF BARIA
(STANDING FIRST LEFT),
AND RAO RAJA HANUT
SINGH *(SEATED EXTREME
RIGHT)* WERE HIGH
HANDICAP PLAYERS AND
AMONG THE BEST IN THE
WORLD.

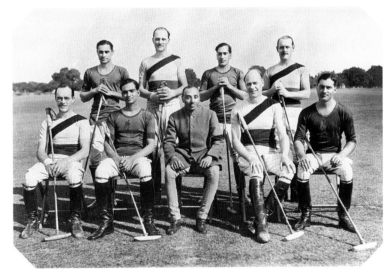

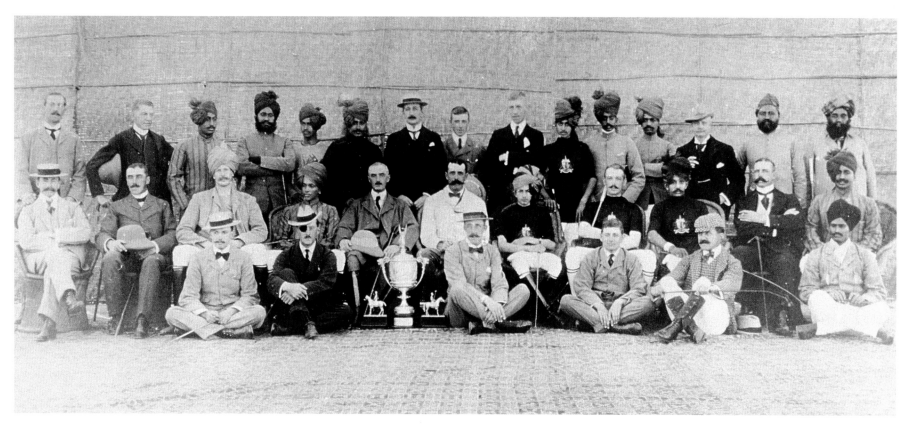

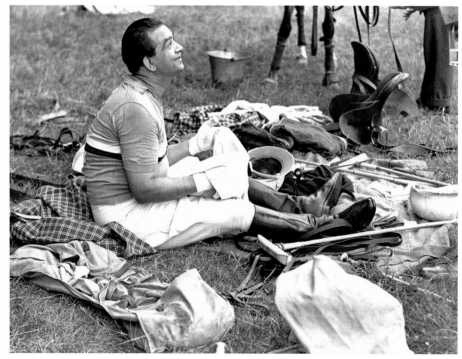

TOP: GROUP PHOTOGRAPH TO MARK A POLO TOURNAMENT AT NASEERABAD WON BY THE ALWAR TEAM, IN 1899 OR 1900. MAHARAJA JAI SINGH OF ALWAR IS SEATED FOURTH FROM THE LEFT.

RIGHT: SAWAI MAN SINGH OF JAIPUR TAKES A REST BETWEEN *CHUKKARS* AT A MATCH AT ROEHAMPTON, 6 JUNE 1965. THE MAHARAJA OF JAIPUR WAS PERHAPS HAPPIEST WHEN PLAYING POLO. FITTINGLY, HE DIED ON A POLO GROUND AT CIRENCESTER, ENGLAND, ON 24 JUNE 1970.

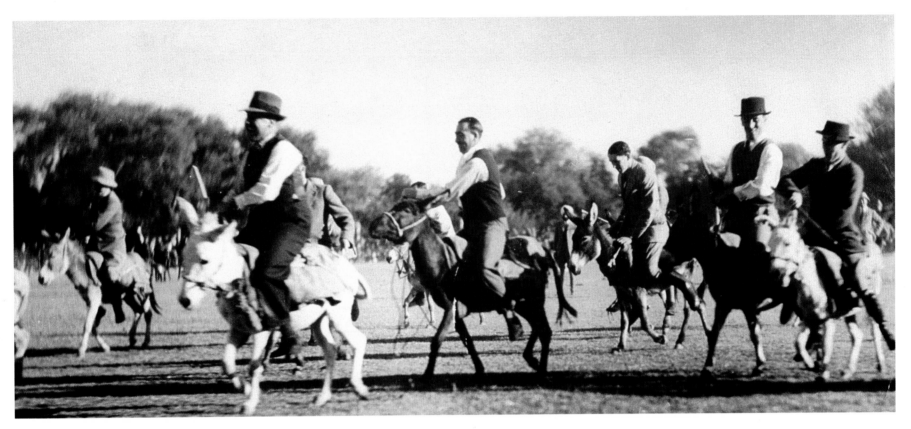

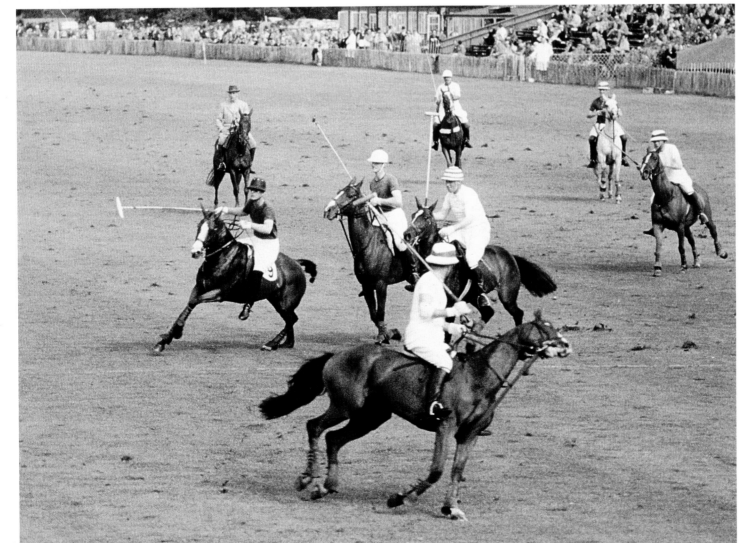

ABOVE: GYMKHANA CLUBS WERE SET UP BY THE BRITISH FOR PROMOTING SOCIAL INTERCOURSE BETWEEN THE INDIANS AND THE EUROPEANS. THEY WERE THE VENUE OF RACES, TOURNAMENTS AND FRIENDLY MATCHES. OCCASIONALLY, AS HERE, THEY WERE ALSO SCENES OF LIGHT-HEARTED BANTER WHEN A POLO MATCH ON ASSES WAS ARRANGED ON PAGAL (LITERALLY MAD) GYMKHANA DAYS.

LEFT: A GAME OF POLO AT THE FAMOUS JAIPUR POLO GROUNDS.

223

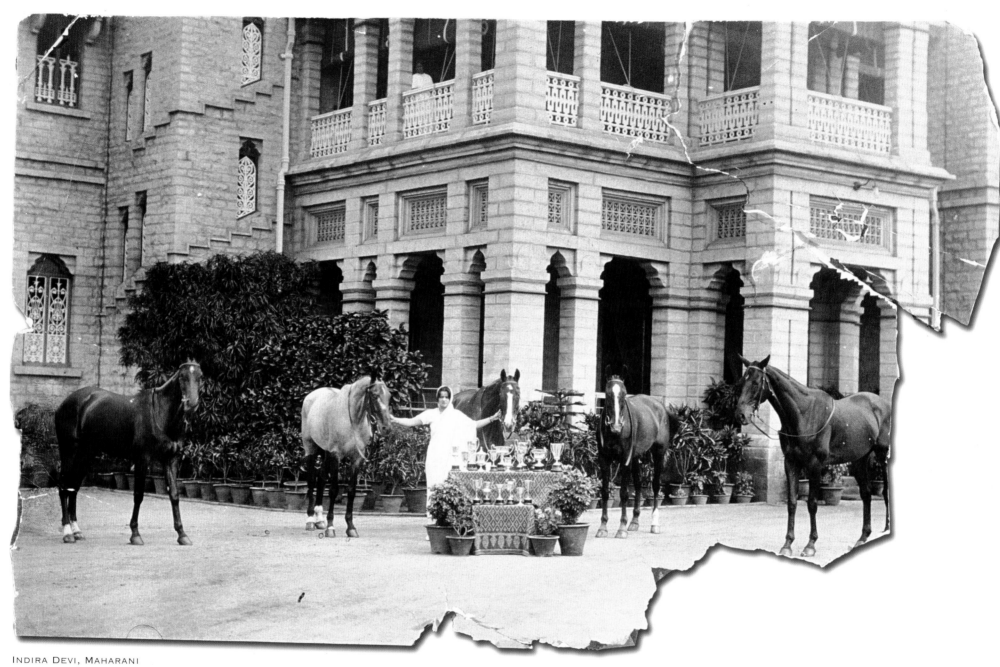

INDIRA DEVI, MAHARANI
OF COOCH BEHAR, IN
BANGALORE IN 1926. SHE
PROUDLY DISPLAYS THE CUPS
WON BY HER HUNTERS AT
THE HORSE SHOW.

MAHARANI GAYATRI DEVI
OF JAIPUR (THE
DAUGHTER OF INDIRA
DEVI OF COOCH BEHAR)
LOVED RIDING. HER
EARLY DAYS AT COOCH
BEHAR INVOLVED
REGULAR, NEARLY
DAILY, HORSE RIDING
AFTER WHICH CAME
BREAKFAST AND
CLASSROOM LESSONS
AT THE PALACE.

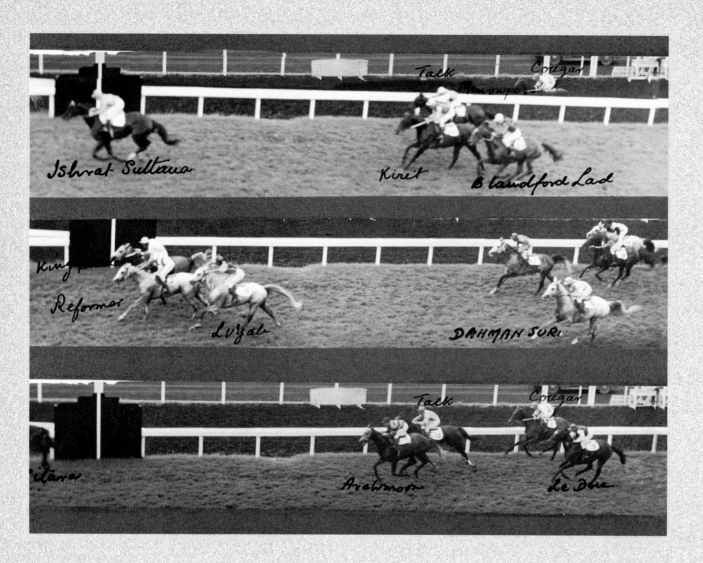

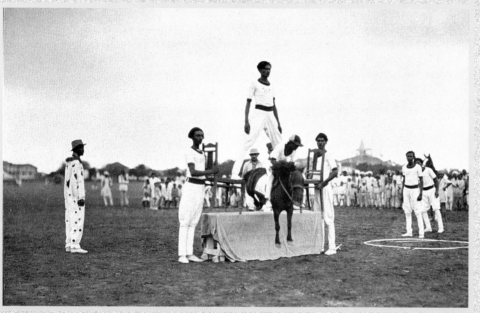

MOST PRINCELY STATES IN INDIA WERE RENOWNED FOR THEIR STABLES AND RACE HORSES. RAJINDAR SINGH OF PATIALA, MADHO RAO OF GWALIOR, INDIRA DEVI OF COOCH BEHAR AND HER DAUGHTER GAYATRI DEVI OF JAIPUR WERE ALL GREAT PROMOTERS OF EQUESTRIAN SPORTS, SUCH AS POLO AND HORSE-RACING.

LEFT: SHOW-JUMPING, POSSIBLY AT A SPORTS DAY CELEBRATION AT ONE OF THE PRINCELY SCHOOLS.

TOP LEFT: HORSE RACING IN GWALIOR. SOME OF THE FAMOUS RACE HORSES OF THE GWALIOR STATE WERE: ISHIVAL, SULTANA, KILVITH, REFORMER, DEHRMAN SURI, SITAVA, TOP, AND FLOWER.

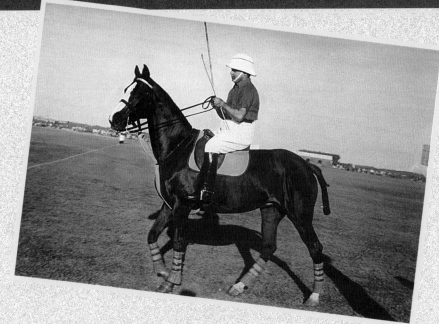

CONTEMPORARY POLO
IS AN ELEGANT SPORT
THAT DRAWS THE ELITE.
GONE ARE THE DAYS OF
THE ALL-WHITE
SPORTSWEAR; A
REMOTE AUDIENCE,
MUCH LARGER IN SIZE
THAN THE ONE THAT
SITS IN THE PAVILION,
AND WHICH SITS IN
FRONT OF THE
TELEVISION SET HAS
BROUGHT COLOUR AND
DRAWN IN CORPORATE
SPONSORS TO THE
GAME. THE PRIZE
MONEY HAS INCREASED
LAVISHLY. THE WINNER,
AS EVERYWHERE ELSE,
TAKES IT ALL.

INDIA IS STILL THE ONLY
COUNTRY IN THE WORLD
WHICH BOASTS OF A
CAMEL CAVALRY. THE
MOST FAMOUS CAMEL
CORPS WAS THE ONE
THAT WAS RAISED IN
BIKANER. THE RIDERS
WERE SKILLED IN THE
ART OF TRAINING THEIR
DESERT MOUNTS.
CAMELS FIND IT
EXTREMELY DIFFICULT
TO JUMP: THEIR LEGS
ARE TOO THIN TO TAKE
THE IMPACT. HOWEVER,
THE OFFICERS OF THE
BIKANER CAMEL CORPS
HAD TRAINED THEIR
BEASTS TO SUCH
PERFECTION THAT THEY
COULD LEAP OVER
HURDLES ALMOST AS
GRACEFULLY AS A
HORSE. THE GANGA
CAMEL CORPS, NAMED
AFTER MAHARAJA GANGA
SINGH OF BIKANER, WAS
ACKNOWLEDGED AS THE
FINEST CAVALRY CORPS
OF ITS KIND AND SAW
ACTION IN THE CHINA
WAR OF 1900.

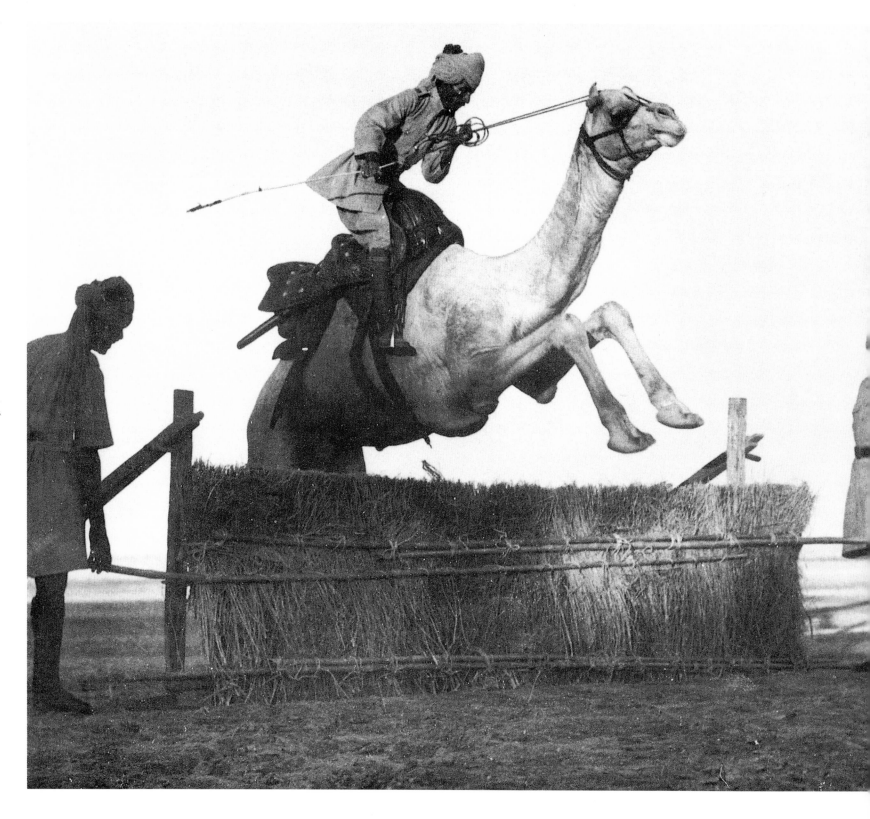

AFTER THE POLO
SEASON IN LONDON WAS
OVER, THE HORSES
WERE SHIPPED BACK
TO INDIA. THIS
PHOTOGRAPH SHOWS
HOW OFTEN ANIMALS
WERE MORE IMPORTANT
TO ROYAL OWNERS THAN
THE MEN WHO LOOKED
AFTER THEM. HERE AT
LEAST TEN GROOMS TRY
TO PERSUADE A SMALL
PONY INTO A HORSE BOX.
EVERYONE SEEMS TO
BE ENJOYING THE
SPECTACLE, EXCEPT THE
PONY! THE PHOTOGRAPH,
DATED 9 SEPTEMBER
1933, WAS TAKEN WHEN
55 POLO PONIES
BELONGING TO JAIPUR
WERE BEING SHIPPED
FROM THE ROYAL
ALBERT DOCKS IN
BRITAIN.

WRESTLING WAS A
POPULAR FORM OF
ROYAL ENTERTAINMENT.
TRADITIONALLY, INDIAN
WRESTLING TOOK PLACE
IN *AKHARAS*, CIRCULAR
MUD PITS. THE MUD
ENCLOSURE WAS NOT
MARKED OFF BY ROPES,
AND CURIOUS
SPECTATORS AS WELL AS
ROYALTY SAT CLOSE TO
THE RING TO GET INTO
THE THICK OF THE
ACTION. THE ROYAL
PATRONS, OF COURSE,
HAD THE RINGSIDE VIEW.

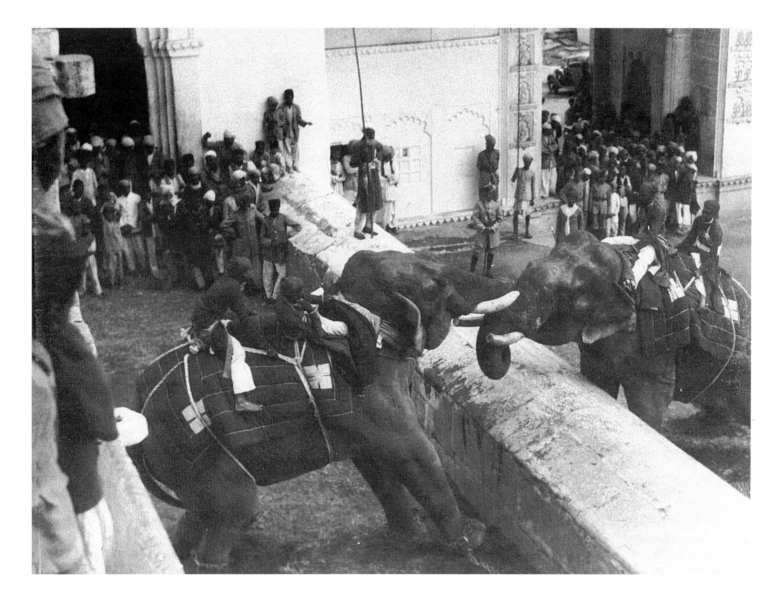

A Fight between the colossus. Two elephants with their feet tied to a wall by thick iron chains come close to blows. Their tusks do the talking as the Mahouts on the back struggle to control their angry beasts.

CRICKET IS ENGLAND'S ABIDING LEGACY TO INDIA. APART FROM THE FAMOUS JAMSAHIB, RANJITSINHJEE OF JAMNAGAR, THERE WERE SEVERAL INDIAN PRINCES WHO DISTINGUISHED THEMSELVES ON THE CRICKET FIELD. MAHARAJA RAJINDAR SINGH OF PATIALA WAS THE FIRST INDIAN MAHARAJA TO ENGAGE PROFESSIONAL COACHES FOR HIS TEAM. HE ALSO SET UP THE WORLD'S HIGHEST CRICKET FIELD IN CHAIL.

ABOVE: MANSUR ALI KHAN, THE NAWAB OF PATAUDI (POPULARLY CALLED 'TIGER') IN A PEAKED CAP, AS A SCHOOLBOY IN ENGLAND. BOTH TIGER AND HIS FATHER WERE WELL-KNOWN CRICKETERS AND PLAYED FOR INDIA. MANSUR ALI KHAN WAS THE CAPTAIN OF THE INDIAN TEAM.

FACING PAGE: HIS FATHER, IFTIKHAR ALI, WAS A DASHING FIGURE AND IS SEEN AGAINST THE SCOREBOARD OF A HISTORIC MATCH BETWEEN AUSTRALIA AND ENGLAND WHERE HE SCORED A CENTURY. *BOTTOM RIGHT:* A STUDIO PORTRAIT OF IFTIKHAR ALI PATAUDI IS INSCRIBED 'TO MY DARLING FROM HER SLAVE' IN 1930.

THE PATIALA XI. THE
FAMOUS CRICKET
GROUND OF CHAIL, AT
7,500 FEET ABOVE SEA
LEVEL, WAS THE
AVENUE FOR MAHARAJA
BHUPINDAR SINGH OF
PATIALA IN SUMMER
WHEN HE WANTED TO
WIELD THE WILLOW.
CHAIL, WHICH BOASTS
OF THE HIGHEST
CRICKET GROUND IN
THE WORLD, DREW
VICEROYS, GOVERNORS,
PRINCES AND
CRICKETERS. MAHARAJA
RAJINDAR SINGH, WHO
CREATED THIS MARVEL,
CHOPPED OFF SEVERAL
TOWERING HIMALAYAN
CEDARS TO MAKE SPACE
FOR THIS FIELD.

FACING PAGE
LEFT: A CRICKET SCENE
FROM AN ALBUM.
RIGHT: DULEEP SINHJI
(1905–1959), A
PRINCELY CRICKETER
FROM NAWANAGAR,
PLAYED FOR ENGLAND
AND SCORED A TON ON
HIS DEBUT.

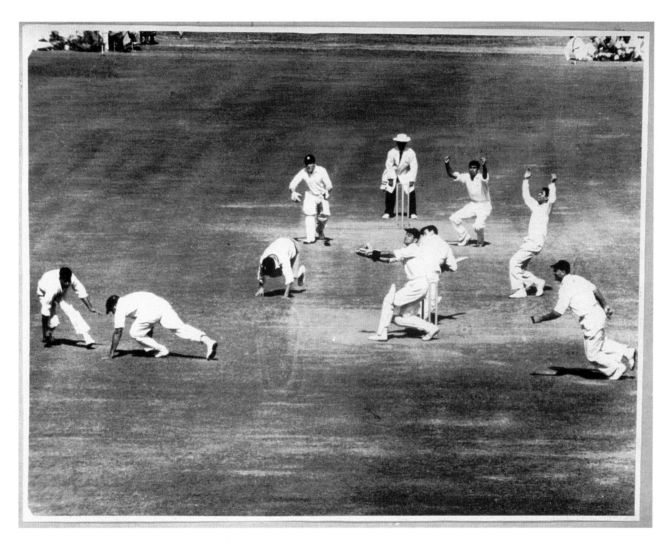

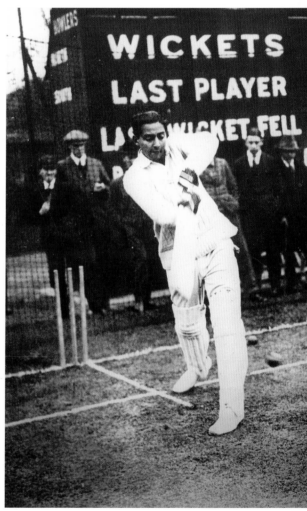

235

IN MOST PRINCELY STATES, MARRIAGE ALLIANCES WERE FIXED WHILE THE BRIDE AND GROOM WERE MERE CHILDREN. MATRIMONIAL ALLIANCES WERE ARRANGED BY THE ELDERS AND IN MANY CASES, DEPENDED ON THE PURITY OF BLOODLINES AND THE DOWRIES THAT BRIDES WERE GIVEN. HOROSCOPES WERE MATCHED BY THE FAMILY PRIESTS AND LENGTHY DISCUSSIONS PRECEDED THE SETTING OF AN AUSPICIOUS DATE FOR THE WEDDING ITSELF. FEW EVENTS COULD OUTSHINE THE POMP AND SPLENDOUR OF A ROYAL WEDDING. SPREAD OVER DAYS, SOMETIMES EVEN MONTHS, THE WEDDING CEREMONY WAS HELD IN THE BRIDE'S KINGDOM AND THE *BARAAT* (THE GROOM'S PARTY) WAS GIVEN A ROYAL WELCOME. THE WEDDING PROCESSION ITSELF WOULD BE A GRAND AFFAIR WITH ELEPHANTS, HORSES, TROOPS, STANDARD BEARERS, MUSICIANS AND BANDS MARCHING TO THE BRIDE'S HOUSE THROUGH THE STREETS, LINED WITH SPECTATORS. FIREWORKS LIT THE SKY AND COINS AND FLOWERS WERE STREWN ON THE PATH OF THE GROOM'S PARTY.

FACING PAGE: FANS KEEP A SUMMER DURBAR COOL.

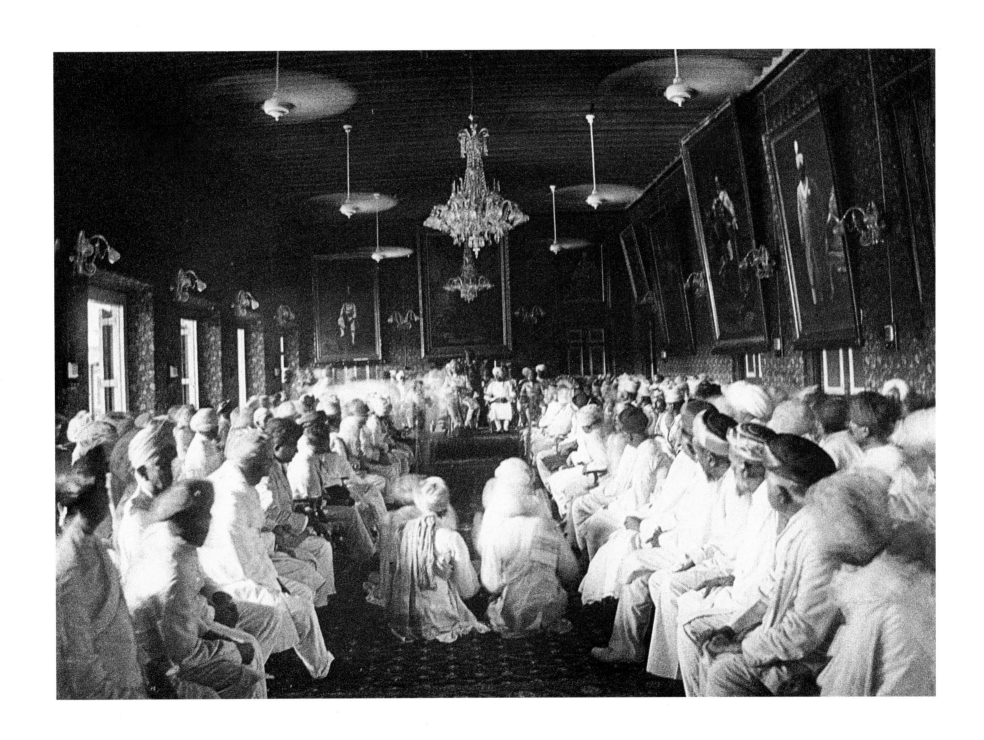

While the British were ruling the roost in India, an Indian cricketer was bowling the English over on their home pitch. While the Indian masses had to stand up against the English baton, an Indian royal was wielding the willow with supple wrists to spirit the red cherry to the boundary.

His name was Ranjitsinhjee, and he was the Jamsahib of Nawanagar. He is said to be the greatest cricketer of his day, the secret of his magic still undiscovered. He played in the late decades of the nineteenth and early twentieth centuries, when there was no video and, thus, no footage for posterity.

Ranjitsinhjee made his debut on the sporting green in the early 1890s. Even though by 1892 he was without doubt the best batsman at Cambridge he was not given his Blue. Many felt that an Indian, however high ranking, should not be encroaching that very English preserve—the cricket pitch. Ranjitsinhjee was, however, too good to be denied. By the summer of 1893, he was given his Blue.

Selection to the English team followed. But, it had the adverse effect of botching his career. An MCC committee member, an admirer of Ranji, was abused by a fellow member for having 'the disgusting degeneracy to praise a dirty black'. The prejudice did not last long because it was soon apparent that Ranji's batting was 'magical.' In 1896, the Australians were in England and in his first Test at Old Trafford, Ranji scored 62 and 154 not out. His second innings, when England was in a losing position on a fiery wicket, was considered the best he ever played.

That season he headed the first class averages, scoring 2,780 runs. It was the highest aggregate ever recorded. In 1899 he broke his own record scoring 3,159 runs and an year later he scored

AN EASY ONE FOR THE BLACK PRINCE.

["Up to last Thursday (August 24) Prince RANJITSINHJI had scored 2,780 runs during the season—'the highest aggregate ever made.' 'He will probably now make 3,000 runs during the cricket year of 1899.'"—*Daily Chronicle*.]

AUGUST 30, 1899.] PUNCH

3,065 runs. At this point, the three highest aggregates ever made stood in his name. Most of these runs were made for Sussex while he was partnered with C. B. Fry.

During his career he scored 24,567 runs at an average of 45 with 72 centuries. Ranji had surpassed every batsmen before him. Punch magazine gave him the nickname 'Run-Getsingji.' In later years his duties as the Jamsahib often limited his appearances on the field. In his last appearances after World War I, he had sight in only one eye.

The way Ranji made his runs caught the public's imagination. The highly esteemed cricket writer Neville Cardus wrote: 'For Ranjitsinhjee cricket was of his own country; when he batted a strange light was seen for the first time on English fields, a light out of the East. It was lovely magic and not prepared for by anything that had happened in cricket, before Ranji came to us.'

The game was basically English, almost Victorian. W.G. Grace had stamped on cricket the English mark. As Cardus Neville wrote: 'It was the age of simple first principles, of the stout respectability of straight bat and good length ball. When suddenly this vision of a dusky, supple legerdemain happened, a

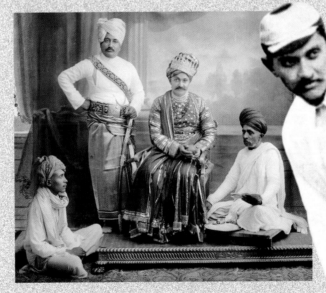

RANJI, OR RANJITSINHJEE, THE JAMSAHIB OF NAWANAGAR, SCORED NEARLY 24, 567 RUNS DURING HIS CAREER. THE RANJI TROPHY IS NAMED AFTER THIS LEGENDARY CRICKETER. RANJI WAS EQUALLY COMFORTABLE IN THE ROLE OF A MAHARAJA, WEARING A TURBAN AND NECKLACE, AS HE WAS WEARING A SUIT, ATTENDING A BANQUET IN INDIA OR CYCLING IN ENGLISH LANES IN PLUS-FOURS. THE ENGLISH MAGAZINE *PUNCH* DUBBED HIM 'THE BLACK PRINCE'.

man was seen playing cricket as no Englishman could have played it. The straight bat did not meet the good length ball, but with a flick of the wrist, the ball was charmed away to the leg boundary . . . I once asked Ted Wainwright, the Yorkshire cricketer, what he thought of Ranji, and Wainwright said, "Ranji, he never made a Christian stroke in his life."

Commentators say that Ranji saw the ball quicker than any other batsman of the day and he made his strokes late. That late movement confounded bowlers, fast and spin alike. The leg glance became Ranji's own stroke and his cut was in itself the single shot that made a dazzling show of batsmanship.

As Neville Cardus said, 'Ranji did not so much bat for us as to enchant us, bowlers and all, in a way all his own'. Not only was Ranji's batting mesmeric, he was also famous for his 'panther-like spring at any fielding chance'—a trait that Tiger Pataudi was to show, too.

In England, Ranji was very much the English gent. He enjoyed entertaining lavishly at his home in Stains. However, when the occasion arose he duly assumed his duties as an Indian prince, which he took seriously. He was elected Chancellor of the Chamber of Princes and was India's representative at the League of Nations. There is no doubting the swiftness of his intelligence any more than the quickness of his eye. Ranji died in 1933 when he was in his early sixties.

239

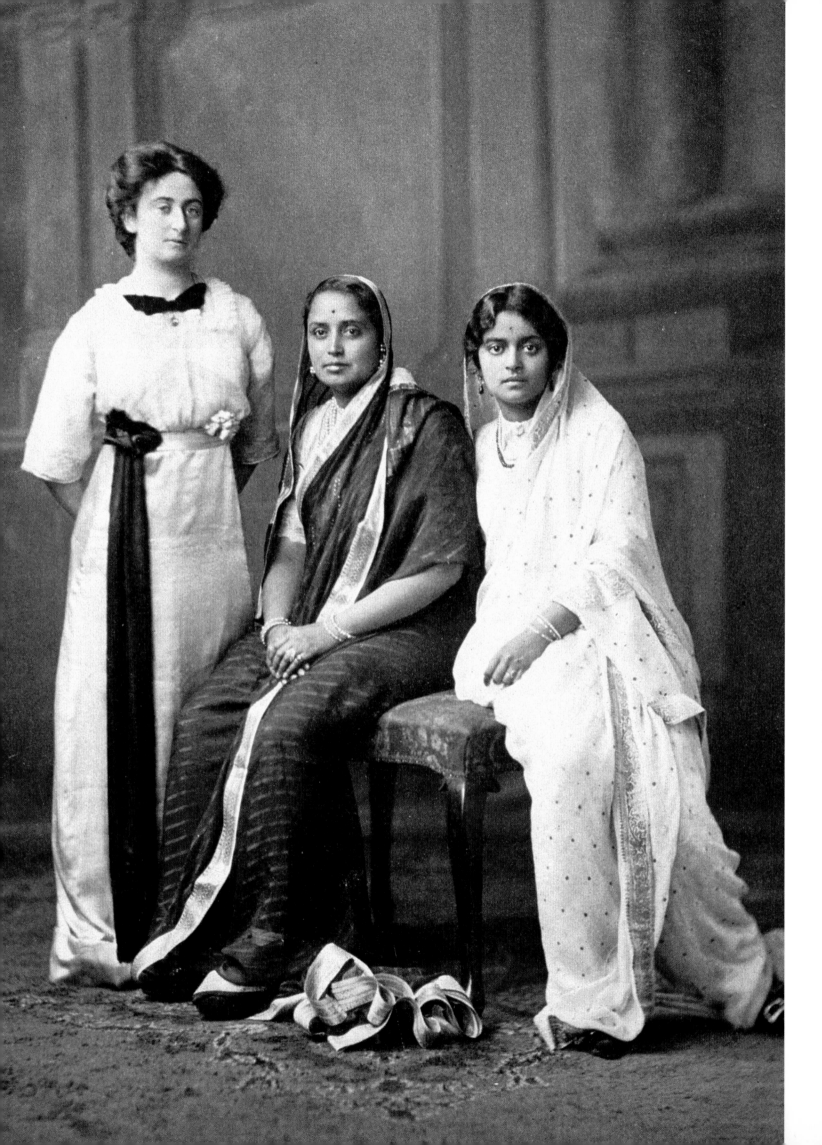

MAHARANI CHIMNABAI OF BARODA WITH HER DAUGHTER INDIRA DEVI, LATER MAHARANI OF COOCH BEHAR, ON HER LEFT. CHIMNABAI'S HUSBAND, MAHARAJA SAYAJI RAO, WAS PROBABLY THE ONLY INDIAN PRINCE WHO NEVER KEPT A MISTRESS. THEY REMAINED HAPPILY MARRIED FOR FIFTY YEARS. SAYAJI RAO HIRED TUTORS FOR HER AND ENCOURAGED HER TO FREE HERSELF OF THE TRADITIONAL BONDS THAT SHACKLED THE ROYAL LADIES OF HER TIME. THE RESULT WAS THAT CHIMNABAI EMERGED AS AN IMPORTANT LEADER OF THE WOMEN'S MOVEMENT IN INDIA. SHE BECAME THE PRESIDENT OF THE ALL-INDIA WOMEN'S CONFERENCE AND AN EFFECTIVE SPOKESPERSON FOR WOMEN'S RIGHTS. SHE AUTHORED A BOOK ON THE SUBJECT, MAKING HER OWN LIFE AN EXAMPLE OF WHAT WOMEN CAN DO IF THEY ADOPT LIBERAL AND PROGRESSIVE IDEAS.

MAHARANI CHIMNABAI
GAEKWAD OF BARODA,
MARCH 1914.
BEAUTIFUL AND
TALENTED, SHE WAS ONE
OF THE FINEST SHOTS
AMONG WOMEN IN INDIA.
SHE IS SEEN HERE
SURROUNDED WITH A
SHIKAR PARTY
OF BEATERS. DESPITE
HER PROGRESSIVE
IDEAS, HOWEVER, SHE
ALWAYS WORE THE
TRADITIONAL SARI AND
COVERED HER HEAD, AS
BEFITS A MAHARANI.
HER GRANDDAUGHTER
MAHARANI GAYATRI DEVI
OF JAIPUR REMEMBERS
THAT CHIMNABAI'S
KITCHEN WAS
RENOWNED FOR ITS
PICKLES AND THE HUGE
SUCCULENT PRAWNS
FROM THE BARODA
ESTUARIES. SHE
PERSONALLY
SUPERVISED THE FOOD
IN THE KITCHENS AND
TOOK GREAT CARE TO
EDUCATE THE PALACE
COOKS ON THE TASTES
OF FOREIGN VISITORS
AND GUESTS.

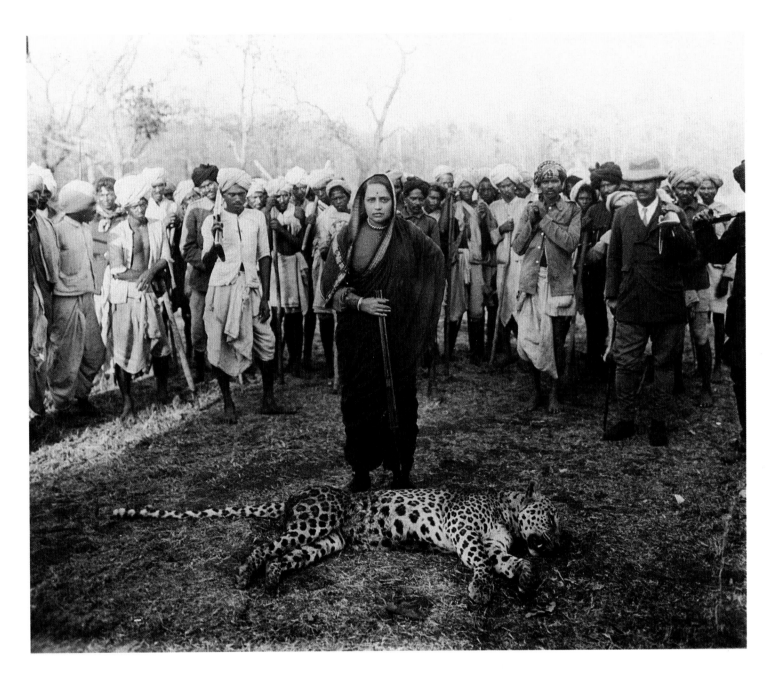

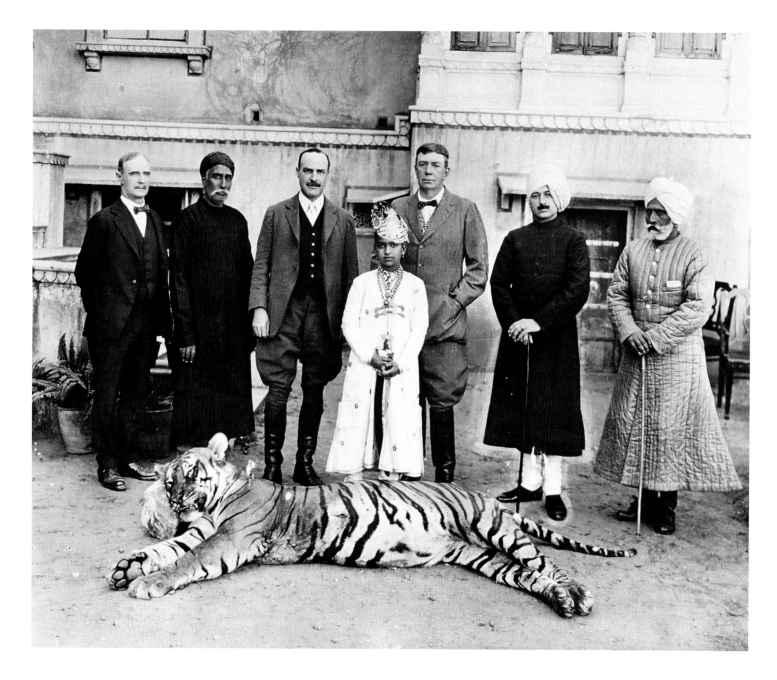

SHIKAR, OR HUNTING, WAS BY FAR THE FAVOURITE SPORT OF THE INDIAN PRINCES. TRAINED TO HANDLE GUNS EARLY IN LIFE, MANY OF THEM WERE MARKSMEN OF INCREDIBLE SKILL. THIS PHOTOGRAPH FROM THE EARLY 1920S, SHOWS MAN SINGH II OF JAIPUR, WITH A TIGER SHOT BY HIM. THE DRY SCRUBLAND AROUND THE ARAVALLI HILLS IN THIS AREA HAD ABUNDANT WILDLIFE. ONE OF THE MOST FAMOUS HUNTING AREAS WAS SARISKA, NEAR JAIPUR, THE PRIVATE HUNTING GROUND OF THE ALWAR ROYAL FAMILY THAT WAS FREQUENTED BY OTHER ROYAL HUNTERS. AMONG THE WILDLIFE FOUND HERE WERE THE TIGER, THE CHITAL (A SPOTTED DEER) AND GREY PARTRIDGES. FOLLOWING AN ALARMING DECREASE IN ITS TIGER POPULATION, SARISKA WAS DECLARED A PROTECTED AREA IN 1979. ALL HUNTING IS NOW BANNED BY LAW.

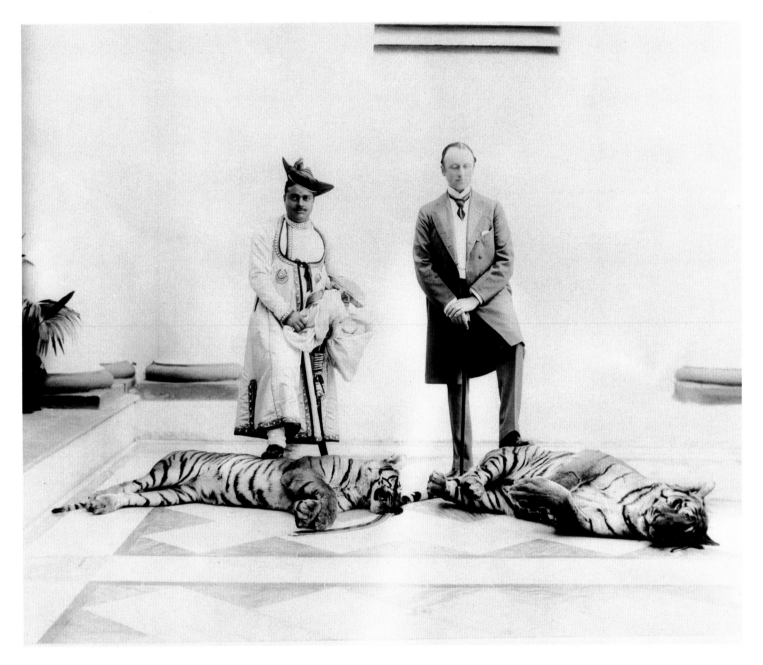

A TIGER SHOOT WAS *DE RIGEUR* FOR ALL VISITING ENGLISH GUESTS TO A PRINCELY STATE. THERE ARE SEVERAL INTERESTING STORIES OF HOW TIGERS WERE DRUGGED FOR THEIR ROYAL SHIKARIS TO BE ABLE TO 'SHOOT' THEM.

LEFT: MAHARAJA MADHAVRAO SCINDIA OF GWALIOR AND LORD CURZON IN 1902 WITH THE FIRST TIGER THE VICEROY EVER SHOT. GWALIOR'S TIGER SHOOTS WERE QUITE SPECIAL. MADHAVRAO MEASURED THE TIGERS SHOT BY VICEROYS WITH A SPECIAL TAPE THAT HAD 11 INCHES TO A FOOT. WHEN THIS TAPE MEASURED THE TIGERS SHOT BY VICEROYS, A 10-FOOT TIGER BECAME 11 FEET! THUS, SEVERAL VICEROYS HAD THE SATISFACTION OF BAGGING COLOSSAL TIGERS. WHEN THE SUBTERFUGE WAS DISCOVERED AFTER SEVERAL YEARS, MADHAVRAO GRANDLY DECLARED THAT HE WAS ANSWERABLE ONLY TO THE KING EMPEROR.

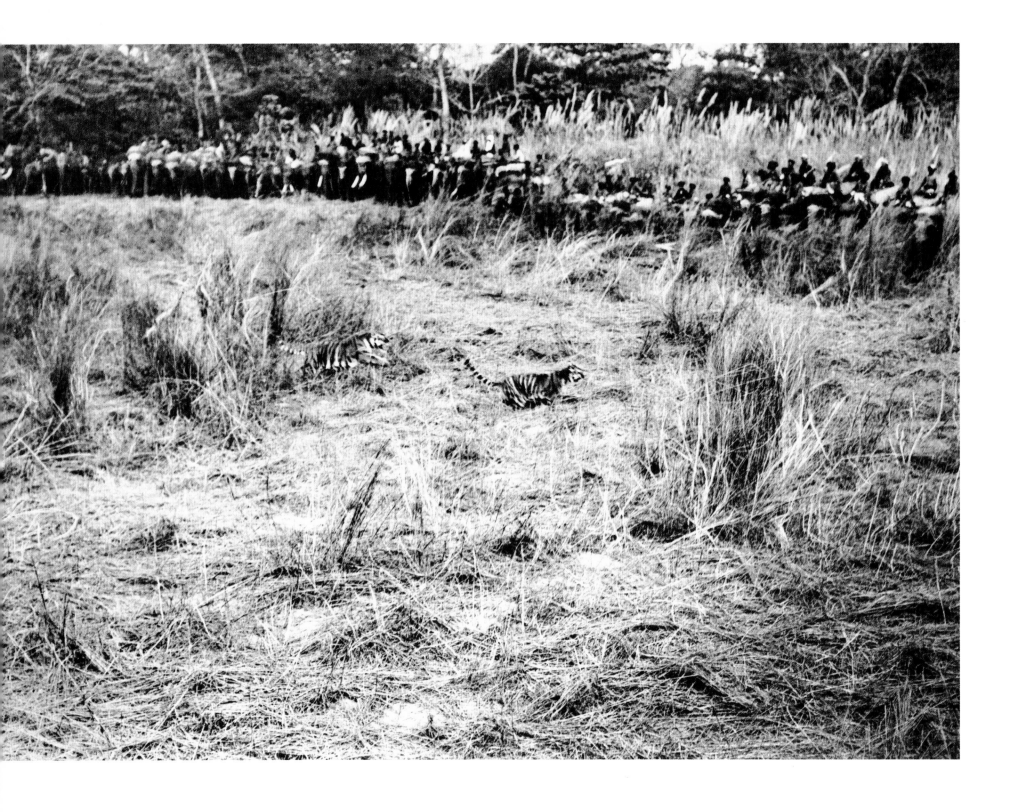

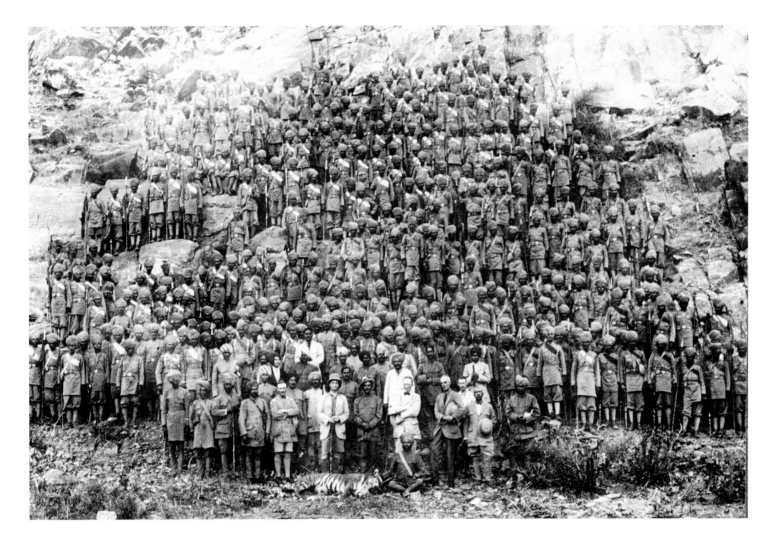

A SHIKAR PARTY POSES
AFTER A SUCCESSFUL
HUNT. SUCH PARTIES
WERE ALWAYS DONE IN
STYLE. ELEPHANTS,
RETAINERS, THE BEST
GUNS, CARPETED TENTS,
CHAMPAGNE, CAVIAR,
AND ROLLS-ROYCE CARS
WERE PART OF THE
EXPEDITION.

FACING PAGE:
'A TIGER RING' IN
NEPAL, DECEMBER
1911. IN THIS METHOD
OF KILLING TIGERS, THE
SHIKAR PARTY WOULD
TAKE THEIR POSITIONS
WHILE A LARGE NUMBER
OF BEATERS WOULD
ENCIRCLE THE TIGERS
AND DRIVE THEM TO
WHERE THE HUNTERS
WERE WAITING. THIS
THE BEATERS WOULD
DO BY MOVING IN
DECREASING CIRCLES
BEATING DRUMS AND
CREATING A LOT OF
NOISE DRIVING THE
TIGERS TOWARDS THE
GUNS.

TOP: A PANTHER MASSACRE, HYDERABAD. HOWEVER, THE MAHARAJAS, MAINTAINED THAT DESPITE COMPETING TO BAG 500 OR 1000 TROPHIES EACH, THEY WERE AMONG THE GREATEST 'CONSERVATIONISTS OF GAME'. THIS WAS PARTLY TRUE, AS ALL GAME WAS THE EXCLUSIVE PRESERVE OF THE RULER AND THE LEADING NOBLEMEN OF THE STATE. THEREFORE ONLY A HANDFUL OF PEOPLE COULD SHOOT IN THE RESERVED HUNTING GROUNDS.

BOTTOM: MEHBOOB ALI KHAN, THE SIXTH NIZAM OF HYDERABAD *(SEATED CENTRE WITHOUT A HAT)*, AND HIS ENTOURAGE DURING A TIGER SHOOT IN THE JUNGLES OF MADANPALLI, HYDERABAD, 1892. MEER MEHBOOB ALI WAS AN EXCELLENT SHOT AND COULD REPORTEDLY HIT A SPINNING COIN IN MID AIR. HE HAD A SPLENDID COLLECTION OF WEAPONS, BUT WAS AGHAST WHEN AT A DURBAR CEREMONY THE VICEROY NAIVELY BUCKLED A DIAMOND-STUDDED SWORD AROUND THE NIZAM'S WAIST—ON THE WRONG SIDE.

FACING PAGE: MEHBOOB ALI KHAN IN A SHIKAR GROUP, 1872.

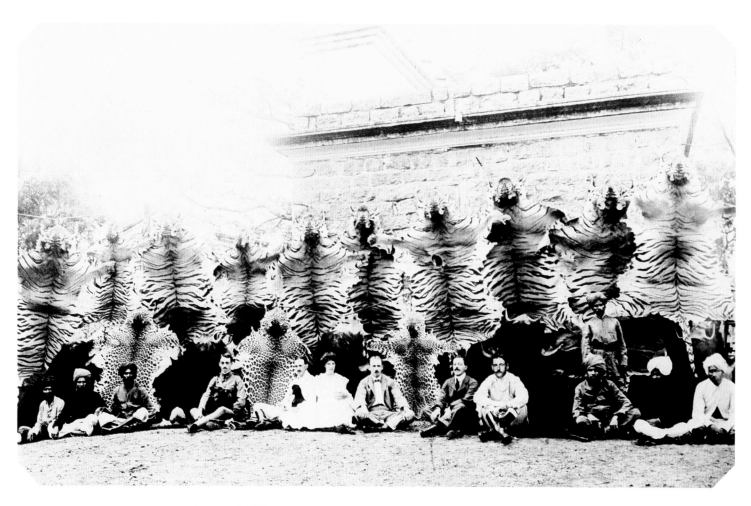

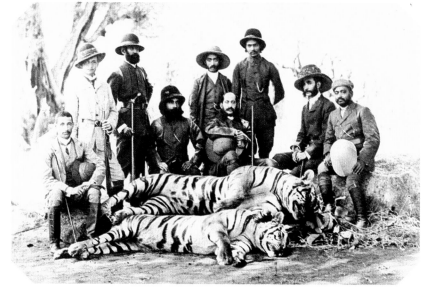

246

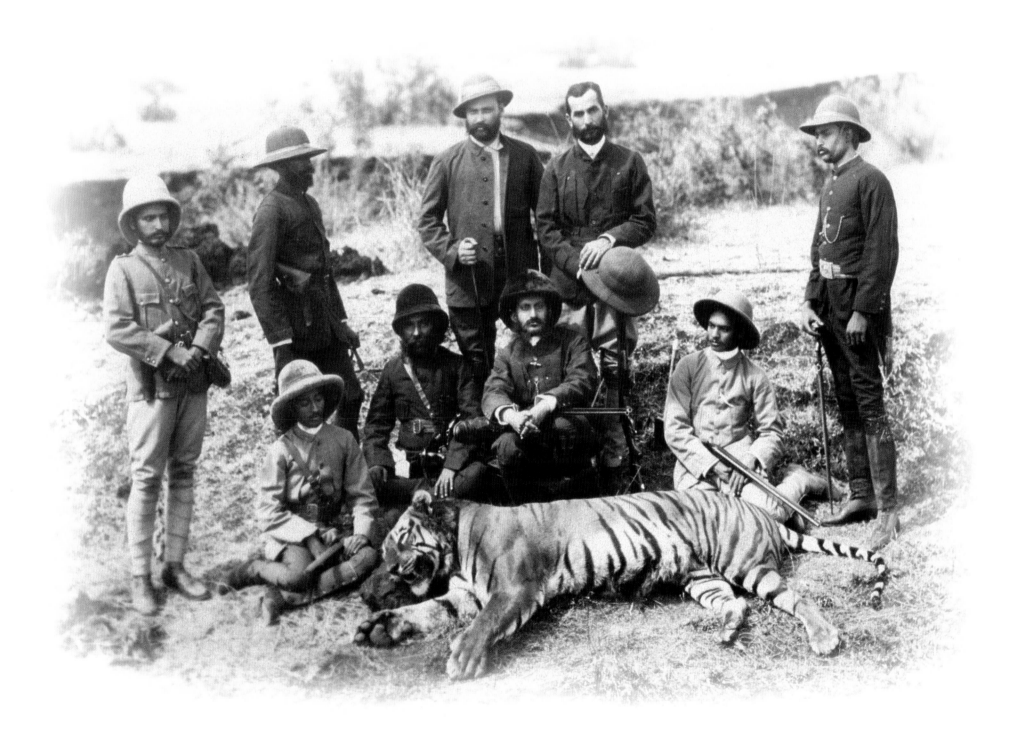

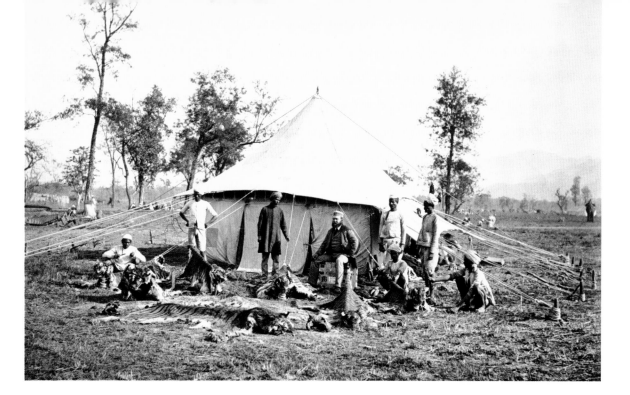

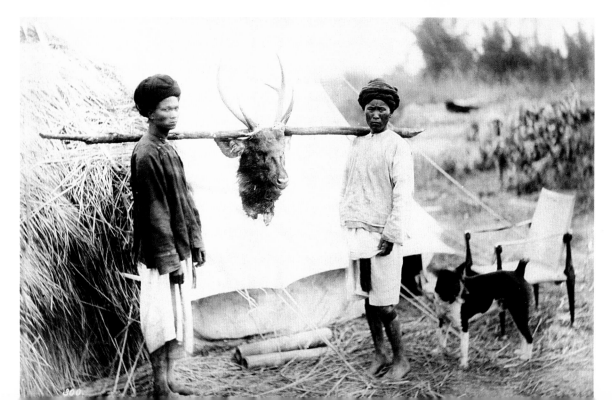

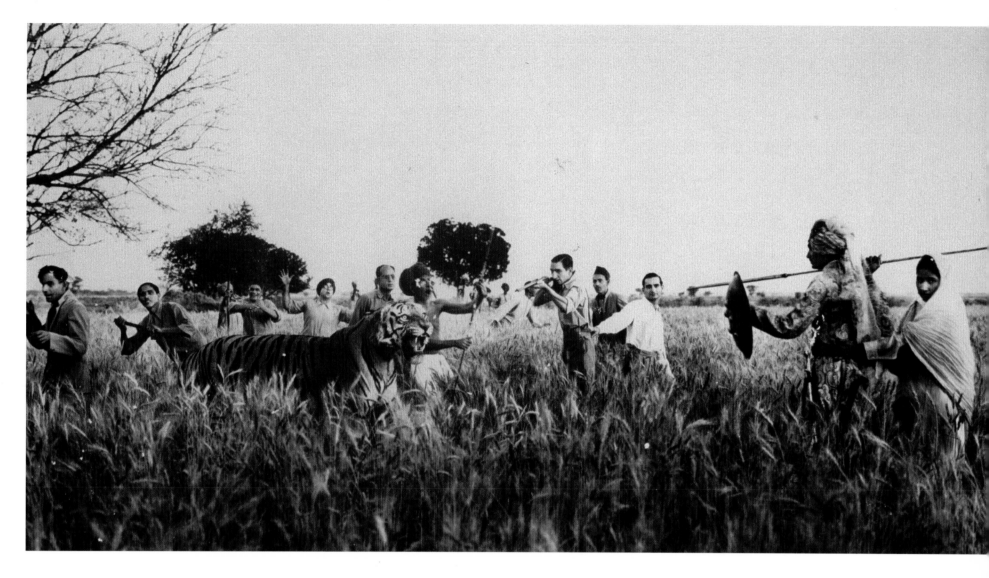

FACING PAGE TOP: FIRST
DAY SPORT OF TIGERS IN
THE TERAI, 1875–76.
THE TERAI,
A MARSHY AREA
BORDERING NEPAL IN
THE NORTH OF INDIA,
WAS A FAVOURITE
HUNTING GROUND IN
THOSE DAYS. THE
LEGENDARY JIM CORBETT

HAS LEFT BEHIND
COLOURFUL ACCOUNTS
OF HIS ENCOUNTERS
WITH TIGERS IN THIS
AREA.

FACING PAGE MIDDLE:
A *MUGGER* (CROCODILE)
SHOT BY LORD CURZON
IN THE SUNDERBANS IN
1904.

FACING PAGE BOTTOM:
HEAD OF A SAMBHAR
SHOT DURING THE
SECOND ANGLO-SIAMESE
BOUNDARY COMMISSION
JOURNEY, 1890.

THIS SHIKAR 'SCENE'
FROM THE PATAUDI
ALBUM IS MEANT TO
FOOL THE VIEWER. THE
TIGER IS A STUFFED
ANIMAL AND THIS
EXPLAINS THE BRAVE
'HUNTERS' AROUND HIM.

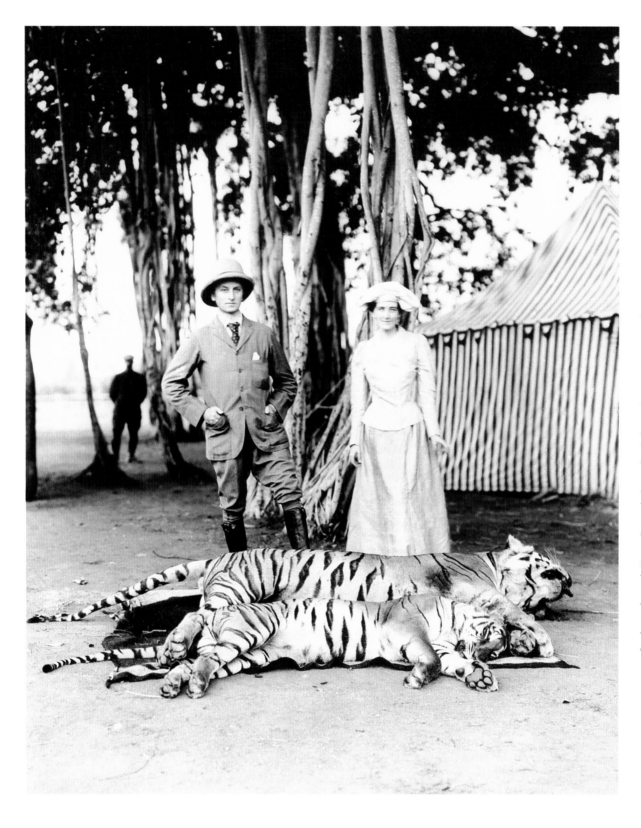

LORD AND LADY CURZON, HYDERABAD, 1902, WITH 'THEIR' TIGERS. IT WAS THE INVARIABLE CUSTOM WITH LEADING PRINCES TO INVITE THE VICEROY TO VISIT THEIR CAPITAL. AN IMPORTANT PART OF THE VISIT WAS A SHIKAR PARTY. LORD CURZON WAS A MAN OF FORMIDABLE INTELLECT AND RUTHLESS EFFICIENCY. HE ONCE SAID, 'AS LONG AS WE RULE INDIA WE ARE THE GREATEST POWER IN THE WORLD. IF WE LOSE IT, WE SHALL DROP STRAIGHT AWAY TO A THIRD RATE POWER.'

FACING PAGE: KING GEORGE V ON A TIGER SHOOT WITH MAHARAJA MADHAVRAO SCINDIA OF GWALIOR. IN GWALIOR STATE, THE BEST TIGER COUNTRY WAS SHIVPURI, 75 MILES SOUTH OF THE CAPITAL. THE MAHARAJA USUALLY TOOK HIS GUESTS TO SHIVPURI BY THE GWALIOR LIGHT RAILWAY, A NARROW GAUGE RAILWAY BELONGING TO THE STATE. THE MAHARAJA TOOK GREAT DELIGHT IN ACTUALLY DRIVING THE RAIL ENGINE HIMSELF MUCH TO THE CONSTERNATION OF HIS GUESTS.

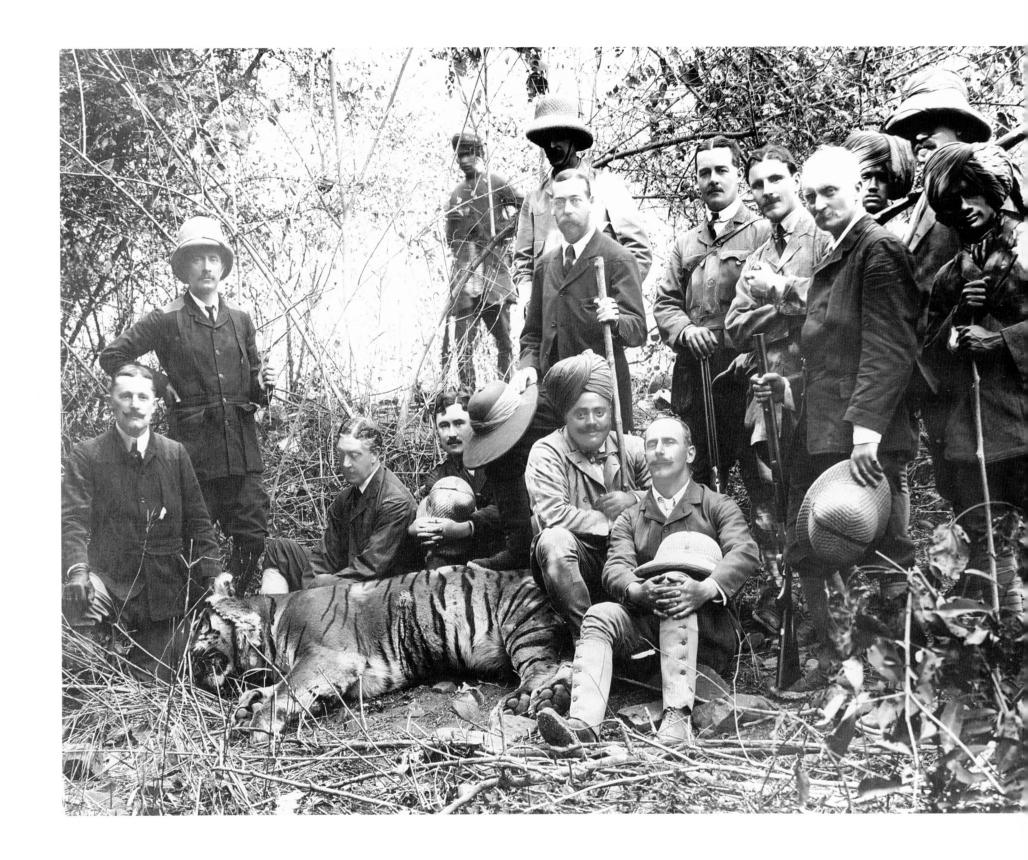

TOP: BARODA, 1899. A CENTURY AGO HUNTING DEER WITH CHEETAHS WAS A FAVOURED SPORT. CHEETAHS WERE TRAINED TO HUNT. WHEN RELEASED BY THEIR KEEPERS, THEY USED TO STALK, CHASE, AND BRING THE DEER TO THE GROUND. THE CHEETAHS WERE THEN COAXED TO LOOSEN THEIR GRIP ON THE PREY BY DANGLING RAW MEAT BEFORE THEIR EYES. THE CHASE DID NOT LAST LONG AS THE CHEETAH IS THE FASTEST ANIMAL ON EARTH.

BOTTOM: THE FAMOUS HUNTING DOGS OF THE NAWAB OF JUNAGADH. THE NAWAB, AN INTERESTING ECCENTRIC, WAS DEEPLY ATTACHED TO HIS DOGS. HIS FAVOURITE BITCH, ROSHANARA, WAS MARRIED TO 'BOBBY', A GOLDEN RETRIEVER BELONGING TO THE NAWAB OF MOANGROL. A THREE-DAY STATE HOLIDAY WAS DECLARED IN JUNAGADH TO CELEBRATE THIS UNIQUE EVENT. THE GROOM RODE AN ELEPHANT IN A GOLD AND SILVER HOWDAH, ACCOMPANIED BY 250 MALE DOGS AS HIS *BARAATIS*. THE BRIDE WORE JUST PEARLS AND LOOKED STUNNING.

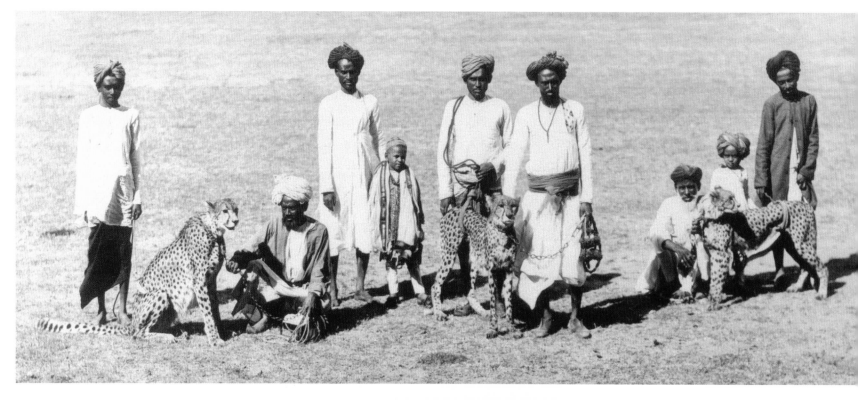

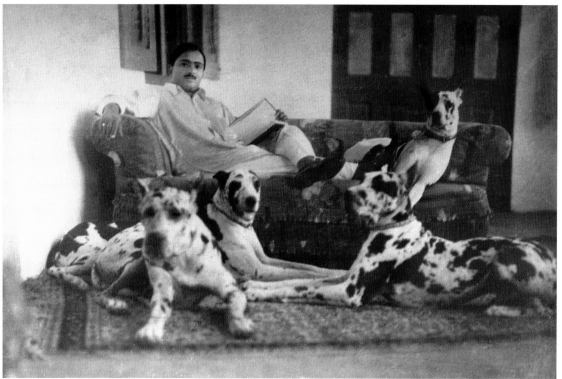

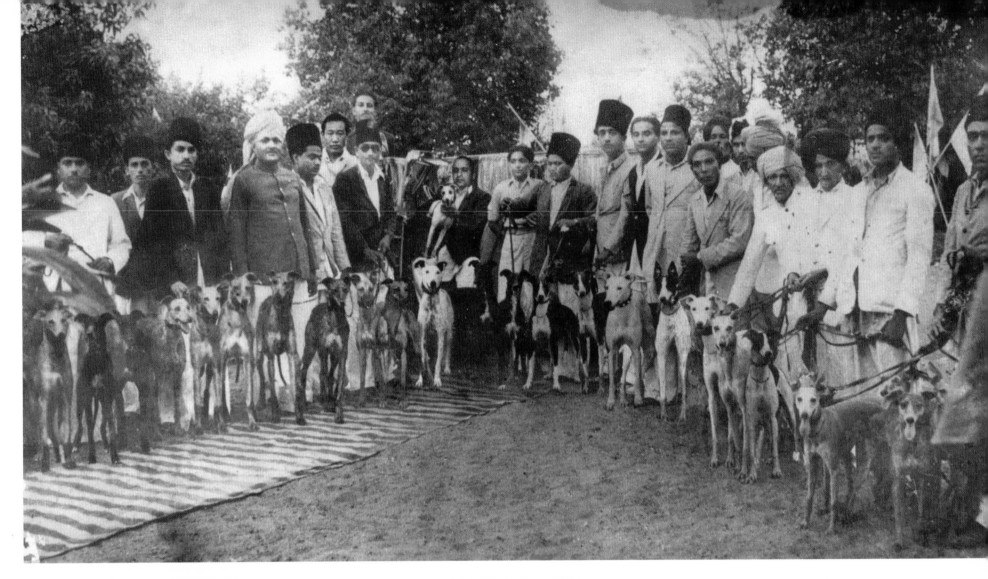

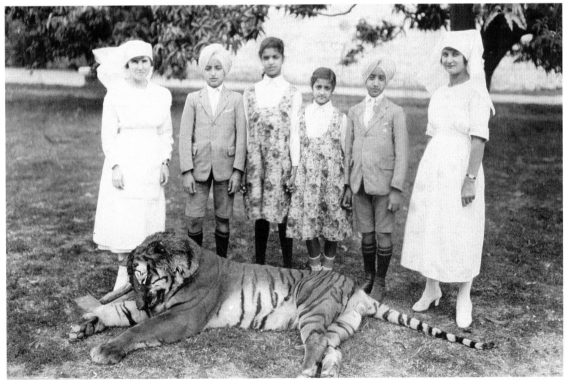

TOP: THE NAWAB OF JUNAGADH, SIR MAHABAT KHAN, WITH SOME OF HIS HUNTING DOGS. HIS KENNELS, WITH OVER 1,000 DOGS, HAD AIR COOLERS AND TELEPHONES, AND THE DOGS' MEALS WERE COOKED BY THEIR OWN CHEFS. WHEN THE NAWAB MIGRATED TO PAKISTAN AT THE TIME OF PARTITION IN 1947, HE LEFT MANY WEEPING WIVES BEHIND SO THAT HIS PAMPERED CANINES COULD FLY WITH HIM ON HIS PLANE.

LEFT: YADAVINDRA SINGH OF PATIALA, HIS SIBLINGS AND NURSES AT THEIR PRIVATE ZOO IN THE MUGHAL GARDENS, PINJORE.

A ROLLS-ROYCE GOES ON SHIKAR; THE DAY'S CATCH IS DRAPED ON TOP OF ITS BONNET.

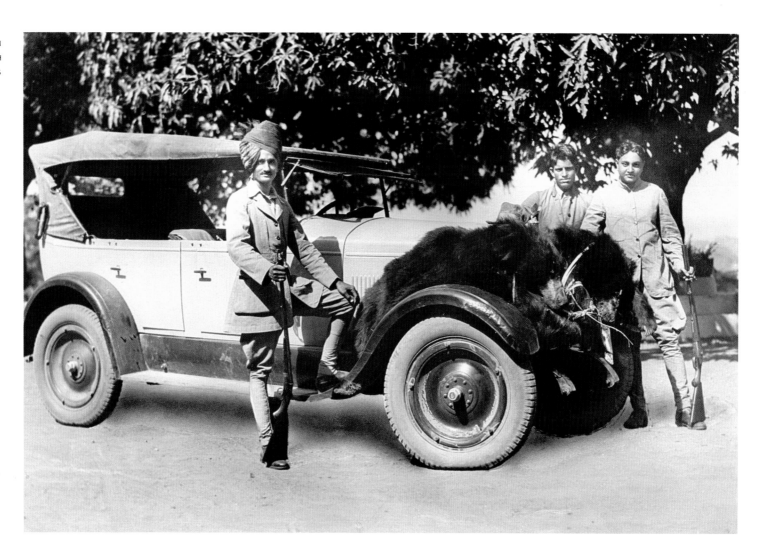

The humble man had his feet; the rajas and Maharajas transported themselves—before the arrival of the motorized car—in several ways. So, elephants, camels, horse carriages, even deer were yoked into service while carrying the Maharajas.

When the idea was to make a triumphant entry, as in the Delhi Durbar of 1903, the elephant was the most favoured beast of burden. Richly caparisoned, elaborately canopied, each elephant had parties of spearman and mace-bearers (*chobdars*) in attendance. Luchman Prasad—an elephant—was probably the most well-decked beast of all times. Luchman Prasad had the weighty honour of carrying the Viceroy and Lady Curzon (and all else besides) to the Durbar arena. Over his back, was mounted a howdah of burnished silver as an umbrella of silk and gold hung over the crimson, velvet seats. A scarlet velvet housing (*jhul*), heavy and stiff with gold embroidery, reached to the ground. Elephant cars were also used to carry many a Maharaja's ladies on a journey. Purdah would be drawn around the carriage.

Horses came next in order of preference and lent speed, agility, and refined style to, say, a shikar outing or to the carriage that took the Maharaja to dinner at a friendly state.

254

By the turn of the twentieth century, however, the pachyderm was replaced by the newest technological marvel from the West—the motorized car. Mechanical wheels, fitted with luxurious compartments and furnishings on top, pushed everything away. Not surprisingly, the choicest automobiles came to the garages of the Maharajas. They performed diverse functions from taking part in ceremonial processions, tours, shikars, to transporting ladies in purdah.

The Maharaja of Patiala, Bhupindar Singh, owned close to 130 cars, twenty-seven of them being Rolls-Royces. Maharana Bhopal Singh of Udaipur had a variety of cars. He went for a drive every evening in a scarlet, open Rolls, sitting alone in the back seat, with an aide de camp in front alongside the chauffeur. Three buses, carrying members of the nobility and their servants, tailed the car. Ranjitsinhjee, famous cricketer and Jamsahib of Nawanagar, was partial to the Lanchester make and is believed to have owned up to forty-two models. His son, Maharaja Digvijaysinhji, had special midget cars fabricated for his children that ran on electricity *(see page 16)*.

Trains were a passion, too. The Maharaja of Gwalior used to take his distinguished guests out for tiger hunts to Shivpuri, seventy-five miles south of the capital, on the Gwalior Light Railway, a narrow gauge system. Maharaja Madhavrao of Gwalior took delight in actually driving the rail engine himself much to the consternation of his guests. Maharaja Ganga Singh of Bikaner organized the railways for his entire state. Every corner of his state was connected with the capital.

(see page 16).

A BLACKBUCK CARRIAGE FROM BIKANER, MADE FOR THE ROYAL CHILDREN. THE SWIFT DEER WERE MUCH LOVED ROYAL PETS. THEY WERE LOVINGLY KEPT AND ONLY RARELY YOKED TO THE CARRIAGE.

TOP: SEVERAL INDIAN PRINCES, PARTICULARLY THOSE FROM PUNJAB, HAD SUMMER RESIDENCES IN SIMLA AND THE NEIGHBOURING AREA. DURING THE HOT SUMMER, THE VICEROY AND THE IMPERIAL GOVERNMENT MOVED TO SIMLA AS WELL AND THE SUMMER SEASON WAS AN UNENDING FLURRY OF PARTIES, BALLS AND FUN. ONLY THE VICEROY COULD DRIVE A CAR ON THE MALL, SO HAND-DRAWN RICKSHAWS WERE PRESSED INTO SERVICE BY MANY INDIAN PRINCES. MAHARAJA YADAVINDRA SINGH IN HIS PRIVATE RICKSHAW ON THE MALL, IN SIMLA.

BOTTOM: THE *PALKI* (PALANQUIN) WAS A SPLENDID VARIATION OF THE EUROPEAN SEDAN CHAIR. MADE OF SILVER FOR SOME PRINCELY OWNERS, IT WAS CARRIED BY FOUR PORTERS. FOUR OTHERS FOLLOWED THE ENTOURAGE TO TAKE OVER THE BURDEN AFTER A WHILE. THIS PALKI IS FROM THE STATE OF DUNGARPUR.

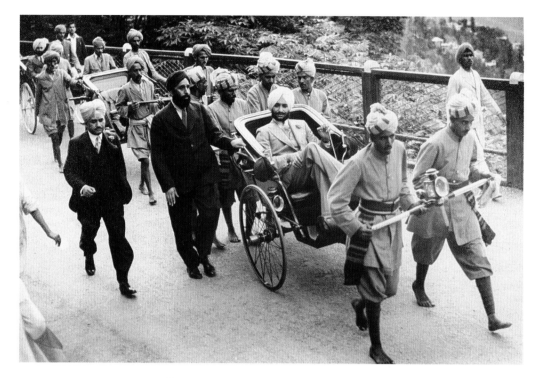

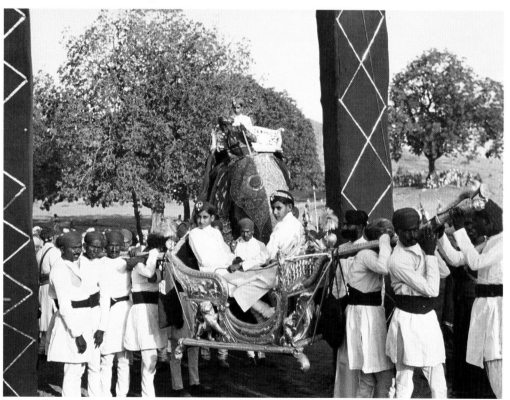

256

AN UNUSUAL PIGGY-
BACK RIDE FOR KING
GEORGE V. DURING A
HUNTING TRIP, THE
KING-EMPEROR WAS
CONFRONTED WITH A
DILEMMA. IN FRONT OF
THE SHIKAR PARTY LAY
A RIVER, TOO WIDE TO
JUMP ACROSS. HIS HOST,
LIKE A LATTER-DAY SIR
WALTER RALEIGH, WHO
SPREAD HIS CLOAK FOR
QUEEN ELIZABETH I
SOME CENTURIES AGO,
GALLANTLY CARRIED HIM
TO THE OTHER SIDE ON
HIS BACK.

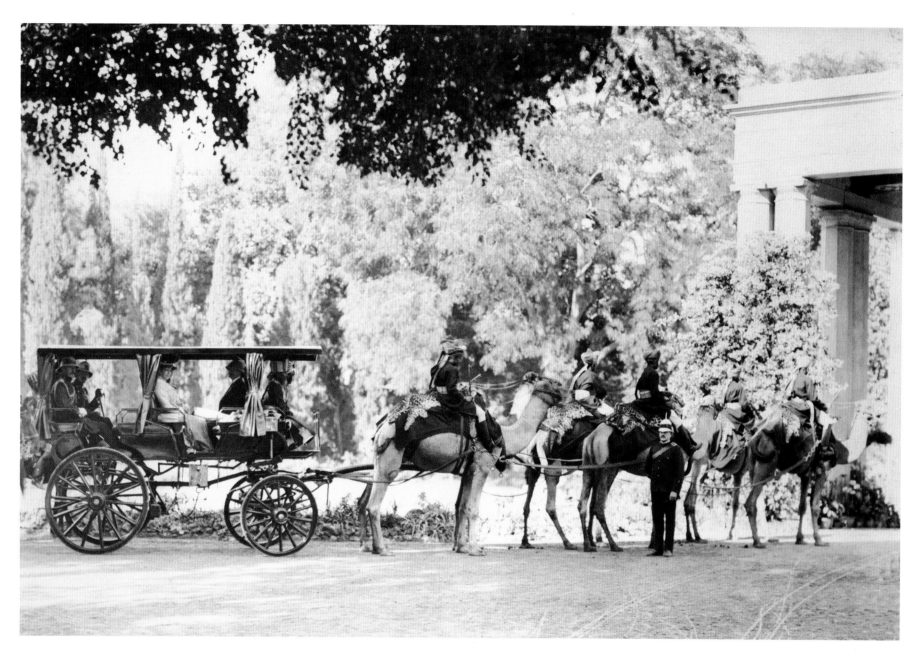

Victoria Mary, Princess of Wales, and officials in a camel carriage, 30 November 1905. The most famous camel carriage belonged to Bikaner. As Bikaner lies in the middle of a desert, the camel carriage was not such a bad way to travel.

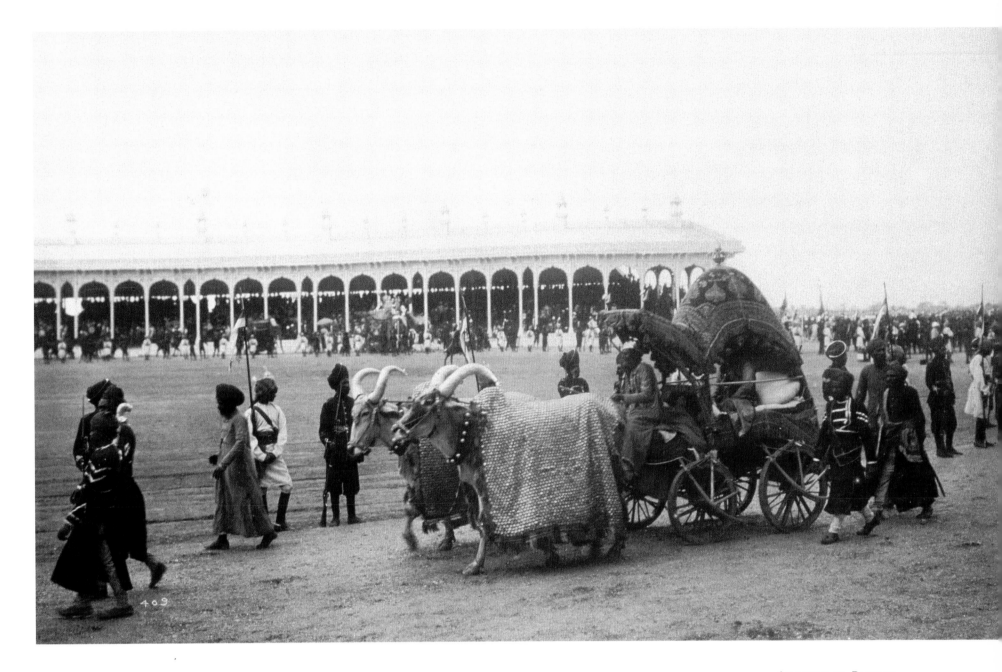

An unusual Durbar
entry in 1911. Indian
princes rode to the
durbar in a variety of
carriages. This one is
drawn by a pair of
magnificent oxen.

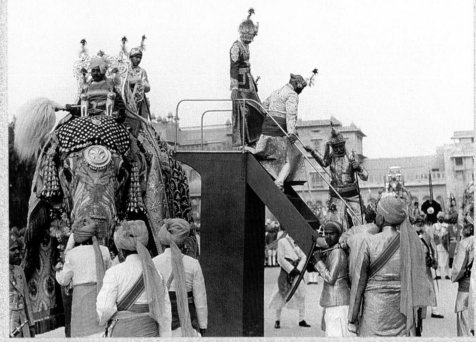

LEFT: THE INDIAN
PRINCES STRADDLED
MODERNITY AND
TRADITION WITH GRACE
AND EASE. A MAHARAJA
COMES RIDING AN
ELEPHANT TO BOARD A
PLANE. SUCH A SIGHT
WAS NOT UNCOMMON IN
THE LAST CENTURY.

RIGHT: A PRINCE ALIGHTS
FROM AN ELEPHANT AT A
WEDDING IN BIKANER.
THE WEDDING
PROCESSIONS OF THE
RAJPUT FAMILIES WERE
SPECTACULAR AFFAIRS
AND AN OCCASION FOR
REVELRY ALL OVER THE
KINGDOM.

THE MAHARAJA OF REWA,
PREMIER CHIEF OF
BAGHELKHAND, WHOSE
FATHER EARNED THE
GRATITUDE OF THE
BRITISH BY HIS LOYAL
SERVICE DURING THE
REVOLT OF 1857, CAME
TO DELHI WITH A LARGE
RETINUE, INCLUDING
TROOPS, NEARLY A DOZEN
ELEPHANTS AND CAMELS.
THE MAHARAJA'S CAMP
WAS ONE OF THE MOST
ELABORATE AMONGST THE
MANY DURING THE 1903
DELHI DURBAR. IT WAS
LAVISHLY EQUIPPED,
PROFUSELY DECORATED
WITH BUNTINGS, AND SO
MODERN IN STYLE THAT A
VISITOR MIGHT HAVE
IMAGINED HIMSELF IN A
CORNER OF A PARIS
EXHIBITION. THE CAMP
CONTAINED THE ENTIRE
RETINUE OF THE
MAHARAJA, WHO
SUCCEEDED HIS FATHER
IN 1880, WHEN HE WAS
ONLY 3 YEARS AND 6
MONTHS OLD.

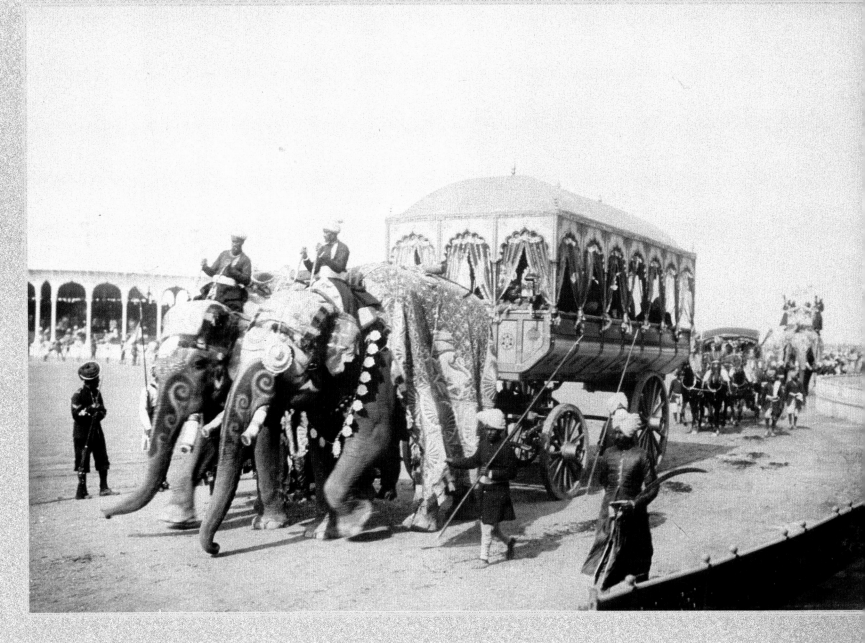

INDIAN PRINCESSES WERE OFTEN ADEPT AT HANDLING HORSES. THE SPRAWLING GROUNDS OF THE PALACES WERE LARGE ENOUGH FOR CARRIAGES TO BE DRIVEN AT BREAKNECK SPEED WITHOUT HARMING ANY PASSERBY. THIS PHOTOGRAPH SHOWS RANI KANARI SINGH, FOURTH WIFE OF THE MAHARAJA OF KAPURTHALA, DRIVING AN OPEN CARRIAGE.

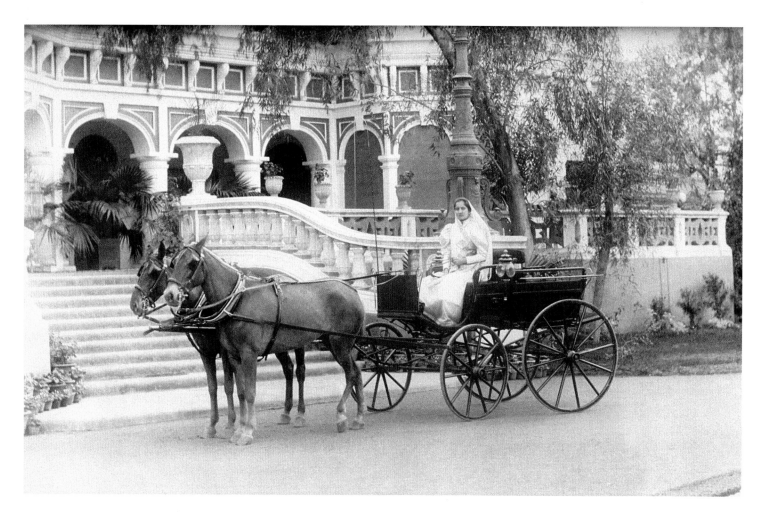

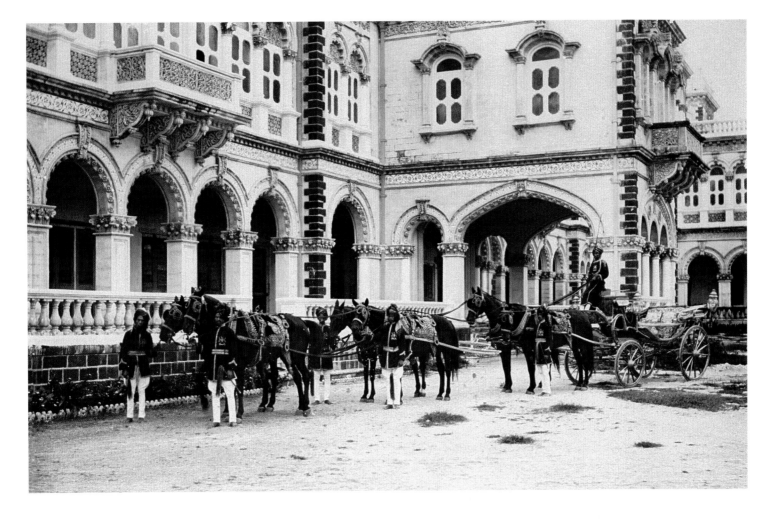

THE MAHARANA OF
UDAIPUR HAD TWO
SPLENDID BARGES THAT
COULD HOLD OVER A
HUNDRED PASSENGERS.
ON FESTIVE OCCASIONS,
SUCH AS THE FAMOUS
GANGAUR FESTIVAL
OF UDAIPUR, THE
MAHARANA INVITED
HIS GUESTS TO A TRIP
ON LAKE PICHHOLA.
MUSICIANS AND
DANCERS WOULD
ENTERTAIN THE ROYAL
PARTY. THE MAHARANA,
SAT IN A SPECIAL
'THRONE' THAT WAS
ERECTED FOR THE
OCCASION.

FACING PAGE: THE
PRINCE AND PRINCESS
OF WALES IN THE ROYAL
BARGE OF THE RAJA
OF BENARAS AS THEY
INSPECT THE FAMOUS
TEMPLES AND GHATS
ALONG THE GANGES,
FEBRUARY 1905.

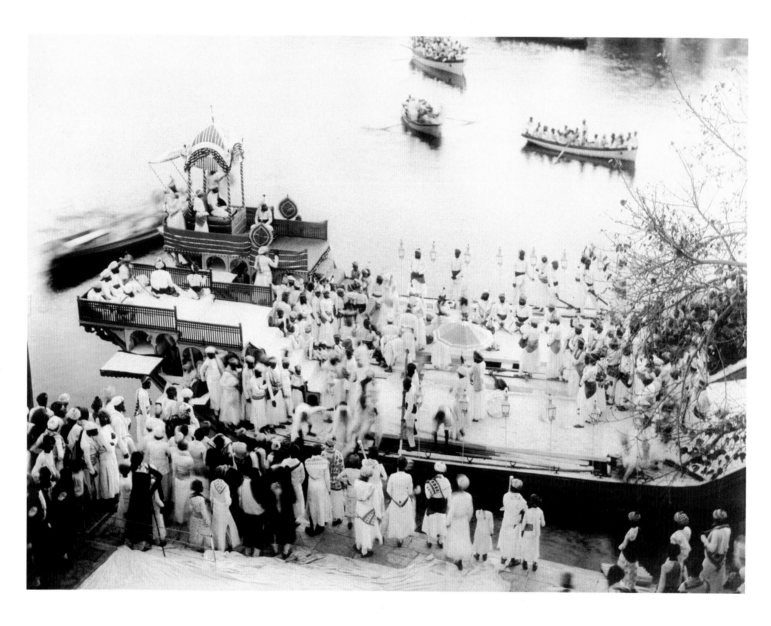

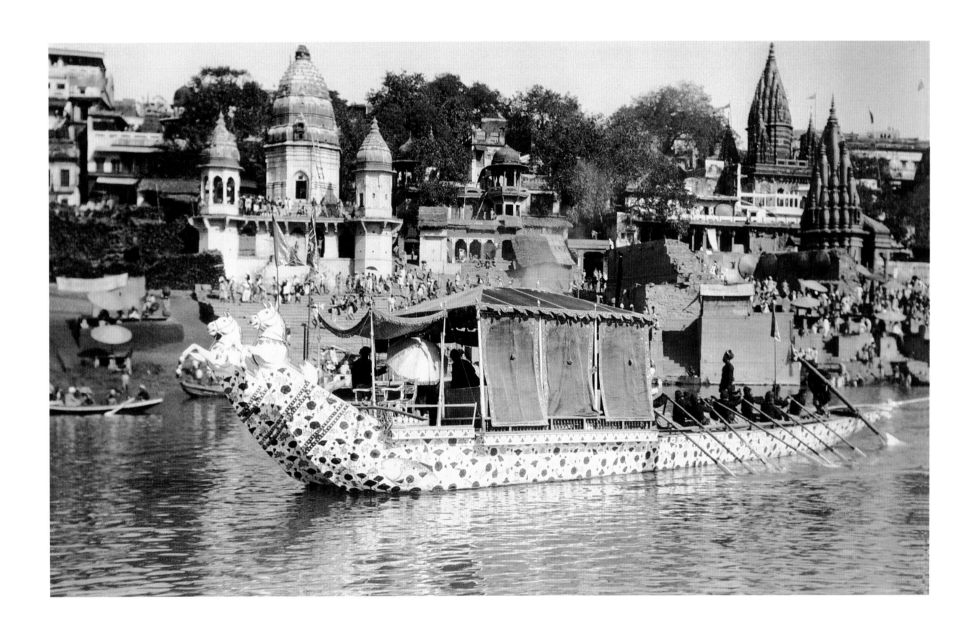

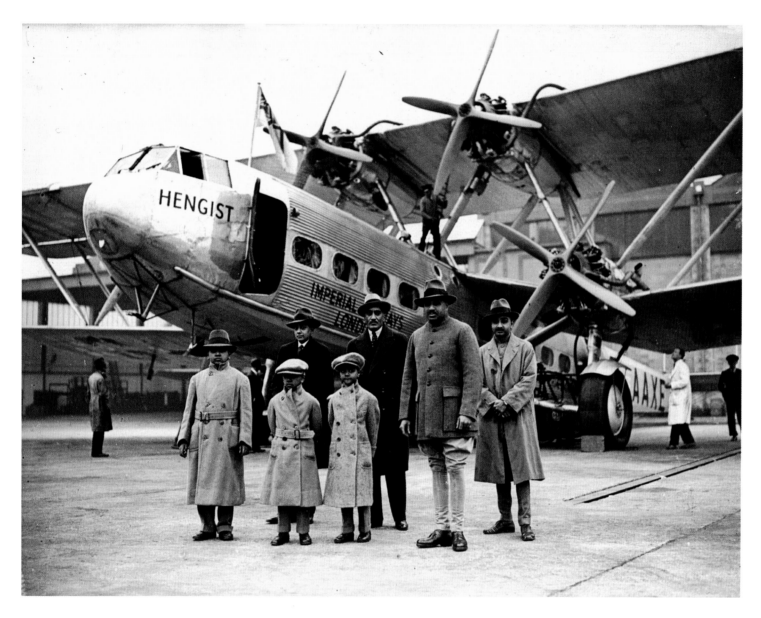

HANWANT SINGH, SEEN HERE (FAR LEFT) WITH HIS FATHER UMAID SINGH (WEARING JODHPURS AND A HAT) AND HIS BROTHERS, POSED FOR THIS PHOTOGRAPH ON 8 NOVEMBER 1938 AT CROYDON AIRPORT PRIOR TO THEIR TOUR OF EUROPE ON THE IMPERIAL AIRWAYS AIRLINER, HENGIST.

FACING PAGE: MAHARAJA HANWANT SINGH OF JODHPUR (FIFTH FROM LEFT) WAS KILLED ON 26 JANUARY 1952, WHEN HIS TWO-SEATER SWIFT AIRCRAFT CRASHED IN GODWAR, NEAR JODHPUR. THE MAHARAJA HAD STOOD FOR ELECTIONS AS A CANDIDATE IN INDIA'S FIRST GENERAL ELECTIONS THAT YEAR. THE RESULTS, THAT WERE DECLARED HOURS AFTER HIS TRAGIC DEATH, WENT OVERWHELMINGLY IN HIS FAVOUR. MANY IN JODHPUR BELIEVED THAT HIS PLANE HAD BEEN SABOTAGED BY HIS POLITICAL RIVALS.

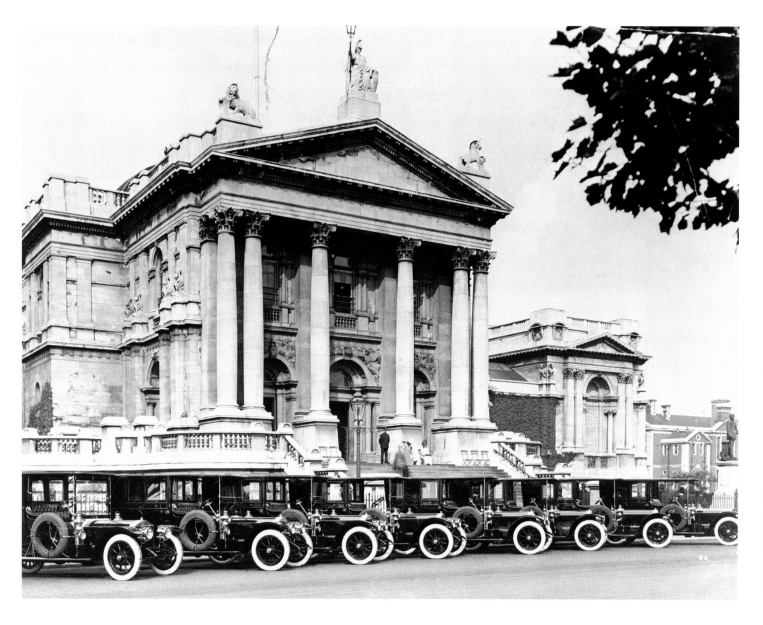

A ROW OF SILVER GHOSTS OUTSIDE THE TATE GALLERY, LONDON. THEY FORMED A CONSIGNMENT OF ROLLS-ROYCES BEING SHIPPED TO INDIA FOR THE DELHI DURBAR. THE SILVER GHOST WAS SO NAMED SINCE A REMARKABLE FEATURE OF THESE SPECTACULAR CARS WAS THE NEAR ABSENCE OF ANY ENGINE NOISE. A MAN WHO WAS HIT ACCIDENTALLY BY A ROLLS CLAIMED HE DID NOT HEAR IT CREEP UPON HIM.

FACING PAGE: A ROLLS-ROYCE OUTSIDE THE SPECIAL INDIAN DEPOT IN LONDON. THIS DEPOT WAS SPECIALLY CREATED BY THE COMPANY TO FACILITATE THE EARLY DESPTACH OF CARS TO INDIA. THE INDIAN MAHARAJAS SOON BECAME THE COMPANY'S FAVOURITE CUSTOMERS, AND SPECIAL FEATURES WERE ADDED TO SUIT ROYAL WHIMS. SOME CARS WERE FITTED WITH GOLD AND SILVER, OTHERS WERE UPHOLSTERED IN TIGER SKIN.

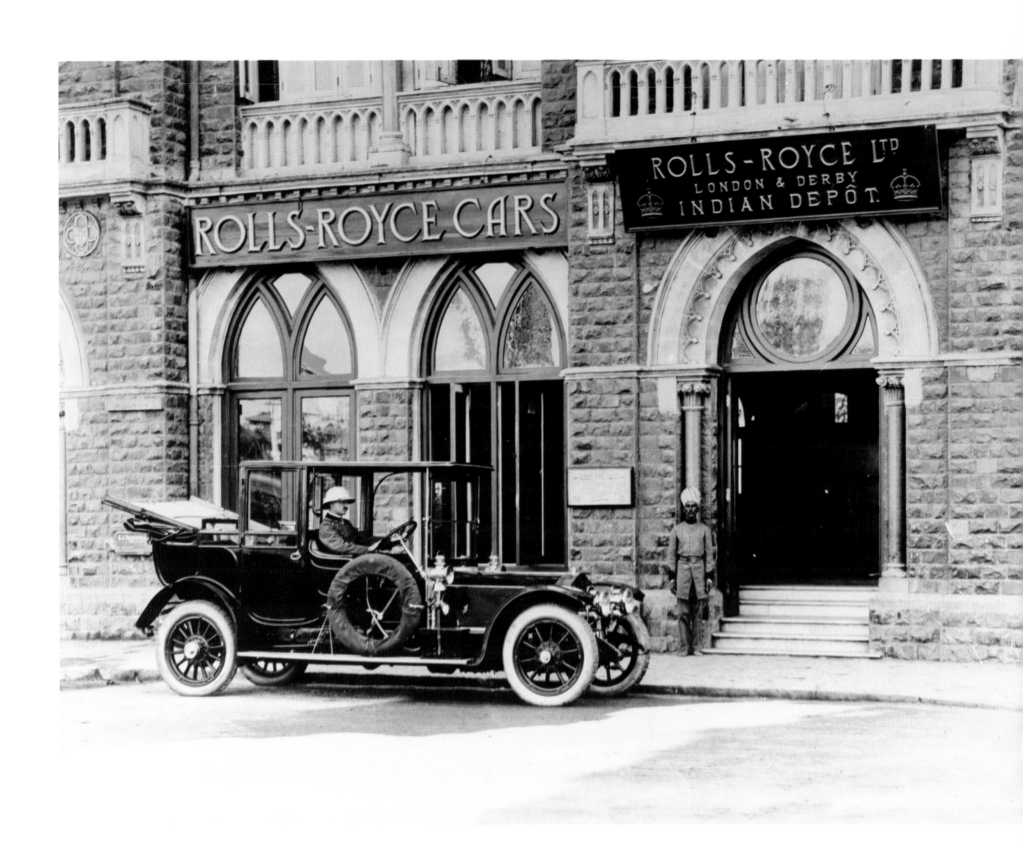

ROLLS-ROYCE MADE FOR THE MAHARAJAS

Simple living has never been a royal practice anywhere. Born with a silver spoon, the Indian princes were reared in the lap of luxury. Unsurprizingly, they grew up to have prohibitively expensive and sometimes even licentious tastes. Fortunately, most of them had deep enough pockets to pander to their material appetites. When they did not, the treasury of states often reached bankruptcy.

The Maharajas were hardly known for financial prudence or restraint. They were greatly fascinated by machines: limousines and luxury trains were their prime choices. Traditionally, they had travelled on splendidly caparisoned, slow-moving elephants or on horses. Elephants were considered auspicious, supposed to have divine attributes and were, therefore, worthy seats for royalty. The Maharaja of Mysore prostrated himself once a year in front of his oldest elephants and prayed for the prosperity of his

subjects. But, the car was to overwhelm this centuries-old means of transport. The first car was unloaded in India in 1892. It was probably a French De Dion Bouton ordered by Maharaja Rajindar Singh of Patiala with the symbolic registration number 'O'.

Rolls-Royces, standing for the best man could make, were the choice of car for the Maharajas. The Rolls-Royce company exported its models to India: open tourers, saloons, coupes, estate cars, and even vans. Apparently, they all found favour and the Maharajas and their Rolls went rather well together: it is estimated that more than a thousand Rolls-Royces were ordered over forty years. Most were custom built, for some princes wanted to hold cabinet meetings in their Rolls, while others wanted to have a small cocktail party, and yet others wanted to travel lying down. Many were 'purdah' models with curtains to shield the Maharanis from prying eyes. A 1926

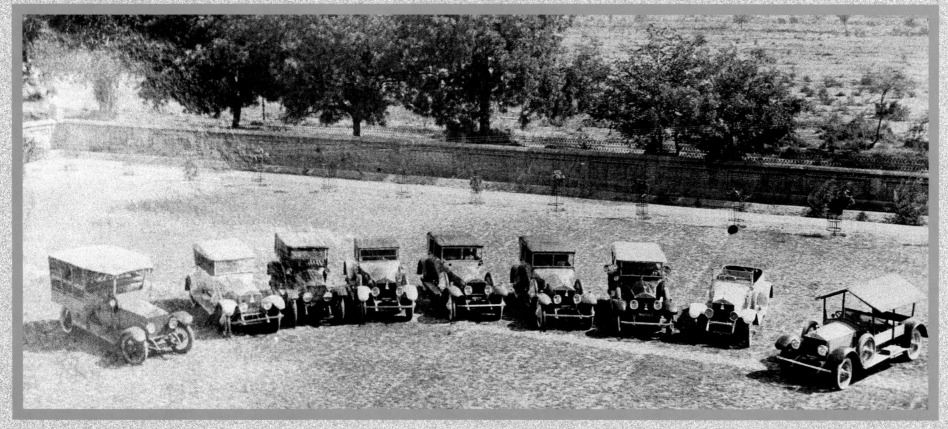

THE MAHARAJA OF BHARATPUR'S FLEET OF ROLLS-ROYCES WERE HIS PRIDE AND JOY. HOWEVER, ON BEING REBUFFED BY THE COMPANY ONCE, HE TURNED THE CARS INTO GARBAGE COLLECTION VANS TO SHOW HOW LITTLE THEY MEANT TO HIM! OTHER PRINCES USED THEM AS HUNTING VEHICLES OR AS HORSE-BOXES FOR TRANSPORTING THEIR PRIZED STALLIONS.

FACING PAGE: MAHARAJA BRIJENDRA SINGH OF BHARATPUR AND A FLEET OF ROLLS-ROYCES FROM HIS COLLECTION.

Phantom I that once belonged to the Maharani of Baroda, grandmother of Maharani Gayatri Devi of Jaipur, had a big cabin with jump seats and a glass screen between the cabin and the driver's seat.

Rolls-Royces took care of their owners' eccentricities. A 1933 Rolls that first belonged to Maharani Sethu Parvati Bai of Travancore had a small stool on the floor. On it sat a dwarf who massaged her legs even as he remained invisible to onlookers.

It was the Maharaja of Gwalior who slipped into gear first, buying a Rolls in 1908. Maharaja Bhupindar Singh of Patiala owned up to 27 Rolls apart from 50 luxury automobiles. A fascinating story is told of how

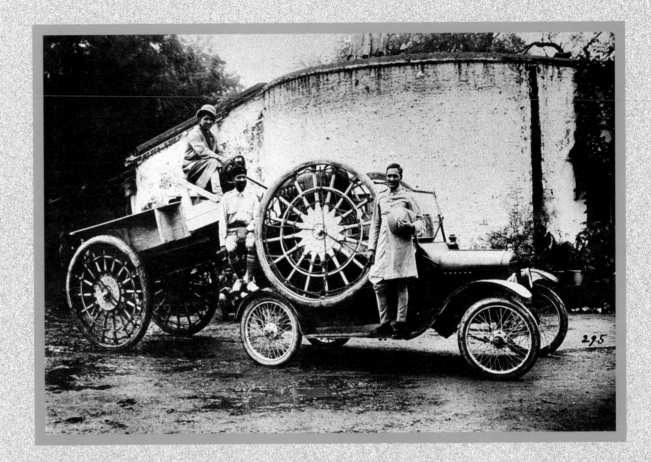

the Maharaja of Bharatpur was offended at the lack of courtesy shown him by the Rolls-Royce staff in England. He bought all the twenty-two cars in their showroom and had them converted into garbage collection vans, which plied all over Bharatpur. The elite cars reduced to doing menial service were photographed and publicized much to the company's humiliation and the delight of the Maharaja.

The Maharaja of Panna, near Khajuraho, had two Silver Ghosts and in a moment of generosity gave one to his family priest in Allahabad and another to his friend, the manager of KLM. Such was the royal fascination for this grandest of cars that when Hyderabad merged with India, the police found a basement full of beautiful old cars on flat tyres. The cars were filled with bullion, jewels and carpets. The fittings changed when the Rolls-Royces accompanied the Maharajas on their favourite pastime—shikar. On tiger hunts, a few cars were fitted with bells to fool the big cat into thinking that the approaching objects were just cattle.

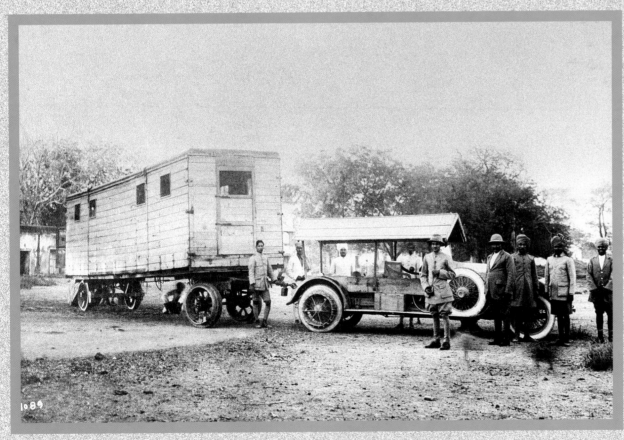

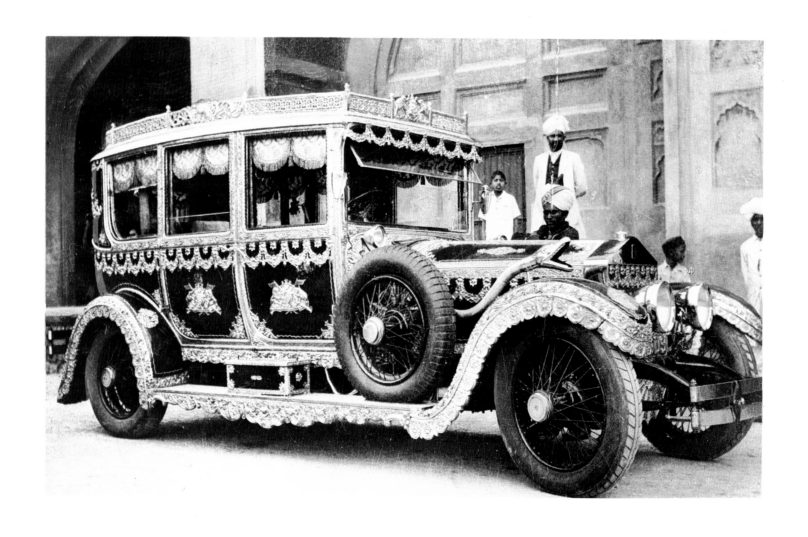

ISBN: 81-7436-295-9

© This edition Roli & Janssen BV 2006
Third Impression
Published in India by Roli Books in arrangement with Roli & Janssen BV
M-75 Greater Kailash, II (Market), New Delhi 110 048, India.
Phone: ++91-11-29212271, 29212782; Fax: ++91-11-29217185
E-mail: roli@vsnl.com; Website: rolibooks.com

Printed and bound at Singapore

PHOTO CREDITS

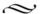

THE ROYAL ARCHIVES, HM QUEEN ELIZABETH II, WINDSOR CASTLE
Pages: 6, 23, 24, 37, 58 (top left), 59 (top right & bottom left), 83, 92-93, 100 (top left),
116, 118, 120-121, 123, 128, 129, 144, 145, 170, 191, 201 (top), 202-203 (bottom),
208, 209, 211, 213 (right), 244, 248 (top), 258, 265

PRINCELY STATES OF INDIA
Baroda: pages 15, 17, 29, 90, 143, 172, 240, 241; **Bharatpur:** pages 51 (right), 173, 271 (bottom)
Bhavnagar: page 189; **Bikaner:** pages 75, 166, 167, 260 (right)
Dungarpur: pages 131, 165, 168, 169, 176, 177, 183 (top right), 256 (bottom)
Gwalior: pages 18-19, 26 (top), 35 (bottom left & right), 36, 53, 68-69, 85 (Kedar Jain),
136-137, 181, 226-227 (top), 227 (bottom), 243, 255; **Indore:** pages 107, 180
Jamnagar: pages 138 (bottom left), 154 (top), 238 (bottom right), 263
Junagadh: page 252 (bottom), 253 (top)
Kapurthala: front cover, pages 46, 60, 64-65, 102, 104, 158-159, 162, 163, 194, 195, 205
Kishangarh: page 86; **Nabha:** pages 11, 77, 78, 79, 125; **Orchha:** pages 54-55, 124
Palitana: pages 70-71, 127; **Pataudi:** pages 26 (bottom), 100 (top right),
101 (right), 233 (left, top right & bottom right), 249
Patiala: pages 2-3, 7, 8, 27 (top), 30-31, 38, 39, 42, 43, 58 (centre left), 66, 67, 72,
76 (bottom left), 80, 81, 87, 101 (top left), 105, 115, 182-183 (top & bottom), 192,
196, 197, 223 (top), 234, 253 (bottom), 256 (top); **Porbander:** page 139
Rajmata Gayatri Devi Collection (Jaipur): pages 9, 10, 48-49, 88, 89, 224, 225

274

MY ROMANCE WITH VINTAGE PHOTOS

The story of this book begins with half a thought, three test prints and barely a page of text. Jaiwant Paul, the author, mooted the idea of putting together a book on the life, times and work of Raja Deen Dayal. The idea was exciting and as the days progressed, he took me to a dealer of second-hand books where we found some beautiful portraits from a late 19th-century Photographic Album compiled by Sorabjee Jehangir. What I saw set my mind ticking. Then, a publishing trip took me to London where I chanced upon the Lafayette Collection of portraits at the Victoria & Albert Museum (V&A). Those breath-taking portraits, almost hundred years old, sealed the fate of this project. What started as a collection of Raja Deen Dayal's photographs turned into a mega project that became *The Unforgettable Maharajas* five years later. My romance with vintage photos had begun.

From that first visit to a second-hand book dealer to a chance discovery at the V&A, my search was long and the quest seemed endless. I made friends with some very interesting collectors, researchers and enthusiasts. Ultimately, we became a club of sorts and still keep exchanging news to lead each other to new sources.

Across the seven seas, I met Russell Harris, the quintessential vintage photo researcher, whom I tracked through the net just as he was about to switch off his computer, pack and ship it to his native land, London. He soon became a partner in crime and as we researched photographs together, he grew into a friend and is now like a family member. He wrote two Pocket Art books (Lafayette Studio and Maharajas at the London Studio) for Roli Books and introduced me to James Stevenson, Head of the Photographic Section at the V&A. A few years ago, they curated an extraordinary show of Lafayette Studio portraits at the British Council in Delhi.

I owe much to Russell Harris in the making of this book. As for James Stevenson: he is a source of inspiration and has often guided me to magical sources of vintage treasures.

Queen Elizabeth II's collection at the Windsor Castle is one of the best-preserved photo archives in the world. It is looked after by the elegant Frances Dimond, who provided us with some of the oldest photographs, dating back to 1860's, used in the book. Windsor still upholds the gracious tradition of taking two tea breaks in the day. My wife, Kiran, and I enjoyed sifting through the mountain of the royal albums almost much as the tea and sympathy provided by Frances.

My grateful thanks also to Dr. Jennifer Howe and Helen George at the Indian Office Library in the British Library, Terrance Pepper at the National Portrait Gallery in London, and to Charles Merullo, Ali Khoja and Sara McDonald at the Hulton/Getty Images. The Henry Royce Foundation, the Rolls Royce Enthusiasts Club, UK, and the Musée Guimet, Paris also deserve mention. Not only did they guide me to some rare photo material used in the book, they cheerfully checked the source details as well.

Some of the most extraordinary and rarest photos came from princely states and private sources. Capt. Amarinder Singh, the Maharaja of Patiala, generously granted us free access to his archives. His brother, Raja Malvinder Singh, and his son Yuvraj Tikka Raninder Singh guided us through the Patiala collection and provided us with crucial information. Later, his cousin, Raja Randhir Singh helped us identify many of the Patiala royals in these photographs. This book would not have been half as attractive without their beautiful faces.

The late Madhav Rao Scindia, the Maharaja of Gwalior, invited me to visit his palace and the fort in Gwalior to see what they had. Though his collection was not very well documented, we managed to find some images that stand out like jewels in the book. Madhav Rao and I spoke to each other on a Saturday and he promised to meet me the next evening to sort out the captions for the pictures I had selected from his collection. Alas, that never happened. Tragically, Madhav Rao passed away that Sunday afternoon in a plane crash. However, his son, Jyotiraditya Scindia, was as generous as his father in granting us permission to use those pictures.

Rajmata Gayatri Devi of Jaipur, was a most gracious host when we spent three days sifting through her collection in her home, Lilypool, in Jaipur. Two of the most unusual 'trick photographs' of the time came from her collection. I can hardly describe what these have meant to the book.

Maharaja Brajraj Singh of Kishengarh was one of the first royals from the princely states to lend us his collection and later helped us identify many of the Rajasthan princes.

Brigadier Sukhjit Singh, the Maharaja of Kapurthala, not only selected the best of his collection but also provided detailed captions for each of them. His gracious help is gratefully acknowledged.

My friend Martand Singh, also from the Kapurthala family, lent us some fabulous photographs from his private collection including one stunning portrait of his late mother, Princess Sita, considered one of the most beautiful princesses of her time. The chapter called Born to Rule would not be as half as charming without these pictures.

'Tiger' Pataudi, Hanuwant Singh of Nabha, Jitendra Singh Alwar, Rajyashree Kumari of Bikaner, Madhukar Shah of Orchha and Richard Holkar of Indore responded enthusiastically to our requests. Their generous contribution to the volume is gratefully acknowledged.

I did not have the good fortune to personally visit the princely states of Baroda and Dungarpur. Jaiwant Paul had the honour of accessing their collection and he was able to select a large number of images from these two states. We both thank Maharaja Ranjit Singh Gaekwad of Baroda and Maharaja Mahipal Singh of Dungarpur.

Mr. Paul's daughter, Viveka Chattopadhyay, helped us source some rare frames of Raja Deen Dayal and inspired her father to write the text.

I would like to mention my colleagues, Ira Pande and Jitendra Pant for help in the research and writing of captions, and to Sneha for the design inputs. Neeta Datta, my assistant in photo research, understood and believed in my obsession. Towards the end she could recognize each Maharaja blindfolded.

Finally, my affectionate thanks to my wife, Kiran who uncomplainingly accompanied me wherever I went in search of photographs. This could be the cool comforts of London museums, but often were dingy old basements in boiling temperature with only mineral water as succour.

PRAMOD KAPOOR
New Delhi, 2003

श्री सवाई श्री मद्गभडार जाधिरप राजसिंह मदनसिंह हुकुमसिंह Rao Khengarji of Kutch

Maharaja Chhatrapati Maharaj of Kolhapur Appajirao Sitole Rao Rajitsinhji Dhangadhra

Bhupindra Singh of Patiala Rao Khengarji of Kutch Dharmendra

Madhav Scindia Maharaj of Gwalior bhili 1911 Bhim Shamsher of Manipur Ajit Singh Jhunjhunu Wahaduzafarkhan of Bhopal

S. Madho Singh Kishen Singh of Bhaartpur Sultan Jahan Begum राजा बहादुर सिंह
Maharajah Jaipur

Ranjitsinhji of Gwalior Krishnaraja Wadiyar Madan Singh Maharajah of Kishangarh Rama Varma of Travancore

Ganga Singh of Bikaner Summair Singh of Jodhpur गुलाब सिंह M. K. Himmatsinghi

Prabhu Narain Ahmad Ali Khan Nawab of Malerkotla of Idar
Maharajah of Benares

महाराजा रघुवीरसिंह Jey Singh - Alwar Rao Bahadur Raja
Delhi 1911 Chatur Singh C.S.I. of Alipura

महाराजा रघुवीरसिंह Raja of Sikkim Ram Singh of Sitamau Madan Singh M. K. Sadul Singh of Bikaner

Madhav Rao Puar of Dewas Junior Branch Mir Osman Ali Khan Nizam of Hyderabad Bhawani Singh of Jhalawar

Tukojirao Holkar of Indore Bhavsinghji Pratapsinh Balwantrao Scindia Mir Mahbub Khan
राजा of Kishangarh Raja Jackson Maharaja Saheb of Jaipur